# Land
# Without
# Ghosts

干遜

落機大山

威斯頓底特力

因底阿土番

密蘇爾鏖

密蘇爾鏖河

威斯頓達多里

因底阿土番

阿甘色

墨西哥界

得撒界

墨西哥界

撒得界

得撒界

魯西安那

椆山

墨西哥界

# Land Without Ghosts

Chinese
Impressions
of America
From the
Mid-Nineteenth
Century to
the Present

Translated
and Edited by
R. David Arkush
and Leo O. Lee

University of California Press

BERKELEY · LOS ANGELES · LONDON

University of California Press
Berkeley and Los Angeles, California

University of California Press, Ltd.
London, England

Library of Congress Cataloging-in-Publication Data

Land without ghosts: Chinese impressions of America from the mid-
   nineteenth century to the present/translated and edited by
   R. David Arkush and Leo O. Lee.
     p.  cm.
   ISBN 0-520-06256-6
   1.  United States—Foreign public opinion, Chinese—History.
   2.  Chinese—Travel—United States—History.   3.  United States—
   Description and travel.   4.  Public opinion—China—History.
   I.  Arkush, R. David, 1940–  .   II.  Lee, Leo Ou-fan.
   E183.8.C6L36   1989
   973.92—dc19

Printed in the United States of America

1 2 3 4 5 6 7 8 9

For Susan and Lan-lan

"American children hear no stories about ghosts. They spend a dime at the drugstore to buy a Superman comic book.... Superman represents actual capabilities or future potential, while ghosts symbolize belief in and reverence for the accumulated past.... How could ghosts gain a foothold in American cities? People move about like the tide, unable to form permanent ties with places, still less with other people.... In a world without ghosts, life is free and easy. American eyes can gaze straight ahead. But still I think they lack something and I do not envy their life."

—*Fei Xiaotong, writing in 1944*

# Contents

# List of Illustrations

# Foreword

by John K. Fairbank

The modern world has grown a bit cynical about ancient pieties like "international understanding," which not so long ago was to be obtained quickly by contact and then lead us toward peace. On the contrary, modern peoples as they know more about each other may only find out why they are in some ways real enemies. But this disaster seems unlikely in Chinese-American relations for two long-lasting reasons—first, the ingrained American liking for Chinese people and sentimentality about "China" and, second, China's customary non-aggressiveness, sense of civility, and current dependence on American technological assistance. Indeed so great has our interdependence with the People's Republic become that both for self-defense and for building a better world we need to know the stereotypes through which the Chinese people have seen us.

On this subject, however, we are amazingly uninformed. In an era when the American television is following the American movie into Chinese households, it is high time we take a look at the written impressions of earlier Chinese travelers to the United States. We can infer that their writings helped to create Chinese images of the United States that form a substratum below the news and advertising images of today.

One thing we know is that inherited cultural values change only slowly. For example, the coarseness or unsophistication of American cuisine compared with Chinese cuisine will be an enduring fact of life. Again, the American tendency for old people to live independently, separated from youth, will not diminish. Modernization may have put

Chinese and Americans in many respects on a converging course, but greater proximity will point up our differences.

Of the many trenchant observations in the pages of this book, the most significant to my mind are those of the young reformer Liang Qichao, who toured the United States and Canada for five months in 1903. The first thing to note is that Liang, as a major interpreter of the outside world to China in the 1900s, was putting his firsthand impressions in writing just about forty years after his Japanese counterpart Fukuzawa Yukichi had visited the West in preparation for his long career of explaining and advocating Western ways in Japan. Forty years was an index of China's lethargy and Japan's aggressiveness in meeting the modern world. During these forty years, moreover, several things had been sorted out. By 1900, for instance, it could no longer be assumed that Western industry, religion, and democracy were triune aspects of an integrated package of Western "progress" for the East to emulate. "The West" had grown to seem far more diverse, and Chinese reformers had to make choices.

Liang's superior acumen was evident in his detailed grasp of American institutions and public activities. In the end he rejected the vulgarity and many evils of American democratic life. For China's purposes he felt the strong state leadership found in Germany and Japan would be more useful. Liang's disesteem of American ways was a fact of great significance—though Americans interested in China have remained for the most part unaware of it—and it reflected China's lesser degree of concern about representative government and civil rights under a supremacy of law.

Two traditions provide a context for this volume. Behind the often pungent and sharp comments of the Chinese writers on the United States lies a Chinese custom. The writing of travel notes about places visited and observed had been a major literary genre from very early times in China. Just as the local scholar might put together a gazetteer describing the sights, historic figures, products, and industries of his region, so the scholar who traveled abroad ordinarily wrote his travel notes, often with an eye to publication. The Chinese who came to the United States during the last century were scions of this old tradition, well prepared in spirit to document a foreign scene. Typically, their writings were based on personal experiences, which made for a more vivid commentary.

The other tradition to keep in view is the enormous flow of writings sent home to America by missionaries in China. During the missionaries' century, from the 1830s to the 1930s, their home con-

stituencies were led to see China through their eyes. The resulting influence on American-Chinese relations was profound and pervasive. The stereotypes and changing attitudes among missionaries and other foreigners in China and their readers in America have by this time received considerable scholarly attention. The present volume marks an effort to even the balance by offering a selection of Chinese impressions of America.

For this purpose the two volume editors are unusually well qualified. R. David Arkush is a scholar of wide experience whose studies have taken him to Yale, Paris, Harvard, Taipei, Hong Kong, and Japan. Since 1972 he has been teaching at the University of Iowa. His best-known work is *Fei Xiaotong and Sociology in Revolutionary China* (Harvard University, 1981).

Leo O. Lee has had a similarly broad experience, receiving his early education in Taiwan and completing his graduate studies at Harvard. The author of *The Romantic Generation of Modern Chinese Writers* (Harvard University Press, 1973), and *Lu Xun and His Legacy* (University of California Press, 1985), he taught Chinese literature and literary history at Indiana University before moving to the University of Chicago. His organizing of conferences and editing of symposium volumes, as well as a copious flow of his own work, have led the way in the new study of modern Chinese literature in the United States.

# Introduction

R. David Arkush and Leo O. Lee

During his visit to the United States in 1946, the Soviet writer Ilya Ehrenburg is said to have remarked that to know a woman or a nation takes either thirty days or thirty years.[1] Leaving aside the bit about women, we can see what he meant about the advantage a newcomer has in perceiving another society. The visitor's impressions of a new country are fresh and sharp; he sees with a comparative perspective and is struck by things natives in their everyday familiarity do not notice. Accounts by foreigners can sometimes be startlingly perceptive. One of the best works ever written about the United States, it hardly needs to be said, was by an aristocratic French prison inspector who spent nine months on these shores 150 years ago. *Democracy in America* is not, to be sure, a simple first impression; after returning to France, Alexis de Tocqueville labored eight years researching and writing his two-volume masterwork. Still, his outsider's perspective on American society has much to do with the book's insights and fascination.

The volume of European writings about America is enormous and well known. By contrast, Americans are almost wholly ignorant of the impressive body of literature in Chinese about them and their country.[2] Henry Steele Commager, who had compiled an anthology of

1. According to the late William Nelson, who traveled with Ehrenburg as his State Department interpreter.
2. A partial bibliography of Chinese writing about the United States may be found in Robert L. Irick, Y. S. Yü, and K. C. Liu, *American-Chinese Relations, 1784-1941: A Survey of Chinese Language Materials at Harvard* (Cambridge: Harvard University, 1968), 168–98. For a succinct overview of Chinese views of the United States and the West (as well as of Chinese laborers and Chinese students in the U.S.), Jerome Ch'en,

largely European writings about America, once claimed that there were only two serious books about the United States written by Chinese authors: *An Oriental View of American Civilization* by No-yong Park (Boston, 1934) and Francis Hsu's *Americans and Chinese* (1953).[3] Commager was speaking of works available in English, of course, and while he might have mentioned a few others, it is true there is not much. Moreover, the works written in English for an American audience by Westernized Chinese expatriates who have lived for decades in the United States are in many ways less interesting than the more truly outsider accounts intended for Chinese readers. (A surprising number of nominally Oriental views of the West in Western languages are counterfeit, but that is another story.)[4]

---

*China and the West: Society and Culture, 1815–1937* (Bloomington: Indiana University Press, 1979) is excellent except for the infuriating absence of footnotes. An interesting short account is Wei-ming Tu, "Chinese Perceptions of America," in M. Oksenberg and R. B. Oxnam, eds., *Dragon and Eagle: United States–Chinese Relations, Past and Future* (New York: Basic Books, 1978), 87–106. An early, brief discussion is W. A. P. Martin, "As the Chinese See Us," *The Forum* 10 (1891):678–88.

3. H. S. Commager, Foreword to Francis L. K. Hsu, *Americans and Chinese: Passage to Difference*, 3d ed. (Honolulu: University Press of Hawaii, 1981), xiii. Commager's own anthology is *America in Perspective: The United States Through Foreign Eyes* (New York: Random House, 1947). Other books in English by Chinese on America are Chiang Yee's many "Silent Traveler" books, and No-yong Park's *A Squint-Eye View of America* (Boston: Meador, 1951); the ingratiating self-mockery of Park's title marks one difference between works written in English and those intended for a Chinese audience. Most recently there is also Liu Zongren, *Two Years in the Melting Pot* (San Francisco: China Books, 1984), and Wang Tsomin, *American Kaleidoscope—A Chinese View* (Beijing: New World Press, 1986). There are some interesting observations, and much whimsy, in George Kao, "Your Country and My People," in B. P. Adams, ed., *You Americans: Fifteen Foreign Press Correspondents Report Their Impressions of the United States and Its People* (New York: Funk & Wagnalls, 1939), 219–45. For an analysis based exclusively on Western-language materials, see Merle Curti and John Stalker, "The Flowery Flag Devils—The American Image in China, 1840–1900," *Proceedings of the American Philosophical Society* 96 (1952):663–90.

4. Because these counterfeit "Oriental" views of the West have too often been accepted as genuine, they are worth mentioning briefly here. Oliver Goldsmith's *The Citizen of the World: Or Letters from a Chinese Philosopher, Residing in London, to His Friends in the East* (1762) is probably the oldest, though preceded by several dozen earlier "Oriental," but not Chinese, views of European lands. G. Lowes Dickinson's *Letters from John Chinaman* (1901; published in the United States as *Letters from a Chinese Official: Being an Eastern View of Western Civilization*) provoked a serious reply, *Letters to a Chinese Official*, by William Jennings Bryan. In 1972 Dickinson's book was reissued by an American publisher as "the work of an anonymous official of the Chinese government," and the newly written introduction earnestly suggested that, on the occasion of Nixon's trip to China, "in the mirror of China we may take a fresh look at ourselves."

*Opinions chinoises sur les barbares d'Occident* (1909) by Comte Harfeld purports to be a translation of documents and a conversation about the West by Chinese officials and others, but scattered throughout are the telltale marks of a fraud: improbable comments (Westerners spend money on dikes instead of pagodas because they do not realize a pagoda will prevent floods) and explanations aimed at a Western audience (age fourteen in China is "really thirteen because we count from conception"). *A Chinaman's Opinion*

Works about the United States written in Chinese, however, are abundant. One bibliography of books and articles on American studies, though limited to items published in Taiwan and Hong Kong between 1948 and 1972, runs to no fewer than 560 pages.[5] That so little of this Chinese writing about the United States has been accessible to Americans is regrettable, for these works offer a fresh perspective on America.

One approach to these materials is to compare them to Europeans' travel notes and essays on America. Immediately one notices that Chinese visitors have tended to emphasize different aspects than Europeans and to draw different conclusions from similar observations. These differences, of course, are a reflection of different cultural backgrounds. In spite of America's geographical remoteness, Europeans have always thought of the United States as a branch of their own culture, a part of the familiar "us" of the West, and this sense of shared traditions shaped nineteenth-century European travelers' expectations of the new world. They tended to anticipate finding something familiar, and when they failed to find it or when what they found failed to appeal to their tastes, their impressions—both positive and negative—often veiled their sense of discomfort.

Consider, for example, early European criticisms of Americans as boorish. Europeans harped on our lack of manners, our "innate crudeness," our mangling of the English language (at least to British ears). We were dirty, picked out teeth, and had no sense of propriety at meals.[6] We were always putting our feet up on the table (even in Con-

---

*of Us* (1927), "by Hwuy-Ung" and "translated by" the Australian missionary J. A. Makepeace, is likewise, to us, clearly a fabrication (T. L. Yuan, *China in Western Literature* [New Haven: Yale University, 1958] gives the author as Theodore Tourrier), though it was excerpted by the French sinologue Roger Pélissier in *The Awakening of China*, 1793–1949, trans. Martin Kieffer (London: Secker and Warburg, 1967).

*As a Chinaman Saw Us: Passages from His Letters to a Friend at Home* (1905), an unsigned work with a preface by Henry Pearson Gratton, seems also a patent fraud, though it is among the primary texts cited by the scholar André Chih in *L'Occident "chrétien" vu par les Chinois vers la fin du XIXme siècle* (Paris: Presses Universitaires de France, 1962). A different kind of forgery is *The Memoirs of Li Hung-Chang* (Boston: Houghton Mifflin, 1913), with two chapters on the famous official's 1896 trip to the United States; it is now known to be a fabrication by William Francis Mannix, an American journalist.

5. *Meiguo yanjiu Zhongwen tushu ji qikan lunwen fenlei suoyin, 1948–1972* (Classified bibliography of Chinese language books and periodical articles on American studies, 1948–1972) (Taipei: Danjiang wenli xueyuan, 1974).

6. Here, for example, is Frances Trollope's description of dinner with self-styled generals and colonels aboard a Mississippi steamboat: "The total want of all the usual courtesies of the table, the voracious rapidity with which the viands were seized and devoured, the strange uncouth phrases and pronunciation; the loathsome spitting, from the contamination of which it was absolutely impossible to protect our dresses; the

gress, Charles Dickens noted); we chewed tobacco and spat incessantly, usually missing the spittoon—the Senate and House chamber carpets were ruined by this bad habit, according to Dickens, who warned against picking up anything there with an ungloved hand.[7] Americans were commonly depicted as loud, brash, and above all boastful: "conceited," "vulgar," "cocksure," in Rudyard Kipling's words.[8] We were perceived as not interested in the higher things in life. Even the well-disposed Tocqueville discoursed on the paucity of American artistic and intellectual achievement, and more than one European called Americans "barbarians." Though he published his remarks as *Civilization in the United States*, Matthew Arnold concluded that "a great void exists in the civilization over there, a void of what is elevated and beautiful, of what is interesting." In the next century, the British scientist C. E. M. Joad could not resist punning on a stereotype from Sinclair Lewis's fiction in the title of his caustic view of America, *The Babbit Warren.*

On the other hand, the positive side of the European commentary emphasized American egalitarianism. In his opening chapters, the aristocratic Tocqueville took egalitarianism almost as the starting point, the social basis of American democracy. Visitors from the old world were astonished—and sometimes discomfited as well—when waiters, hotel chambermaids, and train conductors unselfconsciously engaged them in casual conversation, asking direct questions and plainly showing that they considered themselves as good as anyone else. European accounts repeatedly stressed the self-confidence and sense of dignity of ordinary working people. Education was almost universal, they noted, and the nation's rich natural resources and economic opportunities inspired in all Americans an optimistic hope of rising to prosperity. Such observations often led to hyperbolic visions of America as the classless society. In the 1870s the Polish writer Henry Sienkiewicz declared without qualification: "Here the people of various walks of life...are truly each other's equals....They do not stand on different

---

frightful manner of feeding with their knives, till the whole blade seemed to enter into the mouth; and the still more frightful manner of cleaning the teeth afterwards with a pocket knife, soon forced us to feel that we were not surrounded by the generals, colonels, and majors of the old world; and that the dinner hour was to be any thing rather than an hour of enjoyment" (*Domestic Manners of the Americans* [1832; rpt. London: Folio Society, 1974], 37).

7. Charles Dickens, *American Notes* (1842; rpt. Greenwich, Conn.: Fawcett, 1961), 144.

8. Rudyard Kipling, *American Notes* (1899; rpt. Norman: University of Oklahoma Press, 1981), 124.

rungs of the social ladder, for the simple reason that there is no ladder here at all. Everybody stands on the same level."[9]

Another prominent theme in European accounts is the idea of America as a religious and fundamentally moral society. Tocqueville stated that religion was nowhere more important than in America, where it played an essential role in social morality and in the democratic process. Other also characterized Americans, despite recurrent political corruption and frontier violence, as essentially honest and law-abiding, remarking with surprise on such things as untended newsstands, where customers left money on the honor system, and fewer fences and locks than in Europe. Even sexual morality was viewed as generally stricter than in Europe. American women were thought to be rather virtuous on this count—despite or because of attending school with males and feeling at ease with them, and despite being bold, independent, apt to have and voice their own opinions. Indeed Tocqueville thought married American women acted more restrained than married women elsewhere, and he attributed this to religion.

These images of American boorishness, egalitarianism, and religious morality, however, though so prominent in the European view of America, are all but entirely absent from Chinese accounts. Though Chinese tradition places the highest value on social propriety and cultural refinement, these visitors seem to have been little bothered by Americans' lack of manners. The early Chinese diplomats, as we shall see, were on the contrary rather nonplussed by the etiquette demands of attending and giving dinner parties. More recent Chinese visitors have commented on the politeness of Americans—on how we constantly say "please" and "thank you" even to strangers and spouses, on the frequency of compliments, on telephone etiquette, on the popularity of Emily Post—and at least one thought Americans more mannerly than Europeans.[10] Far from thinking of America as uncivilized, Chinese by the thousands were coming here by the early twentieth century for higher education. Of course, the Chinese were not encumbered by the European mantle of guardianship over Western civilization. Chinese approached America as an alien society and culture, and did not feel themselves to be the custodians of our civilization. They did

---

9. Henry Sienkiewicz, *Portrait of America* (New York: Columbia University Press, 1959), 18.
10. Xing Gongti, "The Politeness of Americans," in Huang Minghui, ed., *Lü Mei sanji* (Notes on staying in America) (Taipei: Zhengwen, 1971), 215–25; Luo Lan, *Fang Mei sanji* (Notes from a visit to America) (N.p., n.d. [Taipei, ca. 1971]), 29–33.

not expect us to act like Confucian gentlemen and did not care if we fractured our Latin or Greek.

That Chinese also took little note of American religiosity and its role in American life is more surprising, perhaps, especially in the first half of the twentieth century, given the presence of thousands of American missionaries in China.[11] Indeed, some Chinese visitors did note that people in America were much less religious than their earlier contact with missionaries in China had led them to expect.[12] But one must remember that the prevailing intellectual atmosphere in modern China has been generally nonreligious. Neither Confucianism nor popular Buddhism in China, despite their heavy ethical emphases, was an organized religion anything like American Christianity. As a consequence of this, no doubt, modern Chinese intellectuals, with a few exceptions, have tended to be little interested in religion in the United States.

As for American social morality, one finds Chinese writers sometimes troubled by certain inhumane or immoral aspects of American social patterns. That Americans are conscientious about small matters but shockingly immoral about large ones is the paradox expressed in a Chinese cartoonist's series of panels about the sale of newspapers on the honor system (see page 189). Like European observers, Ye Qianyu found this bit of sidewalk honesty from an earlier age worthy of note; but in his cartoon the newspaper headline bears an unspeakable horror—a boy has murdered his mother.

As for egalitarianism, Chinese writers have been more apt to underline the *inequalities* in American society—in particular the enormous distance between rich and poor, between the unimaginable luxury of America's millionaires and the misery of urban ghettos. Liang Qichao, an eminent journalist and reformer whose work on America is in some ways comparable to Tocqueville's, hardly mentioned the word *equality* in his travel notes, published in 1903. Liang dwelt instead on the theme of economic inequality, noting that 70 per-

---

11. Hu Shi notes the omission of religion in his foreword to Cheng Tianfang, *Meiguo lun* (On the United States) (Taipei: Zhengzhi daxue, 1959), a thick, scholarly opus on the United States. Cheng devotes attention to America's history, political system, economy, education, women, news media, crime, race relations, and way of life, but, like other Chinese works on the United States, Hu states, Cheng's book neglects the important topics of religion and the judicial system.

12. Xu Zhengkeng, in the 1920s, and Fei Xiaotong in the 1940s, both of whom had studied in American missionary schools in China before going to America, wrote of such mistaken expectations. Xu Zhengkeng, *Liu Mei caifeng lu* ("Things About America and Americans") (Shanghai: Shangwu, 1926), 343; and Fei Xiaotong, *Chu fang Meiguo* (First visit to America) (Shanghai: Shenghuo, 1946), 128.

cent of America's wealth was in the hands of one-fourth of 1 percent of the population. In New York Liang observed that immigrants were living and dying in wretched squalor, crowded into tenements without light or ventilation (see chapter II).

Chinese observers were less likely than Europeans to mistake America's social mobility and lack of aristocracy for classlessness. In the century following the French Revolution, European travelers could not fail to be struck by the absence of feudal and aristocratic traditions in America. China, however, without being egalitarian, had long been a nonaristocratic society with, at least in theory, *la carrière ouverte aux talents*. The Chinese aristocracy of hereditary power-holders had disappeared a thousand years ago, and while the sociopolitical structure remained hierarchical, it entailed considerable social mobility.

Timing, no doubt, is also a significant factor here: European images of America had already taken shape in the early nineteenth century, before industrialization altered the economic and social fabric of American society. The *Harvard Guide to American History* lists well over three hundred European travel works written between 1795 to 1865, but only about half as many titles for the much longer period since then. The Chinese case is the reverse: virtually no serious writing about America existed before 1865, and only in the late nineteenth century did educated Chinese begin to arrive in significant numbers. The America most Chinese visitors came to know, from the late nineteenth century on, was in many ways a different country altogether. America had become less egalitarian and more enmeshed in rapid technological progress and economic expansion. An emergent imperialist power playing an increasingly important role in the Pacific, America was also an immigrant society beset by ethnic conflicts and problems, some directly related to the Chinese themselves.

Racism, of course, is a kind of American inequality to which Chinese visitors have naturally been sensitive. One of the first works of American literature translated into Chinese, early in the twentieth century, was *Uncle Tom's Cabin*, and Chinese writing about the United States since then has seldom failed to include a description of the "Negro question." The anthropologist Fei Xiaotong, who spent a year here during World War II, for example, added an entire chapter on blacks to his Chinese rendering of Margaret Mead's *The American Character*, and he took her to task for not having considered them.[13] To

13. Fei Xiaotong, *Meiguoren de xingge* (The American character) (Shanghai: Shenghuo, 1947), chap. 7.

be sure, Chinese concern for American blacks was not necessarily grea-
ter than that of Europeans. Chinese traveled as whites in the South, did
not particularly identify with blacks, and occasionally seemed all too
ready to adopt the prejudices of the dominant group—as is suggested
by Liang Qichao's remarks about lynching, which curiously blend
sympathy for victimized blacks with acceptance of current racial
stereotypes.

But sometimes white America's treatment of blacks was discussed
as parallel to the discriminatory treatment of Chinese immigrants in
the United States. The awareness of this discrimination not only made
Chinese writers less apt than Europeans to exaggerate the equality of
American society but also constituted their central criticism of
America. Harsh feelings intensified in the late nineteenth and early
twentieth centuries as the U.S. Congress enacted increasingly stringent
measures to restrict Chinese immigration. In response, Chinese
mounted a movement to boycott American goods, the first Chinese
boycott against any foreign country.

As one would expect, many themes not prominent in European
accounts surface in Chinese articles and books about America. Most
obviously, a description of some American Chinatown or other is virtu-
ally de rigueur. The visitors naturally felt a kinship for these fellow
Chinese and an interest in their living conditions. Nevertheless, many
visitors from China felt oddly uncomfortable and estranged in
American Chinatowns, where they often had to speak English with
Chinese-Americans, virtually all of whom were Cantonese from the far
south unable to speak standard Mandarin, and where "Chinese" re-
staurants featured American innovations like chop suey. The literature
of the immigrant experience is now receiving wide attention, especially
among Chinese-American scholars.[14]

America's enviable technology has been a dominant concern since
the earliest firsthand accounts in 1868. These first visitors were officials
and diplomats sent as part of the Qing dynasty's effort to learn more
about the Western powers after China's defeat in the Opium Wars.
Their accounts combine a sense of wonder with detailed descriptions of
American trains, ships, factories, buildings, and military installations.

14. For a thorough annotated bibliography of the Chinese literature, see Him Mark
Lai, *A History Reclaimed: An Annotated Bibliography of Chinese Language Materials on
the Chinese of America* (Los Angeles: University of California, 1986); a companion bib-
liography of works in English is underway. For a succinct biographical essay on Chinese
immigrants in the United States, see Michael H. Hunt, *The Making of a Special Rela-
tionship: The United States and China to 1914* (New York: Columbia University Press,
1983), 329–31. Marlon K. Hom, *Songs of Gold Mountain: Cantonese Rhymes from San
Francisco Chinatown* (Berkeley: University of California Press, forthcoming) presents
translations of poems from the anthologies *Jinshan ge* (1911, 1913).

This fascination with American technology has never totally faded, and in recent writings one sees visitors from the People's Republic again seeking the clues to wealth and power in a postindustrial and "postmodern" American society. Thus from the mid-nineteenth century to the present, America has often seemed to be a model or even to represent the future, and the desire to learn about modern techniques has drawn many Chinese to the United States.

Yet the quest for modernization, whether in late Qing or the present, extends naturally and perhaps inevitably from technology to institutions and values. The initial accounts of America as an alien, exotic new world were soon replaced by more considered examinations of American society as both model and menace. Some of the more astute visitors realized that alongside the technological wonders were peculiarly American techniques of organization. Li Gui, a Chinese official who visited New York in the 1870s, wrote approvingly of the electric remote alarm system and horse-drawn steam-powered pumpers used by fire-fighters, but he also described the organization of people that enabled the equipment to be used effectively (see Chapter I). Later visitors have gone a step further by remarking on political institutions and traditions: the effectiveness and stability of the government, the practices of local self-rule, the makeup of Congress, the system of electing the president, and the public-spiritedness with which Americans support their institutions as responsible citizens.

But American technology and organization also have a dark side for some Chinese. The sensitive and perceptive Liang Qichao, in particular, was aware of the ominous consequences of America's economic progress. At the turn of the century Liang wrote with apprehension of those gigantic industrial and financial conglomerates, the industrial trusts, which he reported controlled 80 percent of the national capital and whose power "exceeds that of Alexander the Great and Napoleon." American capitalism, Liang noted with alarm, was likely to eventually replace England's imperialistic might and could overwhelm international geopolitics.

Despite Liang's grave warnings about the United States as an emerging world power, many Chinese were—and continue to be—impressed by the dynamism and youthful vigor of individual Americans, the same youthful energy decried by earlier European visitors as uncouthness and lack of sophistication. In late-nineteenth-century China social Darwinist ideas and a budding nationalism had turned many intellectuals to thoughts of renovation and reform, or—in the more exuberant imagery that became current slightly later—of revolutionary rebirth from the ashes of an old and decayed culture. The talk

of a New People and a New China in the early twentieth century reflected the ongoing critical reexamination of the Chinese national character and the perceived need for purposeful assimilation of Western values and qualities. For the advocates of total Westernization, America—for better or worse—was again viewed as a model for emulation. Chief among the qualities that had made the young nation so rich and powerful, Chinese commentators explained, were the work ethic and the people's energy, both of which contributed to speed and efficiency. Americans work hard; there is little sign of idleness in offices and factories. Americans seem to know how to renew their energies through rest and relaxation. Americans become independent at a young age and support themselves by working their way through college. Americans know how to plan ahead and how to save time. One Chinese traveler, Tang Hualong, praised the apparent conundrum of Americans' having taken three generations to build the Brooklyn Bridge so that people could save a few minutes going to and from Manhattan (see Chapter III).

As the twentieth century advanced, the United States became the most popular foreign destination for Chinese. More and more Chinese came, no longer as immigrant workers or official representatives, but as individual travelers on much longer stays and as students at American universities. After World War II and the Communist victory in China, many chose to stay and become permanent residents or citizens. In recent years, those coming from Taiwan have reached record numbers. Their extensive experience has bred a familiarity with American society, and the massive volume of their writings on America draw not only on personal experience but on American writings as well, as translations into Chinese have multiplied. At the same time, the ability to read and speak English have become routine skills for many educated Chinese in Taiwan.

Most of these postwar works focus on details of a more social and personal nature. While Chinese have continued to find much to praise, particularly the independence, competence, and self-assertiveness of American women (indeed, since the 1870s, many Chinese have been favorably impressed with American women), they also began to see the negative consequences of the qualities they had initially admired. Some voice serious doubts about aspects of American behavior and about personal relations between the sexes and within the family. Even down to the present day, many are uneasy when confronted with public kissing, provocative clothing, or erotically charged advertisements,[15] to

15. For an example, see Zhang Qijun, *Lü Mei manhua* (Sketches of travel in America) (Taipei: Shangwu, 1967), 89–94.

say nothing of American pornography and the rate of divorce. American friendships have also sometimes seemed weak to Chinese observers. The shallowness of emotional ties with other people, suggests a recent article in the *People's Daily*, may explain why so much attention is lavished on pets—another American peculiarity.[16]

The isolation and loneliness of American life is another theme prominent in Chinese descriptions but not in the European travel literature. In this land without ghosts, as Fei Xiaotong suggested, in a nation without strong traditions or bonds with the past, people lack a sense of continuity with their ancestors and their heritage. Other visitors have seen the ubiquitous automobile as a cell that isolates individuals, separating them from their neighbors and communities. Conceivably Chinese visitors, so many of them students, are more attuned to loneliness because of the isolation they themselves feel, particularly on Sundays and holidays when Americans withdraw to the privacy of their homes.[17] But to the Chinese, the value Americans place on independence and individualism robs them of a supreme satisfaction: a sense of connectedness with others. Furthermore, to the more conservative-minded, independence and individualism have an immoral aspect: the self-indulgent pursuit of pleasure, sexual or otherwise, blinds some Americans to their moral obligations toward others. Coupled with a legal system that is perceived as overprotective of the rights of criminals, this excessive libertarianism has seemed to some Chinese to bear the threat of social anarchy. Visitors from the People's Republic of China in the late 1970s and early 1980s expressed horror at the rates of crime and unemployment, at the instability of prices and the cost of medical care. To members of socialist Chinese society, which provides lifetime job tenure and considerable economic and other security, the price of American individualism seems unacceptably high: an anxious personal insecurity underlies the nation's affluence and political stability.

Of the social themes, perhaps the one discussed most frequently by Chinese observers is the American family system. To some, the nuclear family seems admirably cohesive, while others view it as fragile and almost unethical in its neglect of the aged. In the ideal Chinese family, older and younger generations live under one roof; if this is impossible,

16. *Renmin ribao*, April 20, 1981, 7. As an anonymous Chinese informant put it, "The Chinese say you have to be either an American or a lunatic to talk to dogs or play with dogs" (Margaret Mead and Rhoda Métaux, eds., *The Study of Culture at a Distance* [Chicago: University of Chicago Press, 1953], 118). For a recent caricature of an American woman gushing about her five-hundred-dollar dog at a cocktail party, see *Ding Ling sanwen jinzuo xuan* (Selected recent essays of Ding Ling) (Kunming: Yunnan renmin, 1983), 217–22.

17. Fei Xiaotong wrote of feeling lonely on Sunday, in *Meiguoren de xingge*, 18–19.

proper reverence and care for parents and grandparents are a paramount moral obligation. Thus Chinese visitors have been shocked to see elderly Americans living apart from adult children and beloved grandchildren and accorded little respect or financial support. Expressions of horror at such cold and even cruel treatment are common in Chinese writings about America, and the literature contains countless sad vignettes of lonely, abandoned, pathetic elderly Americans yearning for some word from their distant children. Even within households, family members have their own rooms and live apart, behind closed doors. A recent description of American family life at Christmas time by a student baby-sitter from Taiwan tells of a pattern of constant activity, of TV watching and people coming and going, but little real human contact (see chapter V). The American family seemed like the wooden horses on a carousel—always in motion but never coming together.

To offer Americans a chance to see themselves from this Chinese perspective, we have compiled and translated the present volume of selections from a large body of Chinese literature since the mid-nineteenth century. In choosing the selections, we looked to works that were either representative or of special interest. Almost all the selections were written by people who actually visited the United States, and our survey samples a variety of topics and types of writers. We have given preference to works widely read and influential in China, and many of our selections are by leading intellectuals of the twentieth century, such as Liang Qichao, Hu Shi, Zou Taofen, and Fei Xiaotong, whose ideas about China's future were in some cases affected by their views of America. Beyond that, our guiding criterion has been to find excerpts that we thought would be interesting to American readers. What unconscious biases and preconceptions came into play in making these subjective judgments we cannot say.

We would like to thank the following people for reading earlier versions of this book and offering useful comments and suggestions: John Fairbank, Charles Hayford, Michael Hunt, Linda Kerber, Andrew Nathan, and Shelton Stromquist. Wenxi Liu, an energetic research assistant, carefully checked some of the translations and helped in other ways. The initial impetus for this book came out of the Luce Seminar on American-East Asian Cultural Relations organized by Akira Iriye at the University of Chicago. Research for one semester was supported by a University of Iowa faculty developmental assignment. Above all, we are grateful to Susan Nelson, who gave the manuscript an especially thorough reading, most of it more than once over the course of several years, and improved it in countless places.

NOTE ON THE TEXTS

The titles and section headings of the translations are in many cases our own, and occasionally we have rearranged the order of excerpts from long works. The date after the author's name in each heading is usually that of the visit being described and not necessarily the date of composition or publication.

Square brackets indicate our interpolations, and guillemets (« ») indicate words that appear in English in the Chinese text (though we have silently corrected some misprints in this English). We have often guessed at the spelling of Western names; in the Chinese texts they are written with phonetic approximations that are not always readily identifiable. We have occasionally reproduced such phonetic approximations and rendered literally some expressions (for instance, "fire-wheeled vehicle" for "train") in order to suggest the newness of such terms to Chinese readers. Similarly, we have sometimes left dates in Chinese style as a reminder that Chinese who visited America before 1912 were dealing with a totally alien system of reckoning time. "Miles" in these texts is presumed to mean Chinese miles (*li*), three of which are about equal to an English mile; a Chinese acre (*mu*) is about one sixth of an English acre.

Chinese words are romanized according to the pinyin system, and the pronunciation more or less follows English with the following notable exceptions:

| | | | |
|---|---|---|---|
| *x-* | is like | | 'sh' |
| *q-* | " | " | 'ch' |
| *zh-* | " | " | 'j' |
| *c-* | " | " | 'ts' |
| *z-* | " | " | 'dz' |

*-i* is more or less silent in the syllables *zi, ci, si, zhi, chi, shi,* and *ri*; elsewhere it is pronounced 'ee' as in 'machine'.

# I

# Exotic America

Before the middle of the nineteenth century, Chinese had little interest in Westerners and knew almost nothing about the United States. The most accurate Chinese geographical work of its day, the *Hailu* of 1820, which was based on a Chinese sailor's account of his travels in 1782–1795, could tell the Chinese little more about America than that: "Mie-li-gan country is an isolated island in the middle of the ocean, its territory rather constricted. Originally a fiefdom of England, it now has become a nation." This, to be sure, was a considerable improvement on the contemporary gazetteer of Guangdong province, which located the United States in Africa.[1]

China's defeat in the Opium War of 1840–1842 demonstrated to a few officials the need to learn more about the West, but most still retained a rather haughty and aloof attitude. The official who negotiated China's first treaty with the United States in 1844, for instance, reported to the emperor that:

The location of the United States is in the Far West. It is the most uncivilized and remote of all countries. Now Your Majesty has granted them the Imperial Favor of a special Edict which they can observe forever. You have rewarded the sincerity of their admiration for our righteousness and are encouraging their determination to turn toward culture. The different races of the world are all

---

1. Xie Qinggao, *Hailu zhu* (Shanghai: Zhonghua, 1955), 75. Kenneth Chen, "Hailu: Fore-runner of Chinese Travel Accounts of Western Countries," *Monumenta Serica* 7 (1942):208–26. Chen Shenglin, "Yapian zhanzheng qianhou Zhongguoren dui Meiguo de liaojie he jieshao" (Chinese understanding of and introduction to America before and after the Opium War), *Zhongshan daxue xuebao* 1980, 1:55–74 and 2:32–48.

grateful for your Imperial charity. But the said country is in an isolated place outside the pale, solitary and ignorant. Not only are the people entirely unversed in the forms of edicts and laws, but if the meaning be rather deep, they would probably not even be able to comprehend. It would seem that we must make our words somewhat simple.[2]

The ideas of Americans held by ordinary Chinese, if they had any at all, are less easy to discern, but some notion may be had from this passage from a recollection of a boyhood in rural Guangdong in the 1880s:

I listened and heard much concerning the red-haired, green-eyed foreign devils with the hairy faces, who had lately come out of the sea and clustered on our shores. They were wild and fierce and wicked, and paid no regard to the moral precepts of Confucius and the Sages; neither did they worship their ancestors, but pretended to be wiser than their fathers and grandfathers. They loved to beat people and to rob and murder. In the streets of Hong Kong many of them could be seen reeling drunk. Their speech was a savage roar, like the voice of the tiger or buffalo, and they wanted to take the land away from the Chinese. Their men and women lived together like animals, without any marriage or faithfulness, and even were shameless enough to walk the streets arm in arm in daylight.[3]

Slowly, however, from the mid-nineteenth century on, a few educated Chinese began to form a more accurate and less contemptuous image of Westerners, including Americans. The initial impetus for this interest came from a series of Chinese defeats at the hands of Westerners, beginning with the Opium War, and from the increasingly troublesome Western presence in China. There was a need for intelligence about these difficult peoples. The first serious writings in this vein, from the 1840s, were compiled by high Chinese officials who were in touch with foreigners at the southeast coastal ports. Their interests naturally tended to the political and the sources of American military and economic power. They were also curious about the strange method of selecting leaders. At this time many Chinese officials seem to have thought Americans somehow special, more trustworthy and less predatory than the British and other Europeans.[4]

By the late 1860s Chinese officials began to visit America. They

---

2. Qiying, *Chouban yiwu shimo* (All about managing barbarian affairs), Daoguang 73:29a; translation after Earl Swisher, *China's Management of the American Barbarians* (New Haven: Yale University Press, 1951), 48.

3. Lee Chew, "The Life Story of a Chinaman," in Hamilton Holt, ed., *The Life Stories of Undistinguished Americans* (New York: J. Pott, 1906), 285.

4. Michael H. Hunt, *The Making of a Special Relationship: The United States and China to 1914* (New York: Columbia University Press, 1983), 40–51.

were apparently required to keep diaries of their activities; many of these were subsequently published. Influenced by the contemporary Chinese concern for "self-strengthening" and making China strong and powerful, they tended to see America as a reigning example of a "new continent" of industrial and technological splendor. They were awed by the magnificent multistoried buildings and the speed of the new trains and streetcars, such as those in San Francisco, and impressed by the efficiency and carefulness of Americans. They noted such thoughtful details as menus in both English and Chinese, though these courteous visitors seldom commented on American food itself. High society, which from San Francisco to New York regularly hosted social functions in honor of the official Chinese guests, was also described in positive terms; to Chinese eyes it looked rather elegant. The official Chinese diarists seldom mentioned the beauty of American ladies (who caught the notice of contemporary Japanese emissaries),[5] though they did comment on their clothing—the baring of their necks and upper torsos—and on the custom of mixed company at formal banquets. The general impression seems again to have been favorable. American women with their wildly fashionable dresses and gowns were not regarded as "barbarian" but only different. Any further comment might well have been inappropriate for an official diary.

Even the most sympathetic of these earliest accounts reveal a sense of amazement at the curious customs of these distant peoples.

5. See Masao Miyoshi, *As We Saw Them: The First Japanese Embassy to the United States (1860)* (Berkeley: University of California Press, 1979).

# George Washington and the American Political System

Xu Jiyu, 1848

*Xu Jiyu (1795–1873), governor of Fujian province, never visited America. His* Ying-huan zhi-lüe *(Short account of the oceans around us) was based on information gleaned from foreigners in China and on diverse readings. Xu gives much careful information about American geography, history, and government, most of it apparently drawn from a book written in Chinese by an American missionary, E. C. Bridgman, "A Short Account of the United Provinces of America," published in Singapore in 1838.[6] Xu was favorably impressed with what he learned of the United States, and his descriptions of George Washington and the American political system would remain influential in China for decades (see, for instance, the selection by Zhigang later in this chapter and the poems by Huang Zunxian in chapter II). To the Chinese, recently defeated by England, Washington was particularly interesting for his success in repulsing the British. And, as Xu's account makes clear, the story of Washington's retirement from office appealed to Chinese meritocratic ideals. Legends about the earliest antiquity, before the first dynasties had established hereditary rule, told of sage rulers handing over the throne to men chosen for merit. Such traditions, whose ideals later became institutionalized in China's civil service system, provided Xu's readers with a context for appreciating American democracy.*

6. Fred W. Drake, "Protestant Geography in China: E. C. Bridgman's Portrayal of the West," in Suzanne Wilson Barnett and John King Fairbank, eds., *Christianity in China: Early Protestant Missionary Writings* (Cambridge: Harvard University, 1985), 101. On Xu, see Fred W. Drake, *China Charts the World: Hsu Chi-yü and His Geography of 1848* (Cambridge: Harvard University, 1975) and Drake's "A Nineteenth-Century View of the United States of America from Hsu Chi-yü's *Ying-huan chih-lueh*," *Papers on China* 19 (1965):48–49.

The continent of A-mo-li-jia is not connected with the other three continents. The territory is divided into two lands, northern and southern. The northern land is in the shape of a flying fish; the southern looks like the thigh of a man wearing a billowing trouser. In the middle a narrow waist connects them....

As a separate area, America had no contact with other continents from the beginning of the world. Its people had the five senses, limbs, and trunk, and were quite similar to the Chinese, but their complexion was purplish-red, like copper or like the color of palm fiber. When they cut their hair they left several inches remaining, which was gathered on top of the head and bound together in a top knot....

During the Hongzhi period [1488–1505] of the Ming dynasty a Spanish official named Columbus sailed a great vessel westward in search of new territories. He first reached at the archipelagoes of the Caribbean Sea, and so discovered the spacious land of America....

Mi-li-jian [the United States] is a large nation in the Americas. Because its ships fly a flag with flowers [i.e., stars], the people of Guangdong call it the Flowery Flag Country....

There was one named Hua-sheng-dun [Washington] (also written Wang-xing-teng and Wa-sheng-dun) who ... was born in 1731 [actually, 1732]. When he was ten years old his father died, and his mother raised him. In his youth he had great ambitions, and he was naturally gifted in both civil and military affairs. His bravery and eminence surpassed all others.... When the people rebelled against Britain, they insisted that Dun [Washington] be the commander-in-chief....

When Washington had settled the country, he handed over his military authority and wanted to return to his fields. The people were unwilling to part with him and chose him to be the state's ruler. Washington then said to the people that it would be selfish to take a state and pass it on to one's descendants; it was better to choose a person of virtue for the responsibility of guiding the people. The former territories were separately established as states, and each state has one commander [governor].... He is recommended and selected from among the elders of city and country. Each writes out the name of the one being recommended and casts it into a box. When they have finished, the box is opened to see who has the most, and that person is established in office regardless of whether he is an official or a commoner. A commander who has retired from office is equal with the

*Figure 1.*    Map of the United States, 1848, from Xu Jiyu, *Ying-huan zhi-lüe* (Short account of the oceans around us), 9:12b–13.

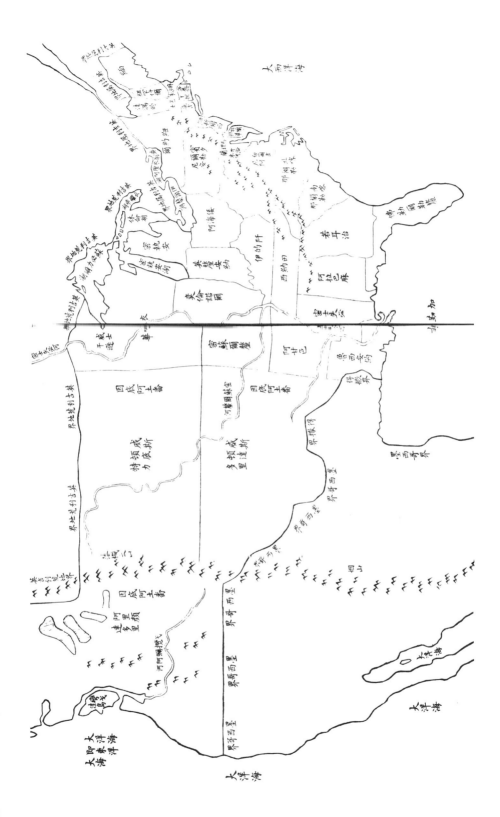

common people as before. From among the commanders of each state, a general commander [the president] is recommended, and he alone governs the affairs of making treaties and engaging in war. Every state obeys his orders. The method used to recommend and select him is the same as that used to select the commanders of the various states. The term of office is also four years, or if he serves a second time, eight....

Comment: Washington was an extraordinary man. In raising a revolt, he was more courageous than Sheng or Guang; in carrying out an occupation, he was braver than Cao or Liu.[7] After he had taken up the three-foot sword and opened up the boundaries for ten thousand miles, he did not assume the throne and did not begin a line of succession, but invented a method of selection. This is equivalent to the world being shared by all people and swiftly carrying out the old ideal of the three dynasties [of ancient China]. He governed his nation with reverence and encouraged good customs. He did not place value on military achievements; he was very different from [the rulers of] other states. I have seen his portrait. His bearing is heroic and imposing without peer. Ah! Should he not be called the most exceptional among men?

The climate of the various states of America is agreeable. In the north it is like Hebei and Shanxi, and in the south like Jiangsu and Zhejiang.... There are many small rivers and here and there the Americans have connected them to make canals. They have also built fire-wheeled vehicles [*huo lun che*, trains], using rocks to make a road-bed, with melted iron poured on them in order to facilitate the fire-wheeled vehicle's movement. In one day they can travel over three hundred *li* [100 miles]. Fire-wheeled ships are especially numerous; they move back and forth on the rivers and seas like shuttles. This is so because the land produces coal (fire-wheeled ships must burn coal, for the power from wood is too weak and cannot be used...).

The United States government is most simple, and the taxes are light, too. A census is taken every ten years. Every other year, out of each 47,700 people a person distinguished in ability and knowledge is selected to live in the capital and participate in the country's government. In the capital, where the general commander resides, the states have established an assembly, and each state selects two virtuous

---

7. Chen Sheng and Wu Guang were leaders of peasant revolts in the third century B.C. Cao Cao and Liu Bei were commanders of the third century A.D., celebrated in both history and folklore.

scholars to be in the assembly. They participate in deciding great matters of government, such as treaties, war, commerce, taxes, and stipends. Six years is the length of office....

The states all believe in the Western religion. They enjoy discussing scholarly matters, and colleges are established everywhere. The scholars are divided into three categories: academic, for the study of astronomy, geography, and Christianity; medical, for curing illnesses; and legal, for managing trials and imprisonments.

Comment: South and North America are several tens of thousands of miles in length, but the best part is the United States. The favorable climate and fertile land are no different from those of China. The English crossed ten thousand miles of sea to obtain the place, and this can be called getting the pearl. They developed it for more than two hundred years and it quickly achieved a prosperity that has overflowed into the rest of the world.... The United States of America has a territory of ten thousand miles. It has not established titles of king and count, and does not follow rules of succession. The public organs are entrusted to public opinion. There has never been a system of this sort in ancient or modern times. It is really a wonder. Of all the famous Westerners of ancient and modern times, can Washington be placed in any position but first?

# Trains
# and Treaties

Zhigang, 1868

*After the Opium War and Xu Jiyu's geography, another
quarter of a century passed before descriptions of America were published
by Chinese who had actually been to the United States. Although some one
hundred thousand coolies sailed to the California coast in the three decades
following the gold rush of 1849, most were illiterates whose horizons and
American experiences were limited, and they left little in the way of
writings published in China. Nor do we find recorded impressions of
America by any of that extraordinary group of 120 students who spent
many years in New England in the 1870s under Rong Hong (Yung
Wing).[8] It is rather diplomats, sent in part to look after the interests of the
coolies, who provide the earliest firsthand Chinese views of America*

*China's first diplomatic mission to the United States arrived in 1868.
It included the recently retired American envoy to China, Anson Bur-
lingame (who used the opportunity to make stirring speeches to Americans
about "planting the shining cross on every hill and in every valley" of
China) and two high Chinese officials. One of these, a Manchu named
Zhigang, published his journal of the trip a few years later. For Zhigang,
as for subsequent voyagers, the trip abroad was a series of physical tortures
and tribulations: he was seasick on the voyage and suffered from the
climate and various illnesses. But his intellectual journey was a series of*

8. William Hung, "Huang Tsun-hsien's Poem 'The Closure of the Educational
Mission in America' Translated and Annotated," *Harvard Journal of Asiatic Studies* 18
(1955):55–73. Rong Hong's own English autobiography has disappointingly little to say
about his adopted country; Yung Wing, *My Life in China and America* (New York: H.
Holt, 1909).

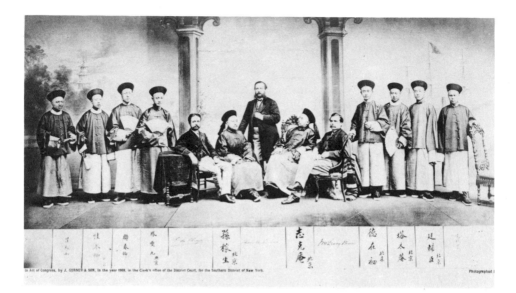

*Figure 2.*    Burlingame delegation, 1868. Anson Burlingame is standing in the middle, with Zhigang sitting just to the right looking at him. Zhang Deyi may be the leftomost of the junior people standing on the right. From The Bettmann Archive.

*wonderous discoveries and insights into the technological marvels of the "New Continent." In his diary he makes almost no mention of disappointments or misunderstandings. Of course, his official mission was to establish friendly diplomatic contacts with various countries, and if he harbored private criticisms he may have felt constrained to omit them from his official account.*

*Still, his sense of delight and wonder seems genuine. In his short diary Zhigang, who knew no English, lavishes his attention on Western technology. His description of the steamship that carried the delegation across the Pacific includes technical and statistical details on the ship's tonnage, measurements, and the workings of its engine. At Niagara Falls he marveled not only at the scenic beauty of the site, which was described in most Chinese and European travel guides, but also at its hydroelectric generating plant. Other stops included shipyards, a mint, a printing plant, an artillery emplacement in Boston harbor, an observatory in Cambridge, a textile mill in Lawrence, a paper-making plant, and a steel mill in Buffalo.*

*Zhigang's preoccupation with technology exemplifies the "ships and guns" mentality of Chinese officialdom of the so-called Self-Strengthening period, which started in the 1860s. Within the following decades, this credo prompted the government to send scores of young Chinese to America for*

*schooling. Nonetheless writing favorably about foreign matters was not without risk in those years; Zhigang's career is said to have been ruined as a result of the trip.*[9]

On the 24th [April 16, 1868] I rode a fire-wheeled vehicle for the first time, to Haiwosi [?] to look at agriculture. The train is light, steady, and faster than Liezi [a legendary Daoist adept] riding the wind. It is constructed like a wooden house twenty or thirty feet wide and three times as long, with rows of seats, two columns of eight, each of which holds three persons, making [room for] forty-eight people in all. On both sides are rows of windows with three layers of glass, cloth curtains, and wooden shutters for protection against wind, rain, light, and dark. Each carriage has four iron wheels. In front is the fire-wheel engine wagon with a driver and behind him two coal-wagon workers. The engine operates in the same way as the engines in the Shanghai Arsenal, but it is used for a different purpose. Each engine wagon can pull more than ten carriages, even twenty or thirty. Behind the coal wagon there are three to five wagons that carry freight, then come those where the passengers sit, and finally ones for carrying luggage. The front wagon burns coal, heating water to produce steam, which goes through a tube to a compartment, causing a rod to expand and contract, which moves the wheels, which makes the train go.... The speed of the train is double that of a steamboat, for a railroad takes much less power compared to paddling water.

Such a road must be built straight; changing directions requires turning in a large circle. This is because the wagons are long, connected with chains, and do not turn easily. Once the route is obtained it must be leveled. [For the track] there are horizontal wooden beams, wider than the train wheels. Iron strips shaped like the character *gong* [工] and as wide apart as the wheels are connected with nails. Even over the course of more than ten thousand miles, a tunnel must be built whenever a mountain is encountered, and a bridge whenever water is encountered. The iron strip protrudes and the wheel is indented so that they fit together like mortise and tenon. The wheels and track are hard and smooth, so even going very fast will not produce the problem of getting off the track. It may be wondered how the iron is cast so that two *gong*-shaped strips of it fastened by nails are able to extend over ten thousand miles; there must be a special method of making iron.

9. Immanuel C. Y. Hsu, *China's Entrance into the Family of Nations* (Cambridge: Harvard University Press, 1960), 171.

*Compared with his detailed descriptions of American technology, Zhigang's discussion of the diplomatic and political aspects of the mission is pale, and his spare style avoids the first person. He dutifully transcribed the entire Sino-American treaty they signed, together with an explication, but says little else about the American political system. Nor does he dwell on social matters. His descriptions of dinner parties are brief, almost formulaic, always emphasizing the cordial atmosphere and the pleasure everyone took in the occasion. The various formal speeches are also uniformly described as cordial, though boring. His account of meeting with President Andrew Johnson is not greatly concerned with ritual or protocol, though he transliterates "president" as* Bolixidun *and begins a new vertical line with it, as was conventional for a term referring to the Chinese emperor. He seems unaware of the recent impeachment proceedings against Johnson.*

On the 16th [June 6], Minister Burlingame and several [of us] went to call on the *Bolixidun,* which means general-in-chief. At noon, went first to the Foreign Ministry and then followed Grand Minister Hua [elsewhere Hua-er-te, a transliteration for William Seward] to the [President's] residence, which is popularly called the White House because it is built entirely of white stone. First [we] went to the rotunda in the middle to wait for the other ministers, still led by Minister Hua. *Bolixidun* Johnson arrived at the rotunda and stood facing south; Minister Burlingame read in the foreign language what was prepared for presentation. When he had finished, Minister Hua took the text in the foreign language that the *Bolixidun* had prepared and read it to Minister Burlingame for him. When he had finished, our national credentials were handed over to the *Bolixidun,* who personally unrolled and looked at them, and then handed them to Minister Hua to be rolled up again. Then Minister Hua one by one introduced [us] to the *Bolixidun,* who shook hands and greeted each in turn, and said he sincerely wanted to help China and wanted China and America daily to increase their amity, and so on....[10]

The evening of the 20th [June 10]. The *Bolixidun* invited [us] for

10. The Chinese government had instructed Burlingame to avoid scheduling audiences with heads of state because it did not want to feel obligated to grant Western envoys audiences with the Chinese emperor. But Burlingame disregarded instructions and also misled American officials into believing that he was of higher rank and superior to Zhigang and the other Chinese diplomat. See Knight Biggerstaff, "The Official Chinese Attitude Toward the Burlingame Mission," *American Historical Review* 41 (1936), reprinted in his *Chinese Steps Toward Modernization* (San Francisco: Chinese Materials Center, 1975).

an official dinner. Attending were the envoys and chief ministers of countries with diplomatic relations with China. At the dinner long tables were used; guests and hosts were seated together and socialized as usual. During the conversations [President Johnson] inquired about the agricultural methods of Chinese farmers and said that China and America, separated only by a stretch of water, were really neighbors and that as the future relationship continued there would surely be more cordiality and harmony. The Minister [Burlingame] respectfully made his response as appropriate, and everyone was happy.

*Zhigang's next entries offer a brief description of the two houses of Congress and a visit to George Washington's grave, which he had read about in Xu Jiyu's* Ying-huan zhi-lüe. *After remarking on the unpretentious decor of the site, its low fences and iron railings, he paid tribute to Washington.*

Of his progeny there is still a female descendant who is a member of the common people. A former military officer, he rose up at a time when people's minds were set on vigorous action and eventually accomplished great deeds extending over thousands of miles. After his mission was accomplished and his reputation established, he retired unshackled by fame or wealth. Truly he was the hero of his epoch!

# Strange
# Customs

Zhang Deyi, 1868

*Zhang Deyi (1847–1919) was a young, low-ranking inter-*
*preter on the same Burlingame delegation as Zhigang. He had been among*
*the first students at the Chinese government's foreign language institute, the*
*Tongwenguan, founded in 1861. In 1866, two years before the Burlingame*
*mission, Zhang had been sent to Europe with an informal exploratory mis-*
*sion led by Robert Hart, the British superintendent of China's Maritime*
*Customs Service. (The foreign-run Customs Service also arranged China's*
*representation at the American Centennial Exposition a few years later.)*
*Zhang went on to become one of China's first professional diplomats. After*
*several missions to Europe, he served as China's minister to England from*
*1901 to 1905.*

*Zhang wrote eight books, totaling some two million words, on his*
*foreign travels. He is "a first-class diarist," the British translator of part*
*of his European journals said, "a born writer with a frivolous, almost*
*Pepysian interest in trivia for their own sake which makes his work of*
*absorbing interest to the social historian."[11] Zhang's diary of his visit to*
*America in 1868 shows him freer in his opinions than Zhigang, doubtless*
*due to his youth and low rank. He was also by nature more fun-loving and*
*curious, sensitive to smells and sounds, and better informed, for, unlike*
*Zhigang and the great majority of early visitors, he spoke English.*

11. J. D. Frodsham, comp., *The First Chinese Embassy to the West: The Journals of Kuo Sung-t'ao, Liu Hsi-hung and Chang Te-yi* (Oxford: Clarendon Press, 1974), xl.

A SCENIC OUTDOOR RESTAURANT

3d month, 23d day [April 15, 1868].... I wrote the following essay on Oulan [Oakland, California]:

"Oulan" means land of oaks. It is a place of quiet beauty with taverns nestled next to the mountain, places for travelers to rest. I was able to visit it in the spring of 1868 in the company of Chinese envoys to this nation. On that day the sky was bright and clear and the breeze gentle. Six or seven Chinese envoys and five or six Western gentlemen rode in carriages to a tavern, where surrounded by a clear stream was a small pavilion and a long table shaded by a trellis of flowers. Diners having a big feast sat in ranks amidst the fragrance of flowers. We followed local custom, toasting with champagne, drinking coffee, holding knives and forks in our hands. In our mouths the taste was like the rank odor of sheep. A winding ridge of deeply luxuriant mountains could be seen in the distance facing the tavern. Behind the tavern, a garden with an ornate terrace was permeated with the fragrance of wild flowers. To the right a small lake, a stretch of water as clear as a mirror without ripples, folded around on the southeast. Between the tavern and the ridge, a long bridge like a floating dragon or a colored rainbow rested on the surface of the lake. There was a grove of oak trees to the left of the tavern, good wood with thick foliage and a pattern of green shadows. The precious flowers of spring in myriads of purples and reds were resplendent like bright brocade.

A while later we heard a plaintive *lili* sound like the chirping of an

---

*Figure 3.*    A gigantic American, ca. 1889. From the woodblock illustrations in *Dianshizhai huabao*, a popular Shanghai picture magazine published from 1884 to 1910, one can see that America was literally pictured as a strange and exotic place, a locale for fantastic scenes and happenings. The texts often related these American oddities to obscure wonders mentioned in old Chinese texts. The inscription on this drawing reads, in part: "In the state of Kentucky in the United States there is a man named Henry Gregory [?], 36 years old, who is 24 feet 7 1/2 inches tall and weighs 792 pounds. Once he was put on display for people's amusement in a small exhibition in New York and won a prize of a thousand dollars. It is rumored that he weighed 11 pounds at birth, but after two years already weighed 206 pounds. Was there something that made him grow—otherwise how could he jump so quickly? People like Zhan Wu can no longer have all the fame." From *Dianshizhai huabao, chen* 10b.

僑如再世

北方人物較其短長雖賢者亦不免前報既登幼女魁格州景讀攀一人馬以相報覽魁格者轉形其短小于此見人有然不可白恃其長故一誌再誌而不媿其詞之視美國閘他雌甘用有享林枯刀哥者現年三十有八長二文四尺七寸半重止百九十二磅曾在紐約之小博覽場供人玩賞淨得千金之彩相傳其誕生時重十一磅及一周歲巳重五十二磅是豈有助之長者歟何其縣也師詹五畢不浮專美于前矣

oriole; it was the barbarian women eating their meal. A cacophony of *dingdang* noises was the sound of all the people wielding their knives and forks. Men and women sat together with their shoes touching. In their enjoyment the seated guests would rise and make a big hubbub. The barbarian speech sounds like *jiujiudongdong*. Later on, when the tea was gone, the wine finished, and the dishes in a disarray like a wolf's den, the evening sun shone on the mountains, a fresh wind blew, birds chirped high and low, and the trees rustled in the wind. The ladies left first, trailing long skirts on the ground like the tails of foxes. The fragrant aroma of their whole bodies was enticing, and although their "lily" feet[12] are a foot long, they still walk with a graceful gait. Drunken guests sat gazing into the distance, unable even to say good-bye. Since the guests were drunk, the illustrious envoys took their leave. Accordingly, I have recorded this for the amusement of my readers.

### NEW YORK STREETS

Intercalary 4th month, 2d day [May 23]; rainy. "New Harbor" [New York] has the same name as the state, and is at the northeastern edge of the United States. The city is about seventy-five Chinese miles in circumference with a population of 1.5 million. The avenues are broad, and the buildings clean and beautiful like those of Paris. The residences are closely packed together, and the shops are dense like London. There are thousands of streets and alleys; those that are called by numbers go from 1 to 229. Every day is like a holiday, and every night a festival. The thoroughfares have carriages and horses running through them making a great commotion day and night, and wherever pedestrians might worry about being run into by these an iron bridge has been built horizontally across the street, flat on top and slanting on the sides with two iron stairways at each end, one for going up and one for going down, so that there is no obstacle whatsoever to coming and going. In order to take care of uncleanness in the streets there are soldiers who rinse and sweep them morning and evening. A cleaning wagon goes through every alley each day with a round broom hanging behind it, about nine feet wide and eight feet in circumference, which turns when the wagon moves, and so the ground is cleaned.

12. The term Zhang uses refers to a Chinese woman's bound feet.

### PRESIDENT ANDREW JOHNSON

15th [June 5, after meeting with the President]....

Comment: When Johnson was young he had great ambitions, but for a time he worked as a tailor. He studied with great diligence everything that was written about astronomy, geography, and governing the people, and he was respected by his countrymen. After Lincoln, the preceding leader, died, the people promoted Johnson to this office, so that his countrymen call him the "tailor leader." His official residence has a perimeter of three Chinese miles, is built out of white marble, and is surrounded by gardens. The natives call it the "white house" in mockery because in this country toilets are called white houses.[13]

### A VISIT TO CONGRESS

19th [June 9]; clear. At noon I accompanied the imperial envoys Zhi and Sun in a carriage for about two Chinese miles to the Bureau for Discussing Affairs [the Congress] of the United States, which is also called the Upper Hall. We walked up the stairs and entered. The building is grand and spacious, the decor neat and beautiful. The hall in the center is round. The head and deputy head sit on a platform on the north side. Below, 270-odd gentry from the different states sit on rows of wooden benches. There are over a thousand seats on the balcony for the men and women of the nation to listen to the discussion. As the imperial envoys entered, everybody stood up. Minister Burlingame and their head Colfax stood talking and thanked each other. All the gentry-men left their seats and formed two columns, one by one shaking hands with us, stating their names and expressing greetings. After all this hand-shaking, my hand and wrist were sore.[14]

13. Conceivably Zhang had misheard "outhouse" as "white house."

14. A Congressman wrote about this visit: "A few days ago Burlingame and the Chinese were presented. It was a singular sight to see that ancient Asiatic countenance, lighted by the conceit and shaded by the tyrannies of 4,000 years, led by the smooth-faced Anglo-Saxon, beneath the shadow of the Eagle and Stars, to receive the welcome of men whose creed it is to hate idolatry and despotism, and whose only ineradicable custom it is to despise caste and ceremony and stability. What a grand spectacle to witness the four hundred millions of Chinamen, as it were, stopping in the long tide of centuries, resting on their oars and catching across the ocean the sounds of republican America, the hum of their machinery, the scream of their whistles, the roar of their trains, and all the multitudinous voices of progress so familiar to us. They have heard of our greatness and our invincible power, and now lean forward to catch on the breezes of their East the faint sounds of a civilisation they feel to be the master of their own." Quoted in F. W. Williams, *Anson Burlingame and the First Chinese Mission to Foreign Powers* (New York: Charles Scribner's, 1912), 132n.

Then each one of them took out a piece of paper and asked me to write my name, which was a great bother. I hear that in the United States everyone has a little book, and everyone they meet is asked to sign their names in the book as a souvenir. There are even those who have never met high officials of the government but send their book to their doors asking for autographs so that when in the future people look at their book of names they will think such-and-such famous officials and eminent gentlemen had been close acquaintances. Thus while I am in the hotel, every day men and women come one after another seeking my autograph, and even when I run into people on the street they take a writing implement out of their pocket and ask me to write my name before going on.

After we left the round hall we toured the various rooms, and then entered a study which had a collection of 175,000 volumes as well as stone statues and paintings and such. After that we returned.

## THE POLITICAL SYSTEM

27th [June 17]; sunny and hot. Comment: In the fortieth year of the Qianlong period, the United States, suffering under English tyranny, revolted and made itself independent. That was one hundred years ago, and now it has thirty-six states. The people are the ruler of this country, communally setting up one leader as head. He is limited to four years in office and each year is paid twenty-five thousand silver dollars. A deputy leader assists him, who receives six thousand dollars a year. After the leader has completed four years of service, the assembled people deliberate about him. If the people consider him virtuous then they keep him for another four years, but not for more than twelve years at most. Otherwise they will promote the deputy leader to the position, or if he does not accord with what people are looking for they will put someone else forward. All citizens, when they reach adulthood, have the right to select. The method of selection is that everyone writes down the name of the person he is selecting and puts it into a box. When all have done so, the box is opened and they pick the one with the most, whether official or commoner and regardless of qualifications. Leaders who have retired are the same as common people.[15]

The head, deputy head, and all the gentrymen of the Bureau for Discussing Affairs are also communally selected. The Bureau has sep-

---

15. The wording here is similar to, but not identical with, Xu Jiyu's. In China retired officials had special status because of their civil service examination degrees.

arate upper and lower halls. When the nation has important business then people come together to discuss it. Matters are first submitted to the lower hall, and the better proposals are chosen and submitted in turn to the upper hall; in the end it is officially handed to the leader. If the leader does not approve then it is sent back to the upper hall to be discussed again; if they still support it without change then the leader must yield.

### SOCIAL OBSERVATIONS

6th month, 3d day [July 22]; sunny. Streets in the United States are neat and clean. There are no people singing or shouting obscenities. There is no theft, no fighting, no beggars, and few burglars All the big and small alleys have toilets for men and women, and those who do not use them are punished without exception.

4th [July 23]; sunny. I heard that someone named Ford had an affair with a woman called Wu [?], who was the wife of a military officer named Webb. Her husband investigated and learned about it. On that day he hired two detectives. He waited for his wife to go out and ordered the two to follow her and inform him of her every act. They reported that the couple first had breakfast at a certain restaurant, then walked around a certain place, and finally spent the night in such-and-such a hotel. The husband complained to the authorities, who had some underlings climb a ladder on the outside of the building, break a window, and enter, and the two were discovered. The reason is that according to foreign custom, wives forbid their husbands to sleep out even for one night, but wives can walk around the streets all night and their husbands will not dare to question this. The detectives he hired were provided by the authorities; when the business was finished they were paid several foreign dollars.

5th day, heavy rain without stop. I read in the newspaper that the Webb case has been decided. The adulterer is to be fined five hundred silver dollars, and the adultress is ordered to return to her father because her husband does not want her. If her husband still cherished his former sentiments and did not want to be rid of her, then the official would allow it. Although the jade is no longer perfect, the broken mirror could still be repaired.

### KISSING

11th [July 30]; sunny. Comment: Foreign infants from the cradle to two or three years old hardly ever cry. Whenever there are celebrations or

funerals their parents never bring them along, and at home they seldom eat at the same table with them. Every day when they go to bed and when they get up there is the ritual of touching lips together with their parents. When they meet friends or relatives they touch their hands to their mouths instead. There are some immoral men and women who when they encounter each other on the street, while at a distance suck the back of their own left hand or suck the five fingers of their right hand. After sucking they put the fingers on the left palm and blow toward the other and part smiling. Such behavior is wanton in the extreme.

BOSTON

7th month, 3d day [August 23]; overcast, fine drizzle. We started our journey at seven o'clock; taking the train 132 Chinese miles [from Worcester], we arrived in Boston at noon. As the train stopped there were fifteen cannon volleys. Local officials met us with carriages. We got off the train and immediately set out in sixteen two-horse carriages. There were four hundred cavalry troops with swords raised and music playing, divided into two groups to escort us. First we rode around, in and out of the city, for over sixteen miles. All along the way American flags were displayed, and among them were some yellow dragon flags of China. Men and women opened their windows and gazed out, took off their hats and waved their handkerchiefs, clapped and threw flowers, shouting "Hooray!" There were people holding up Chinese umbrellas, waving embroidered brocades from China, displaying red quilts, opium pipes, and porcelain dishes in their windows, and wearing Chinese autumn hats. In short, all the Chinese wares they had were displayed. Along the side of the street were many people; some even sat on walls or on the shoulders of others, or climbed trees or ladders. At 3 P.M. the parade was over and we got out of the carriages; officials and gentry led us into the Booker Hotel [?]. That evening there was a party with lavish decorations and music where we met over two hundred officials, gentry, and merchants. The party did not break up until 1 A.M....

4th, clear. At 10 A.M. I accompanied the two imperial envoys Zhigang and Sun Jiagu in a carriage two Chinese miles to Faneuil Hall. The hall is spacious, able to hold over six thousand people. It is so called because it was built with contributions from someone named Faneuil, to serve as a place for citizens to debate public affairs. On this day merchants and artisans from all over the city came to the hall to have an audience with the Chinese imperial envoys. The envoys stood

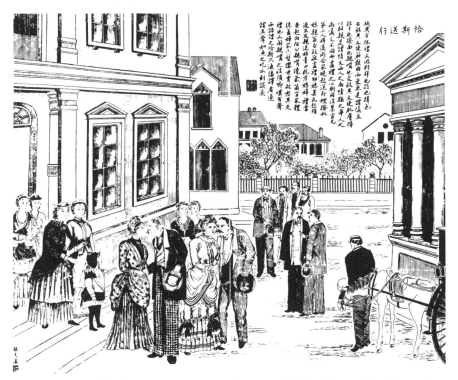

恰斯送行

*Figure 4.* Kissing, ca. 1890. Another woodblock illustration from the popular magazine *Dianshizhai huabao*. The caption reads: "Different places have different customs. Prostrating oneself, kneeling, and bowing—each expresses civility through regulation of the limbs. This is called civility of manners. Shaking hands, brushing cheeks, and kissing are also exchanges of civility by making bodies come together. This may be called civility of sentiments. Westerners esteem sentiment the way Chinese esteem etiquette. Civilities are different but the desire to be polite is the same. A certain official in France was about to travel to a distant place with his brother. The whole family got up in the morning to see them off. The elder's wife brushed cheeks with the younger brother and a daughter-in-law kissed her father-in-law, each expressing respect and politeness. A younger daughter-in-law was too late getting up and did not see them off; she was scolded by the elder brother's wife, who said, 'Since you are a daughter-in-law, etiquette demands that you should get up to kiss your father-in-law goodbye. Such is the propriety befitting an official family.' The older woman, it seems, came from an illustrious family, and so was angry at the lack of etiquette. We have also heard that the way to kiss requires making a chirping sound. In the Western language it is called '*qiasi.*' Those who do not know how to translate say the sound is like fish drinking water, but this is wrong." From *Dianshizhai huabao, wu* 8:60.

on a platform at the front of the hall. There were stairs to the left and right of the platform, and people came up on the left and went down on the right. The first to meet them were Governors Bancroft and Wei [?]; one was originally a carpenter and the other a butcher. From late morning to early afternoon, more than five thousand people mounted the platform to be received by the envoys, and there were still as many people waiting below.

On a balcony were women gazing down, lovely as fairies and lavishly garbed, arrayed in a multitude, beautiful enough to cause cities to fall. The population of the city, if we leave out the high officials and the rich, is still over 200,000; how could we see them all in one day? Although the tunes the musicians played had a local sound, they were still quite pleasing to hear. At 6 P.M. we went to a party at the Prince Hotel; there were flowers and decorations, bright lights all over, banquet tables laid out, and everyone toasting and drinking. Over 250 officials, gentry, and merchants were there, including Governors Bullock, Bancroft, and Cousins; Mayor Shutleff; and others. As the banquet came to an end everyone stood up to show their respect. At midnight we returned to our lodgings.[16]

### POLITICAL PARTIES

7th month, 20th day [September 6]; still rainy, cool. I hear that after the victory of the northern side the people of the south often felt discontented and so grouped together to establish a party called the Party of Hierarchy [Democrats]. They continue to regard blacks as slaves, though they do not dare openly [advocate slavery]. All officials high and low belong to either the Party of Equality or the Party of Hierarchy. Each party has its selfish interests, and they are not in harmony. The incumbent president is about to reach the end of his four years, and the people of every state are to publicly select a chief and deputy high official. Because the two parties are not in harmony, the Egalitarians want to put forward two people named Grant and Colfax, and the Hierarchicals want to put forward two people named Seymour and Blair. The two parties are so much at odds that I am afraid there will be dire consequences.

16. The Chinese envoys' visit to Boston inspired a poem by Oliver Wendell Holmes that begins: "Brothers, whom we may not reach/Through the veil of alien speech,/Welcome! welcome! eyes can tell/What the lips in vain would spell,—/Words that hearts can understand,/Brothers from the Flowery Land!" Quoted in John K. Fairbank, *Chinese-American Interactions: A Historical Summary* (New Brunswick: Rutgers University Press, 1975), 29.

# Glimpses
of a Modern
Society

Li Gui, 1876

*The American Centennial Exposition in Philadelphia in 1876 had exhibits from thirty-seven nations, including China. Li Gui, a minor official about whom little is known, was sent to report on the exhibition. The next year he published a long and interesting record of what he saw there and on his travels to Washington, Hartford, New York, and Europe. Li's* Huan you diqiu xin lu *(A new account of a trip around the globe—emphasizing his new awareness of the earth's roundness) is said to have made a deep impression on the young Kang Yuwei, an important philosopher and political reformer of the late nineteenth century.*

*Li Gui was rapturously enthusiastic about the Philadelphia exposition and the mechanical wonders exhibited there, and he mocked those Chinese who thought machines should be rejected because the ancients did not have them. But he was also impressed by the friendliness of Americans. He seems to have had easier social contacts with Americans and to have been more open-minded about foreign ways than other early emissaries. His appreciation of American social institutions is evident in each of the following selections.*

## THE WOMEN'S PAVILION

Originally the exposition planned to have an exhibit of women's handicrafts as part of the general pavilion and not to erect a separate building. This made women of the whole country dissatisfied because they considered that slighting women's work was slighting women, so they devised a plan to raise funds themselves for a separate building for

women's handicrafts.[17] This building is to the east of the hall of agriculture, 192 square feet, with more than five acres of grounds. It has eight sides, like a tent, with eight gates. The central tower rises eighty feet high. The design of the building, supervision of construction, and decoration and setup were all done by women. It is novel and ingenious, and cost $100,000. Books, paintings, maps, and embroideries done by women, together with [demonstrations of] the techniques of each are gathered here. Another room was used to display women's school equipment and curricular materials; even the people in charge of this exhibition hall were women. I toured the entire exhibition hall and saw books on astronomy, geography, science, mathematics, and sewing and cooking separately on display. There were also many ingenious tools and mechanisms.

Whenever I asked a question, everyone was happy to explain things tirelessly, in an open manner. These women do not have the manner of girls who are kept at home, but the spirit of men; I greatly respect and like them. Western friends accompanying me said that the Western custom was to treat men and women equally and give women the same education as men; therefore women are quite capable of voicing opinions on large matters and performing great deeds. In May of this year a newspaper appeared in which a woman argued what a great injustice it is that all official positions are filled by men and that the president soon to be elected will certainly be a man, too—why cannot we women be elected as well? This is most unjust, she said. I have heard that in England, too, there are women who want to enter Parliament and participate in national affairs. Their arguments are very novel, but after hearing them they seem reasonable.

In recent years, schools for girls have been established in all countries. In English universities men and women take entrance examinations on the same basis. In Germany girls of eight must go to school or else their parents will be held responsible. In America there are as many as three or four million female teachers and students. Such things are increasing daily in order that women's abilities may be fully made use of. There are roughly as many women as men in the world; if only men and not women are educated, then out of ten people only five will be useful. In intelligence women are not second to men, and in some

17. The women's exhibition was forced out of the main building by the unexpectedly large number of foreign exhibitors. European visitors were more critical of the women's assertiveness; see John Maass, *The Glorious Enterprise* (Watkins Glen, N.Y.: American Life Foundation, 1973), 123–25. China's exhibit is described in J. S. Ingram, *The Centennial Exposition* (rpt. New York: Arno Press, 1976), 570–85.

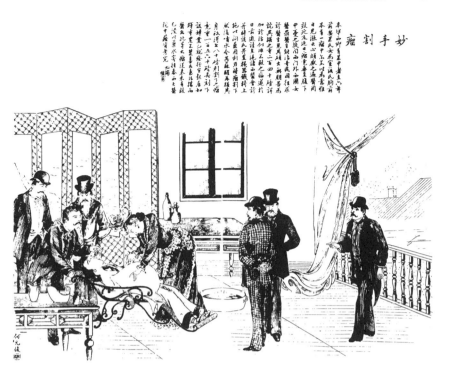

*Figure 5.* A woman doctor, ca. 1895. The caption reads: "A certain Mr. A. in the western district of this city [Shanghai] married Miss So-and-so six years ago. She had a tumor on her chest to which he initially paid little attention, but it gradually grew until he found it repulsive. He sought treatment everywhere, but without results. Recently the tumor came to hang down over her stomach. A. was worried. Then he heard of a foreign woman doctor outside the western gate called Dr. Luo, able to cure strange diseases, and so they went to her for treatment. The doctor was surprised at how enormous the tumor was; the patient weighed 240 pounds. The doctor examined the tumor carefully and it seemed not incurable. So a few days ago she invited several foreign doctors in Shanghai for consultation. She put the woman in a mechanical steel chair, gave her a stupefying medicine, and cut the tumor off with a sharp knife. She then sprinkled water on her to awaken her. Afterwards the woman weighed only 70 or 80 pounds, and the tumor which was cut off was 150 to 160 pounds. The woman is well now, extremely happy to be relieved of this heavy burden as she goes about her life. According to this Western doctor, there had never been such a big tumor, so they put it in liquid and sent it to a foreign hospital to be studied." From *Dianshizhai huabao, yu* 1:6.

ways they are superior; they can apply themselves because they are
tranquil in mind. If we do not teach and encourage them, their talents
will be buried; does this not go against Heaven's intention in creating
people? For this reason in other countries people are happy both when
they have boys and when they have girls, without distinction.

China is just the opposite. Regarding women as inferior and
drowning [infant] girls cannot be stopped by means of persuasion or
prohibitions. I say they are caused by nothing other than the decay of
women's education. I find that officials of the Zhou dynasty [ca.
1050–221 B.C.] included priestesses and female clerks. The Han [202
B.C.–A.D. 220] system had an office staffed by female officials which kept
daily records of the Imperial concubines. Women's learning was made
use of in the past.... In the early three dynasties female education
flourished, but in later ages such things gradually declined. Today
there is even the saying that, "Only a woman without accomplishments
is virtuous." Alas! In my opinion, this one sentence injures all women.
How can their accomplishments be limited to writing poetry about
pretty things? If these are called accomplishments, then it would be
better not to be virtuous. If we could revive women's education so that
they could all study and learn, women's morality would be strength-
ened, their abilities would be made use of, the tendency to look down
on them would be corrected, and the custom of drowning girls would
naturally stop.

As for the opinions of English and American women, they are too
extreme, as my Western friends emphatically agree.

### FIRE-FIGHTING TECHNOLOGY

Mr. Hai [?] had told me about fire-fighting equipment, so we went to
see a fire station. There was a four-wheeled horse-drawn wagon in a
room. The wagon has a steam engine inside, with power equal to fifty
horses, relying on two vapors to suck and release water. It is drawn by
two horses. The coal and materials to start the fire [to make steam] are
placed in the steam engine ahead of time. Four people manage it, and
the wagon costs forty-five hundred dollars. Another wagon to carry the
water hose also has four wheels, is drawn by one horse, has two people
in charge, and costs five hundred dollars. The engine is very powerful
and can shoot water three hundred feet in the air. In the mouth of the
hose are numerous small holes; if the firemen get too hot, they can turn
the hose and water comes out the small holes and cools them.

Most remarkable, there is an electric machine with a brass bell

attached on the left wall of the fire station. If there is a fire anywhere, as soon as an electric message arrives the bell automatically rings, also by means of electricity. The ropes holding the horses in the stable in back are automatically released, and on hearing the bells the horses all gallop out and take their places in front of the wagons. They can be fully equipped and underway within five seconds. If it is nighttime, the firemen upstairs are jolted awake by the noise of the horses running across the floor. Their clothes, boots, and hats have all been laid out when they went to bed, so in only another five seconds they can be fully clothed. From the time the electric message arrives to the time the horse wagons go out the door takes five seconds in the daytime and ten at night.[18]

The wagons go one [Chinese] mile per minute. Bells on the wagons are rung to make pedestrians get out of the way, for the firemen are not responsible if they are killed or hurt. There are only twelve firemen, divided into two shifts. Every day they are allowed to go home for an hour and a half each in rotation, and every month they are allowed to go home for the night twice. The rest of the time they may not leave even briefly. The monthly salary is one hundred dollars; since this is a high wage, they are expected to be constantly on the alert. Their horses are chosen for physical size and strength, and are thoroughly trained. Beside the electric machine there is a board on which is written the names of each street and each section within and without the city.

These methods of firefighting are most perfect and all big cities should imitate them.

### A POLICE STATION AND A COURT

In the evening I visited a police station. According to the captain there are altogether thirty-five precincts in New York with twenty-three hundred policemen. This one was the seventeenth precinct, which has ninety-two policemen divided into two shifts of forty-four each and four deputy captains. It was midnight and they were just changing shifts. After the captain called the roll, the policemen marched out in formation, like a military drill. Each man must report the next morning what he has seen and heard at night, and this is written down in a book. I saw several policemen coming in with people under arrest, drunkards who had been making a disturbance or burglars and the like. The

---

18. This description seems to reflect some misunderstanding about the duration of a second, which is a modern concept.

captain asked them their names and addresses, and recorded these in another book, and put them in cells. The cells are separate for men and women, each holding several to over a dozen people, and have stone walls and iron bars.

Today they had arrested sixty-eight people, including seven or eight good-looking young girls in gorgeous dress, who were put together in a cell as prisoners and appeared to be wailing together. I was very surprised, and on asking was told they were subject to arrest because they were nude entertainers who dirty people's minds, and that the next morning they would be sent to court. The following day I heard they had all been fined and released.

The court building contains jails, roughly five or six cells each for men, women, and juveniles, for those who have been arrested the day before and are to be sent to court in the morning. The courtroom is about fifty or sixty feet square. There is an elevated platform three feet high, like a [Chinese] heated compartment, with a desk at which three judges sit, each with paper and pen, asking questions and recording the answers. Three or four newspaper reporters sit at a table to the side. The clerk who calls the criminals to enter stands in front of the judges' desk. On the left is a chair for the plaintiff or witnesses. The criminals all stand outside a low railing to the left of the judges' desk. A religious book is placed on the left corner of the desk. The criminal is brought into the court by the policemen and first picks up the book, brushes it against his lips, and then puts it back. This is to swear by the book that he will not tell lies. Below the platform, twenty or thirty people, all lawyers or witnesses sit at five or six long tables with chairs. In the back of the court there may be hundreds of people who are allowed to watch. The judges are elected from among the people. There are dozens of cases every day. After being interrogated people are released, or fined, or released on bail; or if found guilty, they are sent to a government

---

*Figure 6.*    A court scene, ca. 1885. In part, the caption reads: "Now we hear of a very strange criminal in San Francisco. When the judge had him brought to court and was about to write out his sentence, he arrogantly tried to get away. The judge, seeing that the guards were unable to hold him and that he was about to escape, climbed down from his seat to personally restrain him. The criminal, seeing how strongly built the judge was, somewhat lost his spirit. When he raised his hands to fight he was not strong enough, and he obediently allowed himself to be taken. It is truly a curiosity of overseas that a criminal should be afraid of strength but not of law." From *Dianshizhai huabao, ji* 5:33.

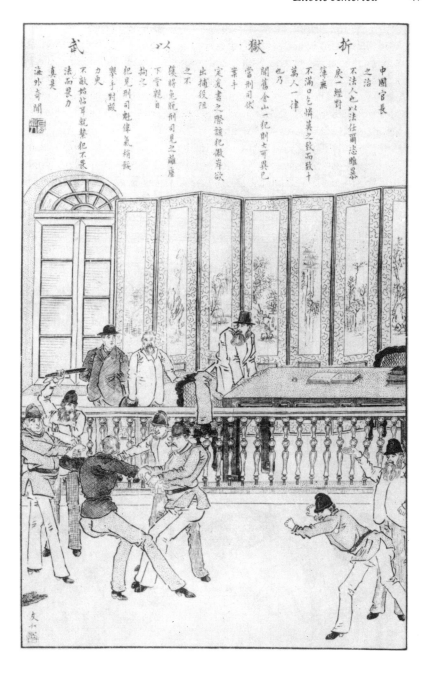

武

不嚴始怡耳就縛犯不畏
法而畏力
擧手對毆
犯見刑司魁偉氣稍餒
力吏
下堂親目
拘之
漢時鬼脫刑見之離座
之不

以人

定爰書之繫護犯岸欲
出捕後阻
案平
當刑司伏
聞舊金山一犯則七可異己
也方

獄

不滿口乞憐莫之致而致十
萬人一律
傳無
庚一經對
不法人也以法往關志雖暴
之治
中國官長

折

真是
海外奇聞

office for deliberation; or if the case is not finished, then they are put back in jail temporarily and interrogated again the next day. This system is the same as the Shanghai Mixed Court.[19] I hear that New York has six such places, each for a certain district, clearly specified.

In Western countries no matter whether the case is big or small, people are allowed to gather and watch the litigation, and newspaper reporters can come and write about it so that everyone may be informed. In this way, how can there be irregularities? If people wanted to use improper means they would not be able to. But is it not making trouble for themselves to handle dozens of cases every day in one place? It must be that they want peace and order. Western nations should think hard about this. And as for swearing by a book, that is nonsense.

### A THEATER

In the theater there is a wide stage and almost a thousand gas lights. Over two hundred actors and actresses with painted faces and false whiskers performed a story set in Turkey, fighting each other with swords and lances. The costumes were multicolored and embroidered with gold. In front of the stage sixty or seventy musicians played. When one act was over the curtain was lowered, and after a while it rose again and there was another act, dramatic or acrobatic, musical or tragic, with fantastic monsters or seventy or eighty scantily clad women holding hands and dancing. The spectacle is unimaginable. The audience numbered one or two thousand. Mr. Hai had a box that cost twenty-five dollars. The next evening we went to another theater, which was even more remarkable.

---

19. The Shanghai Mixed Court, which dates from 1864, had Chinese and foreign judges sitting together to handle cases involving Chinese in foreign-controlled Shanghai.

# Travel
# in the Interior

Chen Lanbin, 1878

*In the 1870s and 1880s a succession of Chinese ministers to Washington prepared detailed official diaries, reporting in particular their conversations with members of the American government.[20] Chen Lanbin first came to America in charge of young Chinese students in 1872. He returned as Chinese first minister to Washington from 1878 to 1881. Like the diaries of his fellow officials, Chen's accounts mainly concern American technology: ships, trains, machines, mines, and factories. As well as the inevitable description of Niagara Falls, Chen relates his impressions of towns and cities he visited across the American continent. The amount of detail, figures, and statistics is typical of the genre: all the official diaries are packed with such data, as if to show the authorities in China that the writers had in fact carried out close on-site inspections. It is likely, however, that most of the figures were taken from American publications or other sources provided by interpreters and assistants.*

*To the extent that they discuss people, the visiting diplomats often survey historical or geographical groups: American Indians and their massacres by whites, the curious customs of the Mormons, the numbers of people in each city or town engaged in various industries, and the like. These*

20. The most important ones, in addition to Zhigang's and Chen's are: Cui Guoyin, *Chu shi Mei Ri Bi guo riji* (Diary as minister to the U.S., Spain, and Peru); and Zhang Yinhuan, *Sanguo riji* (Diary from three continents; 1896), which is excerpted in the next chapter. As Cui Guoyin's account indicates, all envoys abroad were required to keep careful diaries, which would be submitted to the Zongli Yamen, the office in charge of foreign relations, for "mutual reference" and to supply "clues in negotiations" and aid in acquiring information about the "model of wealth and power." See also Kim Man Chan, "Mandarins in America: The Early Chinese Ministers to the United States, 1878–1907," Ph.D. dissertation, University of Hawaii, 1981, 483ff.

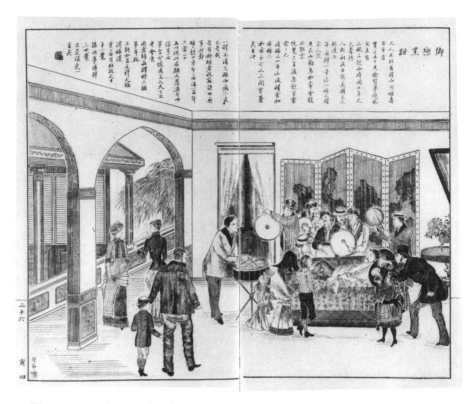

*Figure 7.*     A narcoleptic, ca. 1888. The caption reads: "It is not possible for ordinary people to go without sleep. Even those who live a hundred years are in fact awake for only fifty years, as the rest of their time is spent in the realm of dreams. But never before has there been anyone who went to sleep and in the course of seven years got up only three times. Seven years ago, a German named Henry Heinz [?] who lives in Minnesota in America contracted a strange disease. He fell asleep and did not wake up. His family suspected he was dead, yet he breathed normally. Cymbals and drums could not rouse him. He was left asleep for three years. Then he suddenly sat up and asked for food. Once he had eaten, he went back to sleep for another year. After that he woke up and ate again as before. Then he went back to sleep for three winters and three summers until now. Since waking up this time he no longer sleeps for long periods and has recovered from his illness." From *Dianshizhai huabao, yin* 4 : 26.

*social portraits may be considered the Chinese equivalents of European* chinoiserie—*accounts designed not only for official consumption but also to stimulate in general readers a sense of curiosity concerning these tidbits of "barbarian exotica." Here, for example, is an excerpt from Chen's account of Utah and the Mormons.*

The religion here is different from that practiced in other states of the Flowery Flag country. According to Western custom, a man cannot marry two women, but this religion permits the taking of concubines. The American government, considering this teaching heterodox, has repeatedly sent troops to restrain and reform it, but [the Mormons] did not obey. On July 24, 1847, [Brigham Young] led the followers of this religion to this place. Originally there were only 293 people; now the population totals more than 130,000. The leader died last year, leaving nineteen wives and concubines and sixty-seven small children (not counting those who have grown up)....

At 4:05 arrived at Men-niu [Magna?]. Total mileage covered, 807 miles. This place borders on the Great Salt Lake, and when the wind from the lake blows on the face, the stench is hard to bear. A feather that falls on the lake will not sink. It tastes salty and bitter, like Lake Qinghai [in western China].... At 8:00 arrived at E-dun [Ogden?] for a rest. Total mileage, 881 miles. Passengers from San Francisco stop here for half an hour to change trains. The town itself is located some seven miles from the railway station. Elevation, 4,301 feet. Population, about 6,500, mostly Mormons. There are a few inns. On the roadside metal ores and precious gems are displayed for sale. The climate is mild, yielding rich produce. At 10:45 arrived at Yan-da; total mileage, 890 miles. The elevation of this place is 4,560 feet. In 1862 followers of the Mormon religion and those of Morris (Morris was originally a Mormon who later wanted to be a religious leader himself and so started a war) fought each other here for three days. The followers of Morris were all killed, and some three hundred men and women were captured and sent to work as coolies to construct residential areas that were tens of miles wide and housed thousands. Later the American government dispatched troops there and set them free....

# How to Cope with Western Dinner Parties

Cai Jun, 1881

*Envoys about to depart for the exotic United States needed all sorts of information about everyday life in America and the etiquette expected of diplomats in Western society. Emissaries who had been abroad recorded practical lore about foreign customs, and from such lore we can see what they found strange and discomforting in America. One such matter was social gatherings, which involved not only unfamiliar food and difficult dinner table manners but also social relations with women (in China women were not included in such social functions). Cai Jun prepared a short handbook for envoys after having spent three months in Washington, D.C., as a subordinate emissary in the Chinese mission. He later rose to the post of minister to Japan, in 1902.*

Things for practical use must be brought along in quantity, from brushes, ink, paper, inkstone to abacus, comb, toothbrush, and tongue scraper. For books on international law and treaties, various dictionaries, and such, small-type editions are best; these can be purchased from the Shanghai *Shenbao* and Hong Kong *Xunhuan ribao* newspapers. As for furnishings for [diplomatic] residences, the best trinkets are ivory curios and embroideries. Paintings with bright colors should be chosen and especially flower paintings. Westerners cannot distinguish the calligraphy of famous Chinese, and Western painters are particularly good at bird and landscape painting themselves; only in flowers painted in color are they considerably inferior to the Chinese, so it is advisable to bring only these....

Although the foodstuffs in Western countries are not all that dif-

ferent from Chinese foods, the taste is very different. But the people are curious, and when they become friendly with a Chinese envoy they will customarily invite him for dinner and the Chinese must reciprocate. Beef, lamb, chicken, and pork are eaten in both countries and there is nothing special about these. But seafood, swallow's nest, soy sauce, sesame oil, and such delicacies are generally unavailable in Western countries. Only in San Francisco, New York, and Cuba has the number of Chinese residents increased to the point that all kinds of Chinese foodstuffs are imported for sale; but the prices are extremely high, so it is better to bring them with you to prepare for entertaining. Chinese porcelains, which are greatly appreciated by Westerners, should be brought in quantity. Antique bowls, several sets of high quality plates of various sizes, and tea cups might as well also be brought, as they can be used both for entertaining and as gifts.

Western customs stress simplicity; the temperament of the people is generally forthright, and they like cleanliness and hate noise. When you first come to know them they seem difficult to get along with, but after dealing with them for a while you find they are sincere and respectful, not given to fierce words or angry looks, nor do they take liberties or act lax about manners.

Their homes always have rugs on the floor and are equipped with spittoons so that one can sit and talk. During a visit, if you have to cough, you must use a handkerchief to cover your mouth and you must not let your nose run all over or spit anywhere. If you smoke a cigar, you should put the ashes in the spittoon. Your clothes must be clean and fresh. On both sides of the living room are chairs and sofas; the host will invite the guests to sit on a sofa. If the host's family appears or if there are female guests, you should leave vacant the seat on the right for them, because in Western countries the right is the side of honor. When you talk with ladies you must not smoke, or if you know them well you may ask their permission, for Western women do not smoke. At the end of your visit, when you make your departure, it is the custom to shake hands with all, whether men or women. If they hold out their left hand, then you use your left hand to shake hands; if they use their right hand, then you use your right. Even if you meet the same person several times in one day you should still shake hands. If you have been visiting and are taking your leave, you should be the first to hold out your right hand to shake hands; as you walk to the front hall shake hands once again and then go out the door. When you go on an outing in a horse carriage, let the Westerners sit on the right. What you

say and how you respond in conversation depends on your wits at the moment; the basic tenet is sincerity and respectfulness, and in social intercourse you must never act impoverished or bashful. They have always admired China's reputation and culture, so you should meet their expectations.

Westerners attach great importance to entertaining. After they have come to know a foreign envoy well enough there is bound to be an invitation to dinner. A card will come two days beforehand, and you should immediately respond with a note of thanks; if you do not wish to go, politely send your regrets. On the appointed day carefully determine the distance and arrange for a horse and carriage so as to arrive before the appointed time.... If the host's wife is there, you must shake hands with her too and should not let yourself feel embarrassed because of Chinese etiquette [which forbids physical contact with unrelated women]; otherwise you will appear rude and attract criticism. As you enter the living room and meet the other guests, you should bow. If there are people you have met before or know well, shake their hands and greet them. When the guests are all gathered, everyone goes to

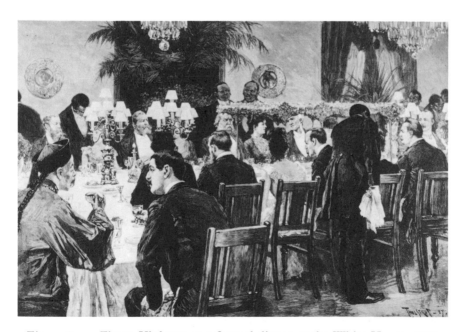

*Figure 8.* Zhang Yinhuan at a formal dinner at the White House, 1888. Copyrighted by the White House Historical Association; photograph by the National Geographic Society.

dinner. The host will have placed name cards at each seat; you should find your own name and seat yourself accordingly. At this time the host will no longer urge you [to eat, like a Chinese host?]. The waiters first serve soup, then the main course, then sweets and other dishes; each course is cleared after you eat it.

When the meal is finished the host rises first and ushers the guests from the table; they may stroll or sit and chat as they wish. At Western dinner parties men and women usually attend together [contrary to Chinese custom], but you may not sit next to your own wife. There may be someone you know well who will sit with her to convey his respects, or wives may politely talk to each other as an expression of attentiveness. If you find yourself seated next to a female guest, when the meal is over you should say to her, "I am honored by *ma-dan*'s kindness; may I be permitted to take your arm?" *Ma-dan* is an honorific term for Western ladies; it means "lady." If she gives you permission, use your right hand to hold her left arm and accompany her to the living room. If she wants to stroll, walk slowly with her. If she wants to sit down, you should take her to a chair; after she is seated, she will thank you and you should then bow politely in return and step away. If you want to leave, you must wait until all the female guests have left before you can thank your host and say good-bye....

Going abroad as an envoy and dealing with Westerners, you should follow their customs in giving dinner parties. Manchu- or Chinese-style dinners should not be given, because Westerners are not accustomed to using chopsticks.

# II

# Menacing
# America

The promise of economic opportunity, heralded by the California gold rush and the construction of the transcontinental railroad, brought half a million poor Chinese men from the Canton delta to the United States during the latter half of the nineteenth century. These men came as sojourners, intending to return to China after accumulating some savings from their labor. By 1880, however, the gold rush was over, the railroad was completed, and anti-Chinese agitation, inflamed by militant labor unions, had become widespread.

The 100,000 Chinese living in the United States, almost all of them on the West Coast, found themselves subject to increasingly discriminatory treatment. Legislation prohibited Chinese from becoming citizens, owning land, working for California corporations, attending white schools, and giving evidence in court (this last made them easy targets for robbery and other crimes). Bigotry, hostility, and violence eventually forced the Chinese into Chinatowns. The worst single act of violence occurred at Rock Springs, Wyoming, in 1885, when twenty-eight Chinese were killed by white miners, most of them recent immigrants from Europe.

Meanwhile, at America's insistence, the right of free migration, which had been ensured by the treaty negotiated by Burlingame in 1868, was restricted under the terms of the Sino-American treaty of 1880. Two years later the U.S. Congress approved the Chinese Exclusion Act, which prohibited the entry of "Chinese laborers" into the United States—the first time America had ever restricted immigration. Henceforth, all Chinese arriving at San Francisco, even returnees and

students, were subjected to arbitrary and humiliating interrogation, physical examination, and detention on infamous Angel Island; many were refused entry and sent back. When Hawaii and the Philippines came under American control in 1898, Chinese laborers were suddenly excluded from these territories, too, where they had previously emigrated in numbers.

The suffering of Chinese immigrants in America is expressed in these poems by anonymous authors, from an anthology published in Chinese in San Francisco in 1911:

> In search of petty gains,
> Idle in my obscure village home,
> I took the perilous journey and risk to America.
> I met immigration officers interrogating me.
> Just for a lapse of memory—
> I am sent and imprisoned in a wild mountain
> Where a brave man finds no use for his might
> And cannot go one step beyond the confine.
>
> American laws are fierce like tigers:
> People are jailed inside wooden walls.
> Detained, interrogated, and tortured,
> Birds plunged into an open trap—O, sufferings!
> Tragedy, to whom can I complain—
> I yell to the sky: There is no way out!
> If only I had known the difficulty of passing the Golden Gate!
> Fed up with this treatment I regret my journey here.
>
> So liberty is your national principle;
> Why is it that you practice autocracy?
> You uphold not justice, O, you Americans;
> You confine me in prison and watch me closely,
> Officials; wolves and tigers—
> You are ruthless, you want to swallow me.
> I am innocent, yet treated guilty; how can I take this?
> When can I get out of this prison and find happiness?[1]

America's treatment of the immigrants attracted considerable attention in China. American goods were widely boycotted for several months in 1905 and 1906, during the renegotiation of the Sino-American treaty. An American visitor to a mountaintop monastery in Guangdong found that "Even the old monks...wanted to talk about

---

1. *Jinshan ge ji* (Songs from Gold Mountain [San Francisco]) (San Francisco, 1911), 5a, 13b; translated in Marlon Kau Hom, "Some Cantonese Folksongs on the American Experience," *Western Folklore* 42 (1983):132.

the exclusion treaty," and many shops and homes in Canton displayed posters like the following:

This shop (or home) does not sell (or use) American goods. The maltreatment of the Chinese laborer by the Americans is unprincipled. Now our citizens have joined together to oppose it. It is right that we do not sell (or use) American goods. Anyone who trades in American goods is without shame.[2]

Though visitors still found much to admire, the issues of immigration and discrimination against Chinese immigrants brought a new and more somber tone to Chinese writing about America. Even diplomats were not always well received in America: In 1880 Chen Lanbin was "pelted with stones and hooted at by young ruffians" in the streets of New York, while police stood by and laughed.[3] Permanent representatives were sent, largely to attend to the problems of the Chinese migrants, and their official diaries, usually rather impersonal, sometimes speak emotionally about the plight of their countrymen.

Apart from these concerns, China was alarmed at the interventionist activities of Western powers, including the United States. In the Boxer crisis of 1900, American troops, together with those of Japan and six European nations, marched into and looted the capital of Peking. To the already considerable powers and privileges the United States enjoyed in China—such as the right to propagate Christianity anywhere in the country, immunity from Chinese laws, and control over certain treaty port enclaves—now was added a huge indemnity and the permanent garrisoning of American troops in the capital itself. In the struggle of nations, China's future was uncertain.

2. Both quotations are from Edward J. M. Rhoads, *China's Republican Revolution: The Case of Kwangtung, 1895–1913* (Cambridge: Harvard University Press, 1975), 86 and 89. For more information on this period, see Michael H. Hunt, *The Making of a Special Relationship: The United States and China to 1914* (New York: Columbia University Press, 1983).

3. Kim Man Chan, "Mandarins in America: The Early Chinese Ministers to the United States, 1878–1907," Ph.D. dissertation, University of Hawaii, 1981, 127, quoting the *New York Times*, Sept. 10, 1880.

# Two
# Poems

Huang Zunxian, 1882–1885

*As Chinese consul-general at San Francisco from 1882 to 1885, Huang Zunxian (1848–1909) was responsible for looking after the rights of Chinese residents during a most difficult period. Huang was an open-minded official of reformist bent who had spent several years in Japan, which he viewed as a model for China, and he arrived in the United States believing it to be the most advanced nation in the world. (Earlier he had objected when China terminated its educational mission and recalled the hundred-odd students then studying in America.) But he was soon disillusioned by the lawlessness and violence he found here, particularly against Chinese.*

*In addition to being a diplomat, Huang was also a fine poet whose work, rich with allusions to thousands of years of Chinese literature, reveals great scholarly erudition. His bitterness and frustration at the way Chinese were treated in America and at the Chinese government's inability to protect them are expressed in this poem lamenting Americans' contempt for the Chinese and their betrayal of the ideals of George Washington.*[4]

EXPULSION OF THE IMMIGRANTS

Alas! What crime have our people committed,
That they suffer this calamity in our nation's fortunes?

---

4. See Noriko Kamachi, *Reform in China: Huang Tsun-hsien and the Japanese Model* (Cambridge: Harvard University, 1981), chap. 5; and also William Hung, "Huang Tsun-hsien's Poem 'The Closure of the Educational Mission in America' Translated and Annotated," *Harvard Journal of Asiatic Studies* 18 (1955): 55–73.

Five thousand years since the Yellow Emperor,
Our country today is exceedingly weak.
Demons and ghouls are hard to fathom;
Even worse than the woodland and monsters.
Who can say our fellow men have not met an inhuman fate,
In the end oppressed by another race?
Within the vastness of the six directions,
Where can our people find asylum?

When the Chinese first crossed the ocean,
They were the same as pioneers.
They lived in straw hovels, cramped as snail shells;
For protection gradually built bamboo fences.
Dressed in tatters, they cleared mountain forests;
Wilderness and waste turned into towns and villages.
Mountains of gold towered on high,
Which men could grab with their hands left and right.
Eureka! They return with a load full of gold,
All bragging this land is paradise.
They beckon and beg their families to come;
Legs in the rear file behind legs in the front.
Wearing short coats, they braid their queues;
Men carry bamboo rainhats, wear straw sandals.
Bartenders lead along cooks;
Some hold tailors' needles, others workmen's axes.
They clap with excitement, traveling overseas;
Everyone surnamed Wong creates confusion.

Later when the red-turbaned rebels rose up,
Lists were drawn of wanted rebels.
Pursued criminals fled to American asylums,
Gliding like snakes into their holes.
They brandished daggers in the same house;
Entered markets, knife blades clashing.
This was abetted by the law's looseness.
And daily their customs became more evil.

Gradually the natives turned jealous.
Time to time spreading false rumors,
They say these Chinese paupers
Only wish to fill their money bags.
Soon as their feet touch the ground,
All the gold leaps out of the earth.

They hang ten thousand cash on their waists,
And catch the next boat back to China.
Which of them is willing to loosen his queue,
And do some hard labor for us?
Some say the Chinese are shiftless;
They first came with bare arms.
When happy, they are like insects milling about;
Angry, like beasts, biting and fighting.
Wild, barbaric, they love to kill by nature;
For no reason, blood soaks their knives.
This land is not a hateful river;
Must it hold these man-eating crocodiles?
Others say the Chinese are a bunch of hoodlums,
By nature all filthy and unclean.
Their houses are as dirty as dogs';
Their food even worse than pigs'.
All they need is a dollar a day;
Who is as scrawny as they are?
If we allow this cheap labor of theirs,
Then all of us are finished.
We see our own brothers being injured;
Who can stand these venomous vermin?

Thus, a thousand mouths keep up their clamor,
Ten thousand eyes, glare, burning with hate.
Signing names, the Americans send up a dozen petitions;
Begging their rulers to reconsider.
Suddenly the order of exile comes down,
Though I fear this breaks our treaties.
The myriad nations all trade with each other;
So how can the Chinese be refused?
They send off a delegation to China,
To avoid the attacks of public opinion.
A dicer can sometimes throw a six after a one;
They have decided to try their luck with this gamble.
Who could have imagined such stupidity,
That we would agree to this in public, eyes closed?
With all of the iron in the six continents,
Who could have cast such a big mess?
From now on they set up a strict ban,
Establishing customs posts everywhere.
They have sealed all the gates tightly,

Door after door with guards beating alarms.
Chinese who leave are like magpies circling a tree,
Those staying like swallows nesting on curtains.
Customs interrogations extend to Chinese tourists;
Transients and even students are not spared.
The nation's laws and international relations
Are all abandoned in some high tower.

As I gaze east, the sea is boundless, vast;
More remote, huge deserts to be crossed.
The boatman cries, "I await you";
But the river guard shouts, "Don't cross!"
Those who do not carry passports
Are arrested as soon as they arrive.
Anyone with a yellow-colored face
Is beaten even if guiltless.
I sadly recollect George Washington,
Who had the makings of a great ruler.
He proclaimed that in America,
There is a broad land to the west of the desert.
All kinds of foreigners and immigrants,
Are allowed to settle in these new lands.
The yellow, white, red, and black races
Are all equal with our native people.
Not even a hundred years till today,
But they are not ashamed to eat his words.
Alas! In the five great continents,
Each race is distinct and different.
We drive off foreigners and punish barbarians,
Hate one another, call each other names.
Today is not yet the Age of Great Unity;
We only compete in cleverness and power.
The land of the red man is vast and remote;
I know you are eager to settle and open it.
The American eagle strides the heavens soaring,
With half of the globe clutched in his claw.
Although the Chinese arrived later,
Couldn't you leave them a little space?

If a nation does not care for its people,
They are like sparrows shot in a bush.
If the earth's four corners won't accept them,
Wandering in exile, where can they rest?

Heaven and earth are suddenly narrow, confining;
Men and demons chew and devour each other.
Great China and the race of Han
Have now become a joke to other races.
We are not as simple as the black slaves,
Numb and confused wherever they be.
Grave, dignified, I arrive with my dragon banners,
Knock on the custom's gate, hesitant, doubtful.
Even if we emptied the water of four oceans,
It would be hard to wash this shame clean.
Other nations may imitate this evil;
No place left to hold our drifting subjects.
In my far travels I recall Da Zhang and Shu Hai;
In my recent deeds, ashamed before Generals Wei and Huo.[5]
I ask about Sage Yu's travels, vast, limitless;
When will China's territory expand again?

<div align="right">(<em>translation by J. D. Schmidt</em>)</div>

*Huang's frustrations with trying to protect the rights of Chinese in the United States soon led him to request a transfer. Even after his experience in California, which strengthened his sense of Chinese nationalism, he continued to admire some American social institutions, particularly the legal system. But he feared that individual liberty and egalitarianism led to selfishness and social disorder, and that if democracy did not work in America it would certainly be impossible for China. This second poem expresses his disgust with the foul tactics and greedy power struggle of the presidential election of 1884, said to have been one of the dirtiest in American history, and one in which both parties had explicitly anti-Chinese platforms.*

THE ELECTION OF 1884

Blow the horn for the Democratic Party,
Beat the drum for the Democratic Party,
Hoist the banner of the Democratic Party,
Write pamphlets for the Democratic Party.
Fellow citizens, hold your peace;
Please listen to our party's plea.
Each person voices his opinions,
Each person has his own inner feelings.

---

5. The ancient sage emperor Yu is supposed to have traveled 230,000 Chinese miles from Zhang Hai to Shu Hai. Wei Qing and Huo Chubing were Han dynasty generals who drove off the barbarian Huns.

Joined together we make a nation;
A man alone is but a foot of earth.
The man we name must be supported by all;
He will be father to us all.

Beat the drum for the Republican Party,
Blow the horn for the Republican Party,
Write pamphlets for the Republican Party,
Hoist the banner of the Republican Party.
Please listen to our party's plea;
Fellow citizens, hold your peace.
Each person has his own inner feelings,
Each person voices his opinions.
A man alone is but a foot of earth;
Joined together we make a nation.
He will be father to us all;
The man we name must be supported by all.

One party brags to the other party:
Look what we will accomplish.
We will champion business and labor;
We will put protectionist policies first.
Gold must accord with the price of silver;
We should have a unified policy.
Everybody a farmer on his own land
Must have ten more bushels of wheat.
Upon this our American land
Permit no foreigners to come and trespass.
Yellow men from far away
Should be excluded from our gates.
Let them not defile our reputation;
Allow them not to snore beside our couch.
Just like Jesus breaking bread
To feed and gratify a thousand people,
As soon as our party wields power
The effect of our policies will be seen in days.

---

*Figure 9.*    A Chinese laborer in California wearing campaign badges for Grover Cleveland and Allen G. Thurman, the Democratic candidates for president and vice-president in 1888. From the archives of the California State Library.

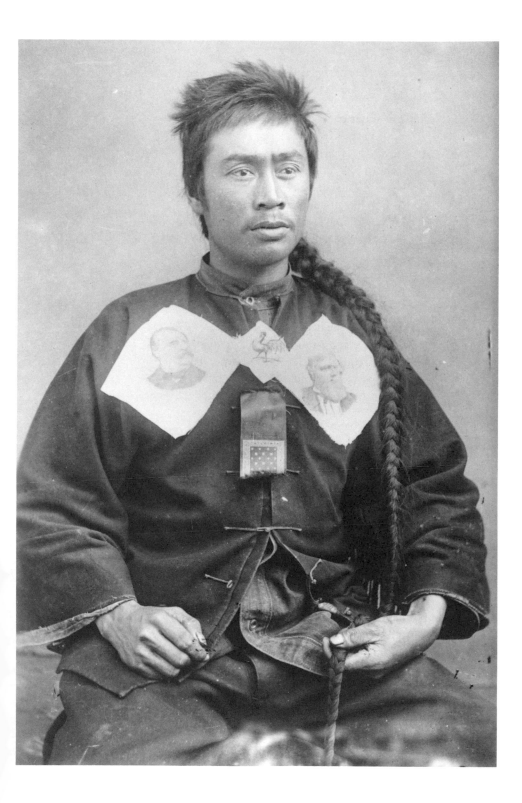

The other party castigates this party,
Saying what is the use of all these empty words.

The other party denounces this party:
Your party's leader is a scoundrel;
In youth he was a vagabond thief
Reported to have stolen neighbors' cattle;
He is said to keep a certain prostitute
And to like to dally in brothels.
He is addicted to dice, a scheming pilferer.
He looks like a devil from the underworld,
Only dressed like an ape with a cap on.
He covers up his countless vices.
Fellow citizens, can't you recognize this?
Who wants to follow one who bares his behind
To shit on the head of the Buddha?
Were his face armored with ten layers of steel
It could hardly conceal his shame.
This party denounces the other party;
Their mouths all make the same racket.

One day a circus tent is set up
To accommodate a thousand spectators.
Rows and rows of black leather benches
Crisscross the ground in tiers;
Colorful lanterns countless in number
Illuminate the ornate canopy.
A boozy rough mounts the stage
To churn and revolve his overgrown tongue.
Yellow beard curling all around,
His piercing green eyes flashing,
From his mouth comes forth a river of words,
Rolling waves that will not be stemmed.
His boisterous laugh rips through the roof;
His anger threatens to pull down the pillars.
At times the audience cheers him on,
At times it boos in disapproval.
The palms of their hands make a sound like thunder
As they beat together in rhythmic union.
At the conclusion hands are raised
To express approval for the party's decisions.

The speeches have yet to come to an end
When a parade is loosed inside the hall.
In steel helmets and coats of mail,
They march on both the right and the left.
Ornate elephants in golden braid,
White horses bridled in purple silk.
The pounding of footsteps is loud and clear;
The sight of the rifles like a forest of masts.
On their faces some wear masks,
Some hold long weapons in their arms.
Gold eyes pretending to be being dreadful demigods;
Black faces painted like the king of devils.
Like Christian crusaders of long ago
Their crimson pennons wave in the wind.
All together they sing patriotic songs;
Their musical voices encircle the rafters.
Thousands and myriads of heads are moving;
Wall after wall they press forward.
The people standing at the side are asked
To see the grandeur of the party displayed.

Out of range of the crowd's eyes and ears,
The stress is on coaxing with sweet words.
Treats like green tender tea,
Wine of a crystalline emerald hue,
Gifts like black velvet woven with stripes,
And a medley of woolens of crimson color.
Even such trinkets as hairpins
Are given out to lure the women.
Candidates pay their respects to the rich and learned on high,
And below call on the lowly of the street.
With ruffians as well as common criminals,
They shake the hands of all whom they see.
They offer things deprecatingly,
Saying this little gift is from so and so.
Holding up a colored placard,
They ask the voters to remember their names:
"I know that you, Sir, have many an in-law,
I know that you, Sir, have uncles and nephews.
I therefore beseech your loyal support;
Our party will surely win the election."

They remind the voters again and again,
Please do not make any mistake.
. . . . . . . . . . . .
Alas! George Washington!
It is nearly a hundred years now
Since the flag of independence was raised
And oppressive rule was overthrown.
Red and yellow and black and white
Were all to be treated as one.

Every man was to be granted his freedom,
All the resources were to be used for their profit.
The people's intelligence was to be developed;
The wealth of the nation was to be doubled and trebled.
Such a magnificent and grand nation:
We sigh with awe at the music of its name.
Who would have guessed this presidential election
Would reveal so many strange things?
Friends are embroiled in angry strife,
Zealously disputing the nation's succession.
In serious cases riots lead to disasters;
On a smaller scale there are assassinations.
Innocent parties are commonly entangled,
And even officials dragged into jail.
Striving for fairness, it produces selfishness.
Abuses are begotten by the general interest.
Is the one chosen of virtue, after all,
Worthy of assuming high office?
How can we imagine the Age of Grand Harmony on earth?

*(translation partly after Chang-fang Chen)*

# Chinese
# in America

Zhang Yinhuan, 1886

*Zhang Yinhuan (1837–1900) was China's minister to the
United States (and also Peru and Spain) from 1886 to 1889. He spent
much of his time here trying to negotiate a new treaty and to obtain re-
parations from the United States government for Chinese who had suffered
damages from mob violence in Rock Springs and other such incidents. Dur-
ing the Boxer movement, in a spasm of violent xenophobia in China, Zhang
was executed by anti-foreign Chinese conservatives.[6]*

## IMMIGRATION DIFFICULTIES

April 7, 1886; rainy. In the morning as I got up, the boat arrived in San
Francisco harbor. Consul Ouyang Ming, accompanied by a foreign
clerk named Philby [?] and interpreter Ouyang Geng,...came on board
to see me. I invited the Consul to my cabin and inquired of him about
recent events in San Francisco. We sat and talked for quite some time
and then went up to the bridge to meet Philby and other [consular]
officials.

A little while later the ship docked. Just as the luggage was being
unloaded, a customs official named Hager stopped me from going
ashore on the pretext of wanting to see my credentials. I protested that
the customs service had no right to receive and read my credentials,

6. Banno Masataka, "Chō Inkun cho 'San shū nikki' (jūhachi kyūroku nenkan) o
yomu" (On reading Zhang Yinhuan's *San zhou riji* [1896 edition]), *Kokka gakkai zasshi*
95(7–8) (1982):491–512; Arthur W. Hummel, ed., *Eminent Chinese of the Ch'ing Period,
1644–1912* (Washington, D.C.: Government Printing Office, 1943, 1944), 1:60–64.

and that if he wanted to see them he must give me written evidence that he was authorized to do so. And I asked Philby to argue with him. At that moment leaders of [various organizations of Chinese in the United States] came to welcome me, so I went down to see them. We negotiated for a long time but the customs official still would not alter his view. I then told him that since I was prevented from disembarking I might as well return to China on the same boat. It is absolutely out of the question to let him read my credentials. The customs official knew that the correctness of my position was unassailable. His supervising officer Tinnin thereupon politely invited me to land.[7]

Then we took carriages to a hotel, where we stayed on the ninth floor. Jintang and Philby came to look after things, so I told them that the Customs had been so unreasonable that they should make further protestations. Philby explained in detail how difficult it was to get things done in San Francisco. He said yes, yes, and left. I instructed Jintang to send a telegram to His Excellency Zheng to be given to the State Department. I had been traveling on a ship for more than half a month. Western food is not what I like, and furthermore from time to time I suffered from seasickness and could not eat. Now I am staying on the ninth floor right in the center of town. Because of the thunder of vehicles I cannot sleep all night.

MEETING WITH SAN FRANCISCO CHINESE

April 10; rainy.... I went to the Zhonghua Huiguan and the Sanyi Huiguan [two of the so-called Six Companies, mutual aid associations of Chinese from the same locality] and stayed for a while. The various merchants last year and this spring were troubled by natives plotting to expel them and bomb them, to the point that they could hardly live in peace and they really felt a storm was brewing. They wanted to close shop and return to China, but their accounts were not easy to collect. But staying here, they would be unhappy and fear for their lives. So they are in a dilemma and do not know if they should go or stay. Since the second month the troubles have eased and their alarmed spirits have calmed down somewhat and they all wished I would stay a few days more so that they could relate recent events to me in detail. As I have received Imperial orders to come all this way to protect Chinese

7. The incident occasioned an exchange of notes between Zhang and the U.S. Secretary of State, and was reported and editorialized about in the *New York Times*; see Chan, "Mandarins in America," 219–21.

merchants and people I have no choice in my responsibilities, so I com-
forted them at length with the following words:

"There have been several decades of Sino-American amity. Under
the Burlingame Treaty of 1868 Chinese enjoyed the benefit of being
allowed to come or go at will in America. At that time America was in-
tent on opening up the western frontier and spared no pains to attract
Chinese. In an instant railways were built in all directions. In the
mountains, inexhaustible mines of coal, iron, and precious metals
mines were developed. The barren area around San Francisco is now a
metropolis. Wonderful structures reach the clouds; merchants and
travelers fill [the city] to the brim. How could all this have been
accomplished without the efforts of Chinese? And yet after a few years
[the Americans] plotted to restrict immigration, and in a few more
years they were plotting to expel the Chinese. Recently they have
been burning, pillaging, robbing, and killing. Their vicious cruelty is
unbearable.

"In view of this, what plan should the Chinese remaining overseas
adopt? They should figure out how to maintain ties with each other and
all engage in proper occupations so as not to be looked down on.
Especially because the Chinese have come from tens of thousands of
miles away they should collectively carry out the practice of people
from the same community respecting each other and not divide up ac-
cording to prefecture and county. Seeking their livelihood away from
home they should be as one family. When occasionally they have quar-
rels they should go to the Huiguan for resolution. Only as a last resort
should they trouble the Consul. We must let the other race know that
we Chinese look after each other so that to some extent we can avoid
being taken advantage of. As for those cases which have yet to be re-
solved, we will of course find measures to expedite them, and you need
not worry too much."

The various gentry and merchants all expressed agreement with
my words and left.

A COURT CASE

Recently a New York judge decided a rather amusing case involving
Chinese. There were two Chinese, uncle and nephew, who worked
washing clothes. A scoundrel of a Westerner came every day and
caused trouble for them. The nephew, who was young and hot-
blooded, could not stand this harassment and chased him with a knife.
The uncle feared there would be trouble and followed him and told him

to stop. Suddenly they encountered a policeman, who took the nephew together with the weapon in to the authorities. The Westerner lodged an accusation. The uncle engaged a lawyer for the case, who told him, "If you yourself admit carrying the knife, it will prevent your nephew from being found guilty." The uncle said, "That way I will just be taking the place of my nephew—why do I need to consult you for that?" The lawyer replied, "Because otherwise your nephew will be found guilty. Just do as I say, and the reason will become clear."

When the Western judge convened his court, the uncle did what the lawyer had instructed. The Western judge told the Westerner, "You cannot tell which one was carrying the knife, so it is clear you are muddle-headed. This affair must have come about because you were pestering people until they couldn't bear it." He ruled that the charges be dismissed, and uncle and nephew were both freed. Could we have arrived at such a judgment in China? Because the lawyer was familiar with Western rules he managed to get the two men off. His methods are shallow, but still we can see that China and the West have different systems.

### SUPERIORITY OF CHINESE ETHICS

There was a lawyer there [at a New York maritime cable company] named Chester [?] who discoursed earnestly on Chinese ethical principles. He had translated Chinese proverbs into the Western language and published them in a volume in the hopes of improving people. He said, "How has China been able to make itself a nation like this, renowned for so long for its civilization? What is the reason for this? Recently I have come to realize that what makes China so is rooted in the term 'filial piety.' When a person can be filial to his parents then the feelings of respecting the ruler, honoring superiors, venerating elders, and caring for the young naturally follow. All institutions come from this. Westerners mostly do not understand the meaning of 'filial piety.' Therefore their customs are not refined and their nations' fortunes are not long-lasting."

When I heard this I immediately felt impressed that America had such a wise person; especially in the Southern Party, he must be outstanding. I talked with him for a long time, all about philosophical and ethical matters. It was very interesting. I told him, "In the investigation of material things, Westerners have applied themselves relentlessly. Yet in weighing ethical principles Chinese have for more than five thousand years become more and more refined in their study. The

Westerners cannot match them. If we could have a thorough under-
standing of Chinese and Western learning combined, then we would
achieve something."

### A RETIRED MISSIONARY

I called at the house of an old man named Peter Parker.[8] He showed me
fifty or sixty pictures of various illnesses that he had cured when he had
been in Canton. There were also more than a hundred pictures that had
been published in books. All had been gathered for publication because
the illnesses were most difficult to cure. More than fifty thousand
people had been cured by his treatment. In Canton, Parker has the
reputation of being a man of virtue. In the war of 1857 he by chance
became involved with military affairs. Now he is eighty-two and walks
with a slight limp. When he goes up and down stairs, his son pays no
attention. I was concerned that he might fall, so I repeatedly asked the
son to support him, but the son said his father did not like to be helped.
This is what the sentiment between fathers and sons is like in the West.

8. Peter Parker served as a medical missionary in Canton beginning in the 1830s. He
later became involved in diplomatic activities and was American minister to China in
1857, at the time of the Anglo-French war against China. See Edward V. Gulick, *Peter
Parker and the Opening of China* (Cambridge: Harvard University, 1973).

# Translator's Notes to Uncle Tom's Cabin

Lin Shu, 1901

*Lin Shu (1852–1924) is modern China's most famous translator. Working with collaborators who knew foreign languages (he did not), he rendered over 150 Western works into Chinese, including dozens of nineteenth-century novels by such writers as Dickens, Rider Haggard, and Walter Scott. To his translation of Harriet Beecher Stowe's* Uncle Tom's Cabin, *published as "A Black Slave's Cry to Heaven," he appended a preface and an afterword that discuss the parallels between Stowe's story of black slaves in America and the oppression of Chinese by Americans and of China by Western nations.*

*Lin's translation was completed in 1901, a year after the troops of the United States and seven other nations, responding to the antiforeign violence of the Boxer uprising, invaded and looted Peking. The book was widely read in China, and Lin's dark and menacing image of the United States seemed apt to many of his countrymen.*[9]

PREFACE

In American history the enslavement of blacks in Virginia can be dated to 1619, when the Dutch transported twenty African blacks in a warship to Jamestown and sold them. This was the beginning of the enslavement of blacks by whites. That was before the United States had been established as a nation. Later, when the public-spirited

---

9. See Leo Oufan Lee, "Lin Shu and His Translations: Western Fiction in Chinese Perspective," *Papers on China* 19 (1965):159–93.

Washington governed selflessly, not seeking a private fortune, he was still unable to change the laws on slavery. It was not until Lincoln's time that the slaves were fortunately emancipated.

Recently the treatment of blacks in America has been carried over to yellow people. When a cobra is unable to release its poison fully it vents its anger by biting wood and grass. Afterwards, no one who touches the poisoned dead branches will escape death. We the yellow people, have we touched its dead branches? Our country is rich in natural resources, but they are undeveloped. Our people's livelihood is impoverished to the extent that they cannot make ends meet. Thus they try to support themselves by going to America to work, and every year send money back to support their families. Of the Americans, the more calculating ones are alarmed at the draining off of their silver and so treat the Chinese workers cruelly so as to stop them from coming. As a result, the yellow people are probably treated even worse than the blacks. But our country's power is weak, and our envoys are cowardly and afraid of arguing with the Americans. Furthermore, no educated person has recorded what has happened, and I have no way to gain factual knowledge. The only precedent I can rely on is *A Black Slave's Cry to Heaven.*

This book was originally called *The Oppression of Black Slaves,* and also appeared under the title *Tom's Family Affairs.* It was written by the American woman writer, Stowe. I did not like the inelegance of these titles and hence changed the title to the present one. In this book the miseries of black slaves are depicted in detail. This is not because I am especially versed in depicting sadness; I am merely transcribing what is contained in the original work. And the prospect of the imminent demise of the yellow race has made me feel even sadder.

The vociferous [antiforeign] libel-mongers these days are too narrow-minded to reason with. Those who favor the white race, on the other hand, under the erroneous illusion that the Westerners are generous with vassals, are eager to follow or join them. In this respect, there are indeed quite a few readers for whom this book should serve as a warning.

The work owes much to Mr. Wei Yi of the Qiushi Academy, who rendered the story orally, which I then put down in writing. It was completed in sixty-six days.

*preface written by Lin Shu (Lin Qinnan) of Min county, at Seaview Tower over the lake, on Chongyang festival of year Xinchou during the Guangxu reign [1901]*

Stowe is an American woman. The reason why the title "Mrs." was not attached to her name at the beginning of the volume is because according to Western custom men and women are treated as equals. Furthermore she did not call herself "Mrs." in the original book and that term appears only at the end of the book, so we have not changed this. According to Stowe herself, the book is largely based on what she personally heard and saw. Seventy or eighty percent actually happened, and only twenty or thirty percent is fiction. The names of men and women in the book are mostly false, but in reality there were such persons.

In translating this book, Mr. Wei and I did not strive to describe sorrow for the purpose of eliciting useless tears from readers. It was rather that we had to cry out for the sake of our people because the prospect of enslavement is threatening our race. In recent years the American continent has severely restricted the immigration of Chinese laborers. A stockade has been erected at the landing place where hundreds of Chinese who have come from afar are locked up. Only after a week do they begin to release one or two people, and some people are not released even after two weeks. This is [like] what is referred to in this book as the "slave quarters." Up to the present, letters have never been opened in civilized nations, but now these people are opening all the letters of Chinese without exception. Wherever the word "America" is mentioned [in a letter], it is taken to be an offense against the nation and no effort is spared to arrest and deport the person. Therefore I ask, do we Chinese have a nation or not?

As we can read in George's letter to his friend, a person without a country will be treated like a barbarian even by civilized people. So if in the future we Chinese become material for slaves, will this not be the basis? The Japanese are of the same yellow race. When the wives of their officials were humiliated by the health examination, they were enraged and fought the case in the American courts, organizing groups among themselves in order to resist. How brave the Japanese are! Do not our Chinese officials realize that their own nationals, though guiltless, are ignominiously being put in prison and wasting to death there? This situation of dominating and being dominated is like that of [the ancient states of] Chu and Yue. Our national prestige has been wounded; need more be said?

Fittingly, this book has been completed just as we are beginning to

reform the government. Now that people have all thrown away their old writings and are diligently seeking new knowledge, this book, though crude and shallow, may still be of some help in inspiring determination to love our country and preserve our race. Perhaps those gentlemen in the nation who are well-informed will not consider these words too excessive.

*Lin Shu, Seaview Tower above the lake,*
*ninth month of Xinchou* [*1901*]

# The Power
and Threat
of America

Liang Qichao, 1903

*Liang Qichao (1873–1929) was only thirty when he visited the United States in 1903 (Tocqueville had been twenty-six when he came) but already well known as a champion of progress and democracy.*[10] *As a young Cantonese scholar, Liang had been associated with the reformer Kang Youwei. In 1898 Liang and Kang had been forced to flee China with prices on their heads following an antireformist coup in Peking. Settling in Japan, Liang became a prolific journalist and China's first true modern intellectual. His writings, smuggled back into China, were to awaken a whole generation (of which Mao Zedong was one) to the world of ideas outside China.*

*Liang stayed two months in Canada and five in the United States, crossing the continent twice by railroad and visiting dozens of cities, including Boston, New Orleans, Seattle, and Los Angeles, as well as traveling to Montana and Yosemite. He talked to Americans of all political persuasions, from socialists to President Theodore Roosevelt, as well as many Chinese residents. He complemented his observations with well-chosen readings, particularly the massive two-volume* The American Commonwealth *by the British scholar James Bryce, regarded by many*

10. On Liang's trip to America and his political views, see Hao Chang, *Liang Ch'i-ch'ao and Intellectual Transition in China, 1890–1907* (Cambridge: Harvard University Press, 1971); Jerome B. Grieder, "Liang Ch'i-ch'ao (1873–1929) and Hu Shih (1891–1962)," in Marc Pachter and Frances Wren, eds., *Abroad in America: Visitors to the New Nation, 1776–1914* (Reading, Mass.: Addison-Wesley, 1976), 279–92; and Andrew J. Nathan, *Chinese Democracy* (New York: Knopf, 1985), 58–61.

*as Tocqueville's successor, which Liang presumably read in a Japanese translation.*[11]

*Liang's* Xin dalu youji jielu *(Notes from a journey to the new continent) is a remarkably informative, incisive, and influential work, one that shaped the views of many twentieth-century Chinese.*[12] *A a promoter of political reform in China, Liang was naturally most interested in American political life. He says little about shipyards or factories—a visit to a navy yard near Philadelphia triggered a discussion of American naval strength, not details on the mechanics of shipbuilding. For Chinese readers, Liang's book was an eminently informative introduction to American history, foreign policy, and politics. He also describes American culture (newspapers, public libraries, museums, universities, city parks), business—especially the largest conglomerate economic "trusts," with their dates of founding and total assets—immigrants and their neighborhoods, religious leaders, and the trans-Pacific cable and its impact on global communications.*

*As Liang notes in his preface, the United States at the turn of the century was "difficult to summarize." His responses to this "complex civilization" were mixed. In general, he admired the founding spirit and basic constitutional structure of the American polity. But he was disappointed by many of its practices: corruption, the spoils system, the overwhelming economic power of the trusts, and the juxtaposition of glittering riches and appalling poverty. He had particular misgivings about the problems caused by the large influx of immigrants; at one point he said, "I don't worry about anything for America except its immigrants"* (Xin dalu youji jielu, *sect. 11).*

*Still, the system worked, he said. It worked because of the peculiar dual structure of government—federal and local—a product of America's particular history: "The American political system is truly [the most] unimaginable in the world. Why?—because the United States has two kinds of government and its people two kinds of patriotism"* (ibid., *sect. 43). America, he explained, had been built from the bottom up: the nation had*

---

11. *Heimin seiji* (People's politics) (Tokyo: Minyūsha, 1889–1891). Compare, for example, Bryce's description of the national and state governments as "a large building and a set of smaller buildings…[such as] where a great church has been erected over more ancient houses of worship" (*The American Commonwealth*, 2d ed., 1891, 1:14) and Liang's similar passage, with the identical image, in *Xin dalu youji jielu* (1903; rpt. Taipei: Zhonghua, 1957), sect. 43.

12. On the influence of Liang's disappointment in American democracy, see Nathan, *Chinese Democracy*. Liang's work was also stylistically innovative—one scholar has called it the prototype of modern Chinese reportage; Yin-hwa Chou, "Formal Features of Chinese Reportage and an Analysis of Liang Qichao's 'Memoirs of My Travels in the New World,'" *Modern Chinese Literature* 1 (1985):201–15.

been organized by the states, and before that the states were formed from smaller colonies. But throughout its history, he cautioned, American democracy was subject to the tension between centrifugal and centripetal forces. As an indication that centralization was now in the ascendancy, he cited a speech in which President Theodore Roosevelt urged Americans to discard their provincialism (literally "village mentality"). In a world moving inevitably toward authoritarianism, even this unique democracy needed some centralization, Liang thought. Compared to republican government, constitutional monarchy "has fewer defects and is more adaptable"; modern nations would do best to foster enlightened statism and encourage strong leaders. In its leadership, America was fortunate, he said, to have had men like Washington, Hamilton, and Lincoln, and it was the founding fathers, meeting secretly to draft the Constitution, who created a workable system: "Who says America is a nation freely formed by all the people? I see only a few great men who imposed it on them. Since this is true even of Americans who are so used to self government, others should certainly take warning" (ibid., sect. 13). The American system, he concluded, was inappropriate for China, whose citizens lacked the Americans' public-spiritedness regarding local government.

"An undertone of marvel and awe" resonates throughout Liang's appraisal of the United States,[13] but two considerations tipped the balance from admiration to alarm. First, he correctly sensed, in arguments like Roosevelt's jingoistic call for a stronger posture in the Pacific, the rising temper of American imperialism at the turn of the century. American military and economic power—the trusts were a "giant monster"—could easily reach across the Pacific and prey on China. Even more important, Liang was convinced that China was not ready for democracy of the American sort. Despite the enthusiastic hospitality he received in Chinatowns, he was scathing in his evaluation of Chinese in America. San Francisco's Chinatown seemed to him a microcosm of China: splintered and chaotic, it showed that Chinese were unable to cope with total freedom and desperately needed tight political controls.

And so, this inestimably influential writer returned from America convinced that his countrymen were not ready for democracy. China needed a centralized government under an enlightened state leadership that could overcome the people's provincialism and forge diverse local bodies into a cohesive whole. Liang subsequently looked to antiliberal German statism as a more suitable model for China's future.

13. The phrase is from Hao Chang, *Liang Ch'i-ch'ao*, 245.

NEW YORK

Uncivilized people live underground, half-civilized people live on the surface, and civilized people live above the ground. Those who live on the surface usually live in one- or two-story houses.... Some houses in Peking have entrances going down several stone steps, almost as if going underground. In New York, buildings of ten to twenty stories are not rare, and the tallest reaches thirty-three stories. This can truly be called above the ground. But ordinary residential buildings in big cities in America also have one or two basements, and so are both above and below ground.

Everywhere in New York the eye confronts what look like pigeon coops, spiderwebs, and centipedes; in fact these are houses, electric wires, and trolley cars.

New York's Central Park extends from 71st Street to 123d Street [in fact, 59th to 110th], with an area about equal to the International Settlement and French Concession in Shanghai. Especially on days of rest it is crowded with carriages and people jostling together. The park is in the middle of the city; if it were changed into a commercial area, the land would sell for three or four times the annual revenue of the Chinese government. From the Chinese point of view this may be called throwing away money on useless land and regrettable. The total park area in New York is 7,000 [Chinese] acres, the largest of any city in the world; London is second with 6,500 acres. Writers on city administration all agree that for a busy metropolis not to have appropriate parks is harmful to public health and morals. Now that I have come to New York, I am convinced. One day without going to the park leaves me muddled in mind and spirit.

Every day streetcars, elevated trains, subway trains, horse carriages, automobiles, and bicycles go clitter-clatter above and below, banging and booming to left and right, rumbling and ringing in front and behind. The mind is confused and the soul is shaken. People say that those who live in New York for a long time must have sharper eyes than ordinary people or else they would have to stand at intersections all day, not daring to take a step.

POVERTY

New York is the most prosperous city in the world, and also the bleakest. Let me briefly describe New York's darker side.

Anti-Oriental agitators criticize the Chinese above all for their un-

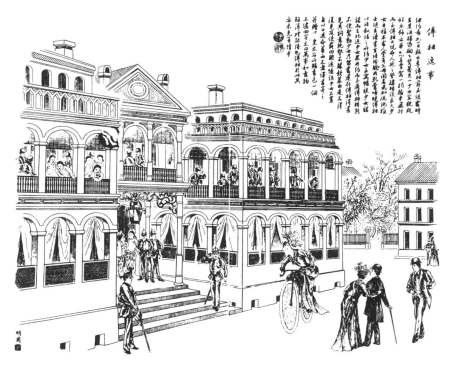

傅相遺事

海外奇事誌日報相指首此道案時
真情海籍悄潮中以息軍第一介末客銀祝
兩西傳花說命人氏曰繁謹聰溪長久行
女日稍午華令金至亞遠溪城指
士現丸遠告官鴻相施拒乳故加無指
以現紅語上府扶少女至凌嬪探之亦槎
謝氏詞為此筆少女耶都遭穢指相報
不便督女最近邊由過傳帽相帽數
溪其詞意絶妙少女由道情話少五厘
復見友住葛國困通憶深亡畢
若鋪及亞諸四字心爲乞已一個
上諸四字大回萬事甲音前
相溪妙指緒電傅相射其其
示未見生前相情說其

*Figure 10.*     Li Hongzhang (1823–1901), governor-general and high commissioner, was the most important official in late nineteenth-century China. In 1896 he passed through New York on the way home from Europe and planted a tree at Grant's tomb. The accompanying text reads: "According to a New York daily newspaper, when the Grand Minister Li Hongzhang visited that place, he was once leaning from a restaurant railing and saw a pretty and unusually attractively dressed young girl flying along on a unicycle [?]. The Grand Minister was pleased and asked someone to invite her to come up to the restaurant, where they talked for a while. The young woman told him she was a native of that place, who lived with her mother and father, named Charitas [?], and currently attending school. She spoke vivaciously, like a young oriole greeting the dawn. The Grand Minister, considering that place not suitable for conversation, invited her to his residence for a long talk. She agreed and left. After he had returned, she arrived as promised, but he was sound asleep and not to be disturbed, so she left a note and departed. When he read the note the sincerity of her wording impressed him greatly, but he was not able to see her again. After he had completed his mission and returned to China, he thought about this young woman ceaselessly, so he dictated a letter, which he had someone versed in Western languages translate, and sent it to her along with a sachet given by the Empress Dowager with the four characters embroidered on it 'May everything go well.' Although the object was small, the honor was great; perhaps the Grand Minister's feelings were involved." From *Dianshizhai huabao, yuan* 5:34.

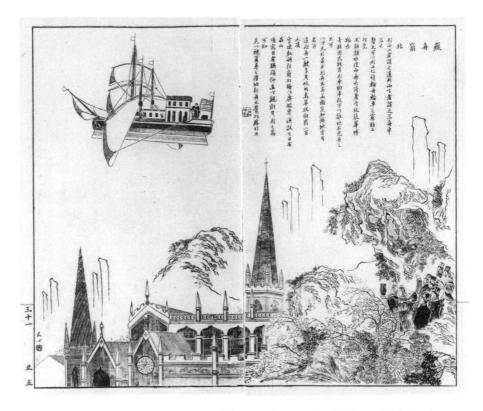

*Figure 11.* Airship, ca. 1888. The caption reads: "That which is above form is called Essence [*dao*]; that which has form is called Matter. Ships and vehicles are both matter; their tendency is not to rise above form. Therefore steamships and wheeled vehicles, no matter how ingeniously made, cannot leave the water or the land without having something to support them. According to Zhang Hua's book *Bowu zhi* [a third-century record of marvels], the people of a certain strange country were able to make flying carts. If carts could leave the land, can it be impossible for ships to fly to the sky? And so flying ships have come about.

"In a place called Chicago in the United States, a famous artisan has built a flying ship with many sails that look like the wings of birds. It can carry two hundred people and soar to the sky. He plans to ride it to the extreme north pole in order to broaden his vision. On the day he tried it out, people watching from the top of a hill had to look straight up to see it, which shows how high it was flying." From *Dianshizhai huabao, chou* 5:31.

cleanness. From what I have seen of New York, the Chinese are not the dirtiest. In streets where Italians and Jews live, in the summer old women and young wives, boys and girls, take stools and sit outside their doors, clogging the street. Their clothing is shabby, their appearance wretched. These areas are not accessible by streetcar and even horse-drawn carriages seldom go there. Tourists are always coming to see how they live. From the outside there is building after multistoried building, but inside each building dozens of families are tenants. Over half of the apartments have no daylight or ventilation, and gas lights burn day and night. When you enter, the foul smell assaults your nose. Altogether, in New York about 230,000 people live in such conditions.

According to statistics for 1888, on Houston and Mulberry streets (where most of the people are Italians, with some Germans, Chinese, and Jews), the death rate was 35 per thousand, and 139 per thousand for children under five. In comparison, the overall death rate for New York was 26 per thousand, so the hardship of these poor people can be imagined. These rates, it is said, are due to the lack of air and light where they live. Another statistician says there are 37,000 rented apartments in New York, in which over 1,200,000 people live. Such dwellings are not only unhealthful but also harmful to morality. According to a statistician again, of the 483 people living in one building on a certain street in New York, in one year 102 people committed crimes. So great is the influence of these conditions.

"Crimson mansions reek of wine and meat, while on the road lie frozen bones. Rich and poor but a foot apart; sorrows too hard to relate." So goes Du Fu's poem [Tang dynasty]. I have witnessed such things myself in New York. According to statistics of the socialists, 70 percent of the entire national wealth of America is in the hands of 200,000 rich people, and the remaining 30 percent belongs to 79,800,000 poor. Thus the rich people in America are truly rich, and this so-called wealthy class constitutes no more than one four-hundredth of the population. It can be compared with one hundred dollars being divided among 400 people, with one person getting seventy dollars and the remaining thirty dollars being divided among 399 people, each getting a little over seven cents. How strange, how bizarre! This kind of phenomenon is seen in all civilized countries, particularly in big cities, [but] New York and London are the most notorious. The unequal distribution of wealth has reached this extreme. I look at the slums of New York and think with a sigh that socialism cannot be avoided.

### J. P. MORGAN

This afternoon I went to visit Morgan. Morgan has been called the king of trusts and the Napoleon of the business world. I had no business to discuss with him, but was led by curiosity to meet this man whose magical power is the greatest in America. All his life he has only received guests and never called on others. Even presidents and prime ministers, if they need his help in their nations' financial matters, come to consult him and do not expect him to visit them. I was also told that his appointments are limited to one to five minutes each. Even extremely important problems can be decided in this briefest span of time, so far without error. His energy and acumen are truly unrivaled. I wrote a letter two days ago expressing my wish to request a five-minute conversation. At the appointed time, I went to his Wall Street office to visit him. There were scores of visitors in his receiving room, who were led to see him one by one; no one exceeded five minutes. As I had nothing to ask of him and did not want to waste his precious time, I went in and talked with him for only three minutes. He gave me a word of advice: The outcome of any venture depends on preparations made ahead of time; once it is started, its success or failure is already decided and can no longer be altered. This is the sole motto for his success in life, and I was deeply impressed.

### THE INDUSTRIAL TRUST

In New York City at the turn of the century, a monster was created called the "trust." This monster was born in New York, but its power had spread to all of the United States and is speeding over the whole world. In essence, this monster, whose power far exceeds that of Alexander the Great or Napoleon, is the one and only sovereign of the twentieth-century world. For years I have wanted to find out its true nature; now in New York, I finally have the opportunity....

The origins of the trust can be traced to the Oil Trust of 1882, which was the personal creation of [John D.] Rockefeller, known to the world as the petroleum king. Then in 1883, the Cotton Oil Trust was formed, in 1886 the Bread Trust, and in 1887 the Sugar Refining Trust. Their profits were conspicuous and startled all the world. Thenceforth the whole country became crazed about trusts, until today almost 80 percent of the capital of the entire United States is under the control of trusts. The United States today is the premier capitalist nation in the world, and American capital amounts to almost half that of the entire

world. Thus somewhat less than half of the world's total capital is now in the hands of this tiny number of trust barons. Alas! How strange! How amazing!...

In sum, the trust is the darling of the twentieth century, and certainly cannot be destroyed by human effort, as is recognized by all of even the slightest learning. From now on, domestic trusts will grow into international trusts, and the nation that will be most severely victimized will surely be China. It is clear that we cannot look at this problem as if observing a fire from the opposite shore.

### THEODORE ROOSEVELT'S SPEECH

For several days after I read this speech by President Roosevelt in the newspaper, I felt frightened...and could not get rid of my anxiety. [Here Liang quotes at length Roosevelt's assertions about the need for American "imperialism" particularly in the Pacific region.] What was his point in talking about "role" and "purpose" when he said, "playing a great role on the world's stage" and "carrying out our great purpose"? I hope my countrymen will ponder this.

Although these words are Roosevelt's, in fact they represent American public opinion....

The general trend of world affairs is daily concentrating more and more on the Pacific, as those with even a little knowledge of world affairs will affirm. Why? Because this trend is converging on China, as those with a little knowledge of current affairs can also say. In that case, no country is in a better position to utilize the Pacific in order to hold sway over the world than China. But China is unable to become the master of the Pacific, and politely yields this position to others. How then can I bear talking about the Pacific? But that is not all I cannot bear to mention.

### THEODORE ROOSEVELT

On the 17th [of May] I visited President Roosevelt at the White House. At the time, Roosevelt had just returned from touring the country, and the reception room was filled with guests. He led me to a side room, where we talked about half an hour. Our conversation was not particularly profound....

In personality Roosevelt is like Kaiser Wilhelm II of Germany. Of the heads of the various countries of the world, only these two men have great ambition and talent and the aura of one who would create a

new epoch.... Since McKinley, the Republican Party has leaned toward an imperialistic policy; Roosevelt, in particular, assumes an extremely aggressive posture and is full of ambition. There is a chapter in his book called "The Life of Struggle." All his speeches take war as the means for building up a nation; from this his character can be seen. For the next presidential election, Roosevelt already controls the majority, and will probably be reelected. If so, during the seven years of Roosevelt's presidency, America's rapid progress will be inestimable.

As everyone knows, America has for several decades considered the Monroe Doctrine an inalienable diplomatic principle. During McKinley's and Roosevelt's terms in office, however, the nature of the Monroe Doctrine underwent a considerable change, and this must be looked into if we want to understand world trends....

The original meaning of the Monroe Doctrine was "the Americas belong to the people of the Americas," but this has become transformed into "the Americas belong to the people of the United States." And who knows if this will not continue to change, day after day from now on, into "the world belongs to the United States"? The pretext for all this will still be the Monroe Doctrine. Alas, how extraordinary! If you do not believe me, please read Roosevelt's speech on the Monroe Doctrine....

When I read this speech, I thought and thought about his words "the Monroe Doctrine is invincible." I could not stop feeling afraid, and could not fathom the intention of Roosevelt and the American people. If the Monroe Doctrine means only that "the Americas belong to the people of the Americas," then what is the need for a navy? Even if it means "the Americas belong to the people of the United States," what is the need for such a powerful navy? If the doctrine is generally defensive and for self-preservation, then other countries will probably tolerate it; but if it is directed against other nations, than I do not know what the purpose can be. Alas, the meaning of Roosevelt's words about being "invincible" can be imagined! Hawaii and the Philippines have been annexed; how can they be taken away without overthrowing the hegemon? I fear that there will soon be a successor to our Opium War with England, battle of Tonkin Gulf with France, and battle of Kiaochow Bay with Germany.

### LYNCHING

Americans have an unofficial form of punishment known as "lynching" with which to treat blacks. Such a phenomenon is unimaginable among

civilized countries. It started with a farmer named Lynch. Because he had been offended by a black, he suspended him from a tree to wait for the police officers to arrive, but the black man died before they came. So his name has been used for this ever since. Recently the common practice is burning people to death. Whenever a black has committed an offense a mob will be directly gathered and burn him without going through the courts.

Had I only been told about this and not been to America myself I would not have believed that such cruel and inhuman acts could be performed in broad daylight in the twentieth century. During the ten months I was in America I counted no less than ten-odd accounts of this strange business in the newspapers. At first I was shocked, but have become accustomed to reading about it and no longer consider it strange. Checking the statistics on it, there have been an average of 157 such private punishments each year since 1884. Hah! When Russia killed a hundred and some score Jews, the whole world considered it savage. But I do not know how to decide which is worse, America or Russia.

To be sure there is something despicable about the behavior of blacks. They would die nine times over without regret if they could possess a white woman's flesh. They often rape them at night in the forest and then kill them in order to silence them. Nine out of ten lynchings are for this, and it is certainly something to be angry about. Still, why does the government allow wanton lynchings to go unpunished even though there is a judiciary? The reason is none other than preconceived opinions about race. The American Declaration of Independence says that people are all born free and equal. Are blacks alone not people? Alas, I now understand what it is that is called "civilization" these days!

LIBRARIES

The various university libraries I have seen do not have people who retrieve books [from the stacks], but let students go and get them on their own. I was amazed. At the University of Chicago, I asked the head of the library whether or not books were lost this way. He answered that about two hundred volumes were lost every year, but hiring several people to supervise the books would cost more than this small number of books and, further, would inconvenience the students. So it is not done. In general, books are lost mostly during the two weeks before examinations because students steal them to prepare for

examinations, and many of them are afterwards returned. In this can be seen the general level of public morality. Even a small thing like this is something Orientals could not come close to learning to do in a hundred years.

CHINESE FLAWS

From what has been discussed above, the weaknesses of the Chinese people can be listed as follows:

1. Our character is that of clansmen rather than citizens. Chinese social organization is based on family and clan as the unit rather than on the individual, what is called "regulating one's family before ruling the country."... In my opinion, though the power of self-government of the Aryans of the West was developed earlier, our Chinese system of local self-government was just as good. Why is it that they could form a nation-state and we could not? The answer is that what they developed was the city system of self-government, while we developed a clan system of self-government.... That Chinese can be clansmen but cannot be citizens, I came to believe more strongly after traveling in North America....

2. We have a village mentality and not a national mentality. I heard Roosevelt's speech to the effect that the most urgent task for the American people is to get rid of the village mentality, by which he meant people's feelings of loyalty to their own town and state. From the point of view of history, however, America has been successful in exercising a republican form of government precisely because this local sentiment was there at the start, and so it cannot be completely faulted. But developed to excess it becomes an obstacle to nation-building.... We Chinese have developed it too far. How could it be just the San Francisco Chinese? It is true everywhere at home, too....

3. We can accept only despotism and cannot enjoy freedom.... When I look at all the societies of the world, none is so disorderly as the Chinese community in San Francisco. Why? The answer is freedom. The character of the Chinese in China is not superior to those of San Francisco, but at home they are governed by officials and restrained by fathers and elder brothers. The situation of the Chinese of Southeast Asia would seem different from those in China; but England, Holland, and France rule them harshly, ordering the breakup of assemblies of more than ten people, and taking away all freedoms. This is even more severe than inside China, and so they are docile. It is those who live in North America and Australia who enjoy the same degree of freedom

under law as Westerners. In towns where there are few of them, they cannot gather into a force and their defects are not so apparent. But in San Francisco, which leads the list of the free cities with the largest group of Chinese living in the same place, we have seen what the situation is like....

With such countrymen, would it be possible to practice the election system?... To speak frankly, I have not observed the character of Chinese at home to be superior to those in San Francisco. On the contrary, I find their level of civilization far inferior to those in San Francisco.... Even if there are some Chinese superior to those in San Francisco, it is just a small matter of degree; their lack of qualification for enjoying freedom is just the same....

Now, freedom, constitutionalism, and republicanism mean government by the majority, but the overwhelming majority of the Chinese people are like [those in San Francisco]. If we were to adopt a democratic system of government now, it would be nothing less than committing national suicide. Freedom, constitutionalism, and republicanism would be like hempen clothes in winter or furs in summer; it is not that they are not beautiful, they are just not suitable for us. We should not be bedazzled by empty glitter now; we should not yearn for beautiful dreams. To put it in a word, the Chinese people of today can only be governed autocratically; they cannot enjoy freedom. I pray and yearn, I pray only that our country can have a Guanzi, a Shang Yang,[14] a Lycurgus, a Cromwell alive today to carry out harsh rule, and with iron and fire to forge and temper our countrymen for twenty, thirty, even fifty years. After that we can give them the books of Rousseau and tell them about the deeds of Washington.

4. We lack lofty objectives.... This is the fundamental weakness of us Chinese.... The motives of Europeans and Americans are not all the same, but in my estimation the most important are their love of beauty, concern for social honor, and the idea of the future in their religion. These three are at the root of the development of Western spiritual civilization, and are what we Chinese lack most....

There are many other ways in which the Chinese character is inferior to that of Westerners; some happened to impress me so I recorded them, but others I have forgotten. Let me now list several that I noted down, in no particular order:

---

14. Guanzi and Shang Yang were both political reformers of the first millennium B.C., remembered for strengthening the power of the ruler in an autocratic, non-Confucian way.

Westerners work only eight hours a day and rest every Sunday. Chinese stores are open every day from seven in the morning to eleven or twelve at night, but though shopkeepers sit erect there all day, day in and day out, without rest, they still fail to get as rich as the Westerners. And the work they do is not comparable to the Westerners' in quantity. Why? In any kind of work the worst thing is to be fatigued. If people work all day, all year they are bound to be bored; when they are bored they become tired, and once they are tired everything goes to waste. Resting is essential to human life. That the Chinese lack lofty goals must be due to their lack of rest.

American schools average only 140 days of study a year, and five or six hours every day. But for the same reason as before, Westerners' studies are superior to those of the Chinese.

A small Chinese shop often employs several or more than a dozen people. In a Western shop, usually there are only one or two employees. It may be estimated that one of them does the same amount of work that it takes three of us to do. It is not that the Chinese are not diligent, they are simply not intelligent.

To rest on Sunday is wonderful. After each six days, one has renewed energy. A person's clarity of spirit depends on this. The Chinese are muddle-headed. We need not adopt their Sunday worship, but we should have a program of rest every ten days.

When more than a hundred Chinese are gathered in one place, even if they are solemn and quiet, there are bound to be four kinds of noise: the most frequent is coughing, next come yawning, sneezing, and blowing the nose. During speeches I have tried to listen unobtrusively, and these four noises are constant and ceaseless. I have also listened in Western lecture halls and theaters; although thousands of people were there, I heard not a sound. In Oriental buses and trolleys there are always spittoons, and spitters are constantly making a mess. American vehicles seldom have spittoons, and even when they do they are hardly used. When Oriental vehicles are on a journey of more than two or three hours, more than half of the passengers doze off. In America, even on a full day's journey, no one tries to sleep. Thus can be seen the physical differences between Orientals and Westerners....

On the sidewalks on both sides of the streets in San Francisco (vehicles go in the middle of the street), spitting and littering are not allowed, and violators are fined five dollars. On New York trolleys, spitting is prohibited and violators are fined five hundred dollars. They value cleanliness so much as to interfere and restrict freedom.

Since Chinese are such messy and filthy citizens, no wonder they are despised.

When Westerners walk, their bodies are erect and their heads up. We Chinese bow at one command, stoop at a second, and prostrate ourselves at a third. The comparison should make us ashamed.

When Westerners walk their steps are always hurried; one look and you know that the city is full of people with business to do, as though they cannot get everything done. The Chinese on the other hand walk leisurely and elegantly, full of pomp and ritual—they are truly ridiculous. You can recognize a Chinese walking toward you on the street from a distance of several hundred feet, and not only from his short stature and yellow face.

Westerners walk together like a formation of geese; Chinese are like scattered ducks.

When Westerners speak, if they are addressing one person, then they speak so one person can hear; if they are addressing two people, they make two people hear; similarly with ten and with hundreds, thousands, and tens of thousands. The volume of their voices is adjusted appropriately. In China, if several people sit in a room to talk, they sound like thunder. If thousands are gathered in a lecture hall, the [speaker's] voice is like a mosquito. When Westerners converse, if A has not finished, B does not interrupt. With a group of Chinese, on the other hand, the voices are all disorderly; some famous scholars in Peking consider interrupting to be a sign of masterfulness—this is disorderliness in the extreme. Confucius said, "Without having studied the *Book of Poetry* one cannot speak; without having studied the rites, one cannot behave." My friend Xu Junmian also said, "Chinese have not learned to walk and have not learned to speak." This is no exaggeration. Though these are small matters, they reflect bigger things.

# III

# Model
# America

By the first decade of the twentieth century, a weakened China, threatened by the menacing power of America and other imperialist nations, could not avoid far-reaching social and political reforms. The abolition of the civil service examinations, which had tested candidates' classical learning, created the need for an entirely new school curriculum and educational system. Some Chinese even began to call for changes in traditional family patterns and in the role of women.

Revolutionary activities—spurred in part by Liang Qichao's piercing journalism—led to the overthrow of the Manchu Qing dynasty in 1911. Liang's doubts about democracy notwithstanding, the imperial government was replaced by a republican form of government whose constitution provided for a representative assembly and elections.

Thus in the years immediately before and after the 1911 Revolution, China was looking abroad for models for more than just ships and guns. In 1905, the same year as the boycott of American goods, the Qing government sent a delegation of high-ranking officials to study the government of the United States and other Western nations. One of these officials expressed particular admiration for Americans' passion for news and information:

The level of intelligence of a people is always proportional to the number of newspapers sold. The people of the United States are addicted to newspapers. Chinese living here have all adopted this custom; with thirty thousand in San Francisco, they have been able to establish as many as five or six newspapers. Although not all their words are worth reading, still how can the domestic [Chinese] scene be compared to the enlightened degree of knowledge here?[1]

1. Dai Hongci, *Chushi jiuguo riji* (Diary of a mission to nine nations) (Beijing: Diyi shuju, 1906; Changsha: Hunan renmin, 1982), 89.

Those opposed to the imperial government also turned to America for inspiration. The most famous revolutionary, Sun Yat-sen, was English-speaking and Western-garbed, having been educated in Hawaii and Hong Kong, and his political ideas included the rights of election, initiative, referendum, and recall; the single-tax scheme of Henry George; and, in an improvement on the American system, a five-way separation of powers. The passionate revolutionary Chen Tianhua (1875–1905), although angered by the treatment of Chinese in the United States, urged his countrymen to follow the example of the American revolutionists by rebelling against the imperial government. Not long before committing suicide, Chen wrote, "When you consider the myriad nations on the five continents, is not the United States the most egalitarian, the freest, and the one which can be called a world of extreme happiness?...The people of this nation are like people in paradise."[2]

The feeling that China could learn from America brought a marked increase in the study of English and in the translation of books from English. Particularly in the field of education, America became a model for China. Already in 1910 the United States was called "the Chinese Mecca of Education," and the number of Chinese students coming to these shores grew rapidly, from about 100 in 1905, to 847 in 1914, to some 2,600 in 1923.[3] (Many of these students were supported by excess Boxer indemnity funds, payments China was required to make, under the terms of the 1901 treaty, even after all the claims had been paid off.) At the Teachers College of Columbia University, the great John Dewey nurtured many Chinese disciples, a number of whom went on to become college presidents, chancellors, deans, and prominent educators in China. Dewey himself spent two years in China, from 1919 to 1921, traveling from college to college, his lectures frequently translated by these former students, and his influence on China's post-revolutionary educational system proved significant.[4]

2. Chen Tianhua, "Meng huitou," in Shi Jun, ed., *Zhongguo jindai sixiangshi cankao ziliao jianbian* (Reference materials on modern Chinese intellectual history) (Beijing: Sanlian, 1957), 722–23.

3. The phrase "Chinese Mecca of Education" is quoted in Jerome B. Grieder, *Hu Shih and the Chinese Revolution: Liberalism in the Chinese Revolution, 1917–1937* (Cambridge: Harvard University Press, 1970), 36. Statistics on overseas students are from Y. C. Wang, *Chinese Intellectuals and the West, 1872–1942* (Chapel Hill: University of North Carolina Press, 1966), 147.

4. Barry Keenan, *The Dewey Experiment in China: Educational Reform and Political Power in the Early Republic* (Cambridge: Harvard University, 1977). See also, Jerome B. Grieder, *Intellectuals and the State in Modern China: A Narrative History* (New York: Free Press, 1981), 212–15.

# Report of an Investigation of American Education

Huang Yanpei, 1915

*Since ancient times, China had always paid enormous atten-
tion to education, and thus it is interesting to see what aspects of America's
young system impressed a visiting Chinese educator like Huang Yanpei
(1878–1965). Huang had been classically educated and held the second-
highest civil service examination degree. In the late Qing period he was im-
prisoned for revolutionary activities. He later studied in Japan and served
as a provincial educational commissioner during the early years of the
Chinese republic. In 1914 he wrote an influential series of articles on the
state of Chinese education, and the next year he was sent on a mission to
the United States. One of China's pioneers in educational modernization,
he went on to lead the vocational education movement, founding the China
Vocational Education Society and various vocational schools. In the 1930s
and 1940s he was active in anti-Guomindang (Kuomintang) democratic
politics. After 1949 he held various prominent positions in the People's
Republic.*[5]

Physical education is the first thing that struck me about American
education. In society at large, the more upper-class people are, the
stronger their physiques; and businessmen almost without exception
use health associations and health clubs as institutions for rest and rec-
reation. In schools, students have stronger physiques than people on
the outside. Both these are exactly the opposite of the situation in our

5. For a biography of Huang, see Howard Boorman, ed., *Biographical Dictionary of
Republican China* (New York: Columbia University Press, 1967–1970).

country. Wherever I went, I paid attention to students' physiques and I did not find a single one who was slight and slender. Even female students are all energetic and lively.

While the thinking of Orientals values orderliness, Westerners are the opposite. From what I observed, orderliness does not seem to be emphasized in the construction of American school buildings or the disposition of their equipment. In the layout of classrooms, if something is of practical use for education, its form is not taken into consideration. Their classrooms are not like ours in China, where concern for orderliness leads to a dull aridity and lack of liveliness. This is a major difference between American schools and ours.

As for content, I gathered much new information on this trip about that pragmatism which we have been studying in recent years. In America the entire nation is moving more and more toward this principle every day. These measures were merely words or ideals for me in the past, but now that I have encountered it with my own ears and eyes I am firmly convinced that it is in fact realizable and effective. And I am saddened that our country is so far behind....

[Schools] have various workshops in which you can hear the *ding-ding* of cutting wood and the *zhazha* sound of machines, so that you do not feel like you are in a school. The teachers and students are all dirtied and in old clothes; when they see a guest, they apologize for not being able to shake hands. The classrooms are designed purely for the convenience of teaching. Blackboards are on all four walls and filled with paintings, specimens, and examples of student work. These are complemented by flowers in pots and birds in cages. Classes are not without order; students must first raise their hands to ask a question and all observe regulations. But they are brimming over with energy and liveliness, and are full of interest, not at all solemn and severe....

[One of the basic differences between Chinese and American education is that] their education follows naturalness while ours uses coercion. For instance, between men and women, in our country... there was not supposed to be contact even with an uncle or sister-in-law, and at meals even one's sisters were supposed to sit at another table. Though such lofty ancient teachings are now being discarded, avoiding suspicion by separating the sexes is still used as the only method to rectify morals. With the Americans it is altogether different. From primary school to college, boys and girls go to the same schools. They go together to play and relax at various places for social contact. Rubbing shoulders and shaking hands are considered normal.... (In

schools in the Orient, when in biology class teachers discuss the sexual organs they often do not mention the words. When I visited a high school in Cleveland, the principal told me that they taught girl students in particular the principles of sexual intercourse and its connection with physiology and hygiene. This is most effective. I cannot but sigh over the great difference in ways of thinking between Western and Oriental educators. But I am merely reporting what I heard, and not suggesting that we hastily imitate them.)

Curriculum. American high schools have many differences from China's, the biggest of which is in the organization of the curriculum. To take one high school as an example, the parents of students are allowed to choose freely [from among?] twelve courses. Every year each student is required to take only four major courses. One course for a full year is worth one point; four points a year for four years comes to sixteen points required for graduation. Although the school offers many courses, each student is required to take only four a year.

I do not want to make a hasty judgment about whether this system is good or not, but I feel it is enlightening when we look back at our country's students. The most painful thing for our students is curriculum: the course load is so heavy they virtually do not know where to start. School administrators may not fully understand this, and those who do are unwilling to speak out. According to students, each difficult course requires more than two hours of preparation. With several difficult courses a day there is no way to prepare and the student must just muddle through. Every father and older brother wants his son or younger brother to complete his studies, but in each school at most only one out of three is able to do so. This can only be regretted. At the beginning of their studies, all have the desire to make progress, but then the course load is too heavy for their mental powers to handle and they become destructively self-indulgent. Or else, they do not develop physically. When we look at Chinese students, those who are good at their studies have poor physiques, while those with good physiques are poor students. School administrators do not comprehend this, and the students have nowhere to complain. Not only in the political world is there a gap between those above and those below.... The Chinese method of school administration in general is for the government to prescribe ten or more courses for each kind of school and order the schools to teach several selected from among them. Apart from these, schools are never allowed to develop other courses. It is different in America: the school curriculums are all selected freely by the localities,

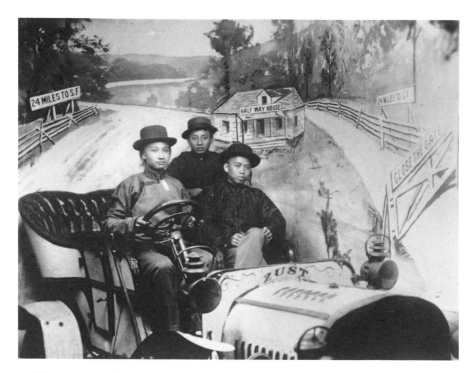

*Figure 12.*    Joy ride at a photographer's studio, 1910, from a postcard, San Francisco. A photographer's setup pose with a strongly American flavor. From the archives of the California Historical Society.

purely in accordance with local needs and conditions. There is nothing that may not be taught....

While Americans value freedom, their students are surprisingly obedient as well as lively. In San Francisco I met a newspaper boy who told me he earned a dollar a day, of which half was turned over to the newspaper. He said he had started selling papers two years ago, did not know how much he had netted, and had not spent it all but deposited it in the bank—he deposited it himself, not his father or older brother. Is it not praiseworthy that a boy can be so independent? As to what he intended to use the money for, he said he did not have to pay tuition in elementary school or high school, but after graduating from high school he would use it for college tuition or as capital for setting up a business. Hearing this I felt very pleased. Is this not a good result of education?...

Next to where I rented a room in San Francisco was a restaurant that hired a number of college students in menial jobs. In America it

is common for students to study half the day and work the other half. Restaurant workers are divided into regular employees and temporaries, the former with higher status. The leader of the workers in this restaurant was a woman, a regular, while the college students were all temporaries working there only during the summer. So they took orders from this woman, both general and specific orders. One day after I finished eating no one cleared the table for quite a while. When the woman saw that the dishes had not been collected, she harshly scolded the student at her side, saying "You should be doing this, not me." The student listened docilely with an abashed look on his face and did not object. His obedience is clear. In our country students are so arrogant and haughty that they are unapproachable, with the result that once they leave school and go to work they often fail. Because American students can be so obedient while in school, when they leave school and take up a job they will be successful wherever they go. Our school administrators should pay attention to this....

In elementary school and kindergarten the most important course is usually nothing other than drawing. This is because drawing is related to all the other courses. For instance, in teaching history, what are called historical drawings, which have historical subjects, are made, that is to say drawings of historical figures, their deeds, places of origin, and so on. In teaching composition, a picture is drawn at the top of the paper and below an essay is written describing what was drawn. In arithmetic, several items are drawn at the top and below are done addition, subtraction, multiplication, and division. So the subjects taken up in different courses are all based on pictures drawn above.... American education places great stress on the subject of art, but what is taught is entirely useful art and not art that is merely attractive to look at. Art is divided into metal working, ceramics, interior design, clothing design, artistic painting, and advertising art. All that they turn out is splendidly beautiful, each with its own wondrousness, but none that is not useful. All of it is art and all of it is useful—this is what is valuable....

Chinese elementary schoolrooms have practically nothing apart from one or two blackboards, because it is thought classrooms are places for teaching students and unsuitable for other objects that would confuse their minds. In America it is different. In their elementary school classrooms, blackboards cover all four walls without an empty corner, for they are used by the students too and not only by the teacher. The method of teaching in Chinese primary schools is generally for the teacher to stand on a platform and lecture, explaining the

lesson without moving half a step. In the United States, by contrast, primary schoolteachers do not stand woodenly on the lecture platform. In each class period they first tell the students to write their lessons on the blackboard and explain or illustrate them, and then the teacher moves around, observing and correcting, which is why they need so many blackboards....

Seen from various angles, American education can probably be summed up by the phrase, seeking to benefit practical life. American secondary schools have long been on this route, sparing no effort in pursuing this task. As elementary schools are to prepare for secondary school, their purpose is to help people's livelihood.

As for differences in educational method with our country, Americans use an individualized approach while our country uses standardization, and our country is conservative while America seeks what is new.... In America the invention of a device is admired by people and everyone has the idea of inventing something new—evidence of both individualism and a desire for novelty. I investigated what inventions were discovered in America in the course of one year and found that more than 40,000 were approved by the Department of Agriculture and Commerce, a figure that does not include inventions not approved or not submitted. One man, the great electrical scholar Edison, designed as many as nine hundred inventions, from which the number of inventions in America can be imagined. Is this not the accomplishment of education?

The two principles I draw from this investigation of American education are that it is oriented toward livelihood and individualism or, to put it in one word, practicality. Practicality encompasses both these principles.... Competition [between nations] is becoming increasingly fierce in today's world. If a country's education is not directed toward people's livelihood, the country will not be fit for survival. The natural endowments of people are different; unless individualized methods of instruction are used, their capacities will not be developed. For schools to use the same textbooks and emphasize the same topics—how is that different from "cutting the foot to fit the shoe.".....

Although school education is well developed, it can bring together only a limited number of students for individualized education. Only social education can give a common education to all the people of the country. There are many methods of social education. The most widespread is the moving picture. Only cities in America have playhouses, but every city, town, and village has a movie theater. The love of Americans for movies is very great. According to a certain American's

report, one quarter of the entire American people go to movie theaters or playhouses every day (the American population is one hundred million; one quarter of that is twenty-five million). The content of films is not very different from that of Chinese movies, but there are two special characteristics that I must report to you. Moviegoers are largely workers, and the movie companies pay attention to them, for American workers make good wages and cannot resist falling into wasteful luxuries. Movie companies make many films exhorting people not to be extravagant and bringing to them the idea of frugality. Therefore movie houses are built in many locations every year especially for workers. During intermission in movie houses there is often a band to play the national anthem and the entire audience sings along, or the national flag is displayed in a movie and the audience must take their hats off and bow as a sign of respect. These special characteristics have educational functions, one to educate workers, the other to make citizens not forget to love their country....

Since most American schools are also involved in social education, various functions link them to society. Libraries are the most highly developed, apart from educational meetings in schools. The number of national, school, and private libraries in the whole country is too great to be counted....Now that people are talking about social education in China, we should establish numerous libraries. We should never argue that this can be delayed on the excuse that our countrymen do not like to read. We should be aware that before libraries were established in America, their people did not like to read, just like ours, but that after libraries became widespread there was no one who did not like to read....When America first established libraries, many methods were devised to lure people to reading, such as having small wagons loaded with books deliver them to farms every day while the farmers were resting, in order to persuade them to read, or having them send books to railway stations to encourage people to read while waiting for trains. The books supplied all use simple words but are sufficiently rich in interest to arouse people's interest in reading. If we can emulate this, what worry will we have that after we establish libraries no one will go there to read?

# The American Woman

Hu Shi, 1914–1918

*Of all twentieth-century Chinese intellectuals, the one most closely associated with the United States in the public mind was Hu Shi (1891–1962). Hu earned a bachelor's degree from Cornell University, where he also made Phi Beta Kappa, won first prize in English, and almost converted to Christianity. In 1919 he received a doctorate from Columbia University, where he was a disciple of John Dewey. A cosmopolitan liberal, Hu for decades promoted in China the kinds of progressive ideals cherished by Americans, even indulging in the rhetorical hyperbole of calling for the total Westernization of China. He was Nationalist China's ambassador to the United States from 1937 to 1942. In 1954–1955, when he had moved to the United States, a propaganda campaign in the People's Republic targeted him as, among other things, a "slave of American imperialism" whose pervasive influence on Chinese intellectuals had fostered in them a "worship-America mentality."[6]*

*The diary of his seven years as a student in the United States, from 1911 to 1917, was edited and published in four volumes in the 1930s. It provides a fascinating glimpse of the everyday activities of a Chinese thoroughly at home in Western culture and society. Perhaps because he was so at home, his accounts do not contain much in the way of reflection on or analysis of American characteristics; there was not much Hu found strange in America. When he was not thinking about Chinese matters—poetry,*

---

6. On Hu Shi, see Grieder, *Hu Shih and the Chinese Revolution*, and Min-chih Chou, *Hu Shih and Intellectual Choice in Modern China* (Ann Arbor: University of Michigan Press, 1984).

*language reform, the history of philosophy—he was apt to record reflections on his reading of Shakespeare or Shelley or his thoughts about contemporary politics. Hu admired Woodrow Wilson's liberalism, and during World War I he became passionately pacifist and internationalist.*

*At the beginning of his stay in the United States, Hu favored Chinese ways in matters concerning the family and he was critical of Western freedoms regarding marriage. But he was impressed with what he saw at the homes of American friends, and his descriptions of American families came to sound like idyllic odes to marital harmony. Above all he was influenced by friendships with American women, particularly Edith Clifford Williams, a liberated and unconventional woman of strong opinions. They had long conversations on philosophical and ethical questions, and carried on a voluminous correspondence, excerpts from which he included in his diary. He visited her in her apartment in New York, even stayed there for a time while she was away. A passage in one of her letters clearly indicates they discussed sex,[7] but their relationship seems to have been platonic. Hu had been betrothed in 1904 to a woman he had never met, a traditional Chinese woman, with bound feet and little education (in a letter to his mother he said the family need not bother about his fiancée's education). In 1917 he returned to China, was introduced to his betrothed, married her, and remained devoted to her throughout his life. But he also greatly admired educated Western women and wrote to the Cornell student newspaper in defense of the suffragists.[8]*

*Back in China during the heady intellectual revolution of the May Fourth period, Hu was a key promoter of reform in Chinese family ethics, as well as in other matters, and often held up as models examples from American society as he understood it.*

*(Proper names and terms that Hu wrote in English characters are here enclosed in guillemets.)*

January 4, 1914

It suddenly occurred to me that the position of women in our country is higher than that of Western women. We look after a woman's modesty and chastity, and do not allow her to be burdened with having to arrange her marriage, which is taken care of by parents. Men and women are both born to make families. Our women do not need to

---

7. *Hu Shi liuxue riji* (Hu Shi's diary of study abroad) (Taipei: Shangwu, 1959), entry for Feb. 3, 1915. On the conflict between Hu's affection for Miss Williams and his sense of duty toward his fiancée, see Min-chih Chou, *Hu Shih and Intellectual Choice,* chap. 5.

8. *Hu Shi liuxue riji,* July 27, 1915.

offer themselves in social intercourse for the sake of marriage; nor need they labor to find a spouse for themselves. This gives weight to the dignity of women. But in the West it is not like this. As soon as a woman grows up she devotes herself to looking for a spouse. Her parents get her to study music, practice dancing, and then let her go out with men. Those who can please men or have techniques to entrap men will find spouses first. Those who are plain and dull or who do not want to lower themselves to charm men end up as old spinsters. Thus, lowering women's dignity and making them offer themselves as bait for men is the flaw in Western freedom of marriage....

January 27, 1914

A few days ago I gave a speech on the merits and demerits of our country's marriage system. I defended the old customs of our country.... Some people may suspect that this kind of marriage necessarily has no love to speak of, but that is definitely not so. Love in Western marriages is «self-made»; love in Chinese marriages is «duty-made». After engagement, a women has a particular tenderness toward her betrothed. Therefore when she happens to hear people mention his name, she blushes and feels shy; when she hears people talk about his activities, she eavesdrops attentively; when she hears about his misfortunes, she feels sad for him; when she hears about his successes, she rejoices for him. It is the same with a man's attitude toward his fiancée. By the time they get married, husband and wife both know that they have a duty to love each other, and therefore they can frequently be considerate and caring to one another, in order to find love for one another. Before marriage this was based on imagination and done out of a sense of duty; afterwards because of practical needs it often can develop into genuine love.

June 8, 1914

My progress in the last ten years had been entirely on the side of «intellect», and «emotions» have been almost totally forgotten. As I ponder this in the still of the night, I realize I have almost become a cold-blooded man of society and am just lucky not to be altogether a calculating operator, though the danger is there! But it is still not too late to mend my ways; I resolve from now on to pay attention to the development of my emotional side. I am living in a coeducational school in this country, and should use the opportunity to associate with educated women and benefit from their refined influence and lessen my cold and solitary nature, so that what remains of my innocence may be revitalized....

I have been here four years and known numerous co-eds but never visited any. In four years I have never called on a female friend in «Sage College», the girls' dormitory. I used to boast about this, but now I feel ashamed when I think of it. This evening I visited a girl for the first time, and plan to do so often in the future.

August 16, 1914

«F. King», the broher-in-law of my friend «Fred Robinson», invited me to dinner at his house. He has three sons and three daughters. Two daughters are grown but not married; his married children all live in nearby towns and often return to visit their parents. Today, Sunday, the two spinster daughters were both there, and one of the sons came with his wife and two daughters. Mr. Robinson and his wife were there too. The atmosphere, overflowing with family happiness, made me feel envious. I said that in my country a son and daughter-in-law live together with his parents in order to care for them, whereas in the West after a son is married he and his wife move far away and no longer concern themselves with his parents. Both patterns are extreme and go too far. The trouble with our country's way is that the daughter-in-law cannot live in peace with her mother-in-law and sisters-in-law, and that it fosters a dependent spirit. The trouble with the Western way (America in particular) is that parents are discarded. Both are wrong. The golden mean lies in the married son and his wife living separately but not far from his parents, and visiting frequently. A family like Mr. King's is a good example. With such an arrangement, family quarrels are not likely to erupt, a son and his wife and his parents will both maintain their independence, and there will be no estrangement between parents and son.

October 20, 1914

On Saturday I went on an outing with Miss «Edith Clifford Williams». We walked along the lake in beautiful weather. At the end of the path we turned east and walked a few miles to the village of «Etna» before returning via the village of «Forest Home». It had been raining for several days and only turned clear today. The roads were covered with fallen leaves, the sun was setting over the mountain, a cool breeze brushed us, and the feeling of autumn was intense. That day we walked together for three hours; talking as we walked, we did not notice it was getting late.

Miss Williams is the younger duaghter of «H. S. Williams», a geology professor at the university, and is studying fine arts in New York.

She is extremely intelligent, well read, unworldly to the point of eccentricity. Although born to a rich family, she pays no attention to dress. One day she cut her hair off, leaving only two or three inches; her mother and sister upbraided her but could do nothing, so willful is she. I once said to her in jest, "«John Stuart Mill» wrote that people today seldom dare to be eccentric; this is the hidden problem of this age. «Eccentricity» is a virtue and not a defect." She replied, "It is not good to force yourself to be eccentric just for its own sake." I agreed. When we got back to her house it was already six o'clock and I stayed for dinner. After dinner we sat around the fireplace and talked. I didn't get home until nine.

November 22, 1914

Tonight I went over to the room of my friend Mr. Bogart, who is a teaching assistant in law, for a short visit and we talked about the problem of marriage. He had heard me lecture on the Chinese marriage system and approved of it. He also thinks that in the Western marriage system choosing a mate is not an easy matter, but takes time, effort, and money, that «the ideal woman» may not be found in the end; after a long time one may have to «compromise» and settle for second best. He said that the level of intelligence of women in this country is not very high. Even among college co-eds very few have really wide learning and can enlighten others in discussion. If we take "intellectual equality" as the standard for finding a mate, we will undoubtedly remain bachelors our whole lives. Actually, in choosing a wife there are many considerations besides intelligence; for instance, physical health, passable appearance, and a good temperament should all be considered. We should not emphasize only intellect. If intellectual companions cannot be found in the family, they can be found among friends. This is why I did not oppose my own [arranged] marriage [with an uneducated woman]. From what I can see of families in this country, couples who are truly intellectual matches are rare even among famous university professors. In looking for a wife, the people of my friends' generation do not like the so-called «Ph.D. type» of woman, whom they think to be over-educated. This, however, is going too far in the other direction. The "Ph.D. type" woman may be slightly older but there is no reason why she cannot be a virtuous wife and good mother.

December 14, 1914

I received a telephone call from Mrs. Patterson inviting me to have dinner at her house Thursday evening. I had to decline because

of another engagement, and it was changed to Friday evening. Then I thought about it. Thursday was December 17, my birthday, and Mrs. Patterson was having this dinner for my birthday. Living in a foreign country, one loses track of time. To have friends who are considerate to such an extent, who relieve me of my sense of being away from home, comfort me in my loneliness—how can I ever forget such friendship? Thinking of it moves me nearly to tears. Mr. and Mrs. Patterson look on me as a member of the family, and I regard them the same way.

January 4, 1915

I took the train to «Niagara Falls» to visit «Dr.» and Mrs. «Mortimer J. Brown», who had taught in China for two years.... They live in Niagara Falls now and had written several times inviting me to stay in their house, but for various reasons I could never make it. This time my travels brought me through here, so I visited them for a day and a night.

The Browns get along very well. They have no children and share the burdens of housework. The depth of their love and respect for each other cannot be described in words. This is a most happy Western family. The wife does the washing and cleaning herself, and, taking pity on her, the husband found a way to buy her a washing machine to save her work. She pointed to it and told me, "This was a Christmas present from my husband this year." When Mr. Brown had asked his wife what she had to give him, she had smiled, pointed to a wrapped gift on the table, and said nothing. He opened it and it was a platen for a typewriter. Mr. Brown's office typewriter had been used so long that the surface of the platen was damaged by the type and became uneven. Mr. Brown had happened to mention this once and his wife secretly made note of it. One day she sneaked into his office and wrote down the model number of the typewriter and the measurements of the platen and so purchased this platen for her husband. The kitchen table was very low, Mrs. Brown was rather tall, and out of consideration Mr. Brown himself acted as a carpenter to lengthen the legs for her by a foot. Such little matters are sufficient to show the feelings of shared love and concern of this family. In comparison, what do [such traditional Chinese notions of love and honor as] "Respecting each other like guests," "Raising the tray to eyebrow level," or "Painting eyebrows on one's wife" amount to?

January 23, 1915

In the afternoon I visited Miss Williams in her apartment [in New York] and we talked with great pleasure. Her apartment overlooks

the Hudson River. It was foggy that day and the features of the opposite bank were enveloped in mist; the scene was beautiful.... Around five o'clock we went to have dinner at the East-West Restaurant. I told her I had recently decided to advocate the doctrine of «non-resistance» and had resolved on a three-year plan of working for world peace groups. Miss Williams was greatly pleased. She considered this decision to be my most important recent accomplishment, and encouraged me to keep to this resolve without slackening. When I had discussed this question with her last summer I was still ambivalent. Even in mid-November when I spoke at «Syracuse» on «The Great War from the Point of View of an Oriental», I still felt that national defense was an urgent concern. On December 12, I recorded that I had finally made a decision. Miss Williams knows that I am very careful in making up my mind, and now when she heard my most recent resolve and it was just what she had been hoping for, she was very pleased. The loftiness of her views is truly not matched by ordinary women. I have met many women. Only one embodies intelligence, perception, courage, and earnestness.

May 8, 1915

Miss Williams is carefree and unrestrained, and does not bother about such trifles as clothing. Women's «fashion» in Europe and America is constantly changing, striving for novelty, and one does not know what to follow. Miss Williams's clothes have not changed for several years. Her straw hat is torn, but she still wears it. Because her long hair was not easy to care for, she cut it and it has been disheveled for a year or two. On the street she often attracts attention from passers-by. Her mother has talked to her about this many times, but she says "These women on the street who change their clothing every day are altogether bizarre, but they don't consider themselves bizarre and others don't think them bizarre either. Why do they find only me strange for not changing with fashion?..." Her broad-mindedness can be seen from this.

June 5, 1915

Miss Williams had invited Miss Crane for a walk in the country yesterday. When I met Miss Crane in the dining hall she mentioned this, and I said playfully, "After you get back, if you would grace me with a visit to my room I will serve you tea." She accepted with a smile. Around five o'clock in the afternoon they came. I prepared Longjing tea and they stayed until early evening. Both are very unconventional, not your average type of girl, and unconcerned with petty proprieties. Today Dr. Brown, a French instructor who lives in my building, asked

who the girls were who had been laughing and talking in my room yesterday. I told him and he informed me of an incident. A few months ago, he together with a certain history teacher and another French teacher, invited Miss A. and Miss B., who work in the library, to his room for a little gathering. After accepting, Miss A. happened to mention it to the daughter of the former president [of the college] Dr. Crane (a different Crane), and she was shocked and asked who the chaperone was. When she heard there was none she was even more startled, considering it a breach of etiquette. The story gradually got around, causing a lot of talk and criticism, so Mr. Brown changed the date to a coffee house. When they all arrived there was no room for them, so Mr. Brown said, "Why don't we go to my room? Why should people like us be afraid of other people talking?" They all agreed and returned to Mr. Brown's room for tea.

Although this is a small incident, it proves what I remarked on before, the lack of freedom in social intercourse between men and women in this country.

July 20, 1915

Last night I heard the mother of my friend the lawyer «Sherman Peer» tell the following story about «Prof. C. L. Crandall», chairman of [the department of?] railroads in the School of Engineering. Crandall's wife is blind but known for her virtue all over the locality, and ladies and gentlemen here all respect and love her. I too know her but didn't know about her youth or when she had become blind. Her blindness actually came after she was engaged to Crandall; when they were engaged but not yet married, she fell ill and lost her sight. She did not want to burden her beloved with this physical defect and urged him to break off the engagement. He staunchly refused, eventually married her, and loved and respected her their whole lives. Now they are both old, and all who know this story say Crandall's not breaking the engagement is rare and admirable. This is a model of Western faithfulness and duty that deserves to be emulated, and so I have recorded it.

*In the summer of 1915, Hu left Cornell and went to New York City for graduate studies in philosophy at Columbia.*

October 30, 1915

Since knowing my friend Miss Williams, my lifelong views toward women have changed greatly, as have my views about social relations between the sexes. I have always believed deeply in education for

women, but before I was concerned with education as preparation for family, to produce good wives and virtuous mothers for our countrymen. Now I have come to realize that the highest goal of women's education lies in creating a type of woman capable of freedom and independence. If a country has such free and independent women, this will lead to improving the morality and elevating the character of the citizens. For women have a kind of transforming power, which if used well can inspire the weak and timid, change people and customs. Those who are patriotic must know how to preserve and promote this, and make appropriate use of it.

October 30, 1915

On October 23, the women's suffrage organizations of New York and surrounding areas held a "women's suffrage «parade»." This was because of the approaching New York state elections (November 2), when the question of women's suffrage will be decided by statewide referendum....

The "women's suffrage parade" was a truly unprecedented spectacle with more than forty thousand men and women marching. Zhang Xiruo and I stood on Fifth Avenue watching for three hours and still it wasn't over.

The most impressive things about this parade were: (1) Orderliness.... (2) Seriousness of attitude. Although most of the marchers were young men and women (Westerners consider anyone below forty to be young), quite a few women were middle-aged or older, and there were some whose hair was totally white. Seeing these makes one feel immediately respectful. (3) The large number of female teachers participating.... How these women serve their country and society and how hard they work! How can they still be deprived of their rights as citizens? (4) The perseverance of the marchers....

New Jersey is the home state of the American president Wilson. Wilson announced some months ago that he favored women's suffrage for this state, and during the election he returned to his hometown to vote. Members of his cabinet from the state also declared their support for this proposal. But still it did not pass. That even the endorsement of the nation's chief of state does not get the people in his home state to follow shows the high degree of independent thinking among Westerners, and that they are not easily moved by people of high rank.

One evening I was reading in my room when I suddenly heard the sound of a bugle outside my window. I leaned out the window and saw a car with a number of women in it, all suffragettes. One woman was

blowing a bugle, the sound solemn and moving. Pedestrians gradually collected around the car, the bugle stopped, and a woman announced that there would be a sidewalk speech in front of the university library and invited everybody to attend. I went. Several men and women made speeches, all of which were not bad. Suddenly I noticed in the middle of the crowd «Professor John Dewey», chairman of the Philosophy Department at Columbia University and the foremost person in this country in the field of philosophy. At first I thought my teacher had just happened to pass by, but after the speeches were over the car door opened and Mr. Dewey got into the car with the suffragettes and rode away. Then I knew that he was helping in their «campaigning». Alas, should not all twentieth-century scholars be like this?

On November 2, the opponents of the referendum won in the New York election. Still, votes in favor numbered as many as 500,000; though they lost, they can still feel proud. (Written November 3.)

July 13, 1916

My friend Miss «Marion D. Crane», who studied philosophy and just received a Ph.D. from Cornell, has been appointed by that university as «Adviser for Women». She is the first to hold this position, which was newly created this year with rank equal to that of a «professor».

Cornell was the earliest coeducational college in this country, but in fact men and women are not euqal in the university. Apart from academic honors, female students have no political rights at all. The school newspaper does not even print news about the girls' dormitory and other things related to women. Only recently have things begun to move slightly toward equal rights. There is now a woman on the board of trustees and several on the faculty (all in the School of Agriculture). That a young woman has been appointed Adviser for Women to keep track of the needs and well-being of female students represents a big step forward in expanding women's rights.

It seems Miss Crane comes from a very poor family. She is studious, well read, courageous, and thoughtful. She is free-spirited and sincere with people, who are in turn sincere with her. She has the courage to act on matters; if she disagrees with something, she never fails to make her views clear, arguing with great vigor.

August 21, 1916 (recorded later)

In mid-August my friend «Lewis S. Gannett» invited me to stay briefly with his family. They live in «Buck Hill Falls», which is in the

mountains and inaccessible by railroad. The scenery is magnificent, even better than Ithaca.

Mr. Gannett's father is seventy-six, in good health and open-minded in his views. His mother is kind and warm. His sister is a «Vassar» graduate who is involved in social reform efforts in Boston.

This family, in which everyone has ideas and education, and in which everyone's temperament is compatible, can be said to be a perfect family.

The sister is filial in serving her father. She anticipates his wishes and is gentle and accommodating, something not often seen in this country.

Mr. Gannett recently met a woman at work, fell in love with her, and became engaged without his family's knowledge. He works as a reporter for the *New York World*. He came home with me on vacation and informed his family about the engagement, then telegraphed the girl to invite her for a visit, and she came. Her name is «Mary Ross», and she is also a Vassar graduate. She seems to be quite talented and a good match for my friend.

After she had come, everybody liked her, so every day they let the couple go out together. When the whole family went on an excursion with their guests, they intentionally allowed these two to fall behind. This is because New York is so crowded, and as both are newspaper reporters they have little time to be together. Even when they are together they cannot have such gorgeous scenery as a background.

I was fortunate to have this opportunity to observe the doings of this family and so have recorded it.

November 9, 1916

My friend «Paul B. Schumm», a Cornell classmate, is quiet, industrious, and a good writer. He majored in «landscape architecture» and in his spare time won poetry and literary prizes at the university to help meet his daily expenses. He is an independent thinker. Of all the classmates I knew at Cornell (not counting graduate students) I consider «Bill Edgerton» and him most able to think for themselves.

Last year he introduced me to his parents. His father, «George Schumm», believes in ''anarchism'' and is fond of the philosophies of «Proudhon» and «Herbert Spencer», but he is kind and generous and does not look like an anarchist.

One day I received a letter signed by Miss «Carmen S. Reuben», who said that she was the wife of my friend Schumm. Though married, she calls herself a «new woman» and uses her maiden name instead of

her husband's name (normally wives take their husband's surnames, like «Carmen Reuben Schumm»). She had heard her husband and father-in-law talk of me, and knowing that I was still in New York, wrote inviting me to meet her. I went. She is good-looking, able to think, a wonderful woman, and truly a good mate for my friend. She had gone to school with him, which is how they met. This year they were married. After the wedding, he went back to Ithaca to take care of some old business, leaving her in New York to support herself as a typist and to study music at night. Since meeting her I have seen her a few times, and I deeply respect her as a person; she is truly a "new woman."

Last night I went with her to have dinner at the home of Mr. Schumm (the father), so I have written about this couple here.

*Hu returned to China and a professorship in philosophy at Peking University in 1917. The next year he gave a lecture on the American woman to a women's college in Peking. He began by praising American women's independent spirit.*

Last winter my friend Mr. Tao Menghe invited me to dinner. There was a foreign traveler present, an American woman who was on her way to Russia to make a special investigation for several newspapers. Also present were an English couple and two Chinese couples, and at this dinner which "combined Chinese and Western, male and female" I made a comparative observation. The two Chinese and one British wives were not that different from the American in terms of education or knowledge. But I felt the American woman was not at all like them.... She was not over thirty or so in age, I estimated, but she had a mature appearance, a stubborn spirit.... That this woman traveled thousands of miles by herself, fearing neither hardship nor danger, wanting to go to Russia in upheaval to investigate the reality of Russia's postrevolutionary internal strife—I consider this spirit to express a philosophy of "going beyond being a good wife and virtuous mother" and to be representative of the spirit of American women....

From what I have seen, American women, whatever their material circumstances, occupation, or marital status, almost all have the idea of "independence." Women of other nations for the most part take being a "virtuous wife and worthy mother" as their goal, but American women mostly take as theirs "independence." "Independence" means simply developing one's individual talents, not relying on others, being able to support oneself, and being able to do something for society....

# The Contradictory American Character

Tang Hualong, 1918

*Tang Hualong (1873–1918) was a prominent political figure associated with reform and modernization in the first two decades of this century. He had studied in Japan, participated in the 1911 Revolution, was allied with Liang Qichao in the Progressive Party, and served briefly as minister of education and then minister of internal affairs in the early Republic of China. In 1918 he spent a few months in Japan and the United States. On the way home, awaiting a ship in Victoria, British Columbia, he was shot and killed by a Chinese assassin.*

*Not long before his death, he spoke before the Chinese Chamber of Commerce in Boston. His analysis of the strengths of the American national character identifies four contradictions it embodies and reconciles: speed with farsightedness, hard work with hard play, individualism with public-spiritedness, and science with religion.*

To understand in what ways the Chinese national character is in decline, we must compare it with the virtues of foreigners. From what I have observed on this trip to the United States I think the American mentality has four sets of contradictory characteristics and that these four contradictions are the virtues of the American national character. Let me discuss them one by one.

1. Americans on the one hand seek speed in everything, but on the other they also have a spirit of perseverance and farsightedness. Americans have been called an impatient people. That there are trains and ships called "expresses" merely answers a common desire of passengers; this is the same in all countries and nothing to be wondered at.

But that shop advertisements and restaurant signs use the word "fast," and that even funerals aim for speed—this is incomprehensible to us Chinese. As to why Americans are always in a hurry, in a word it is because of their attitude of respect for time and their striving to economize on time. What is economizing on time? It is using the shortest possible time to the greatest possible effect.

When I was in Washington, I noticed there was something called the Bureau of Efficiency. I inquired as to how efficiency can be increased and was told it is nothing other than saving time. Saving time is the purpose of mechanical inventions and the function of electricity. Again, in New York City I observed that all the traffic arteries have elevated trains above, trolleys on the street, and subways below; in addition there are over half a million private and public motor vehicles. This proliferation of traffic is, to be sure, due to the development of the economy, but it is also not unconnected with Americans' special respect for time.

This attitude can frequently be seen in regard to leisure, too. Today moving pictures are so popular that there is hardly any place in America without them, while on the other hand theatrical performances are attracting hardly any customers. This is not just a question of [relative] expense, but also of time, for all the events in a whole novel can be depicted in a moving picture in several tens of minutes, while to act them out with people would take at least a week or two. Such is the American respect for time.

Now, people live in this world for less than a hundred years, and if they are to accomplish great things they must seek economies of time. Americans, because of their respect for time, always seek to save time, with the result that what was a bleak and barren wilderness a hundred and some years ago has quickly become this splendid and magnificent new world. Thus it is clear that concentration on seeking speed in everything is a major cause of the achievements of the American people.

---

*Figure 13.*    The tallest building, ca. 1889. The caption reads: "In Boston [?] in America, because the price of land has been increasing recently, a construction company built a 28-story building, 350 feet tall, 800 feet in circumference, with columns made of steel. The lowest story is completely open, with two staircases and twelve lifting-and-lowering machines marked with the numbers of the floors on them, so that if you want to go from a certain floor to another floor you sit in a machine accord-

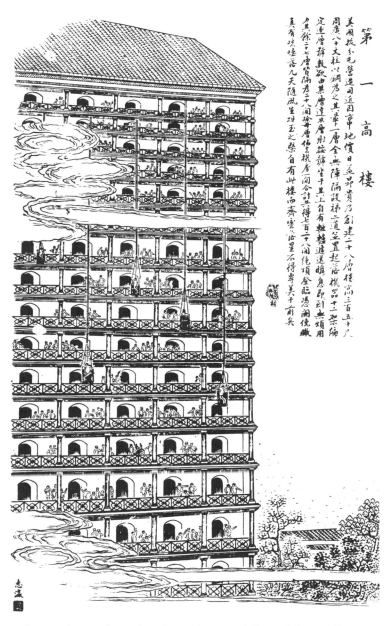

第

一

高

樓

美國坡夯毛營造司近因車地價日益昂貴乃創建二十八層樓高三百五十尺同廣八分柱以鋼為之其第一層全無障隔設禊二道置起落機器十二架編定逐層辦數欲由其層達某層別捺牌坐于其上自有軌輪連送瞬息即到無煩用名其餘二七層皆隔房三八間驗眷層問合計其得七百二八間統頂登臨憑闌俯瞰真有吸唾落九天隨成璀璨珠之榮自有此樓而奇雲怡星不得專美于前矣

ing to its number and are then in an instant delivered there effortlessly by means of a windlass. Each of the other 27 floors has 28 rooms, one of which is taken over by the elevator, making 728 rooms altogether." Note the use of clouds to indicate height in the manner of Chinese mountain land-scapes, and the ropes and baskets on the outside of the building raising and lowering people. From *Dianshizhai huabao, chen* 1:4.

Our ancient Chinese sages had the sayings "Don't make haste" and "Hurry and you won't succeed," meaning that in all things if you just seek speed, the results will be sloppy and in the end unsuccessful. But it is not that way with the Americans, for while they seek speed in everything at the same time they are also concerned with persevering and taking the long view. In Seattle I saw the Smith Building with over forty stories, towering so high that it pierces the clouds, and I was told that it took the Smiths, father and son, two generations to complete.

Or take the Brooklyn Bridge in New York, which stretches three or four [Chinese] miles across. I hear that before it was built, traveling between New York and Brooklyn on a small boat took forty or fifty minutes, and in winter when the waves were high it was most inconvenient. So certain people, wanting to save time and yet with a spirit of perseverance and farsightedness, built this bridge, which took three generations to finish. Today trains, trolleys, and motor vehicles rumble across it at the rate of over three hundred a minute, reaching the opposite shore in a twinkling. The point is not simply that this is altogether faster than the old boats, but that it is the result of a preoccupation with saving time combined with a spirit of farsighted perseverance. This is one of what I call the contradictions in the American mentality, and this psychological contradiction is a virtue in the American national character.

2. On the one hand Americans believe in the sanctity of labor, but on the other they are also full of zest for play. Life cannot be without work, and work is a kind of labor. But working just to make a living is not the same as regarding labor as sacred. To work for a living is to take life as the final goal; when this goal is attained the labor can stop. Furthermore, working for a living is inevitably to regard work as unpleasant; today's work is done to avoid the unpleasantness of another day's work. But it is different if labor is regarded as sacred, for work is seen as a joy of life. Although Shantantongling's [unidentified] family accumulated hoards of money, still his taste for work was not diminished—this is the kind of mentality I have seen in the United States.

Passing through various places, I found that many hotel workers were college or high school students. At first I thought they were forced to work because of family circumstances, but on inquiring further I found some were from wealthy families. When I asked why they were engaged in this unpleasant job, they said it was not unpleasant and in fact they enjoyed it. Hearing this, I could not help blushing. Such things as President Wilson's love of walking and Roosevelt's

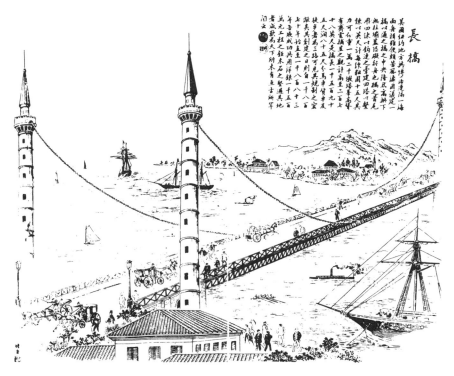

長橋

美國紐約的地方與博弈連海一海
面身特羅便願苦羅處用謂建之
而柱橋是礙礙行身地橋之首也
無柱礙是礙礙行身地橋之首也
用四梁只鉤建之蛋建四塔十八
錄此英尺計每條租開十五尺其
五丈洞十五丈可見其規制之寶
狹以率一萬二十噸塔車高二丈
十八英尺八十五人金車車等十
五天洞八十五丈可見其規制之
力可仍重一萬二十噸塔車高二
錄此英尺計每條租開十五尺其
用四梁只鉤建之蛋建四塔十八
探其其創建之日則一千八百七
七年始至五十一千八百八十三
年矣歲功成共用洋銀一千五百
萬元工程之鉅木石之整通其地
者威就為大下所奉真並古所軍
閔文

Figure 14. The Brooklyn Bridge, ca. 1892. The caption reads: "The place called New York in the United States is separated from Brooklyn by a patch of ocean. Although ships are convenient, storms cause difficulties. So a bridge was planned to link them. In the middle of the bridge stands a high arch. Underneath there are no columns or embankment, as these would obstruct the passage of ships. The head and tail of the bridge are tied together with four chains. On the sides are built four towers to fasten the chains, each 15 feet in circumference in English measure and strong enough to hold 12,000 tons. The tops of the towers extend so high as to provide a view on a level with clouds and stars, 278 English feet high. The bridge is 1,595 feet long, 85 feet wide, and has three lanes, for horse carriages, wagons for goods, and pedestrians. The vast scale of its design can be seen. Construction was started in 1870 and lasted until 1883. Altogether it cost $15 million. The scale and strength of construction are greater than anywhere else and admired as unprecedented in the world since ancient times." From *Dianshizhai huabao, ge* 8:58.

love of hunting we Orientals regard as strange. In sum, there is not an American, male or female, young or old, who does not like work, and consequently society progresses daily. For this reason, the idea that labor is sacred is a major cause of the achievements of the American people.

If Americans pursued only this love of labor, it would lead to a spirit of regarding work as the only thing in life, with no interest in leisure, and they would spend all their time busily toiling at a life of bitter work without regard for higher things. But Americans are not this way.

While they love work, they are also full of zest for recreation. Theaters, music halls, and moving picture houses can be seen everywhere in America these days. In the number of parks, America is first in the world, and all kinds of people can be seen in them—scholars, soldiers, and even farmers, working men, and merchants—busily coming and going, some linking arms and singing, some holding hands and dancing. They happily stroll and go swimming in the breeze and moonlight; it seems like a world apart from this society of trials and tribulations. President Wilson is reputed to be a very hard-working man, and during this world war his public duties must be more numerous than in peacetime. Yet I understand he sets aside one or two hours every day after meals and after work for various kinds of recreation, and that every Wednesday he goes with his wife to a certain theater to see a play. Again, Yellowstone Park was a wilderness a few decades ago, and the government developed it into a recreational place for all citizens.

Thus can be seen the Americans' taste for recreation. Now, recreation provides relief from labor and its effect must be to dissipate feelings of vexation and to nourish a sense of perspective. For these reasons, peoples who do not like labor will decline, and races who lack a taste for recreation cannot hope to achieve much. The Chinese attitude is that those who enjoy leisure will want to avoid hard work, preferring quiet to action. But Americans are not like that. They delight in recreation and at the same time consider labor sacred. This is another of what I call the contradictions in the American mentality, and this psychological contradiction is also a strong point of the American national character.

3. While Americans are full of individualism and independence, they are also rich in public-spiritedness. That the ideas of individualism, independence, equality, and freedom are the fundamental spirit on which the nation was founded is remarked on by all who touch on American political history, and this is known even by those who have not visited the country.

When I visited the University of Washington I was told by the president, Mr. Suzzallo, that the aim of American education was above all to nourish individual independence. And when you look at social institutions, there is not one that does not manifest individualism. Especially surprising is the fact that even moral concepts are exclusively based on the idea of the individual. Everywhere I have been I have seen U.S. government recruiting posters, all of which rely mostly on words of inducement and rarely on the language of compulsion. There is even a picture of a beautiful woman in uniform with the legend, "I wish I were a man. If I were a man, I would join the Army." Such examples are too numerous to cite one by one, and are also familiar to you. The conscription law is compulsory, but the posters use persuasion. The government vigorously enforces the draft; last month the Senate established penalties for draft evasion, and President Wilson has decided to stop issuing passports for foreign travel starting July 1. With such means of compulsion there is no need for persuasion, but the American government finds it natural to establish a public relations office with a large budget for advertising expenses. This is because individualism, independence, equality, and liberty are national credos. People's behavior toward the nation is voluntary and they do not want to be coerced by another class, so the government must use advertising to lure them. That is why a hierarchical system has not emerged in politics or in the economy in the hundred and some years since the country was founded.

From this it is apparent that the American spirit of independence is rightly called the greatest in the world (Americans love to call themselves the world's greatest, as you are all well aware). From this spirit comes the idea of self-realization, that everyone should advance by using his own talents and developing his own abilities. The more individuals develop, the more society progresses; this is another important reason for American national success.

Although the common conception is that if individualism is strong, public-spiritedness must be weak, it is not that way with the Americans. They are both full of individual independence and strong in social consciousness. Though in ordinary times they remain uninvolved, at moments of political or social change the feelings of the whole citizenry become aroused and completely dominated by this [public-spiritedness].

Before elections politicians always vie in giving speeches, for they want to use this mass psychology to win the sympathy of the majority and thereby gain victory in the end. From this it is evident that Ameri-

cans are strong in public-mindedness. Furthermore, they have a greater than ordinary willingness to sacrifice private interests to the common welfare. Proof of this is found in the war between the North and South. Also, when the United States joined the current war, it adopted the draft, vigorously enforced prohibition and food rationing, and brought the railroads, telegraph, and other private enterprises under state control. All these actions are incompatible with the idea of individual freedom, but Americans in fact accepted them and, moreover, the whole nation, high and low, unanimously praised President Wilson. According to a recent U.S. government report, American casualties in the fighting on the French border were very high, and a military cable the other day reported that [Theodore] Roosevelt's fourth son had been killed on the Western front. It is clear that Americans are both a truly freedom-loving people and also—in contradiction to this—a people truly capable of sacrifice. This is another contradiction in the American mentality, and it is also a point of strength in the American character.

4. Americans are on the one hand rich in the spirit of scientific research, but on the other they are also earnest in their religious beliefs. Psychologists divide human talent into three kinds: ability to invent, ability to put to practical use, and ability to imitate. Because the United States is a late-comer nation, inventive ability is not frequently seen, but America's practical and imitative talents are unusual and unmatched by other nations. No matter what the branch of science, once it is transmitted to the United States, Americans use their talents to imitate it, put it to practical use, and develop it. Americans are proud of this ability, and all the nations of the world, East and West, are astonished at the science of the United States.

America is first in the entire globe today in the number of schools. Almost the entire nation goes to school, both male and female, and they all study thoroughly. This is a result of their talents of application and imitation. *Application* means taking what is learned and applying it to practical use; *imitation* means taking what others have invented and copying it. Although imitation does not require accurate research, imitating others only superficially will not produce good results, and Americans in fact are also strong in accurate research. Whenever they study something they investigate its origins and causes, then gather facts and submit them to precise study, analysis, classification, experimentation, and proof, from which comes a systematic and organized scholarly discipline. By these means in recent years the progress of American science has reached breakneck speeds. The more science pro-

gresses, the more society develops, so this is another important factor underlying the achievements of the American people.

We Chinese generally believe that science is basically incompatible with religion and that where science flourishes, religion will wane because those strong in scientific spirit must be weak in religious faith. But it is not so with the Americans. They are both strong in scientific spirit and earnest in religious faith.

A few days ago in New York I was told by President [Nicholas M.] Butler of Columbia University that even today Christian ideas still constitute a large component of the American character. Again, according to Butler's book *The American as He Is*, the most recent statistics show there are 160,000 clergymen in the United States, over 200,000 churches, and more than 32 million church members. Butler is currently a great American educator of high repute; his words cannot be groundless. Moreover, I have observed in the American Congress that both the upper and lower houses open their sessions each day with a prayer ceremony, and I hear that most state legislatures do this too. Even troops going into battle are accompanied by chaplains. These things suffice to show how great is the influence of religion in America.

In fact, America from its origins was managed by Puritans, with their unshakable faith, and became a splendid and magnificent new world. Later generations have preserved their ancestors' traditions, and the power of these traditions has not diminished, though science changes daily. This inherited faith has nourished Americans' spirit of struggle, hard work, bravery, and sacrifice. I said a moment ago that Americans are most rich in practical ability. Precisely because of this, their inherited faith, though very deep, has not produced any kind of obstacle to scientific progress. Furthermore, they use science to renovate religion. This is not empty speculation on my part; take Boston, where you gentlemen have long lived. Boston is a center of American culture and also the place where Christian Science was founded. Yesterday I visited the Society for the Study of Christian Science and noted that the many publications issued by that society use scientific explanations to propagate religious beliefs. This must be familiar to you without my chattering about it. It is evident that Americans are both strong in scientific spirit and ardent in religious faith. This is another contradiction in the American mentality, and also a virtue in the character of the American people.

# *"Things About America and Americans"*

Xu Zhengkeng, 1918–1921

*Xu Zhengkeng ( 1898?–?) was educated at two American-supported missionary institutions in China, the middle school attached to St. John's University in Shanghai and then Nanking University, which graduated him in 1918. He then came to the United States and studied at Cornell University from 1918 to 1920. Before returning to China, Xu traveled around the country for six months and worked for a while at the University of California.*

*Xu's book about America, published in 1926, remains one of the most comprehensive in the Chinese literature to date, a 358-page compilation of information about everything from restaurants to Japanese immigrants. Beginning with its copyright page, which bears the English title "Things About America and Americans," Xu's text is liberally sprinkled with names and terms written in English characters ( here enclosed in guillemets)—an indication that his Chinese readers could be expected to know some English. Although Xu voices reservations about America, he is speaking to an audience he thinks too apt to be "intoxicated with Westernization" ( p. 343).*

### HOW AMERICANS CHERISH TIME

Americans cherish time because of their worship of money. They have a proverb that time is gold. The impatience of their temperament, the hurry and pressure of their affairs is visible in the way they walk. There is no one on the streets anywhere in the country just looking around or

wandering aimlessly like the loafers in China's streets and alleys. Americans have also invented all kinds of labor-saving machinery, such as candy vending machines that a passer-by can activate by inserting coins, making a fixed amount of food jump out. Or stamp vending machines next to mailboxes, in which someone mailing a letter can put two cents, which activates the machine and causes a two-cent stamp to come out of its own accord. Or paper-cup machines that are activated when a customer inserts one cent, making a paper cup drop out. And so on. All have been created because of Americans' idea of cherishing time. In addition, in busy places there are so-called «automat or self-service» restaurants, managed by machines instead of people. Various kinds of food can be taken out of the machine by a customer who pays the price. The cleverness of this makes one sigh ceaselessly with wonder.

A plan for how civilized people should allocate time over their whole lives appeared in an American newspaper. Out of a life span of 70 years, sleep was calculated to take 23 years and 4 months; work, 19 years and 8 months; sports, recreation, and going to church, 10 years and 2 months; eating, 6 years and 10 months; traveling, 6 years; illness, 4 years; and washing and dressing, 2 years. From this we can see the economical attitude Americans have toward time. Every action must be calculated meticulously and no time wasted.

### THE IMPORTANCE OF MONEY

Americans are adept at the art of doing business and making a profit. Their whole civilization has its origin in this, and they are first among nations in their emphasis on money. Even when friends socialize there is a commercial motive. Americans often haggle over money, creating a rift; this is due to their love of money. The easiest ways to riches in America are banking and railroads. Capitalists in these two industries have great power and prestige. But while power and prestige are easy to gain, they are frequently also easy to lose. Only two men today have been able to maintain their enormous holdings, «Vanderbilt» and «Gould», both railroad capitalists. No one is more highly regarded in the whole nation than these two, who hold the power of life and death over others. Sometimes even the president or a state governor has to bow his head and take orders from one of them.

Apart from these two, the person who can be called the richest man in the world, with incalculable wealth, is the petroleum king «Mr.

John D. Rockefeller», the chief of Standard Oil Company.[9] Originally from a humble family, he made his mark in petroleum and gained control over the world's petroleum industry. His every move directly or indirectly affects the whole population. One year, taking pity on the poor, he donated a large sum of money at Christmas, to be distributed all over the country. For a time he was lauded in the newspapers, praised everywhere, and had the reputation of being a great philanthropist. But in no more than two months the price of gasoline was increased, revealing his mercenary intentions, and he was castigated all over the country.

In recent years he has made great efforts to aid Chinese universities and, in particular, he has at great expense established a medical school in Peking. On the surface he did it purely for public benefit, but in fact it was a tactic to win people's hearts for the purpose of developing his business. He has never set foot in the political realm, but can be seen as enthusiastic in projects to improve society. The most famous and well-equipped university in America, the University of Chicago, was founded by him alone. He is also an ardent Christian; teaching the Bible to ordinary young people, which he insists on doing himself, is what makes him happiest every day. Apart from him there are many people called the king of this or the king of that. These are titles for people whose financial power controls a whole industry. Since these titles are so common in America, the hope of attaining such a position is deep in everyone's heart. Thus the worship of money becomes even more firmly fixed.

Countries differ in the preliminary expressions used when strangers first meet. In China we begin by asking a person's name, native place, age, and occupation, for we need to know the details of his social background before socializing with him. In England it is most common to ask, «Who is your father?» This represents the national character of an autocracy. If someone's father is an aristocrat, no one will fail to be respectful at once. What Americans ask is «How much have you?» This shows the importance Americans attach to money. This can be seen everywhere. An American newspaper carried an advertisement of a performance by the famous actress «Miss Minnie Palmer» saying, «Minnie Palmer will wear all the diamonds in the third act». The American preoccupation with money is even used by theaters to attract customers.

9. Xu's reference to Vanderbilt, Gould, and Rockefeller as contemporary figures is curious. Gould had died in 1892, Vanderbilt in 1877, and Rockefeller had retired in 1911.

### SUPERSTITIONS

Americans have many superstitions. For instance, if a certain kind of bird (similar to an owl) flies by late at night, according to a folk saying, this is a sign that someone is going to die. The number thirteen is also considered unlucky, so in inviting guests you must have either twelve or fourteen and never thirteen.... The reason for this superstition is that Jesus had twelve disciples and the thirteenth was Judas, whose betrayal caused Jesus' death. So people do not like to use the number thirteen. Again, Friday is called «black Friday», and many people who are superstitious do not go out on that day. Anyone who gets sick or has an accident on Friday considers it especially unlucky, because that was the day of Jesus' death. There are techniques of fortune-telling and astrology that rural Americans in particular believe in. They consider the day, month, and year of birth important, but [unlike Chinese] not the hour. Families who raise bees never tell others the exact number of beehives they have, and on President Washington's birthday they must move their hives or it is said there will be a death. Also, if some bees escape while [the hives are?] being separated, then they will ring a bell or beat an oil drum in the belief that the bees will hear it and return—this is really laughable. The United States always brags it is a civilized country and ridicules us as a superstitious one. Who would have imagined that superstition there is more widespread than with us!

### INSIDE AMERICAN HOMES

Before marriage most American women learn about household management, and so after becoming wives they can set up an orderly home and handle housekeeping with ease, taking care of even aesthetic, hygienic, and spiritual matters. When you enter the homes of people, no matter of what class, they are always neat and quiet with a dignified charm. The average home has a piano or a gramophone and such items of entertainment. In winter there is central heating and hot water, and some also use gas stoves so that the inside of the house maintains a fixed temperature. Though it may be freezing cold outside, inside it is like spring. At times of leisure husband and wife play the piano and make music—their happiness together is enviable. Because the standard of life is high and labor expensive, they cannot afford servants, so they take care of everything themselves. If they want to buy something, they call the store and ask for it to be deliverd. The sound of hubbub or quarreling is never heard inside the house. If on occasion there is an

argument, it is hidden so people do not know. In summer the whole family goes to the country. On Sundays, too, they go for a ride in the car, packing food to take on a walk in the countryside, and not coming back until evening. The American family is indeed the happiest and has the most enjoyment.

### BIRTH CONTROL

Because the American living standard is too high, they have various methods of birth control. Ordinarily if there are more than two children, some relatively safe means of contraception will be found. In recent times this matter has resulted in such things as Mrs. Sanger coming to lecture in East Asia.[10] Besides, the expenses of raising a child from infancy to adolescence and then to adulthood are not negligible. And what a burden it is for poor families to be saddled with many births! Eugenicists say that highly educated people bear fewer children. A nation benefits from the production of children with superior inherited characteristics and full education. So are not the material civilization of the United States today and the cleverness of its people due to birth control?

### THE EDUCATION OF CHILDREN

The United States is a paradise not only for women but also for children. Society thinks children important, just as it does women. Municipal governments have «Child Welfare Departments», which intervene with any family that mistreats children or takes insufficient care of them. The government has fixed April 7 of every year as Children's Day. On this day the President opens the White House for children to come in the back garden to play «egg-rolling» [Easter?]. On Christmas and Mother's Day mothers and children give gifts to each other. Every Sunday fathers and mothers take their children to worship in church and then in the afternoon go to the movies and eat candy. Their pleasure is boundless.

The Americans' method of bringing up children combines the three kinds of training [moral, intellectual, and physical] and also self-reliance and independence. When you see children selling newspapers on the street, it is not necessarily because their families are poor. There

---

10. Margaret Sanger, the pioneering American advocate of birth control, was invited to China in the 1920s, where Hu Shi acted as interpreter for her.

are also children who carry things for people, or deliver telegrams, or raise chickens at home. These activities are to develop their spirit of independence. As for their intellectual side, aside from reading, they are often taken by parents to visit museums or circuses so that they can broaden their knowledge by learning more names of animals and plants.

Attention is also paid to their physical side. Things like driving, horseback riding, baseball, and swimming, which Chinese parents consider dangerous and forbid their children to learn, American mothers and fathers teach their children to do. If a child invents a new toy, various companies will reward him and manufacture it for sale. Even when children bump their heads or cut their hands climbing trees or sledding or such, parents do not urge them to stop. Once in late winter when I was visiting a Western friend, his three-year-old son was standing next to the fireplace playing with fire, and my Western friend seemed to take no notice. Then the boy stuck his hand into the fireplace and was burned and cried. I asked the father why he had not stopped the boy earlier, and he said it was not good to stop him, that he should experience the pain himself and then he would not do it anymore. When a three-year-old boy with his childish understanding is taught by his father this way, it can be imagined what kind of a man he will become.

### TRAIN CONVERSATION

Once I had a conversation with an American on a train. I said, "I have been in America for two years and am not too fond of your country." The other looked severe and asked why. "The prosperity of your country is acquired with money. There is nothing in the world that cannot be bought with money. My nation suffers particularly from poverty, so it is all right to call your nation rich. But it cannot be said that your country is totally civilized." At that moment the attention of all the whites in the car was attracted by a person of the yellow race making such a provocative remark. The man then asked me what I admired in his country. I said, "In my view there is only one thing." "Is it the economy? Municipal government? Communications? Industry?" "No, no," I said. "What I most respect are your nation's university professors, who are able to devote their whole lives to scholarship when their salaries are the lowest of any occupation. This is in fact the foundation on which your country stands and the source of its power and prosperity." As soon as the words were out, he indicated his agreement and said nothing more.

AMERICAN UNIVERSITIES

America has a great many universities, large, medium, and small in size. Each state has at least one. They are most admirable educational institutions. Students with motivation and ability are admitted regardless of race, age, or sex. They may be as old as sixty or as young as fifteen. They are white, black, red, and yellow—these universities may be said to be not for one nation but for the whole world. All students are treated the same without distinction. The campus gates are open all day, permitting anyone to come in and listen. America's true republican spirit can be seen in its universities. The ones on the East Coast are the best, and what I have just said applies mostly to those in the northeast. The universities in the west not only are of low caliber but also discriminate against foreigners; except for Chinese, few non-Americans are admitted.

# Presidential Elections

## Li Gongpu, 1928

The promise of the 1911 Revolution to bring a measure of constitutional democracy to China soon evaporated. The statecraft of the young republic devolved into more than a decade of warlord politics, as brutal and corrupt regional militarists struggled for power. The revolutionary forces of the Nationalist Party, or Guomindang (Kuomintang), under the leadership of Sun Yat-sen and his successor Chiang Kai-shek, and with considerable popular sympathy, overcame the warlords and took power in 1927. The new government promised democracy, including checks and balances within a five-branch government—sometime in the future.

In this context, Chinese intellectuals and political activists such as Li Gongpu (1902–1946) became deeply interested in the mechanics of the American electoral system. As a young student, Li had taken part in the heady anti-imperialist and anti-warlord political movements in China of the mid-1920s. In 1927 he came to America as a scholarship student at Reed College in Oregon. He studied government, worked washing dishes and cleaning floors, and wrote articles for journals in China. On returning to China, he became involved in mass education.

In 1936–1937 Li was arrested and detained for several months for his role in the National Salvation Association, which was pressuring the government to resist the Japanese. During the war Li was a leader in the Democratic League and in the so-called democracy movement opposing the Guomindang dictatorship. He was assassinated in July 1946, presumably by government agents.

November 6, from 8 A.M. to 8 P.M., was the period when Americans all over the country cast ballots for the next president. At 8:50 P.M. here [Oregon] the same day, the radio reported that the Democratic candidate Smith had sent a telegram to the Republican candidate Hoover congratulating him on his victory (the time in the west is two hours different from that in the east; at 9 P.M. here it was 11 in New York), and the whole country knew that the Democrats had lost again. In point of fact, however, the policies proclaimed by the Democratic party and its candidate Smith this time had both been given considerable approval and support by ordinary people all over the country, so that at the time of the election no one dared predict that victory would go to the Republicans, who had long been in power. So what are the real reasons for the Democrats' loss? In order to answer this adequately, it is necessary to summarize the general situation, for although the membership and influence of the Republican party is greater than that of the Democrats, the following were important factors:

1. The religious question. American presidents have historically all been Protestants, but Mr. Smith is a «Catholic». Although there is nothing in the Constitution prohibiting a Catholic from being president, still, in the mind of the average person, this has become an «unwritten law» passed down through history. Although, in accordance with the constitutional provision of freedom of belief, people are not willing to oppose Smith openly on these grounds, nonetheless it is clear to me that the power of American Protestantism is great and that especially among older people prejudices run deep. I remember meeting two white-haired old people at a dinner party at a friend's house a few months ago. When I asked them whom they were going to vote for, they both exclaimed at the same time, "Neither!" Later in the conversation it became apparent that both were Republicans but were unhappy with the achievements of the past administration (Republican) and with its newly proclaimed policies, and so were unwilling to vote for Mr. Hoover. As for the Democrat, to put it briefly, they would have been most happy to vote for Mr. Smith had he not been a Catholic. According to surveys, this situation has influenced an enormous number of votes, and Professor McGree [?] of Reed College declares that it is the major reason for Mr. Smith's defeat!

2. The Prohibition question. It is nine years now since January 29, 1919, when the United States promulgated the law prohibiting liquor, but the result has hardly been better than that of opium prohibition in China. No matter where you are, all it takes to obtain good liquor is money, so that the American prohibition law is a dead letter, needless

to say. Mr. Smith is one of those who advocate the repeal of Prohibition because they do not want America to have laws that are ignored. To eliminate alcohol in America under present conditions seems to be generally recognized as impossible, so those who advocate the repeal of Prohibition think that since the law is without substance, why not find a better and more viable method? I hear that those favoring repeal made large contributions to the Democratic party's campaign expenses this time, but the opponents of repeal are nevertheless more numerous than the supporters. For example, in the states of the American South, the majority are Democrats, but many voted Republican this time because they were opposed to repeal. Therefore commentators say the Prohibition problem is also one of the reasons for Mr. Smith's defeat.

3. In addition to these two, another relatively serious problem was Mr. Smith's origins in the New York political club «Tammany Hall of New York City». Because in the past this club was used by most politicians as an organ for discussing how to seize political power, it is regarded by Americans in the same way that the "Anfu Club" [of warlord politicians] used to be regarded by Chinese. In fact, the club has for a long time been no different from other political party organizations, but most Americans do not trust Mr. Smith because of this prejudice. We should keep in mind that in voting for president the average American places great weight on individual moral reputation. Only a minority, I can say, study the policies and theories of the two parties. I frequently asked fellow students of voting age why they were going to vote for Mr. Hoover. Six or seven out of ten replied, «Because he is a good man!» Although a simple reply, the attitude of ordinary Americans toward the presidential election can to some extent be inferred from it.

### VOTES AND EXPENDITURES

The total number of votes received nationally by the two parties in this election has yet to be made public. Present estimates are in the ratio of 21 to 16 (21 million votes for Mr. Hoover and 16 million for Mr. Smith). If we consider the total number of votes they received, this could be considered an unprecedented accomplishment for the Democrats, for even Wilson, the former Democratic president, did not receive as many votes. As to the total received by the Republicans, on the other hand, it was far fewer than the number the present president, Coolidge, got. Taking the states as units, Mr. Hoover won as many as forty states and Mr. Smith only eight.

The expenditures made by the two parties in this election were five million dollars by the Democrats and six million by the Republicans, the total being equivalent to the huge sum of twenty-two million Chinese dollars. The size of these expenditures is enormous! The source of these funds is mostly contributions from businessmen who want one or the other party to win the election, a circumstance that really gives one pause for thought.

### CONDITIONS ON ELECTION DAY

A week before the election I made preparations to go to a polling place on election day to watch the excitement and to observe the attitude of the people of this country at the time of the election. Who would have imagined that when I went with my schoolmate Cane [?] on the afternoon of the sixth, the so-called polling place turned out to be nothing more than a little house! A small sign outside the door stated that this was Municipal Electoral Polling Place No. 137. In one half of the ground floor sat a ballot issuer, a checker, a ballot receiver, and four overseers; in the other half was room for ten people to fill out ballots. While Cane did his, I asked in detail about the procedures for filling out a ballot, and I also received an explanation of the ballot from the lady who was issuing them.

Lastly, after getting permission from the chairman of the polling place, I went upstairs and observed how the ballots were counted. Four people were counting the votes, one calling them out and three recording them. Each ballot had on it not only the presidential candidates of the various parties but also important state officials whose terms had expired, the city's mayor, and a number of important state referendum questions, such as whether to increase firemen's disability benefits and old-age pensions, whether to increase the automobile gasoline tax, and so on, with detailed rationales included, to be decided by the opinion of the majority of the people. The poll workers were deputed by a state administrative organ; each precinct has no more than three or four hundred voters registered in it, and there was not the slightest crowding or clamor.

Election regulations require that the parties stop all propaganda activities on election day, so that day was unusually peaceful everywhere. I watched two workers and an old lady fill out their ballots with extraordinary care. Such an atmosphere is truly worthy of our respect! It is extremely discouraging to compare this with our own former elections for provincial assemblymen and national assemblymen, which

were confused and disorganized, without the slightest order, even to the point of knives and guns, beheadings, and bloodletting!

But if we carry our examination of the American electoral system and its true nature a bit further, the conclusion will be that the democratic form of government in the United States has so far only taken the first step and not yet reached perfection. In political matters the people are still completely manipulated by the two parties. Before an election, promises are made: if elected, this will be done or that will be carried out. Once the election period is past, the party that has gained power exercises its authority in any way it wishes. The policies and matters they had promised are for the most part treated only perfunctorily, and there is nothing that the people can do. In this respect, the external expression and inner strength of America's so-called democratic spirit are not as great as those of the English people.

As for the election of state government officials and city mayors, most are controlled by political parties, and the majority of the people do not know about the record of experience or character of nine out of ten people on the ballot and just mark any name when voting. This is a fact admitted by many of my schoolmates and professors of government. Of the personnel employed in various organs of state government and so on, more than half are mediocrities interested only in making a living, as was declared by a Democratic senator in a public speech in the city.

If people at the level of Americans still have politics that are so imperfect, then it is clear that the realization of "democracy" is not an easy matter. At the same time we should also be aware that if from now on the Nationalist government actively devotes itself to constructive work, strengthening the five-branch organization of the government, and at the same time education and the economy suddenly develop and spread, then after twenty years the progress of our politics, industry, and commerce could easily be equal to that of England and the United States. It all depends on the wisdom and hard work of us Chinese.

*November 16, 1927 [ 1928 ]*

# IV

# Flawed America

$B$y the 1930s and 1940s, America was becoming increasingly familiar to literate and urban Chinese. The study of English was common among the privileged few whose education extended through high school or beyond. The sixteen colleges and two hundred schools founded by American missionaries were graduating tens of thousands of students, and other schools increasingly adopted an American-style curriculum, often taught by teachers who had studied in the United States. Of full professors at Tsinghua, one of China's leading universities, in 1937, for example, sixty-nine had studied in the United States, fourteen in Europe, five in both the United States and Europe, three in Japan, one in Hong Kong, and only one solely in China. Newspapers and magazines were full of information about America, and between 1912 and 1940 almost three thousand books translated from English were published in China.[1] Urban life in cities like Shanghai was becoming Westernized in countless little ways, and beginning in the late 1920s Hollywood movies brought vivid depictions of American life before the eyes of a large audience of city dwellers, including illiterates.

Chinese writings of the later Republican period, then, no longer portrayed America as an exotic geographical and technological wonderland or as a unique democratic polity. Every year over one thousand Chinese came to study in the United States, many of whom stayed on

---

1. Tsuen-hsuin Tsien, "Western Impact on China Through Translation," *Far Eastern Quarterly* 13 (1953–1954):320.

for years and became quite at home in American society. Thus the perspective of the curious and naive outsider was replaced by that of the "half-insider": frequent travelers, long sojourners, and long-term students. The sprinkling of English words in Chinese texts suggests a readership whose knowledge of America through books now exceeded what an earlier generation had attained only through traveling.

Nationalist China's view of America remained generally friendly and favorable, influenced no doubt by the countries' amicable relations. World War II brought the two nations even closer together as allies against Japan. Still, with familiarity and deeper understanding came a somewhat sharper awareness of less attractive aspects of American society. And, as the Communist challenge to the Nationalist government grew in strength and in influence among intellectuals, they began to frame a leftist critique of capitalist America.

# The American Family: Individualism, Material Wealth, and Pleasure-Seeking

"Gongwang," 1932

*One aspect of American society most frequently remarked on by Chinese observers is behavior toward family members, a cornerstone of Chinese ethics. Even modernized Chinese often found American conduct in this area incomprehensible or improper. The following analysis of how American individualism, living standards, and hedonism affect family patterns was published in a Shanghai magazine in 1932 under a pen name. We have been unable to identify the author, who was apparently a student at Columbia University at the time. "Individualism," it should be noted, is a word that in Chinese connotes a degree of selfishness.*

That America is a most extremely individualistic nation can be seen from the family system and family life; that material civilization there is highly developed is apparent in family life; and that this is the most pleasure-seeking nation in the world at present is likewise something that can be seen in family life. Let us discuss the American family from these three perspectives.

### INDIVIDUALISM

*Individualism* means, first, that people all look after themselves and are not dependent on others. Second, it means that all have the right to determine their own actions, and that, except after due process of law, no one may interfere with these—neither the government with its citizens, nor a group with its members, nor parents with their children, nor a husband with his wife.

145

The first aspect of individualism is seen in parents not providing for their children after they grow up or marry, and in parents, too, having to support themselves in their old age and rarely being taken care of by their children, much less by relatives or friends. Since coming to America, this correspondent has several times met laborers who said that their children were company managers and their brothers university professors, but they themselves still had to do hard manual labor. One of the people this correspondent stayed with when traveling in Michigan during spring vacation last year was a woman in her sixties who lived alone on a hillside. Although her daughter lived a mile away, she visited the old lady only once a week. Because this lady had saved some money, she spent most of every day at home reading and relaxing, and in the mornings would drive herself to the countryside for an excursion.

Such examples are in fact not rare. There is a joke that goes: "An American father stayed at his son's house for several days, and when it was time to leave the son presented him with a bill. The father looked at it and said, 'Everything is correct except for this ham sandwich, which I didn't eat.' The son replied, 'You didn't eat it, Father, but you ordered it!' " This is a bit of an exaggeration, but it is true that Americans keep careful accounts between father and son and between brothers.

Last year there was a Chinese student studying in the United States who sacrificed his graduate education and sent all his savings to a brother who had fallen into debt and gone bankrupt. When an American professor was told about this, he considered it remarkable and unprecedented—which shows the common American mentality. A friend of this correspondent's has charged that of the [five Confucian] ethical relationships Americans recognize only half of one, that between husband and wife: the words *ruler* and *subject* have never existed in the American brain, nor are moral obligations recognized between father and son, between older and younger brother, or between friends. As for husband and wife, although they share property and pleasures, with the increasing divorce rate extremely few actually grow old together. So all that is left is half of the husband-wife ethical tie.

Indeed, the present American divorce rate is astonishing! When one couple marries, another is getting divorced at the same time. Because divorce laws vary from state to state, being easier in some states and harder in others, people who want a divorce go to the easy places, such as famous «Reno», where government revenues come mostly from

divorce and gambling. It is only necessary to spend two weeks there to attain «residence» status, and then petitioning the court for divorce is completed in ten minutes. As a rule, Hollywood movie stars make several trips to Reno a year, providing the city with divorce fees. If a couple mentions that they are going to Reno, the rest of what they have to say will not be happy!

The other aspect of individualism is that «Every man is his own boss» and no one may interfere with another. There is a common American expression, «Mind your own business», which at first glance seems to mean the same thing as the Chinese saying, "Each sweeps the snow from before his own door; none cares about the frost on another's roof." But the former implies "you stay out of my business," expressing the desire of an individual not to be restricted, while the latter implies "do not get mixed up in other people's business," which expresses the desire to avoid the trouble or complications of involvement in others' affairs.

The way children and parents act like equals in an American family never fails to astonish Chinese who witness it. A landlady said to me, "Young people these days are like wild horses. Going out at night with friends of the opposite sex and not coming home until all hours of the morning—there were no such goings-on when we were young." The eighty-year-old mother of «Prof. F. A. Fetter» of Princeton said to this correspondent, "I would like to go to China. I hear the Chinese respect old people. If you live in America, when you grow old people think of you as a useless wart." These two remarks vividly show what a family system without authority is like—though it should be explained that only after the children are grown does the head of the household have no authority over them; when they are little, he of course has the power to discipline them.

That is how American individualism is manifested in the family. In the economy it is manifested as free-enterprise capitalism; politically, as democracy and localism; socially, as a social system with a weak idea of status based on occupation; and legally, as public and private laws that strongly protect private power. In China human rights have no protection; but in America they are overprotected, so that nothing could be done about the Chicago gang leader «Al Capone» because of lack of evidence, though everyone knew he was involved in bootlegging, gambling, murder, kidnaping, and every other crime, and only recently has he been found guilty of not paying income tax and given a sentence of eleven years.

MATERIAL CULTURE

American homes generally fall into three categories. First are wooden houses; slightly nicer than the foreign-style buildings in Shanghai's Joffe Road, these are most numerous in small towns, and are where workers, students, and middle-class people live. Second are «apartments» in buildings five or six to ten stories high with several separate apartments on each floor; these are mostly in big cities, inhabited by all kinds of people. Third are the grand mansions of the capitalists, mostly where the scenery is beautiful; some capitalists have four or five mansions in different places.

Houses of the first kind are very common. Five or six to ten feet distant from each other, each has a grassy area and most have some flowers growing. In back is an open area for drying clothes or the like, so that from the street one never sees clothing fluttering as in China. Most of these houses have two stories. On the first is living room, kitchen, and dining room. The second floor has three or four to six or seven bedrooms and a bathroom with wash basin and toilet. Wastes from the toilet are carried off through underground pipes to a certain place, so that there is no need for nightsoil buckets and pits, and the bathroom is entirely free of odor. Other facilities such as electric lights, telephone, rugs, running water, hot water, and radiators or hot air are found in nearly every home, whether in big cities or small towns. For cooking, the most common fuel is «gas»; you have only to turn a knob to be able to light it, and preparing a meal takes an hour at most. For washing clothes, most houses have a machine, which saves much time. In China the enjoyment of such things is possible only for the rich and can be seen only in cities. But in America they are extremely common and might even be called the basic level of living.

The second kind of home, apartments, are at least as well equipped, though the light and air are not as good since they are in the city. This type of housing is necessary in cities, where most people are unable to buy houses and furthermore do not need houses because they move often. The facilities in apartments all are taken care of by the landlord, so people need not worry and can save money. As to the third type of home, the mansions of capitalists, these are grand and extremely sumptuous inside, as the reader can see to some degree in American movies.

Finally,...not only is American agricultural and industrial production completely mechanized, but in the home also machines take the place of human labor. For instance, there are machines for washing

clothes and for drying them, for cleaning the floor (invented by Hoover), for cutting meat, and so on. These are not only more efficient but also generally do better-quality work than is done by hand. To have all this work done by machines requires both that general scientists rack their brains to do research, improve, and invent, and also that consumers have the capital to purchase machines. For society to have this purchasing power requires working hard and reducing unnecessary expenditures....

### PLEASURE-SEEKING

Because the married couple is the most important structural element in the American family, family life can be said to be basically the couple's life. The couples this correspondent has seen have all been on extremely good terms with each other. There are various reasons for this, but the simplest explanation is that those who are not on good terms get divorced so that those who are left are. Relations between men and women in the United States are very free; there are ample opportunities for sexual enjoyment, and the age of marriage is generally late. After marriage, some women continue to hold jobs and some manage household affairs, also working hard. The average person gets up early and few sleep late; after rising, most go for a drive in the country and then to work. After returning from work, husband and wife are full of "Sugar" and "Honey" and «Darling» and ceaseless affection. In the evening they sit together on the sofa in the living room and listen to music on the radio, read, or play «bridge», all the time their faces shining with joy. Sunday is even more a time for enjoyment, either driving to the country for a «picnic», or going to the beach to swim (there are places to go swimming in winter, too) or horseback riding or boating—there is a great variety of ways to have fun.

On the subject of Americans' life of pleasure, this correspondent would like to call the reader's attention to several points. First, while Americans enjoy pleasure, they are also industrious; whether male or female, young or old, rich or poor, very few are idlers who do not work. That the United States can be so rich and populous today is because of (1) its abundant land and resources, (2) its exploitation of colonies, and (3) its having taken advantage of the opportunities offered by the European war to raise itself up and prosper. But the major underlying factors are that all the nation's people work diligently in productive pursuits and that they face the outside united instead of committing suicide in civil wars. (There has not been a civil war since the war

between the North and South to free black slaves, and there will not be another one.) Second, the pleasures of the rich in America—boating, riding, dancing, golf, and so on—although to be condemned from a socialist perspective as the pursuits of the leisure class, still have the advantages of being of some use to society and promoting health for the individual. They are not in the same category with our country's smoking opium, playing mahjong, and going whoring. Third, enjoyment for Americans is a basic philosophy and can be called a national trait. (In fact, Americans do not like philosophy, quite the opposite from Chinese, who love abstract discussion.) The rich make «whoopee» and the poor also all make whoopee. American songs, literature, movies, and plays are all concerned with romantic enjoyment between men and women; and whoopee is omnipresent in the rest of their lives. Thus, the good side of American culture is that it is full of zest and vitality. But viewed more critically, it is just the culture of the dollar and the art of sexual intercourse; at heart, it is nothing more than seeking pleasure.

*Columbia University, June 5*

# Alabama: Reds and Blacks

Zou Taofen, 1935

*Taofen was the pen name of Zou Enrun (1895–1944), one of twentieth-century China's most renowned journalists. For many years Zou was editor-in-chief of the weekly magazine* Shenghuo *(Life)—originally the organ of Huang Yanpei's China Vocational Education Society—which he built into the largest magazine in the country, with a circulation of 150,000. In the 1930s he became increasingly critical of the failure of Chiang Kai-shek's Nationalist government to resist Japanese aggression. Fearing for his life, he went abroad, spending two years in Europe, primarily England, before coming to the United States for two months in the summer of 1935.*

*Fluent in English, having majored in English and literature at a college run by American missionaries in Shanghai, and a skillful journalist, Zou also had the unusual advantage of a ready-made nationwide network of connections. These contacts stemmed from friendships he had made the previous summer in Moscow with American delegates of the National Student Federation; they were clearly American Communists, though in the book he wrote about this trip after returning to China (indeed, part was written in a Nationalist jail) he uses expressions like "the American reform movement." Not surprisingly, Zou, who formally joined the Chinese Communist Party on his deathbed and is revered as a martyr in Communist China even today, was highly critical of American society. Some of his book just retails secondhand condemnations of capitalism, but in its better parts his resourceful inquisitiveness, sharp eye, and fluent pen, together with his good English and helpful acquaintances, combine to create first-class journalism.*

*In the following vivid account of his trip to the American South during the Great Depression, Zou discusses the discrimination against blacks and the activities of idealistic young white radicals, for whom he came to feel warm admiration. He also conveys a sense of what it felt like to be Chinese in the American South.²*

After only a week in Washington I took a train south to «Birmingham», a city in «Alabama», one of the southernmost states and an important place in the Black Belt. Along the way, changing trains several times, I observed that blacks are not allowed to sit in the same cars with whites, and that stations had separate entrances and exits with big signs marked «White» and «Color». In New York an American friend had told me that when I encountered such a situation in the South, I could go on the "white" side, and that is what I did. A little before arriving in Birmingham there were only two other people in the car I was riding in. After talking to them I could tell they were workers, but more backward in their ideas than any I had encountered in New York. The South really is different, I thought to myself. Both warned me that I must by no means stray onto the colored side, that that would be terrible. In a natural and confident manner, they informed me that blacks were not considered human and could freely be killed without legal sanctions.

They also said that on intercity buses in the South I should take care to sit well up toward the front, for sometimes if there were a lot of blacks in the back and few whites in front the blacks would push forward, and if you weren't sitting far enough front you could get mixed up with them, which would again be terrible. When I asked why it would be so terrible, the answer was that people would look down on you. This made me think how strong the narcotic poison of the ruling class in the American South is. But I just played dumb and did not seriously argue with them, because I had been repeatedly and earnestly warned by several progressive American friends in New York that when traveling in the South I should be careful not to reveal my attitudes and especially my sympathy for the American reform movement, except with friends I could trust. They had also taught me a number

---

2. For more information on Zou Taofen and his travels, see Margo S. Gewurtz, *Between America and Russia: Chinese Student Radicalism and the Travel Books of Tsou T'ao-fen, 1933–1937* (Ontario: University of Toronto–York University Joint Centre on Modern East Asia, 1975); and Parks M. Coble, Jr., "Chiang Kai-shek and the Anti-Japanese Movement in China: Zou Tao-fen and the National Salvation Association, 1931–1937," *Journal of Asian Studies* 44 (1985):293–310.

of ruses, such as not saying anything about coming from New York, claiming to be a faithful Christian, and staying at YMCAs. Only afterwards when I saw how things were in the South did I understand that there were good reasons for these friendly warnings. Let me say frankly that the ordinary Americans I met in the South were cordial and honest and gave me a good impression. Still, I know that the southern bourgeoisie's fear of the reform movement was at an extreme and that if it had become known that I sympathized with this movement, things would have been different.

Seeking accurate information in a strange place with so many taboos requires guidance from reliable friends on the spot. In New York I had obtained a strong letter of introduction from an American I had known in summer school in Moscow, introducing me to a Miss «C» in Birmingham. Miss «C» worked in an accounting firm and was an ardent supporter of the labor movement. As soon as I got off the train I went directly to the YMCA, but unfortunately they only took in long-term members, not temporary travelers, and even my declaration that I was a faithful Christian was in vain. It was getting dark, so all I could do was scurry blindly to a little hotel and settle in.

I immediately called Miss «C», but—misfortunes never come singly—the woman's voice at the other end of the line, though warm and friendly, was not Miss «C», and she informed me that Miss «C» was sick and had not come to work for several days. When I anxiously asked for the address of Miss «C», she said she did not know it, though she would try to find it out for me. She also said she would be happy to help me if she could. When I heard these last words I felt as if I had returned from the dead, and arranged to go see her the next morning. I knew that the accountant [for whom Miss C worked] was sympathetic to the reform movement and that a number of young men and women in his office relied on his protection to participate in the labor movement after work, so, having missed Miss «C», I thought to find another helper.

The next morning's conversation, I happily recall, turned out extremely satisfactorily. Not only did I obtain the enthusiastic aid of the Miss «M» I had chanced to talk to on the telephone, but through her I was also introduced to Mr. «R», who had important responsibilities in directing the labor movement there, and to his "comrade wife" Miss «D». They were all thoroughly likeable young people: energetic, passionate, sincere, full of enthusiasm for their social cause. I presented my letter of introduction from the friend in New York to «R», who read it and then smilingly tore it to bits, saying that it was dangerous to

carry such a letter, which could cause me much trouble if discovered by spies. Listening to his gentle and straightforward words, I gradually came to realize the seriousness of their situation there.

After several frank talks they treated me as one of them, holding back nothing, and I then learned that «R» and Miss «D» had come out of jail only a few days earlier. Because they had been organizing oppressed black workers, they were seized by secret agents hired by the boss, stuffed into a car as though being kidnaped, sped off to a deserted area outside of town, beaten, and then turned over to the police, who locked them up for a month. «R» was physically strong, and with a hearty smile said he was not afraid of being beaten, the work needed to be done; at the same time Miss «D» happily held out her arm to show me a big scar from a wound she had received. I was astonished that such things could happen in a country supposedly under the rule of law. I hear that all the big bosses there, whether landowners or magnates, openly have their own detectives, seizing at will anyone on the streets, and the police not only do not interfere but actually cooperate. You want to take them to court? You may well find that the judge is their lackey and rules that you wounded yourself in order to bring a false accusation!

What I respected most about these young American friends was that after so much suffering they did not slacken in their work in the slightest, showed not the slightest discouragement, but continued to push forward, as brimming with enthusiasm and untiringly cheerful as before. I will never forget their spirit; I would gladly be one of them! Although they did not fear danger for themselves, they were most protective toward me. Once they invited me to listen in on a meeting with some black worker comrades. I was sitting next to the window (it was upstairs), when «R» suddenly thought that it was not a good idea and told me to move, saying that if a spy outside saw me, it could cause me complications. With their assistance, I went further south to «Selma» ...to see how black farmers are treated. It was a four-hour bus ride, but they thought it was only three, and on the day I was to return, when I was not back at the time they expected, they feared I had been seized by landowners and immediately held a meeting to plan my rescue! They were just in the middle of anxiously discussing this when I arrived, and their joy at seeing me made me think how their friendship for me was as deep as for beloved brothers and sisters.

I do not have space to recount in detail the discrimination against blacks I saw in Birmingham; in brief it is like this. They are able to live only in slum districts, needless to say. On trolleys there is a small separate section of seats marked "Colored" and a large one marked "White." I personally witnessed a black woman go into a coffee shop,

buy a cup of coffee, and—not allowed to drink it inside—take it out to the sidewalk to drink, before returning the cup....

The bellhop in the little hotel I was staying in, a young black who treated me most attentively, several times asked surreptitiously if I was going to New York. I answered vaguely that maybe I was, but I did not know what to make of it, especially his furtive manner. Later he came to my room to clean up, and after glancing all around looked me in the eye and in a whisper complained that his work there night and day was very hard, that he had not enough to eat nor to wear, and wanted to go North to seek work. Over and over he entreated me to recommend him for a position when I got to New York, saying he was willing to do any work, did not care about the wage, and only wanted to get away from the hellish South.

His surreptitious hemming and hawing made a big impression on me, for was it not pathetic that, though looking for a job or changing jobs is supposed to be everyone's free right, he seemed to think it was something improper and illegal that could only be whispered to me after looking around to make sure no one else was near?

This bellhop also expressed to me an admiration for the Chinese, saying the Chinese in that city were very rich, especially one Zhou, the owner of a Chinese restaurant called «Joy Young», who had two cars, which the bellhop delighted in talking about and repeatedly praised. I went to the address he mentioned and found the Chinese restaurant myself. It was indeed lavishly decorated, and had two managers, named Lu and Zhou, who, though both Cantonese, were fortunately able to speak English with me; they were most polite and would not hear of letting me pay for my dinner. I was told that the city had only forty-five Chinese, all with good reliable jobs, and that there were two large and one small Chinese restaurants. Because the Chinese there were doing well financially, dressed neatly, and were honest, most people in that city had a good impression of Chinese.

When afterwards I asked «R» about this, he admitted that the Chinese were relatively well off, but said that for that reason they felt themselves part of the American bourgeoisie and, far from helping the labor movement, were indifferent to it. I thought what he said was not groundless, for when I had talked with the Chinese restaurant manager Mr. Zhou about the livelihood of the people there, he said there was no poverty, whereas I had seen numerous poor shacks with my own eyes—though most belonged to blacks. What I heard about Chinese in this city doing well is encouraging, but as for them having a particular ideology because of this life, that is another matter.

«R» told me that most people there were very status-conscious and

that on the street I should walk with long strides and chest out, not be too polite to anyone, and if I had to ask directions first ask the way to the «Tutwiler Hotel», for it was the biggest and best in Birmingham and if people thought you were staying there they would assume you were rich, would be respectful and especially attentive, and would do their best to answer your questions. But I had never before acted rich and would have found it uncomfortable. Fortunately, Birmingham is not large and the streets are regularly and clearly laid out, so I had no need to put on airs and ask the way.

To be sure, if you did not go see too many poor people's shacks but just looked at the busy downtown and elegant residential areas of Birmingham, you would certainly describe it as a beautiful city. The municipal public works are well attended to, for the streets are built according to plan, straight and broad, with right-angled intersections, all laid out to the four corners of the compass. In these streets, which the city keeps in good repair, you can see bustling men and women— whites of course—neatly and attractively dressed. The women especially are all very pretty, fair and charming such as you do not frequently meet in New York.

One day I went to a nice barbershop for a haircut. The barber was well dressed, much better than I. I deliberately got him talking and learned that he welcomed Chinese in his shop, for he thought them just as respectable as Americans and was willing to serve them equally. But when I asked about blacks, his amiable countenance suddenly turned severe and he said he would never let "niggers" in. How could a "nigger" be worthy of a haircut from him! Why not, I asked, if they paid the same money? You don't understand, he said; if just one "nigger" entered, from then on no more white customers would come, and so for business reasons he could not possibly let "niggers" in.

I went several times to see the slums of the blacks. They all lived in one-story broken-down wooden shacks, crowded close together. At what was supposed to be the best "apartments" among them, I pretended to be looking for a place to rent. The landlady seemed very surprised at first, and only when I said I had business in the area and wanted a comparatively close, quiet, and suitable room, would she take me to see what she considered the best place she had to rent. Apart from the broken bed and lame chair, the window was just a frame with nothing in it, and outside was the street. I said that without a window might not my things "fly away," to which she declared repeatedly that if I was willing to rent the place, she herself would sit outside the window and keep watch day and night. I thanked her and said I would come back when I decided.

Going around these filthy run-down slums, I was particularly impressed to see often here and there rather nice churches. Sometimes I also saw black ministers inside leading black believers in worship, singing hymns at full voice. Churches, too, are divided between white and black, and blacks are not allowed in the ones built for whites, though I do not know if this is for the same reason as the barber gave.

The American southern bourgeoisie regards the exploitation of blacks as its lifeline, and whoever helps blacks voice their grievances or organize themselves to struggle for their free rights will be regarded as a subversive, to be arrested at any time and put into jail or to be kidnaped and beaten up by privately hired detectives.

Birmingham is still an industrial city, known for its steel. At the suggestion of «K», I went further south to Selma to see disguised serfdom. Selma is a small town 112 miles south of Birmingham, in «Dallas County». The population is only 17,000, of which 5,000 are whites, 2,000 are servants for whites, and 10,000 are disguised serfs. So 12,000 blacks serve 5,000 whites! What kind of society this is can be imagined.

From Birmingham to Selma was a four-hour bus ride. The buses are somewhat larger and more comfortable than ours in Shanghai; there are spring seats for two people on each side of an aisle down the middle—in all ten-odd rows. Above the windows on each side is a rack with a little brass railing for suitcases and so on. The driver, who also sold tickets and helped passengers with their bags, was white. He wore a cap, a close-fitting shirtlike uniform, and brown leather boots, tidy and sprightly just like a vigorous army officer.

When I got on, there were whites in the front row on both sides, so I sat in the second row. Subsequently, several white passengers boarded, all sitting as far forward as possible. Then some blacks got on and their seating principle was just the opposite of the white passengers': the whites sat as far forward as they could, and the blacks struggled to sit as far to the rear as possible. This may have been a familiar sight for them, but I watched attentively and curiously. Gradually, the white area expanded back and the blacks forward toward a borderline row of seats in the middle. This border between white and black was not fixed, but simply the last row left empty after the front filled with whites and the rear with blacks. If just one white sat in this row, blacks would have no more seats and would not dare come near; conversely, if one black sat in the row, whites would not want to. So the line between black and white was clear and allowed no confusion.

Halfway from Birmingham to Selma, a black sat in the last empty row, leaving three empty seats. I witnessed a white get on, look at that

row, but not sit down until the driver opened up a folding canvas camp stool from his side and placed it in the aisle between the front-row seats. A while later another white boarded and the driver again hurriedly opened a little canvas seat from nearby and put it next to the second row. I remember there were blacks from the sixth row on; I do not know what would have happened if whites filled up canvas stools in the middle back to the fifth row, because not enough whites got on to find out. The canvas stools were very small, just supporting the middle of the buttocks. Those large middle-aged women, in particular, must have been very uncomfortable, I know. But they preferred it, even though comfortable upholstered seats were vacant, because they were unwilling to sit in a black row. What is more, when the bus stopped and people from in back wanted to get off, those crowded on the two stools had to drag their fat bodies off to let others squeeze by. What a nuisance, yet they preferred it that way. Not only they but probably the driver and all the passengers except for me—I was astonished—thought that that was the way it should be.

Those two borderline rows of seats—one black and one white—changed as black and white passengers increased and decreased in the course of the journey. For instance, if at a stop more whites got off and more blacks got on, the black border would gradually move forward to the empty seats in front; if more blacks got off and more whites got on, the white line would gradually move toward empty seats in back. Later I saw the last remaining row have one white in it, when a black woman got on. She was neatly dressed and attractive, carrying some books, but she did not dare sit in the empty places in that row, and just stood near the door. The bus was terribly bumpy on that stretch, and she several times gazed at those empty seats with a helpless look. I felt especially pained to see an innocent black child of three or four years sit silently and obediently in back with his mother and then silently and obediently shuffle forward with the mother and get off. His empty expression made you feel even more deeply the sadness of a life of oppression.

Probably very few Chinese travel in the American South, especially in small towns like that, so the passengers on the bus, both white and black, showed some interest in me, or at least they all glanced at me several times. But all they could see was my exterior; they could not possibly imagine my thoughts and feelings at that time. While I sat silently, solitary and all alone, my brain swirled with thoughts of the wretchedness of an oppressed people and the cruelty of this irrational world!

# Impressions on Reaching America

Lin Yutang, 1936

*Lin Yutang (1895–1976), who is well known to many American readers, was one of modern China's more Westernized intellectuals. The son of an early Chinese Christian minister, he was educated at St. John's University in Shanghai, at Harvard for one year (earning a master's degree in Comparative Literature, 1921), and at Leipzig, where he completed a doctorate in linguistics in 1923. Back in China in the 1920s and 1930s, he taught English at various universities and became known as an essayist, humorist, and magazine editor.*

*In 1936 Lin settled in the United States, where he remained for many years, writing dozens of books about China in English, including the popular* My Country and My People *(1935), an interpretation of Chinese culture and the Chinese character; translations from Chinese, such as* The Wisdom of China and India *(1942); autobiographical reflections, like* The Importance of Living *(1937); and novels, among them* Moment in Peking *(1939). In 1966 he moved to Taiwan and Hong Kong and devoted himself to the compilation of* Lin Yutang's Chinese-English Dictionary of Modern Usage.

*The following informal impressions are excerpted from two articles Lin wrote for the Chinese press shortly after he moved to America. His viewpoint is not that of an earnest leftist (like Zou Taofen) but rather that of a more Daoist humorist, a cultivated, slightly cynical observer who likes to see pretensions punctured.*

I am writing this letter from the country house of an American friend in the state of Pennsylvania. The mountain scenery here is truly

beautiful, in spite of being strange and unfamiliar. You can see I much need to adjust my aesthetic notions. Everything is very green, peaceful, beautiful; there are elms and maples, and other varieties of green-leafed shade trees and, believe it or not, even willows here! But they are so unfamiliar, so beautiful, as to make you unable to associate them with anything. Without realizing it, I have been looking for things that would remind me of my mother country and my youth. Now I understand why Englishmen always carry umbrellas. I yearn for rocks, for instance. Scenery without rocks cannot really be counted as scenery. Although the trees are lovely here, they hide the rocks and you cannot have both trees and boulders together; or at least that is the way it is in this particular place.

The beautiful «Delaware» River gave me a feeling of gentleness. Driving along the straight and level road, when you catch a glimpse of one or two willows, solitary, scattered in this alien landscape, it gives you a start. No one notices these willows growing there, but standing alone, their willowy waists gently swaying in the breeze, they smile welcomingly at people. In the breeze the willows do a gentle and graceful dance, not jazz—I think that would be a fatal injury for willows in America....

As I said earlier, the United States has the material basis for making people happy. Americans have bountiful food and clothing, there is an atmosphere of peace in the country, people's lives are secure, and America also has charming oaks and elms. I think you and I are both asking in the same voice, "And what else?" Are Americans happy, and what makes them happy? What kind of people are Americans? Because life's value is determined not by what people own but how they behave....

The average American is like a child; he has to have a new toy to play with, whether it is Radio City or a mahjong set, and like a child as well, he quickly tires of playing with it. The average American always has to be seeking fun, and this fun is somewhat different from pleasure and even more different from true happiness. I think the average American does not know how to enjoy himself. If you take away his car, lock him in his house, turn off the radio, he will be as unhappy as a monkey in a cage.

What about the love of nature expressed by «Thoreau» and «Emerson»! Everyone admits that American civilization is not perfect, but what civilization is? The American character is particularly lacking in serenity, or else they do not dare express serenity; this is the result of objective conditions. The dynamics of American life, the tradition of

the frontier, the immigrants coming from Central Europe every year, all these things make it impossible for their lives to be quiet. How can America assimilate these immigrants rapidly without making the nation's civilization lose its distinctive character? I think America resembles a magic potion that is still being refined in the ethnic melting pot. Perhaps in a hundred years it will come out perfectly clear. We must give them a little time. We loosely criticize a culture and a civilization as though they were snacks in a little restaurant that could be cooked in a minute. In fact it is not like that.

You may say that Chinese civilization is more in accord with human feelings, more leisurely, more suited to human life, and at certain times has more individual freedom. But you have to admit that in his everyday life, in his everyday work, in his social attitudes, in his compassion for children and animals, in his staunch spirit of independence, in his courtesy in dealing with people, the average American has a fine character worthy of our respect. Though it is a little embarrassing to say so, the average American bus conductor, elevator operator, fellow passenger, policeman, or store clerk is more polite than the Chinese you find in modern cities. If Confucius could see the behavior of Shanghai tram conductors, he would throw up his hands and shake with anger.

In addition I want to say something about America's democratic spirit. I am referring to self-respect and individual liberty, which are the ultimate goals of the democratic spirit. To take freedom of the press as an example, «*The New York Herald-Tribune*» attacks [Franklin] Roosevelt with complete abandon, just as «*The Nation*» used to ridicule Hoover. The Ziegfield dance company has even made up a skit called "The Federal Commission for Squandering Resources" to mock government agencies. (The skit makes fun of government waste. The so-called Federal Commission on Squandering Resources, planning the construction of a bridge, is unhappy that the river is too narrow, the bridge too short, and thus expenditures will be too small. One commission member says it should not be hard to make it longer, and when questioned by the others explains that instead of building the bridge across the river they can build it along the shore.) I think this is a good phenomenon....

Actually, I am not overly impressed by America's democratic politics, because democratic politics, or the common people's control of the government, is all along in my opinion a little ridiculous. In not too long I will see a presidential election. Americans must become feverish every four years with the same regularity as with malaria. I want to see

who tells more lies to the people, the Republican party or the Democratic party. If the Republicans are able to tell more lies, then a Republican president will be elected; if the Democrats are able to tell more lies, then a Democratic president will be elected. I am talking here about the party organizations and not the presidential candidates themselves, because the presidential candidates are only honest gentlemen running around the country telling lies for the parties.

People are the same everywhere, with the same round heads and square toes, so what can we hope for? Actually, when I spoke of the democratic spirit I meant people like «Will Rogers», because I consider Will Rogers the prototypical American, who hates tuxedos and white ties, snobbish behavior, and is happy, carefree, humorous all day. Will Rogers's democratic spirit is certainly worth cultivating. Were a biological experiment to cause a hundred men like «Andrew Mellon» (a financier and several times America's Secretary of the Treasury) to suffer in order to produce one Will Rogers, it could not be considered a waste. If Americans are perceptive, they will thank their Creator....

I walked into an American drugstore and at first observed the Americans there. American drugstores are well suited for this kind of research. In American drugstores are the four «C»s: «cigars» to sell to men, «chocolate» to sell to women, «candy» to sell to children, and «cough drops» to sell to old people. I watched men buying cigars, women buying chocolate, children buying candy, and old people buying cough drops. I discovered that the women and children were possibly more cheerful than the men and old people, and that they were definitely happier than the women and children in other countries.

That is because the United States is women and children's territory. America is called the new continent and Europe and Asia are called the old. When you speak of the new world, what you mean is that American women are new and American children are new, unlike the women and children of Europe and Asia. It is women and children who make America a new world.

America gives women the opportunity to develop. Old-world men, especially Asian men, are frequently astonished to hear that women are given this opportunity to develop. Men who consider themselves protectors instinctively ask, "What good is there in that?" What good is it if you give women the opportunity to develop, for instance, if you let girls live in the vast world without restrictions?

After obtaining the opportunity to develop, women have not encountered disaster, which surprised me a little. They evidently are

capable of looking after themselves. Whereupon I began to sigh: What have we men of the old world been doing making trouble for ourselves looking after women?...

If we want to understand the position of the ordinary man, the first step is to understand the nature of American democracy. American democracy is essentially based on the ideal, «The greatest goods sold to the greatest number». The ordinary man, who represents the greatest number, thus becomes an important element of society. Maybe I am wrong, but I believe that in Americans' eyes democracy means the «greatest goods» and not just some invisible «greatest good». Only in America do we hear the expressions «sell an idea» and «buy an artist».

The ordinary man is the cornerstone of American democracy because he, and not the gentry, represents the greatest number, because the greatest quantity of goods is sold to him, and because radio programs and movies exist for him. What would American democracy be if manufacturers did not sell large quantities of goods or if movies were not seen by thousands and thousands of common people? Therefore we have life, prosperous life, under American democracy, because there are vast numbers of cars, magazines, and radio receivers. Thus the ordinary man flourishes and has a happy life; the more ordinary and common he is, the happier his life.

This is so because in this nation of America the ordinary man, woman, and child has the opportunity to discover himself and his ability. Since Americans are so pleased to accept everything that is new, anything can be put into the big pot of American democracy: new women, new children, new medicines, new customs, new clothing, new games, new schools, new machines, new sofas, new jazz—all these things can be stirred in and simmered together. My thoughts tend toward the experimental, and so I would very much like to know what will come out of this big pot in another fifty years.

# Burlesque

George Kao, 1937

*Gao Keyi (1922–   ), who writes under the name George Kao (Qiaozhi Gao), was born in Ann Arbor, Michigan, where his parents were studying, but raised in China. After graduating from American-founded Yenching University in 1933 (in the same class as Fei Xiaotong, author of the next selection), he returned to America to study at the University of Missouri School of Journalism and then at Columbia University. While in the United States he contributed numerous essays to Chinese journals. He subsequently worked for the Nationalist government's Ministry of Information and then, in the 1960s, for the American government's Voice of America in Washington, D.C. More recently he has been editor of the journal* Renditions, *published in Hong Kong and devoted to the art of translation. His* Chinese Wit *and* Humor, *an anthology of translations, was published in 1946; not a few of his own essays are in a jocular style.*

"This, too, is American culture, old Wang. You must see it!"

When a precursor in studying abroad advises you thus in a half-humorous, half-apologetic tone of voice, you can be ninety percent certain with your eyes closed that the culture he is talking about is not the Library of Congress in Washington or the Metropolitan Opera in New York, much less a puritan church in New England, but the burlesque, which is found in all American cities.

Chinese are plain spoken, and the words "leg theater" [burlesque] suggest the meaning in a way everyone understands without need for

explanation. But the name displayed on the marquees of American bur-
lesque theaters is not so straightforward. They are all called «bur-
lesque» or simply «burlesk». If you had just landed in San Francisco and
were looking for the red-light district in search of firsthand "knowl-
edge," unless you had been guided by an elder in studying abroad, you
would probably not understand the name and miss an opportunity.

You could look up «burlesque» in an English-Chinese dictionary,
but the definitions "comedy," "ridicule," "fantastic, bizarre writing
or play" do not capture the essence. The theater entrance does not
look like a movie house or a playhouse; who would guess it is this
kind of a theater! But don't panic. As long as you do not consider
yourself a moralist who only looks at and speaks of what is proper, as
long as you do not have to obtain a master's degree from a rural college
to carry back across the Pacific within the space of nine months, you
cannot pass up this opportunity. Before "returning home with studies
completed," you can certainly obtain a little knowledge about bur-
lesque in so-called American culture. As for going once, twice, a third
time, and becoming addicted, that is your affair and you must not
blame me.

Now let us not hem and haw and mince words. America provides
many opportunities for pleasures of the flesh, and the exposed chests
and backs, the short pants and bare legs of American women are
nothing! An elegant lady's evening dress, an athlete's tight costume, a
beach mermaid's sleeveless top, a screen star's new gown—the material
used by all these together is probably not as long as Granny Wang's
footbindings. To write an essay about everything the eye encounters, is
that not getting too excited about trifles? Okay, there are reasons for
discussing burlesque. First, it has become an extracurricular activity
sought out by foreign students; of this nothing more need be said.
Second, believe it or not, it really is a typical American product, native
to American culture.

To get back to the word and its meanings, «burlesque» is pro-
nounced «bur-lecue» by insiders. But in recent years another term has
come into greater use, «striptease», for which there is no equivalent in
Chinese..... It is a woman standing on a stage in front of an audience
taking her clothes off piece by piece to the point considered by police
regulations to be an offense against morals—except that, frankly, the
morals in New York and most other American cities have already been
damaged to the point that nothing more can be done to them!

Of course "stripping and teasing" are just two basic actions,

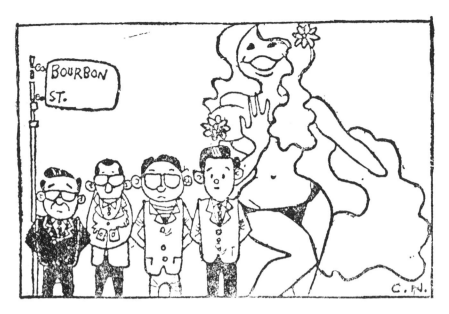

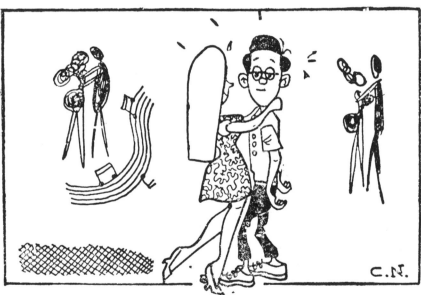

*Figure 15.* Chinese students and American sexuality, 1960s. [*Top*] "Having one's picture taken in New Orleans together with a billboard of a striptease queen." [*Bottom*] "Suddenly the ballroom lights went dark." These illustrations are from Zhao Ning's book of vignettes about his experiences as a student from Taiwan in the United States in the 1960s; *Zhao Ning liu-Mei ji* (Zhao Ning's stay in America) (Taipei: Huangguan, n.d.), 61 and 143.

merely "leg" without the "theater." When you have actually paid thirty-five cents to one dollar for a ticket, you want more than that, you want to see a program that fills at least an hour or two. What does this program include? Comic characters come out and do humorous routines, gaily costumed men and women mount the stage to sing songs, bands of dancing girls leap and spin about; some burlesque theaters even show old movies, displaying them in cycles so as to draw out the time. But the interest of the audience naturally is not in these miscellaneous acts, of which there are sometimes too many, making people restless, waiting impatiently. When this supplemental program is finally finished, the lights dim, cymbals and trumpets blare forth from the orchestra pit, and through a loudspeaker from backstage a gravelly voice announces: "From Paris, the platinum blonde, Fifi Lamour!"

A burst of applause, a flash of purple light, and out comes a heavily made-up beauty. The audience holds its breath, rapt with attention. Our Parisian Fifi (a genuine American article, Jewish, from Brooklyn, New York, her platinum hair the product of «peroxide» chemistry) first listlessly sings a couple of songs. What songs? Who knows! As soon as the singing is over, the band plays faster and Fifi begins to revolve around the stage, sometimes stepping to the music as if dancing, some-times mumbling words as if singing. The audience is very excited, sitting on the edges of their seats, craning their necks forward. The three or five musicians in rolled-up shirt sleeves loudly play the same tune two or three times. Suddenly, faster than it takes to say it, Fifi has torn off one sleeve. She turns around a couple more times, then dis-cards the other. A little more humming and in a flash her skirt is off—earth-shaking cymbal crashes from the band, while in the audi-ence eyes grow round and mouths gape. But Fifi goes to the side of the stage, pulls the velvet curtain over herself and, smiling over her shoulder, walks off. There is wild clapping, foot-stamping, whistling, and calling from in front.

The music starts again, and in response to the audience's demands Fifi comes back on. She then continues to dance, sing, and strip, only starting from a half-naked state this time. But at a crucial moment she again suddenly goes behind the curtain, marking the end of a segment of her routine. It is like [traditional Chinese] novels, when it says, "And if you want to know what happened next, you must listen to the next episode." It is like the description in an essay, "Mountains multi-ply, streams double back—I doubt there's even a road; willows cluster

darkly, blossoms shine—another village ahead."[4] Again and again in the same way the audience's applause will bring Fifi "shyly" out, to strip layer by layer, piece by piece—until her name seems less Fifi than Eve.

The ordinary burlesque theater will hire four or five striptease stars like Fifi, and put on from two to five continuous shows every day, with a "midnight show" on Saturday and a new program each week. But to avoid being ridiculed for having only a "skin"-deep interest, I went to the library and did some research on the historical origins, artistic status, scholarly worth, and so on, of burlesque. Let me discuss these with my readers before talking about the current state of the striptease industry.

There are two theories about the origins of burlesque. One school is represented by the American literary scholar and musicologist, «Prof. John Erskine, Ph.D.»[3]. According to this venerable gentleman, burlesque should be considered the most ancient form of drama, having a history of at least three thousand years. Ancient Greek comedy had displays of nudity before Aristophanes....

As to the reason for watching burlesque, Professor Erskine totally rejects the accusation that it incites lust. He says that since burlesque originated in ancient Greece, passed to Rome, and is a traditional art form still today, a burlesque theater is equivalent to a museum preserving old relics. Even if the customers are not all archaeologists, they can still be considered intellectuals able to appreciate ancient culture; the attitude of a burlesque audience is reverential, the same as that of upper-class people patronizing opera, or poets and men of letters worshipping Shakespeare....

In contrast to Professor Erskine's theory of Greek origins, there is also what might be called the American national-essence school. They hold that burlesque is indigenous American culture, and they believe that it is America's only contribution to the world of art. Once, when there was a bill before the American Congress to restrict visas for foreign performers, the committee considering it subpoenaed two owners of New York burlesque theaters, who with patriotic fervor declared that "burlesque is a specialty of American women." This little incident can be confirmed in the Congressional archives.

3. Professor John Erskine of Columbia University.
4. Burton Watson, trans., *The Old Man Who Does as He Pleases: Selections from the Poetry and Prose of Lu Yu* (New York: Columbia University Press, 1973), 3.

# The Shallowness
# of Cultural
# Tradition

Fei Xiaotong, 1943–1944

*Fei Xiaotong ( 1910–    ) is China's most eminent anthro-*
*pologist and sociologist. During World War II he was invited by the*
*Department of State to spend a year in the United States; at the time he*
*was a rising young professor with a London doctorate, earned under the*
*eminent Bronislaw Malinowski, and a book out in English,* Peasant Life in
China. *His year was a busy one, translating his own and his colleagues'*
*works into English, raising funds for his sociological research station in*
*China, arranging for his best students to come to the United States, per-*
*suading the Chicago anthropologist Robert Redfield to come to China for a*
*year and finding money to finance that visit, traveling to various uni-*
*versities to meet leading sociologists and anthropologists, and writing arti-*
*cles about the United States for publication in China.*

*Fei's year in America was a time of young, self-confident, energetic*
*achievements, and it was largely in those terms that he thought of*
*American culture. His early articles in particular were full of praise for the*
*wholehearted war effort, the willingness of all Americans to make sacrifices*
*in the common interest—rationing applied even to the White House, he*
*wrote—a stark contrast to the wartime demoralization in Nationalist*
*China. As the year wore on, however, he began to feel weary and lonely,*
*tired of the hustle and bustle of American life, and he thought more fondly*
*of Chinese tradition; his articles about the Unites States became more*
*ambivalent.*

*After returning to China, Fei applied his expertise on the United*
*States to the writing of three books and scores of articles on American*
*society and politics. His lucid and engaging magazine essays were very*

171

*popular, and his views of the United States were probably the most widely read and the most influential at that time, a crucial turning point in Chinese history. In the late 1940s political disappointment with America's continuing support for the unpopular Nationalist regime turned Fei into a severe critic of American foreign policy, though he still maintained his faith in the Anglo-American ideals of representative democracy and freedom of speech.*[5]

*The following two articles are from his wartime year in America, the first a little earlier and more ebullient, the second a bit more reflective and wistful for China. Both concern America's lack of common and venerable traditional culture, which he initially saw as a virtue but then came to view as entailing something of a loss.*

### "THE DARING OF A YOUNG CULTURE"

The one thing we Chinese can be proud of is the length of our history. It is undeniable that only we have a culture that has been handed down since ancient times and is still extant and vigorous. But we should not blind ourselves to the fact that this long history, for all its beauty, makes for a force of tradition that restricts us and makes it difficult to modernize quickly. A person reared under its tenets of caution and of following precedent cannot help feeling startled on coming to this new continent, which lacks a long history. Here people are so bold, daring, and willing to experiment that they become rushed, careless, and superficial. A young culture, like a young person, has no taboos. I really do feel alarmed, not that their youthful lack of restraint may lead them into trouble and harm—if, given free rein, they kill themselves in a fall, it will have been of their own free will. What worries me is that the fruit of our experience and prudence may dry up in the shade into a tasteless chestnut, to be thrown into the fire by others, where it will not even produce much heat.

The United States was founded less than two centuries ago. If I should attend its bicentennial celebration, I will probably be able to bring my grandchildren, for it will not take place for over thirty years! Two hundred years ago this continent was a land of red men and whites. People traveling in the wild interior carried a pistol at each side. I remember reading in a history book that just a generation before Lincoln there were still instances of Indians burning and looting villages.

5. See R. David Arkush, *Fei Xiaotong and Sociology in Revolutionary China* (Cambridge: Harvard University, 1981).

Now what was a savage and desolate land two centuries ago has become a booming civilization reminiscent of the classical idea of utopia, where "doors are not locked at night nor lost articles picked up by others." Such a transformation is a rare achievement in modern times. The people who have accomplished this unprecedented performance cannot be without some special character and ability. What it is I think can be summed up in the word "boldness."

Without boldness they could not have turned their backs on their homelands and come to make their fortunes in this wilderness. Boat after boat of immigrants from all over the world converged on the new continent, each person fed up with the suffocating decay of his old country, coming to this open land in the hope of being able to develop freely. America is a hodgepodge of the cultures of the world, a melting pot of the world's peoples. But for all their differences, Americans have one thing in common: a pioneering spirit, manifested in their boldness of character. To understand America one must look at a youth of sixteen. Every cell in a sixteen-year-old's body is reproducing, growing, and not yet at maturity; but this body can already exist independently. The growing cells are synthesized into a bold and spirited confidence. How could this youth not think himself a favorite of Heaven with limitless prospects? But there has also never been a sixteen-year-old who understood clearly what kind of a world he would wake up in or what tasks awaited him. Habits not yet fixed, tradition not yet formed—this is America.

Not long after coming to Washington, I became tired of paying formal visits and one evening sought out a young anthropologist.[6] Though we had just met, there was a kind of connection between us. At the time that I had been studying the village of Kaixiangong, he too was doing fieldwork in an Asian village. Though we had never exchanged ideas, our two books were published at about the same time, our style of work was about the same, and as soon as we met we could dispense with formality. I said to him, "After spending several days with gray-haired people all day I'm restless. Let's the two of us go out and have fun and see some American sights." He thought for a moment. "We'll go to an American Chinese restaurant, and you can see what becomes of Chinese things when they come to America."

I thought, why not? Although I had had a Chinese meal in Miami,

---

6. The young anthropologist was John Embree, whose *Suye Mura*, about a Japanese village, had been published in 1939, the same year as Fei's *Peasant Life in China* on the Chinese village called Kaixiangong.

I had not had one since coming to Washington, and could in addition find out how strong "Americanization" really was. The word *Americanization* has a special significance in the United States. Americans have all come from other places, as I said; they came bringing a variety of customs and ideas about social behavior, but people with different ways of life cannot easily live together in the long run, and so they came up with this slogan of people from various places melting together in a pot to produce an American culture that is not identical with any of the originals.

The Chinese restaurant my friend and I went to had entertainment and was a little like a small nightclub. The waiters were Chinese, dressed neatly in tuxedos. They spoke the Toisan Cantonese dialect, which is the language common among Chinese-Americans. I spoke to them in Mandarin, which did not surprise them, only they apologetically replied in English that they could not understand me.... It was called a Chinese restaurant but, except for the overdone and offensive Chinese decor, nothing made me feel the slightest at home. The names «chop suey» and «chow mein» on the menu, seemingly half-Chinese and half-Western, are in fact peculiar dishes and neither Chinese nor Western. «Chop suey» is shredded pork, or sometimes beef or shrimp, fried together with various vegetables. It is really a very ordinary dish, though I do not know why it has to be called by this odd name, which is neither Chinese nor English. But in any case I did not like it and tried it only once. «Chow mein» is a transliteration of *chaomian* [fried noodles], which is reasonable enough, but what is strange is that though fresh noodles are available, these are deep fried and then baked dry to serve to foreigners. In some restaurants these fried noodles are not bad, a little like the *liang mian huang* of Suzhou snack bars.

The table setting was completely Western, with knife and fork, except that because I was a newly arrived countryman they brought me some bamboo chopsticks stamped «Made in China». What made me most uncomfortable was the glass of water. American ice water has its good points (except for Chicago's, which tastes of bleach), but to drink it with Chinese food that has been cooked in oil is all wrong. I'm amazed American stomachs can stand such an invasion of congealed grease; maybe this is the reason foreigners say Chinese food is hard to digest. In any case they cannot put down a meal without ice water.

Looking up from the table, I saw right in front of us a troupe of half-naked women doing Spanish dances. I had seen Spanish dancing once when I was in London: some of the audience there wore evening clothes, all had come to see the dancing, and they sat attentively,

applauding at the end of each number. Here it was different. People were at the same time eating chow mein, joking with girl friends, and watching out of the corners of their eyes the many swinging legs. The music accompanying the Spanish dancing was jazz, which is currently popular in America. I do not claim to know much about music but cannot understand why these sounds are considered music at all. Suddenly the dancing stopped and, to the same kind of "music," a young woman whom one would guess to be Cuban came on and in a loud voice sang one of her country's folk songs. Constantly moving about on the stage and announcing the numbers with a megaphone was a man whom one knew at a glance to be a product of southern Europe.

At that moment, in that spot, various cultures of different origin came helter-skelter together and were arrayed, as though oblivious to the fact that these were Chinese waiters, Oriental embroidery, Spanish dancing, Cuban songs, jazz music, a south European face. A great number and variety of elements inextricably mixed—a merry laugh, a hearty drink, a new culture! As we came out of the restaurant my anthropologist friend asked me what I thought of it. What could I say? "Truly bold! A young culture!"

### "A WORLD WITHOUT GHOSTS"

Accepting an invitation from the University of Chicago, I went there to work on my book «Earthbound China». After I arrived, a secretary showed me to room 502 on the fifth floor of the Social Sciences Building and asked politely if it would do for an office. When I noticed the name «Robert Park» in the brass card-holder on the door, the alert secretary hurried to say, "I was waiting until you decided before putting your name up."

"Don't change the name. I like that one," I told her. But she could hardly have understood why.

Robert Park had been my teacher. He came to Yenching University [in Peking in 1932] when I was an undergraduate there. Though I was just an ignorant student, I absolutely worshipped him—except for the old man's perverse insistence on teaching at 7 A.M. and never missing a class or even coming late, which meant I had to skip breakfast to get there on time. For better or worse, his course determined the direction my life has taken in the ten-odd years since, and to him should go the credit or the blame. The founding father of the Chicago school of sociology, he maintained that sociology should take as its subject understanding human nature. Perhaps I liked him because he

wanted me to read novels and not sociology textbooks. More than reading novels, he urged going and personally experiencing different kinds of life. Ten years later I still follow this teaching. On this trip to the United States, I had hoped to go hear his classes again. But I was busy with other things, and it was half a year before I got to Chicago, and the old professor had already gone south to escape the Chicago cold. And so it happened that I was put in his office.

This arrangement, whether accidental or not, was full of meaning for me. I had been an unremarkable student in Professor Park's class, a matter for some regret, and ten years later, though still without achievements, I remained eager for a word of praise from the teacher. I was secretly happy that, sitting in the chair he had used, I would surely absorb something of his spirit, and hoped to write a book that would compensate for my earlier failure to be worthy of the pains he had taken in rising so early all those mornings to teach us. There is here a sort of historical causal connection: because of a past memory the present takes on a significance greater than anything in the current situation. My strong desire to have the name left on the door arose out of a need for concrete, living, moving history. I felt that if the nameplate, the old books lining the walls, even the air in the room were not disturbed, then, surrounded by this lingering past, perhaps in a few months I would see a draft of «Earthbound China» on the table. But if these were disturbed, all might be lost.

This, in fact, is the "tradition" of which I have written in an earlier article. Tradition need not be an obstacle to innovation. True, it has its bad side. When old people, with the various privileges and respect that have been accorded them in the past, prevent any change in the status quo, that is a bad aspect of tradition. But it is also undeniable that everything new is born out of that which is old. These ties of kinship should not be obliterated, and recognizing them gives to the connection between old and new the significance of succession and continuity. If we can develop this kind of feeling for history, I believe the world and mankind will be richer. When we go on a trip into the country, we can enjoy the scenery merely as a present phenomenon; if we have left there earlier memories worth recalling, this can bring on a pleasant nostalgia; and if this is a historical site, our feelings are further enriched because of what others did there. People do not live only in the here and now; life is not just a string of moments. We need history, for it is a wellspring of inspiration. When we take tradition in this way, that is another aspect of it.

Sometimes I think the world is very strange. We in the Orient

accept tradition, but what we seize on is its bad side. The West seems to want to disregard it, with the result that the good side is lost too.

Of course, it is not entirely true that Westerners purposely disregard tradition. For the most part, they all know much more about the history of their own country than I do. Every child who goes to New York has to go gaze at the huge Statue of Liberty and then on the way back visit the church that George Washington frequented. In Washington, D.C., there are the hundred-foot tall Washington Monument, the Lincoln Memorial, and now the Jefferson Memorial. Buildings just a few hundred years old are preserved as historical monuments. On a personal level, Americans keep diaries and write autobiographies. I have elsewhere described how on Thanksgiving the year before last my host brought out a big pile of his father's diaries. At Professor Redfield's house, Mrs. Park especially wanted me to see the pictures of Redfield ancestors in a corner of the living room.[7] On Professor Ogburn's staircase wall were neatly lined up generation after generation of ancestor portraits. Perhaps because at a dinner party I had once expressed the view that Americans lack any feeling for history, all the friends I came into contact with were particularly anxious to correct my misapprehension by showing me their concern for their ancestors. All this is true, but still I feel their regard for tradition is to a greater or lesser extent conscious, intellectual, and artificial. It is not the same as ours. The reason I feel this way is that I have found Americans do not have ghosts.

When tradition is concrete, when it is a part of life, sacred, something to be feared and loved, then it takes the form of ghosts. This is equivalent to the statement by «Durkheim» that God is the representation of social cohesion. As I write this, I feel in my heart that Chinese culture in its essence is rather beautiful. To be able to live in a world that has ghosts is fortunate. Here let me relate some personal experiences.

When I was a boy, because the family was in decline...we lived in a big old building of which at least half was closed off awaiting uncles who seldom came home, and in another part of which were dark rooms that had never seen sunlight.... In these dark and desolate rooms, there were more places for ghosts than for people.... This environment was already sufficiently frightening, but in addition not a day passed when

---

7. Robert Redfield, the University of Chicago anthropologist, was married to Robert Park's daughter; Margaret Park Redfield helped Fei translate *Earthbound China* into English.

people did not talk of ghosts to scare or amuse us children.... I am not exaggerating when I say that to a child like me brought up in a small town, people and ghosts were equally concrete and real....

Because I grew up half in a world of ghosts, I was particularly interested in them. Gradually my fear changed to curiosity and then to attraction, to the point that I even feel a little sorry for people raised in a world without ghosts. The thing that felt most strange to me during almost a year of living in America was that no one told me any stories of ghosts. I do not want to overpraise such a world, but I will admit that children who grow up in it are more comfortable than we and do not have to live with fear in their hearts all day long. But perhaps there is a heavy price for this, a price I would be unwilling to pay.

The beginning of my gradual change in attitude toward ghosts occurred the year my grandmother died. One day not long after her death, I was sitting in the front room looking toward her bedroom. It was almost noon. Normally at that time Grandmother would go to the kitchen to see how the lunch preparations were coming along, soon after which lunch would be served. This had been a familiar sight for me, and after her death the everyday pattern was not changed. Not a table or chair or bed or mat was moved. Every day close to noon I would feel hungry. To my subconscious mind the scene was not complete without Grandmother's regular daily routine, and so that day I seemed to see her image come out of her bedroom once more and go into the kitchen.

If it was a ghost I saw, it was the first one in my life. At the time I felt nothing unusual, for the scene was so familiar and right. Only a little later when I remembered that Grandmother was dead did I feel upset—not frightened, but sad the way one feels at a loss that should not have occurred. I also seemed to realize that a beautiful scene, once it had existed, would always be. The present loss was just a matter of separation in time, and this separation I felt could be overcome. An inextinguishable revelation had struck; the universe showed a different structure. In this structure our lives do not just pass through time in such a way that a moment in time or a station in life once past is lost. Life in its creativity changes the absolute nature of time: it makes past into present—no, it melds past, present, and future into one inextinguishable, multilayered scene, a three-dimensional body. This is what ghosts are, and not only did I not fear them, I even began to yearn for them.

I cannot get used to people today who know only the present moment. To take this moment as [the sum of] existence is a delusion.

Our every act contains within it all the accumulated history from the beginning of the universe right down to the present, and this every act will determine the destiny of endless future generations. If the present moment, fragmentary, abstract, false, is taken for life, this life will necessarily be shallow and base and even empty—since the moment cannot last, one might as well indulge oneself and revel, for when the instant is gone what is left?

American children hear no stories about ghosts. They spend a dime at the «drugstore» to buy a «Superman» comic book. This "Superman" is an all-knowing, resourceful, omnipotent hero who can overcome any difficulty. Let us leave aside the question of what kind of children this teaching produces; the point worth noting here is that Superman is not a ghost. Superman represents actual capabilities or future potential, while ghosts symbolize belief in and reverence for the accumulated past. As much as old Mrs. Park, trying to lessen the distance between East and West, might lead me over to the corner of the living room to look at faded photographs, it was the Redfield's little boy who showed me the heart of American culture, and it lay in Superman, not ghosts.

How could ghosts gain a foothold in American cities? People move about like the tide, unable to form permanent ties with places, to say nothing of other people. I have written elsewhere of the gap between generations. It is an objective social fact that when children grow up they no longer need parental protection, and the reflection of this in the family is children's demand for independence. Once when I was chatting at a friend's house, his daughter sat with us chain-smoking. The father happened to remark that it was senseless to smoke like that, but she paid no heed and afterwards told me that she was eighteen, it was none of the old man's business, smoking was her own affair. Eighteen is an important age for a girl; after that her parents need not support her, but neither can they tell her what to do.

I also know an old professor whose son teaches in the same university as he but lives apart from him—which might be all right, but he seldom even visits. During the war they could not get a maid and it made my heart sick to see the professor's wife, old and doddering, serving a guest coffee with shaking hands.

When I was staying at the Harvard Faculty Club, I noticed sitting at the same table every morning a white-haired old gentleman who lived upstairs and who from his looks was not long for this world. Whenever I saw him I felt outraged. He must have been a famous professor who had educated countless people and worked hard for society.

Now old and failing, cast out of the world into this building, without relatives even to care for him much less give him pleasure, he might as well have been dead. One day he said softly to the waitress, "I don't know if I'll be able to make it down the stairs tomorrow." Afterwards I asked her where his home was, but she did not know the answer and only shook her head. In America, when children grow up they have their own homes, where their parents are mere guests.

Outside the family there is certainly much social intercourse, but dealings with people are always in terms of appointments. On my office desk is an appointment calendar marked in fifteen-minute intervals with a space for a person's name beside each. Apart from business there are various kinds of gatherings, but if you go to one you will find it is no more than social pleasantries: a few words with this person, a few words with that one—it is hard even to remember their names. I cannot say all Americans pass their lives like this. But I once asked a fairly close acquaintance how many friends he had whom he could drop in on at any time without a previous engagement. Counting on his fingers, he did not fill one hand. In fact, unless they have business or an engagement they spend most of their time at home, where they don't much like to be disturbed by guests. At any rate, friends warned me not to go barging in on people all the time.

With interpersonal ties like these, naturally they seldom see ghosts after death. Moreover their movements are so easy and they have contacts with so many people, that there seldom comes about the kind of relationship I had with my grandmother, living interdependently for a long time, repeating the same scenes, so that these scenes came to seem an inalterable natural order. Always being on the move dilutes the ties between people and dissolves the ghosts.

As to attachments to places, that is another thing that made me uncomfortable in America. Not the beds and mattresses, for I believe there are none more comfortable than those of the Americans, but the constant moving around that year was the cause of my discomfort. I visited many places, but when I think of them now it seems I went nowhere, for I felt no particular attachment to any place as all were alike, differing only a little in the height of the buildings. The cities are all more or less the same, at least for a traveler: you get off the train and your bags are taken by a black man who everywhere wears the same type of cap (you may not encounter this kind of man, but you will not encounter any other); you take a similar taxi to a similar hotel—no matter what hotel, if you have stayed anywhere once you will not feel it unfamiliar. The hotel rooms are all comparable, some bigger and some

smaller, but none lacking a bathroom, a cold-water tap, a Simmons mattress, and nice stationery and envelopes. Since it is the same everywhere, you can never take away a particular impression from any hotel.

Hotels are not exceptions; it is basically the same with homes in American cities. Moving house is no more difficult than changing hotels; a phone call is all it takes. Move here, move there—the houses are about the same. In New York I thought of renting a house and visited ten possibilities in succession. In the end I said to the friend who was accompanying me, "Why bother to see each one? Why not draw straws?" Moving here and there dilutes people's ties with houses.

Whenever I return to my native place, I go to see the house I lived in as a child. I have lots of questions about the tung tree and the loquat tree; the tung tree still has my name carved on it. In London, where people do not move so frequently, I still remember where I lived on Lower Station Road and Ridge Avenue [?]; while I was in the United States I heard that the old buildings there had been bombed, and it made me feel bad for several days. In America, at least for me, no house has yet produced such a feeling.

I cannot get used to the way lights illuminate all the parts of a room either. Living in such rooms gives you a false sense of confidence that this is all of the world, that there is no more to reality than what appears clearly and brightly before your eyes. I feel the attitude of Westerners toward the unknown is very different from that of Orientals. They think of the unknown as static, waiting for people to mine it like an ore—not only not frightening, but a resource for improving life in the future. They are very self-assured. We Orientals feel some measure of reverence for the unknown; our reverence for fate makes us content with our lot, makes us aware of human limitations, and keeps our eyes fixed on the humanly attainable. I cannot assert that this attitude is ultimately due to the form of the houses we live in as children, but I believe that my own early feelings of uncertainty toward the big kitchen and the back garden and my fright toward the closed-off rooms have still not dissipated, but only expanded into my view of the universe. If many people in traditional China had similar experiences, then these experiences may have determined the basic structure of our traditional attitudes toward people and things.

In a world without ghosts, life is free and easy. American eyes can gaze straight ahead. But still I think they lack something and I do not envy their lives.

# Some Judgments About America

Xiao Qian, 1945

*Xiao Qian (1911–   ), another Yenching graduate (journalism, 1935), is an all-around man of letters, known for his essays, journalism, fiction, and literary criticism. He spent six weeks in the United States in 1945, covering the inauguration of the United Nations in San Francisco and then traveling to a few other cities as a correspondent for the* Da gong bao, *the most respected newspaper in China at that time. He had spent the previous seven years living in England and published several short books in English during the 1940s. The following is a brief essay of miscellaneous impressions.*

Of American cities I like New Orleans best, because it least resembles my mental image of the United States, just as I like New York least because it is most like that image. New Orleans is as leisurely, as unrestrained, as suave as eighteenth-century France. In the middle of the day its public squares with their tall straight palm trees are filled with people resting in the shade. On the "lake front" of the Gulf of Mexico people in broad-brimmed hats are fishing. All along the shore are crab restaurants. At dinner the most delightful thing is brandied coffee: after dessert the light is suddenly turned off, and all that can be seen in the dark is a blue flame. When the light comes on, coffee mixed with fragrant brandy has been served in front of the customer.

As for architecture, Washington from the train station and the post office to the Capitol and the White House is worthy of the name "capital." The Library of Congress is certainly an imposing palace of books. I spent a long time in just the Chinese section, indeed just the modern literature part. How many books that have been banned in

China have found welcome among foreigners! Looking at this mass of books, I suddenly felt nostalgia for the past twenty-five years, especially the early part of that period, the thrilling days of *Weiming, Yusi, Chenzhong, Xinyue, Chuangzao,* and *Nanguo* magazines; I do not know if the Chinese clock is running forward or backward. At the marble «Folger» Shakespeare Library an Englishman might feel ashamed, for England does not have such a treasure house for doing research on Shakespeare, not even at Shakespeare's native place, which so attracts tourists....

In the American capital they like to carve inscriptions on buildings. These express America's youthful sentimentality and perhaps also the enthusiasm of revolutionary pioneers. The inscription running along the outside of the Post Office Building is almost maudlin: "Messenger of sympathy and love. Servant of parted friends. Consoler of the lonely. Bond of the scattered family. Enlarger of common life. Carrier of news and knowledge. Instrument of trade and industry. Promoter of mutual acquaintance, of peace and goodwill among men and nations." On the triangular frieze on the west end of the Supreme Court Building, it says, "Equal justice under law"; and on the east, "Justice the guarantee of liberty." Of course in China there is hardly a government office that does not have written in big letters over the front gate, "Impartial and incorruptible."

In addition to the language, the style of life in England and in America is similar in many ways. A hundred years ago the differences in society were greater than they are now. The English aristocracy is being made poorer by taxes, while the wealthy in America are becoming more aristocratic. In the South rich people, unable to confer upon themselves a title of nobility, adopt the honorific "Colonel." But the socially influential in America still fall far short of those in England. A man with several millions and a beautiful villa will certainly be considered a gentleman above others. (On the way from Denver to San Francisco I asked the train porter what were the sights to be seen. He told me there were six villas of rich people, including «Bing Crosby».)

When the wife of an important Chinese man came to the United States and the American newspapers kept referring to her as "Mrs.," she launched a protest, so they changed to «Madam». But this was no better; again she protested, and only then did they change to the aristocratic-sounding «Madame». This is because social classes in the United States are only in the process of evolving and are not yet established. In England, where social classes have solidified, there would be no need for such protest. I was once invited to dinner by a

rich American man on the West Coast. I asked, "Where is your wife?" He laughed and did not answer. Only after the coffee did I discover that the woman in the white apron serving dinner was really his wife. This kind of joke would be unthinkable in England.

In nightclubs Americans can be seen hard at play. In the Tennessee Valley even chief engineers are visible in shirt sleeves hard at work. What Shanghai has learned is the nightclub bit. What the sons of rich Chinese come into contact with is also only this nightclub side. American construction workers are ten times more efficient than those in England; coal miners and weavers are also much more efficient. And Chinese are of course not even up to the English. In view of this contrast, for Chinese to learn pleasure-seeking from the Americans is to court our own disaster. The western state of Arizona was originally a barren desert. Only in 1916 or 1917 [actually, 1912] did it enter the United States of America. Today it is already highly industrialized. What do Chinese sitting idly and consuming their resources have to compare to this?

It is precisely because America has riches underground and the people above ground are full of energy and hard working that America can take three different stands toward Argentina in the course of one month. In personality America is impetuous. This is not just a matter of temperament but also because her environment is so kind she does not need to be wary and cautious. But what is worrisome is the countries tagging along behind her, whose circumstances cannot possibly be compared to America's; they are like a pauper following a dandy to a house of pleasure. In the end the pauper will certainly be taken advantage of.

As for racial prejudice, East Europe is better than West Europe, France is better than England, and the United States, Australia, and South Africa are the principal nations discriminating against non-whites. Discrimination in America is not just against blacks. In the West it is against Orientals, in the South against blacks, and in the East against Jews. And there are really some Chinese (especially those who have gone to the South) who, having eaten at the American table, end up copying Americans' prejudice against blacks and call them retarded, lazy, and dishonest.

The racist views of America, South Africa, and Australia are founded in economics. In America there are a great many Orientals in the West, and in the South there are more blacks than whites. In Australia, which is in area twenty-six times as large as the three British Isles, the white population is not even as large as that of the city of

London. Their discrimination against nonwhites is clearly a matter of rice bowls [jobs]. As much as Chinese may objectively understand and even forgive this reality, they hardly need accept or encourage the idea of American ethnic superiority. At nearly every session of the Institute for Pacific Relations, the United States raises the question of India, and England responds with the question of equality for American blacks.

Compared to England, America is a generous nation, and because of that has a lend-lease act and a general relief administration and surplus goods. But when this virtue is combined with her impetuosity, it may in the end be a matter of chance whether she is a blessing or a misfortune for mankind.

*Figure* 16.     A cartoonist visits America, 1946–1947. Ye Qianyu (1907–   ), famous for his satirical newspaper cartoons, and his wife Dai Ailian, a dancer and later founder of the Central Ballet of China, were invited to the United States for a year under the State Department's cultural exchange program. These cartoons are from a series of over thirty, later published in the Peking newspaper *Xinminbao*, depicting the "American style of life" (in his words), with Ye and his wife pictured in most of them. Ye went on to hold prominent artistic posts in the People's Republic and chaired the department of Chinese painting at the Peking Academy of Fine Arts. From Ye Qianyu, *Sanshi niandai dao sishi niandai—Ye Qianyu manhua xuan* (The 1930s to the 1940s: Selected cartoons of Ye Qianyu) (Shanghai: Renmin meishu chubanshe, 1981).

# Shipboard Dreams

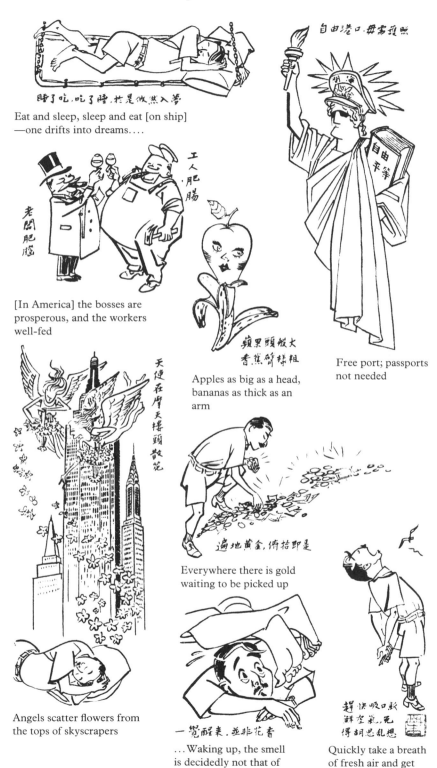

睡了吃，吃了睡，於是做然入夢

Eat and sleep, sleep and eat [on ship]
—one drifts into dreams....

自由港口，毋需護照

老闆肥腯

工人，肥腸

[In America] the bosses are
prosperous, and the workers
well-fed

自由
平等

蘋果頭般大
香蕉臂樣粗

Apples as big as a head,
bananas as thick as an
arm

Free port; passports
not needed

天使在摩天樓頭散花

遍地黃金，俯拾即是

Everywhere there is gold
waiting to be picked up

Angels scatter flowers from
the tops of skyscrapers

一覺醒來，並非花香

...Waking up, the smell
is decidedly not that of
flowers

趕快吸口新
鮮空氣，免
得胡思亂想

Quickly take a breath
of fresh air and get
rid of crazy ideas

# Chinese Wait

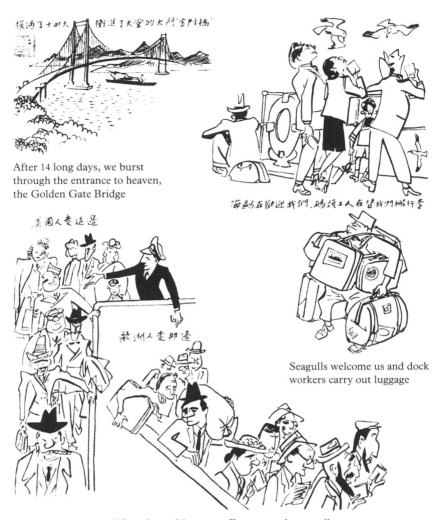

After 14 long days, we burst through the entrance to heaven, the Golden Gate Bridge

Seagulls welcome us and dock workers carry out luggage

"Americans this way.... Europeans that way."

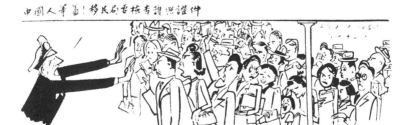

"Chinese wait! Immigration needs to check your passports."
(...stand from 8 a.m. to midnight...)

# Self-Service Newsstand

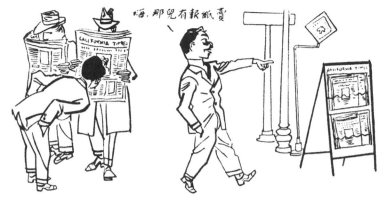

"Oh, there's a newsstand."

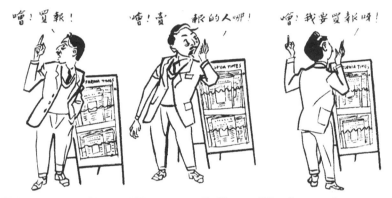

"Hello—newspaper!"  "Hey, paper seller!"  "Hey, I want to buy a paper."

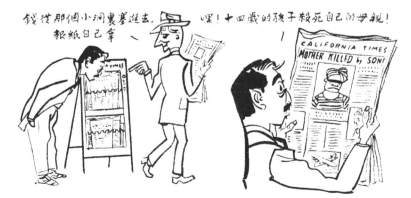

"Just put the money in that slot and help yourself to a paper."

"What?! A 14 year old kills his own mother!"

# In a Nation of Cars, Parking Problems

"Bill, take us to a department store."
"I can only stop here a minute, get in quick."

"Wait while I park, and then I'll go with you."

"We've been waiting half an hour. Has something happened to Bill?"

"What a mess! Not an inch of free space. There's no way to leave the car, so I can't go shopping with you. Good-bye!"

# A High Level of Consumption

紙杯喝水，喝了就丟

Drink from a paper cup, then throw it away

紙手帕，一天消耗兩打

Paper tissues, two dozen a day

整本整本的雜誌塞在街頭字紙簍裡

Good copies of magazines stuffed into a street corner trash basket

野餐以後杯盤狼藉

After a picnic, cups and plates scattered all over

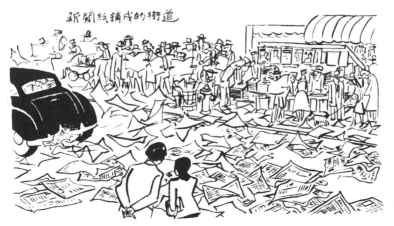

新聞紙鋪成的街道

The road created by a newsstand

# A Food Mistake

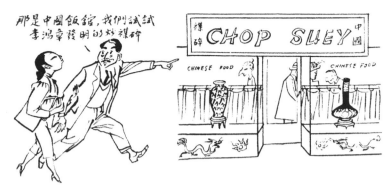

"Here's a Chinese restaurant. We can try some of this chop suey which Li Hongzhang is supposed to have invented."

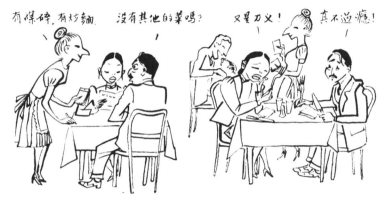

"We have chop suey and chow mein." "Nothing else?"

"Knives and forks!"
"How unsatisfying."

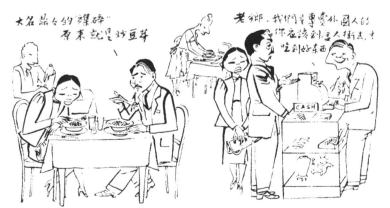

"So, this famous 'chop suey' is just fried bean sprouts."

"Countrymen, we cater especially to Americans here. You must go to Chinatown for something good to eat."

# Betty:
# A Portrait
# of Loneliness

Yang Gang, 1948

*Yang Gang (the pen name of Yang Jiwei, 1905–1957) was a student in the English Department at Yenching University from 1928 to 1933 (at the same time as Fei Xiaotong and George Kao), where she joined the underground Chinese Communist Party (CCP) and was arrested for participating in radical activities. She went on to become editor of the literary page of the* Da gong bao, *one of China's most important newspapers, and was a good friend of Xiao Qian, who recently edited her collected works.*

*Yang lived in the United States from 1944 to 1948. She studied for a time at Radcliffe College, then lived in New York and traveled around the country, writing articles for the* Da gong bao *and talking to American intellectuals, trying to weaken American support for the Nationalists. John Fairbank, who knew her then, describes her as follows: "Slight of build and comely rather than beautiful, Yang Gang was fluent in English, highly intelligent, and thoroughly devoted to her literary work.... She was a leftist but not openly Communist, in fact an 'outside cadre' urged by the CCP to pursue her career in the outer world, keeping clear of CCP connections."[8]*

*In 1957 Yang committed suicide in despair after losing a notebook that she feared might be used against her during the Anti-Rightist Movement, when thousands of intellectuals were being attacked and arrested for alleged antisocialist tendencies.[9]*

8. John King Fairbank, *Chinabound: A Fifty-Year Memoir* (New York: Harper & Row, 1982), 275.

9. Hu Qiaomu, "Xu" (Preface), in Xiao Qian, ed., *Yang Gang wenji* (Collected writings of Yang Gang) (Beijing: Renmin chubanshe, 1984), 1–2; see also Xiao Qian's

*The following piece, a profile of an American woman in New York in the 1940s, seems a mixture of fact and fiction. In depicting an archetype of the lonely, isolated urban American, Yang presents the unhappy side of American individualism.*

There has been so much excitement of various sorts since returning that I have virtually forgotten about my nearly four years of life abroad. Moreover, because I came to feel tired and depressed about the work of those four years, I sometimes wanted to put out of my mind the phony so-called politics of that political whirlpool. But it is not easy to forget events and people who have touched your emotions. I cherish their memory. I remember their rational and irrational struggles in an irrational society. I run into them in everyday life. They are not a threat or a burden to anyone, only a worry to themselves.

Traveling in the South one spring, I happened to write to a friend in New York, an American girl, among other chit-chat, that after the trip was over my first problem would be finding a place to live. I knew that in New York even hotels were hard to find, and was just giving voice to my worries. A reply came quickly a few days later, and my friend warmly urged me to stay with her. Although our relations were not close, I understand the admirable friendliness of Americans and answered that when I got back to New York I would squeeze into her one room with her.

This girl's round face was sincere and lovely, surrounded by hair already turning from light gold to chestnut and combed in a way that suited her. She was from Minnesota but had spent half her life and work moving here and there on the East Coast, sometimes in a factory and sometimes in an office. (The distinction between factory and office work is not as strict in the United States as in China.) We had come to know each other over some typing; she had typed one or two school papers for me and we became friends. For convenience I shall call her here by a common American name, Betty.

Her room, near the southern tip of New York, in what is called "downtown," was as dark as an old temple. We also had a little balcony, as if on the side of a mountain, a kitchen, and a bathroom. It was part of what had been one apartment divided in two by the tenant to

---

afterword and the biographical chronology on pp. 580–94. It has recently become known that Yang Gang was the author of the "Fragment from a Lost Diary" in Edgar Snow, *Living China* (London: G. G. Harrap, 1936).

share the rent. The two of us each paid almost forty dollars. We slept in two small beds pushed together, each just big enough for one person.

Early in the morning of the second day, half-asleep, I heard a radio playing softly in the room. Though I had not been in the United States long, I knew about Americans' love of listening to the radio, even while reading or writing, which made me detest and dread it. My first thought was to ask her if I should not move away from that ceaseless noise.

"Betty," I said aloud.

"Mm." From the next bed came the sound of someone startled from slumber. So she had been asleep. The room was dark.

Embarrassed I said, "That's strange. If you are asleep, who turned on the radio?"

"I did. I always play it all night." Betty turned several times, as though sleeping badly.

I was amazed. Even asleep they want the radio on. "Aren't you afraid of it disturbing you?" I asked.

Betty spoke listlessly. "It's better if there is a little noise when I wake up in the night. Otherwise I feel afraid."

"Afraid of what?"

"If you don't like it, turn it off. I can't get to sleep at night if there is no sound; and to wake up in total silence makes my heart tremble." As she spoke there was a lot of noise going on outside, but these sounds did not exist for her.

Getting out of bed, Betty said, "Let's go swimming today." I told her I didn't know how and moreover was busy. She said nothing and went to fix something to eat—a cup of coffee and dry cereal soaked in milk. After a while she said, "If you have things to do, then do them, of course. I would if I did. But the beach is nice now; there's sunlight and people."

I secretly thought there was something wrong with this girl. She feared loneliness so much it was as though her life were in danger when she approached it. What was the reason? I didn't ask.

It was like this for several days. She left every morning and did not come back until evening. Once back she would take out her beloved whiskey and come drink with me, wanting to talk with me incessantly. Swimming was good because once in the water she forgot everything. She applied whenever she saw a help-wanted ad, but could not find work. Every day she had two meals of dry cereal with milk, spending only twenty or thirty cents a day on food. She was half-hungry but had no alternative. She had only one black nylon skirt and jacket, which she

wore when she went out summer and winter. She had not bought a hat in ages. Imagine an American woman going out in an old hat all the time. How could she appear in public? And furthermore she dreamed of having boy friends come see her. She had to drink. She had been unemployed for almost five months, and if she did not drink, how would she get through the day?

As for relatives, she said, "I don't want to seek them out. I'm only having a hard time for a while. I still want to tell them I'm fine, happy, and can get along." In the thirty years of her life she had lost several men. Each ran away just when there was hope of marriage. But she still had high hopes for one of them, called Jimmy, who was rich and unmarried. She dreamed that he would come find her when he came to New York. Her days were really unbearable. She had only twenty dollars left. Her only hope was five hundred dollars in severance pay from her last job, which she should get soon. But would not five hundred dollars be quickly gone? She was not willing to give up this eighty-dollar-a-month old-temple room. If you descend to living in twenty- or thirty-dollar rooms, you cannot even receive guests and no boy friend would go with you. Furthermore, you know, she had had a higher education, not only college but a master's degree. How could she treat herself like garbage and go live in a slum tenement?

Perhaps the reader thinks Betty's confused reasoning just shows her to be a foolish woman, but she did not see it that way. In fact, she was not completely foolish. She understood that she belonged to an irrational society. When she read in the newspapers of the virtues of a "free economy" and of "American prosperity," she mocked it. She often asked me if I thought a crisis could occur in America. And she frequently expressed opinions she had heard somewhere about American democracy. She thought the American democratic ideal had reached the peak of perfection, and it was only because unfortunately the common people did not concern themselves with it and uphold it that they were controlled by bosses. What she most wholeheartedly admired about her country was liberty, by which she meant that no matter what, she could make fun of anything she wanted to criticize. Only her criticism could just be spoken to me in the room, while others' declarations of the merits of "free economy" could be loudly proclaimed to the heavens all over the world. I don't know where her freedom was, even just freedom of expression, to say nothing of her lack of freedom to eat.

Finally Betty found a job, assembling products in a cosmetics factory, taking home sixteen dollars and some cents a week. The hours

were eight to five. The factory was only twenty or thirty blocks from where we lived, which was considered close, but she had to get up before seven every morning to have time to eat something at home. And in the evening she got home to make dinner at five-thirty at the earliest, and sometimes as late as seven, when the boss wanted her to do extra work, which she did not like for it did not pay anything—the wartime overtime system had been abolished—but still had to.

In all she spent ten to twelve hours a day on this job, which came to fifty or sixty hours a week for sixteen dollars and some cents.[10] But she was much more cheerful, did not play the radio at night, and drank less whiskey. After buying seven days' worth of food with her sixteen dollars, she could still get a stylish new hat for thirty dollars, which she wore in front of the mirror for a long time, turning her head this way and that. Even I became less worried about her. Her problems were simple, for she had no children and her work was nearby. How did all those people manage who wasted nearly two hours a day getting to work from Long Island, Brooklyn, and Staten Island, and who had to cook for their children? Betty told me that nine out of ten of her fellow workers needed sleeping pills to get to sleep at night, but I do not know if she said that just to show that her use of sleeping pills was normal.

Good times do not last long. Betty gradually started complaining again. Once she was two minutes late to the factory, and the woman in charge of checking people in held her watch threateningly in front of Betty's eyes and told her to check the time before coming in the next day, that if it was after 8:05 to turn around and go home. A few days later Betty said she needed a day off to take care of something. In fact she was fed up with the factory, which always wanted her to work more and where the foreman was always spying on the workers as though they were thieves and swore at them at every turn. Betty was secretly making arrangements with another factory and needed time off to proceed with this. She asked for a day off (without pay), but was refused. A day later when she telephoned to ask again, the foreman told her to settle her account and not come back. And then the arrangement with the other place did not work out. That day Betty went in and out totally distraught, so that I got nothing done all day either.

Still, Betty had some happy times, too. One evening when she came in I handed her a telegram, which she opened and said: "Oh, it's from Jimmy. He's come from Chicago and wants me to call him. Didn't

10. This seems low, and may have been exaggerated for political reasons. In 1950 the minimum wage was seventy-five cents an hour.

he telephone? Hasn't he phoned? His number is \* \* \*. He'll certainly be at the hotel now. I'm going to go call him."

The phone was in the landlady's apartment in the basement, but it was already after midnight, and Betty was afraid she would not be pleased, so she went out to the street to telephone. After awhile she came back with her mouth in a pout but her eyes smiling, making her somewhat childlike round face very cute. She said, "Harrumph. He wants me to go see him at six tomorrow. Who knows what he wants? But he was very nice. He called as soon as he got here; you must have been out. I think I'll ask him to take me swimming tomorrow. He says he's busy." And she kept on talking to me about Jimmy ceaselessly. In brief, the man was so handsome, so rich, a lawyer, so able, they were so good together. But he never proposed marriage; Betty did not know why. Her forced air of pride made one think that the man was trifling with her and she knew it, but would not admit it in her heart. She set in to boasting over again about how he had phoned, he had phoned. In fact, she later said, she did not sleep all night.

The next night at 2 A.M. I had just washed and was putting on my nightclothes, about to go to bed, when Betty noisily burst in, still talking, answered by a man's voice. After a while she called to me, saying Jimmy had come and I should come out and talk. I ignored her, and she came into the bathroom in her new hat and said, "Come out. I want you to see him." I was furious and said in a loud voice:

"It's very late. I'm already undressed and about to go to bed." She paid no attention and even started to push me out, as though she had lost her senses. Then from outside the man tactfully apologized, said it was too late, and left.

I was angry at Betty and scolded her, saying that we Chinese were not in the habit of receiving strange men in our nightclothes. Betty turned red in the face and admitted she was in the wrong. Later she said to herself, "After dinner there were so many people talking I felt bored and had to take a nap on his bed. See, invite a girl out and you make her so tired she falls asleep." These last phrases she repeated over and over, and gave me a helpless look. Afterwards she again discussed with me why she wanted to marry, because not marrying was like having one's life hanging over a cliff. Finally she said, comforting herself, "I don't know what it would be like to marry. This man has money. I wouldn't have to worry about basic needs. But he is very conservative. If he wanted me, it would be to entertain his rich friends for him. Then what would I do?"

Jimmy left the next day and Betty did not see him again, but talked

about him for several days running. American girls talk about men the way Chinese talk about delicious dishes. Every day she hoped he would telegraph or write, until she finally gave up hope and, moreover, found a fourth new job.

After being unemployed three times in two months, Betty again joined a cosmetics factory. Her wage was still between ten and twenty dollars a week. This time she was happier with the factory, and said the manager was a reasonable gentleman and good to the workers. But after a month she lost her job again. This time she did not know whether to blame her co-workers or the factory or herself. It happened this way. This factory, unlike the other ones, had a rather powerful union. Betty said it was Communist controlled; but she was not sure, it was just the boss and the foreman who said so. In short, soon there was a protest movement. A supervisor bullied a female worker, swore at her, and hit her. The union made a stir, and the factory apologized and fired the supervisor. Betty sided with the worker at first; and since she was educated and spoke well, she represented the workers in negotiating with the manager. She found him gentle and cultivated, sympathetic and reasonable; he understood that workers should not be bullied and praised workers' cooperation with management. Then he told her the union was being used by Communists to make trouble and gave lots of examples of unreasonable trouble in the past that had harmed production.

Betty had already had mixed feelings about the Communist party and at heart was frightened by it. She did not fully believe the manager and did not fully disbelieve him either, but felt he was a gentleman and reasonable, someone who would not push the workers into a corner. She felt sympathetic to him, and because of her education he took a fancy to her and had her do typing in the office after hours. But she was still a worker, going to union meetings. She did not betray anything, nor did she contribute anything. But the workers became thoroughly suspicious of her and whispered behind her back, just as if she were a scab, until she herself came to feel she was a scab for typing for the boss.

In the last few days before I moved out of that room, Betty became emotionally distraught over whether to keep that job or give it up. She sensed that if she did not go on working for the boss he might think she had joined the Communists, and that would be risky. But to continue put her in an awkward position with the workers, because among American workers there is something of what in China is called the code of gang loyalty: no matter who is right or wrong, you do not show

sympathy for the boss in the struggle between management and labor, unless you have been bought.

Betty begged me repeatedly not to leave—on the one hand, to keep her company so as to avoid a frightfully lonely life and, on the other, to share the eighty dollars in rent. She wept and said if I left she would not be able to bear life. But that old-temple room, and Betty's problems, had made me unable to work and was driving me crazy. This woman's life reflected the problems of almost the entire society, spiritual to material. I was not of any use to her.

The night before I left, I was awakened by a voice like an autumn cricket. Opening my eyes, I saw it was not yet light. In the dark, the sound of heartbroken sobbing mixed with the light shuffle of feet on the floor gave me goose bumps—it was as though in the darkness an aggrieved ghost was seeking a life. I clenched my teeth and looked out for my life. Out of the gloom gradually appeared a gray figure, shoulders hunched over into a ball, head pulled in, hands tightly clasped in front, slowly walking back and forth in the dark. From this gray shadow came a constant sound like quiet weeping or swearing or complaining. It was Betty.

*September 25, 1948*

# V

# Familiar America: The View from Taiwan

After the Communist victory in 1949, mainland China was cut off from contact with America, but Taiwan, under the anti-Communist Guomindang, remained closely aligned with the United States. From Taiwan, and to a lesser extent tiny British-ruled Hong Kong, came thousands and tens of thousands of students, immigrants, and visitors, scores of whom have left travel accounts of one kind or another. Though many of these are not of great interest, their very numbers indicate a sizable market in Taiwan and Hong Kong for books about America. One focus of the attraction the United States held for these people is revealed by the considerable attention many authors devote to descriptions of universities. Moreover, much space is often given to accounts of conversations with important people and visits to important places, for contact with America has become a source of status.

This new generation of visitors from Taiwan and Hong Kong tends to have a good command of English and considerable knowledge about various aspects of the United States. As Taiwan and Hong Kong have themselves become prosperous and cosmopolitan, certain aspects of American society have become less alien. But other facets of American life continue to trouble recent visitors, a discomfort that is all the more interesting for being based on familiarity.

# A Day
# in the Country

Du Hengzhi, 1946–1948

*Du Hengzhi (1913–    ), formerly chairman of the political science department at Tunghai University in Taiwan and more recently dean of the college of humanities at Soochow University, is the author of a number of books on international law. He holds a master's degree in government from the University of Michigan and doctorate in law from the University of Paris. After World War II, from 1946 to 1948, he lived in the United States, apparently as a Chinese military officer attached to the American army, mostly at various bases in the South. He has returned to the United States many times since.*

*From Du's reminiscences of his postwar stay, we see his fun-loving, curious, gregarious personality. The following piece, from a book of essays first published in Taiwan in the early 1950s, shows him driving a car, riding horseback, and having some sort of a romance with an American high school girl. Possibly there is an element of fantasy in his depiction of this romance, but he leaves little doubt of the real attraction he felt for the zest and boldness of American women, at least in Texas, and the warmth of rural people.[1]*

America's great cities are the masterpieces of material civilization, of course, but it is necessary to go see the countryside in order to com-

---

1. Other Chinese have also been touched by the warmth and kindness of rural Americans. A visitor from the People's Republic in the early 1980s was astonished at the friendliness of a Missouri family he spent a couple of weeks with one summer; Liu Zongren *Two Years in the Melting Pot* (San Francisco: China Books, 1984), chap. 9. And a student from Taiwan in the 1960s who spent Christmas vacation with two rural families in Missouri called it "the most meaningful two weeks of my life"; Wang Xiang, "Zai Meiguo jiali zuoke" (As a guest in an American home), in Huang Minghui, ed., *Lü Mei sanji* (Notes on staying in America) (Taipei: Zhengwen, 1971), 123–33.

prehend fully the level of American civlization and the people's standard of living. I was fortunate at one time to be able to spend a day visiting a farm family in Texas, in the South.

Although I had known Jenny for the greater part of a year, I only knew that she came from the countryside; I had never been there. She was studying in high school in the city at that time, seemed not to go home often, and was such an urbanized girl that I almost forgot her rural origins. One day the two of us, driving to a «seafood» restaurant ten or so miles from the city, passed some farmhouses on the side of the road, and I blurted out: "I would love to be able to spend a day in one of those houses."

"What are you talking about?" She looked at me with surprise. "If you want to go to the countryside, why don't you come to my home?"

"Is your home like these farmhouses?" I too was surprised.

"Absolutely. I always thought you didn't want to go to the country!"

And so I spent a whole Sunday at Jenny's home.

Early in the morning—in fact, too early—she was already at my window yelling, "Are you ready? It takes an hour to drive there!"

Sticking my head out from the covers and looking out the window, I saw her standing next to my car dressed altogether differently from usual. Although she still had brown flat shoes on her feet, tight blue jeans replaced her usual full skirt and above she was wearing a dark-blue shirt with the sleeves rolled up. Her blond hair hung free over her shoulders and blew in the wind. Her usual gentleness and sweetness had disappeared; she had changed into a wild child, terribly wild!

"Jenny, why are you dressed like that?"

"Is there something wrong with dressing like this?" She laughed high-spiritedly. "In the country everyone dresses like this. You should copy me or at least wear an old uniform." Having said that, she seemed not to want me to look at her clothes any more and got into my car, honking the horn to get me up.

It was a full fifty miles from the city to her house. She loved to drive, and as I did not know the road I let her. She drove fast, her hair blowing wildly in the wind, and from her frequent loud laughter and the funny faces she put on, I understood what an American farm girl is.

She stopped at a mailbox next to the road, jumped out, opened it, and took out the letters; it was her family's mailbox. Driving down a narrow dirt road, before long we saw a house in the middle of the woods. Her parents and younger sisters were already on the porch waving in welcome to us, for she had telephoned the night before to let

them know. The first visit to a girl friend's family is naturally a little embarrassing, but the extremely cordial reception of her mother and father soon made me feel right at home.

Her father could not be considered old, probably in his forties, but because he had worked in the fields he was deeply tanned, his face heavily wrinkled, and his hands rough. Not very skilled at conversation, he used a lot of slang and had a peculiar accent that I found difficult to understand and sometimes even had to ask Jenny to translate for me. She often made fun of him, saying, "Dad, speak right. Don't make such strange sounds."

Her father did not get angry when she spoke this way but said, "I should learn from you how to speak!" And everyone laughed. I was deeply moved by the simple sincerity of this typical farmer.

Her mother was healthy and also deeply tanned. I observed her carefully: her appearance was pretty, her eyes especially affecting. Unfortunately her teeth were rather irregular and also yellowed, apparently a common flaw in farm wives. She still wore lipstick and nylon stockings, and her clothes were clean and altogether no different from those of city women. She took me by the hand to see everything, ceaselessly calling me "dear"—she was really very kind.

The house had no upper stories, but the rooms were not small: a sitting room, four bedrooms—one for Jenny's parents, one for her two little sisters, one for Jenny herself, and a guest room prepared for distant relatives or friends from far away to come here on vacation. There was also a kitchen, a bathroom, a pantry, and a fine little study. The exterior was built of gray planks and had a rather old-fashioned look, but inside all the rooms had white painted plaster walls and wall-to-wall carpeting, exactly like the homes of city people. Of course, the furniture and much of the decor was somewhat old. For example, the radio, I was told, had been bought the year Jenny was born. Her father knew how to repair it and had installed many new parts so that it still sounded fine. I should explain here that a farmer needs to know not just how to till the fields and raise animals but also lots of other things such as how to repair automobiles, electric lights, plumbing, bathrooms, and everything else he uses. He may not have built the house he lives in, but bit by bit the repairs are all by his own hand. The onerous job of repainting the white walls every year is never given to anyone else. Sheds for various kinds of animals and simple waterways are all built by the farmer himself.

Jenny's family raised a good number of animals: cows, horses, pigs, chickens—all with tidy sheds. The animals themselves were all

extremely clean without the slightest bad odor. The owners often stroked them with their hands, the way one would a beloved dog. We tend to think of pigs as filthy creatures, but in America they are all clean and can come into contact with people; only their stupid expression makes people laugh.

At ten-thirty in the morning everyone went to worship in a nearby church. Jenny again drove, I sat next to her, her two sisters—twelve-year-old Mary and nine-year-old Nancy—who seemed to like me, also squeezed in the front seat, and her parents sat in back. Mary and Nancy fought over who would sit in my lap, Jenny tried to snuggle next to me while she drove, and everybody made a lot of noise, constantly laughing, with even the old couple in the backseat laughing along.

The church was also built of gray planks, with a little steeple on top, which showed right away that it was a church. The interior was spacious: it could hold two hundred people. A great many people had come to worship that day, so that in addition to the full seats there were a good many men standing in back. I was told that every service was this crowded, which shows how strongly religious rural people are. Most interesting, everyone took the service seriously; some old ladies wore colored hats and the men had all changed out of their work clothes into suits, so that judging from people's clothes there was not much of a rural flavor. Just as in a city church, the minister led a group of children singing hymns and a grand piano resounded loudly.

Returning from church, everybody felt a little hungry. Jenny's mother immediately directed a group of young people to move a big table out to the yard, build a temporary fireplace out of stones, and prepare a bounteous outdoor meal. In addition to Jenny, her two sisters, and me, these busy young people also included Jody and her boyfriend Paul, whom Jenny had encountered in church and invited back. They were all accomplished cooks and cooperated most efficiently in making the fire, cutting up the meat, and washing vegetables.

At first I was to keep watch over the roaring fire, but after I almost let it go out I was assigned a new job of taking eggs out of the pot and shelling them. But again they thought I worked too slowly, and in the end ordered me just to wait until it was time to eat. Lunch for eight people was prepared in less than half an hour. Five or six sumptuous platters were placed on the table and each person took a paper plate and served himself what he liked to eat together with a bottle of fresh milk. In order to save on the dishes, the same paper cup was filled with coffee after the milk was finished. The forks and spoons were of wood and were thrown out with the paper plates and paper cups after the meal.

This saves the work of washing dishes and is indeed convenient. But the table was littered with bottles and empty cans and again everybody was busy for a spell.

After lunch Jenny's mother and father went inside for a nap while I went with the young people, each on a horse, galloping off in the open countryside, which extended as far as the eye could see. When we had ridden probably ten-odd minutes, Jenny stopped her horse and, winking at me, said to Jody: "Jody, Paul, you turn that way. It's not so much fun to ride with everyone crowded together." Paul was delighted to hear these words, of course, and immediately replied, "Okay, we'll see you in a while. Come on, Jody." Jenny gave a laugh in my direction and galloped ahead, the two little sisters and I following close behind. But the trail went through some wooded spots where my face was nearly scraped by branches, so that I had to keep slowing down and consequently lost sight of the three sisters. I thought to myself how embarrassing that I should be the one to fall behind, when they were just girls and I was in a grand military uniform. Only after riding on for another ten minutes or so did I see Jenny, by the side of a little stream, sitting on a sloping rock washing her feet. Mary and Nancy were not to be seen. When she saw me she waved hurriedly and called, "Come quickly, I've been waiting for you. Mary and Nancy are ahead."

"Why did you ride so fast?"

"We were testing your riding ability," she laughed.

"And I was testing your manners." I succeeded in covering up my inferior horsemanship.

"Oh, I'm sorry, dear. I've offended you!" She stretched out her hand and pulled me down beside her on the rock.

Most of this area of the countryside is undeveloped, with only miscellaneous animals scattered here and there. There is much undeveloped land in the American South, some because it lacks water and some because there are not enough people. But roads have been built, and when needed it will be easy to develop.

Wandering in the open country is a great joy. Only then did I realize how practical those clothes of Jenny's were, in which she could lie down anywhere. She was concerned about mine, on the other hand: "Before you sit there, wipe it with your handkerchief." She told me many stories about her childhood life and games in this countryside, about which she felt always the greatest enthusiasm, and I then understood why American youths do not all flock to the cities and why many resolve to become farmers. American farmers are comfortable, all have houses and land, and they are secure; they do not have to worry about

losing theirs jobs the way workers do, and do not need to live crowded and rushed city lives.

When it began to get dark we started back, soon meeting up with Jody and Paul, all the way going slowly, very relaxed. Suddenly Paul asked me, "Did you have a good time playing around?"

I did not know how to respond, when Jody interrupted, "Of course. Look how Jenny has dirt all over her!"

"Humph! Look at yourself!" Jenny pointed at Jody, and in fact even her face was dirty.

Everyone laughed wildly, and I felt astonishment at the boldness of these girls. Texas is famous for its beauties; the women here all have big eyes, thick eyebrows, tall bodies, robustness, unusual boldness, and unusual zest. Jenny and Jody were both of this type.

When we got back to Jenny's house we found the two little sisters had long since returned by another route. Everybody began busily preparing supper; this was a much simpler meal, just one or two sandwiches, a bottle of milk, and a cup of coffee for each person. Paul lived in the city and was going to ride back in our car. He could not do without a little intimacy with Jody before parting, so Jenny chased the two of them into the little study for their supper, forcefully closing the door, which made us all break out laughing.

When we said good-by, Jenny's parents held onto my hand and repeatedly expressed the wish that I would often come and play. Jenny's two sisters also had become fond of me and hugged me as though they could not bear to let me go. Such warmth of human sentiment is indeed the most attractive aspect of rural America.

# Americans'
# Lack of
# Personal Style

Yin Haiguang, 1954

*Trained in China in philosophy and logic, Yin Haiguang (1920–1969) was a Western-oriented intellectual who kept a picture of Bertrand Russell over his desk. He came to Taiwan with the Nationalists in 1949 and was an influential writer and a popular professor at Taiwan University until he was forced out by the government in the early 1960s because of his growing political iconoclasm. He died of cancer in 1969 at the age of forty-nine. As one of his many students now in America said in dedicating a book to him, his "courageous challenge to political orthodoxies has inspired a generation of Chinese intellectuals."[2]*

*Yin was able to go abroad only once, to spend several months at Harvard in the early 1950s, about which he published a small collection of articles. Much of what he found in America he liked, including a political liberalism that he contrasted with Guomindang authoritarianism at home. But more interesting is what he did not like, despite his intellectual Westernization and familiarity with American culture. In the following essay he discusses his distaste for what seemed the inappropriately undignified behavior and bearing of Americans, even those of status and age. A small man, Yin's own bearing was invariably erect and dignified.*

Personal style is not the same as character but it reveals character. If we look at an ancient monument or the statue of a person who has had an influence on human life over the ages, its venerable appearance

2. Winston Hsieh, *Chinese Historiography on the Revolution of 1911* (Stanford: Hoover Institution, 1974).

always strikes some chord in us. We often talk about "architectural styles" or "artistic styles"; why should we not have a similar aesthetic feeling for human character? Classicism, symbolism, and realism in painting have different styles and produce different psychological responses. In the same way a person's style can also attract or set an example or even arouse admiration. This process is not easy to talk about. Language is in the end a pathetically poor tool—those who write endless love letters at the slightest provocation are often not the ones most deeply in love, something young girls should beware of! But the power that a person's style has to affect us is not in the least mystical, nor is it ungraspable because of some "metaphysical basis." It is something that can be experienced; indeed, it seems unavoidable in interpersonal life. It is seen often in the bearing and manner of religious leaders, artists, thinkers, scientists, and poets.

What America has most of are automobiles and what it has least of, I think, are things like style. Not far from a certain university here, there is a church; it is a grand building, lofty and imposing, towering into the sky. The minister inside is a man over sixty years of age. His venerable head is like Japan's Mount Fuji or some snow-topped mountain peak in China. He concurrently holds professorships in two divinity schools, has written many books, and has been minister of this church for over thirty years. To my way of thinking such a man should have a certain personal style, revealed in his bearing and movements. But he is not at all like that! According to the program, the service this minister conducts should last an hour, and indeed after exactly an hour has elapsed, no more and no less, he ends it. It is the same every time; his punctuality exceeds Kant's. What is more, when the service is over he marches double-time to the door of the church, where he exchanges a few perfunctory words with each worshiper. His polite attentiveness and warm courtesy are just like those of a YMCA secretary. At first I thought it an individual peculiarity, but then I found more or less the same thing in other churches in the area. And if the older pastors act this way, it goes without saying that the younger ones are altogether conventional in manner.

The philosophy department at a certain elite university here is considered one of the best in the country. The senior professors are all pretty old and what they are really like I do not know, but I have met several of the younger big names. According to my feeling, philosophers ought to seem a little different from ordinary people. One of these professors, in spite of the fact that he is famous throughout the English-speaking world, is personally amiable and easily approachable.

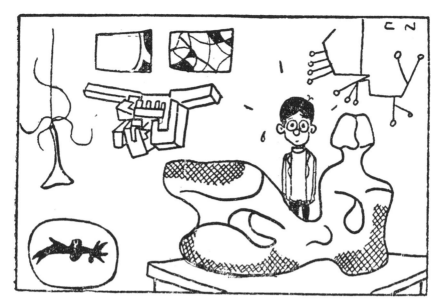

*Figure 17.*    Modern art, 1960s. "A corner of the Art Institute in Chicago." From Zhao Ning, *Zhao Ning liu-Mei ji*, 135.

But he is a little lacking in what I had hoped to sense. He enters a room abruptly, moving quickly and vigorously just like a soccer star. "Ai," the traveler sighs. "How can a great philosopher be like that?"

From what I have observed, religious and philosophical circles are for the most part this way. There is no need to ask about ordinary people—they are largely just office-worker types. Then, it is the same with females' sense of beauty; American girls like to doll themselves up from head to toe. There are pathetically few American women who do not have permanents. In fact their hair is curly enough already; why do they insist on giving their money to beauty parlors? And not just young women; almost all of the older ones do it, too. The lady who lives downstairs from me is on the other side of seventy and, having lost every bit of her hair, wears a wig. One day, supported by her daughter, she set out shakily for Boston. I thought they had gone shopping, but when she returned her wig was suddenly all trimmed and completely different. I had never imagined she could care so much about three thousand artificial hairs as to undertake a trip all the way into Boston for them. Of course, to look at this positively, we see here Americans' virtues, too. They are energetic, not intimidated by old age, and always interested in things. True enough, but I do not think these are always

necessary. Compare the French girls I have seen, who have, instead of permanents, hair worn loose down to their shoulders so that it moves in the breeze like willow branches. Is this not beautiful, too? I prefer naturalness.

I cannot explain the Americans' lack of a sense of personal style, unless it is part of the mentality and lifestyle of advanced industrial civilization. But do not seize on my saying this to talk to me about China's Confucian moralists. Those whom I have seen have been to a man priggish and affected, and some are unbearably foolish. That does not matter; what makes one most uncomfortable is that while in their "great writings" these gentlemen exhort others in a tone higher than heaven, their own behavior is in fact quite unworthy. This shows the bankruptcy of their line, its inhumanity and unreasonableness. Apart from the Confucians, however, are any of China's other types of personality at all attractive?

# Black
# Ghost

Yu Guangzhong, 1965

*Yu Guangzhong (1928– ) is one of Taiwan's most famous poets and essayists, and he has taught English and Chinese literature at various universities in Taiwan and Hong Kong. Yu holds a master of fine arts degree from the University of Iowa and has come to the United States several times to teach at different colleges, including Gettysburg College, where he was when he wrote the following piece.*

*This sensitive Chinese writer finds ghosts in America, even if Americans do not. In rhapsodic, almost hallucinatory prose, not inappropriate to the subject, Yu shows an America that is stimulating for having produced a great artist, Edgar Allan Poe. Clearly, American culture, in the form of Poe's writings and his memory, has become part of Yu's own heritage, and is not alien in the least.*

Although it was noon, a black shadow of odd shape was pressing on my mind. Eddie and I were sitting on a black iron railing that ran along the stone steps of someone's house, gazing silently and unhappily at the scene in a small alley. This should be considered Baltimore's slum. Black children in the back door of a smoky red brick house were jumping rope, riding on a skateboard, and arguing loudly. The wooden door of the basement opened at an angle toward the street like an air-raid shelter. Black women with protruding eyes, thick lips, and no waists trudged up and down the stone stairs in and out of the house, and from time to time shouted like crows cawing to stop their naughty children. A skinny old black man staggered slowly from the end of the alley, a shriveled mouth mumbling something underneath a broad nose

half covered by the brim of a ragged woolen hat. Even if you sharpen all your hearing senses you cannot make out this kind of Negro English, with its indistinct consonants and blurred vowels.

"Hey, what time are they going to open the door?"

"What?"

"I'm asking when the caretaker is going to open up?"

"The caretaker ..." Under the ragged hat his unkempt beard moved. "Open what?"

"Open this run-down house of Edgar Allan Poe's!"

"Poe? Who is Edgar Allan Poe? I've never ..."

A robust middle-aged man halted his steps and stared fiercely at us. I explained to him that we had come especially to visit Poe's old home, and that although it was past opening time the locked door still kept people out.

"I'm not sure." The robust black knitted his brow. He pointed at another black across the street, "Ask him."

"Oh, you want to see Poe's house?" A worker, grease all over his face and dirt all over his body, crawled out from under an old Ford. "You can't tell with this fellow. Sometimes he comes and sometimes he doesn't. If he's not here by three, he's probably not coming."

Eddie and I walked over to Poe's house. At the top of three wooden steps, a rectangular plaque hanging on a white wooden door said: "203 Emmart Avenue. Edgar Allan Poe House. Open: Wednesday and Saturday, 1 P.M. to 4 P.M." On the upper right-hand side of the door was nailed a bronze plaque with the following words engraved on it: "Edgar Allan Poe lived here." Like the houses of blacks on both sides of Emmart Avenue, number 203 was also a two-story red brick house. It was a typical mid-nineteenth-century lower-class home, narrow in front with two wooden shutters outside glass windows, a small basement door opening to the street, and another small gable window on the slanted roof. Eddie and I went around to the back of the house and peeked through the iron bars for a long time, but there was nothing to see except a cramped little courtyard.

This was the fourth time I had visited Baltimore. The second time was with Wang Wenxing, in a downpour. The third time was as a guest at the home of «Prof. Oliver W. Quinn of Goucher College»; it was a Sunday morning, one half of Baltimore was in church and the other half in bed. It was just in the middle of the cherry blossom season; cherry blossoms were blooming like miles of brocade, the «weeping cherries» hanging down their bashful pink petals in the thin spring drizzle, and mixed among them magnolias with their white blossoms

lined with red. On people's green lawns, tulips went all the way with red, their scarlet petals like drops of frozen blood. We slowly slipped south along broad Charles Street, turned onto Saratoga, and then into Emmart Avenue. Because it was raining, we merely looked at the old building through the rain-streaked car window. Afterwards we also stopped at the port and in the steaming rain saw the white ship *Star*, which dates from the late eighteenth century. It was a rainy morning that should become part of a volume of poems, although I still do not have any poem to attest to it.

This, the fourth time I had come to Baltimore, was at the invitation of Goucher College to give a lecture on Chinese classical poetry. As the lecture was at eight in the evening, I had the whole afternoon to call on Poe's black ghost in the red dust of Baltimore, so I asked Professor Quinn's son «Eddie» to come with me. We two Poe fans waited from 1:00 to 3:15, but the caretaker of the Poe house never showed up. I wanted to have the experience of going inside the house because Poe had lived here for over three years, from 1832 to 1835. Actually, it was the home of his widowed aunt, «Mrs. Maria Clemm», and Poe only stayed here temporarily. It was on this street that Poe first fell in love with his younger cousin «Virginia», who had tuberculosis. At the end of summer in 1835, Poe went south to Richmond to become an editor, and Virginia and her mother Mrs. Clemm followed. The next year, on May 16, they were married in Richmond.

The site of Poe's early work and love is within these four red brick walls. I wanted to enter in order to see the oil portrait of Poe over the fireplace, the old curtained four-poster bed, and the attic where his gothic imagination ran wild. If possible, I was even prepared to bribe the gatekeeper ten dollars to let me come back after my lecture that night and bravely sleep one night on Poe's bed. How can you achieve a ghostly poem if you do not enter the ghost's lair? I really wanted to try to taste sharing a bed with this black spirit, this prince of terror, this angel of melancholy. Even if at the hour of witchcraft I woke up from a nightmare in a cold sweat, a blind black cat pressing on my chest, an evil raven perched on the windowsill with the fire of hell in its pupils! Even if on the next morning I were discovered murdered on Poe's bed, my stiff hand still clutching his "The Masque of the Red Death," that would not be the worst thing that could happen—

"It's almost three-thirty," Eddie said. "The guy still hasn't come. Let's go."

"Let's look for Poe's grave."

In Baltimore in May, south of the Mason-Dixon line, the sun is

already fierce. It was the middle of a Baltimore newspaper strike. The *Baltimore Sun* was on strike, but the sun was not. The sun's rays were melting the tar on the road. The birds were silent. The hubbub of the city was indistinct and oppressive. The bass voice of black singers was upsetting. When the light turned red, the line of cars, stopped bumper to bumper, their engines rumbling, were like cats with their backs up howling. We walked north along Greene Street to the corner of Fayette Street and stopped. According to the map, Poe's grave should be here. Looking over a red brick wall not five feet high, we saw a rectangular graveyard less than an acre in size, the white tombstones standing in disarray, a two-story church rising up on the other end with a thick band of narrow windows and a tall slender bell tower, overlooking the realm of the dead. Suddenly Eddie called to me, "Mr. Yu, I found it!"

Running toward the sound of Eddie's voice, I turned around the northwest corner of the graveyard. A bronze plaque hanging on a black railing said "Grave of Edgar Allan Poe" and underneath "Westminster Presbyterian Church." Pushing open the unlocked iron gate, Eddie and I stepped inside. In the corner of the wall, Poe's grave was awesome. I say "awesome" because my heart was suddenly startled; it would not have seemed an awe-inspiring structure to a passer-by who was not looking for it. The marble monument was only as tall as a person and the stone base was just three feet square. The monument had four sides: the front side faced east, and on the top part laurel leaves and harps were carved, traditional artistic symbols. In the middle was a bronze bust of the poet in relief, more or less life-size. This powerful relief sculpture was loosely based on the oil portrait by «Thomas C. Corner». Curly hair fell down on two sides revealing a forehead that should be considered broad; thick dark eyebrows pressed on the ledge over his eyes, under which in deep caverns a suffering, sensitive, worrying black soul flashed out from hell's deepest recesses, but the somberly cold yet menacing gaze passed beyond the afternoon sun to fall into emptiness.... The bronze bridge and tip of his nose were shiny from having been constantly caressed by Poe fans for the last hundred years and looked like gold plate.

Unconsciously, I too put out my hand and rubbed the sculpture for a while. Under the blazing May sun the bronze imparted a touch of warmth. My heart gave a cold shudder, and goose bumps spread in waves over my forearm and cheeks. Suddenly Baltimore's city noise receded and the sun went black; I was standing in the nineteenth century—no, in dark nothingness without light, facing a pair of sunken, suspicious eyes; the black soul wailed and howled like a ghost,

lost angels flew desperately and blindly into each other, and the sound of mad laughter spiraled up from the bottom of an abyss. My heart was numb with pain—

"Look at the back—," from the other side of the abyss came my companion's voice. Giving myself a shake, I returned to Baltimore. I went around to the back of the monument and read the dates inscribed on it, "January 20, 1809–October 7, 1849." Though his talent was as vast as the sea, his life was like a thread. Here, underneath a mound of barren earth, was buried the most unhappy soul of the new world, the founding father of the detective story, the bridge from romanticism to symbolism, a man with the German sense of fear and trembling and with French clarity; here was the plague of hell, the disease of genius; here was suffering during life and desolation after death; buried here was terror in all its purity and beauty at its cruelest. A hundred years later his body has disintegrated and he has turned into spring grass and worms under the grass. But where did that sensitive and refined soul disappear to? It has not disappeared. Only that what was congealed before is now dissipated, what had functioned in one body now functions in countless bodies. When you think and when you dream, when you are distrustful and anxious, when you experience the purest terror, then you are Poe's reincarnation. What is experienced in a genuinely powerful way can never ever disappear....

At eight o'clock that evening in Goucher College's student center, I began my lecture this way: "Today is for me a day to remember, not only because I have the special honor of being able to introduce classical Chinese poetry to you, but also because this afternoon in the south side of Baltimore I respectfully visited the former house and the grave of your great writer Edgar Allan Poe and the Poe room in the Pratt Library. Poe's idea of poetry resonates at a distance with Chinese classical poetry. He contended that poetry should be highly refined and not valued for its length, that a long poem was not a poem. This theory would have been happily accepted by Chinese writers of quatrains. If Poe, carrying his slender volume of poems and riding a scrawny little donkey, should have appeared in eighth-century Chang'an [capital city of the Tang dynasty (A.D. 618–906), the golden age of Chinese poetry] because he did not understand the Heavenly Khan's traffic regulations, he would have collided—don't worry, not with ruffians using violence to sway an election for a political party—but with the chariot of Dr. Han Yu, the mayor of the city. Han Yu would have invited Poe to ride back with him to his official residence and introduced him to the young poets of Chang'an.

"Certainly, certainly, Poe would have met Li He, and in the course of conversation discovered that they shared the same taste for ghosts and fairies. Then the citizens of Chang'an and its aristocratic youths would have seen the two men together riding donkeys. His lines of poetry would have been thrown into the young servant's old brocade bag. Sooner or later he would have been kicked out by Li He's mother for being drunk. Finally, the citizens of Chang'an would have seen him and the poet Jia Dao competing to catch lice in the porch of an old temple.[3]

"I am very happy that this afternoon I found Poe's grave monument. I stroked his nose. When I return to China I will be able to describe today's excursion to Chinese poets, and I will stroke their noses so as to spread to them a touch of talent. In truth, at this moment I would rather be not on this platform but on Poe's grave under the moonlight. The moon is beautiful tonight, isn't it? Seeing Poe, you would think of Li He's famous line, «And amidst you autumn graves ghosts are chanting Pao's poetry». «Poe» and «Pao» are only a letter apart."

*Gettysburg, May 15, 1965, evening*

---

3. The figures named are all famous poets and writers of the Tang dynasty. Riding a donkey and getting drunk were conventional images of Chinese poets and free spirits.

# *Eating*
# *in America*

Cai Nengying, Luo Lan, and Liang Shiqiu, 1960s–1970s

*Food is taken seriously in China, which has produced one of the world's great cuisines; some people have called it an "oral civilization." For many Chinese, no matter how familiar they become with the West, American food has been a trial, and they have preferred to eat Chinese food while in the United States. The following three excerpts are from accounts written by visitors from Taiwan. The first, from an article "A Housewife Staying in America Talks About Household Matters," was written by Cai Nengying, apparently the wife of a graduate student.*

American restaurants are all the same. They prepare food in only three ways: boiled in water, grilled, and deep-fried; apart from these there is no other variety. Then, on the table a lot of "condiments" are served so that customers can make things as sweet, salty, sour, or peppery as they like. All over the whole country food stands on the street sell the same hot dogs, hamburgers, sandwiches, french fries, and so on; wherever you go the taste is the same. Especially for someone who has just arrived in America, the sight of a hot dog dripping with red tomato sauce and yellow mustard is enough to take your appetite away. But when you are hungry, there is nothing to do but close your eyes and swallow it. Hamburgers are even worse: semiraw beef with a slice of raw onion and a slice of raw tomato, and then some hamburger sauce—one dares not try it. Sandwiches sound good, but are in fact bland and tasteless. So eating is the most troublesome aspect [of living in America].

Being invited to dinner is a big treat for Americans, but I find it a

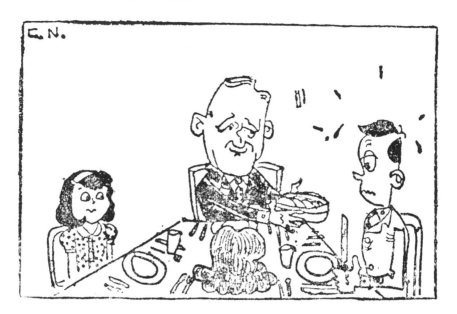

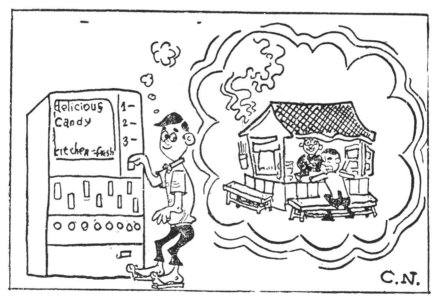

*Figure 18.*    Eating in America, 1960s. [*Top*] "Being invited to dinner at a foreigner's house." [*Bottom*] Thinking about a noodle stand (in Taiwan) makes the heart sad." From Zhao Ning, *Zhao Ning liu-Mei ji*, 56, 91.

painful assignment. First, I cannot get used to eating sweet and salty things together. Second, terrible-tasting food must be praised to the skies. Third, it is not filling and you have to make yourself another meal after going home.

One time a colleague said to my husband, Fan Guangling, "My father is a good cook and invites you two to have a taste of his culinary skill this weekend." It would have been embarrassing to refuse, so we had to accept. The meal turned out to be canned chicken with vegetables and rice, which tasted funny. Following this dish was a dessert of cored apples stuffed with plum jam and coated in sugar. Eating it made me feel like vomiting, but I had to say, "Delicious! Delicious!" It was unspeakably painful.

Often when we were invited to dinner by Americans I felt that they were not inviting us to eat but to look at the tableware. They do not use rice bowls. At the beginning of the meal the table is set with three plates for each person, three glasses, knife, fork, big spoon, and little spoon. The big spoon is seldom used, however, for they do not drink soup but lots of cold water, so the glasses see much service. The first course is usually raw salad or fruit salad, followed by bread and butter. After that some strange-looking and odd-tasting little dishes are served while people eat and talk. Then comes the main course, usually a piece of chicken or steak or a slice of ham, with a few fried potatoes, and some peas, or whatever, boiled to a pulp. When this is finished dessert is served, fruit pie or ice cream and cake, which is murder to eat for it is tasteless. Moreover, it is not a lot of food in the end, but just a lot of dishes and silverware on the table. Last comes coffee or tea. American tea is a bag of tea leaves in a cup of hot water, at which point the dinner is considered over. Then you are invited into the living room to talk for two or three hours. The foreigners talk and laugh, and we Chinese do not understand what is being said. It is really unbearably painful. That is why I find eating American meals most troublesome.

*This next excerpt is from a book by Luo Lan, a popular television personality who spent two months in the United States in 1970 at the invitation of the State Department. She had a generally favorable view of America—but not of the food.*

How do Americans eat? Even Chinese who have never been to the United States know that they eat very simply. Especially what they serve guests is, to Chinese eyes, so simple as to seem almost stingy.

For breakfast, ordinary Americans eat bread, coffee or milk, and a

glass of fruit juice; only those who are not dieting have fried eggs, sometimes with a little ham. For lunch they hastily stuff a sandwich or hamburger into their mouths. Only in the evening do they have a serious meal, but this serious meal is merely soup, a plate of salad, and a main dish, plus bread and dessert. To us Chinese, that is no more than two dishes and a soup, and could not be more humble.

Many Chinese who have been invited for meals in American homes have had the feeling that there were not enough things worth eating. You sit in the living room waiting and waiting, and then after much to-do the hostess announces that dinner is ready. You go in and see: a bowl of salad, half a small panful of beef, a basket of bread or a plate of rice. You take a plate and serve yourself a spoonful of each, and then must wait until dessert for something to fill your stomach. Sometimes when there are many guests, the buffet table will seem well laden with various dishes, colorful and attractive. But when you count up you find, apart from hard-boiled eggs, turkey slices, ham slices, beets, and boiled potatoes, there is only one real dish. Chinese cannot get used to seeing this, and cannot get used to eating such fare. Some Americans these days are aware of Chinese feelings about being invited for dinner and will jokingly ask if you had a bowl of noodles before coming.

And what is also strange is how Americans can eat so haphazardly and still grow as tall and stout as they do.

Comparisons have been made, and Americans are known to be the largest or next to largest in physique of all the peoples in the world today. Sitting on the bus I have seen heavyweight drivers holding the steering wheel, so broad-shouldered and stout-waisted that it seemed that were the bus to tip over they would be able to right it effortlessly with their bare hands. Seeing their physical size, you cannot help thinking of the phrase used in our historical novels and novels about fighting heroes, "with the back of a tiger and waist of a bear." ... Is it not strange that such large people can eat so simply? And what is stranger is that eight or nine out of ten of them are always dieting like mad.

It shows that nourishment does not necessarily go together with variety of food. In eating, Americans concentrate on one thing and do not mind a lot of one kind of food. They concentrate either on meat or on vegetables, and do not pay much attention to whether they are stir-fried, sautéed, or deep-fried, sliced long and thin or short and thick. The materials and preparation are both simple, but the food is amply nourishing. Children drink milk like water; meat is their main food-stuff, accompanied by bread. This is the opposite of what we do, which

is to take rice as the main food and accompany it with dishes of other things....

How much people eat may have something to do with their level of civilization. When people are too civilized, the purpose of eating changes from nourishment to taste, and they eat less but increase the variety of foods.... Americans work like mad every day and, busy and dead tired, do not care about a variety of subtle and refined dishes but only about quick and full nourishment.

*Finally, here is an article by Liang Shiqiu (1901–1987), a famous scholar, writer, and translator of Shakespeare. In the 1920s Liang studied at Colorado College, Harvard, and Columbia for three years. After retiring, he returned to the United States for four months in 1970 to visit relatives and wrote a short book about his impressions.*

The average American is not very particular about food. Even on a big holiday like Thanksgiving they do no more than just roast a turkey, a custom that is still carried on after over three hundred years. When I was a student in the United States, I lodged for a time at a Mrs. Mitchell's house in Colorado Springs. Several days before Thanksgiving the landlady's third daughter ran all around in a fluster declaring, "We are going to have a big turkey dinner!" When the big bird was served on the table the atmosphere was special; it should have been fragrant and succulent, but when you cut into it and tasted it, whether breast or drumstick, it was tough, old, and leathery! Furthermore, as the turkey was not finished in one meal, the disaster was extended to another. Ever since I have not had kind feelings about turkey.[4]

Hot dogs and patties of ground beef stuffed into round pieces of bread continue to be what ordinary people fill their stomachs with, still popular after a long time. Before, such things all used to be sold by small-scale restaurants. I cannot forget a little place near Colorado College that could hold at most ten or twenty people. The proprietress, wearing a black dress and with a lion's nose, would normally shout in a loud voice, "Two dogs! One *heng-bo-ge-er*—raw!" With a lot of mustard and black pepper, especially when one's stomach is growling with hunger, such things can solve the problem. This time in America, more than once I had giant-sized hamburgers: three pieces of bread wrapped

---

4. In the 1940s Fei Xiaotong believed Americans ate Thanksgiving turkey—which he had to force down with ice water—in order to remind themselves of how hard life had been for the pilgrims; *Chufang Meiguo* (First visit to America) (Shanghai: Shenghuo, 1946), 17.

around two layers of meat with pickles and lettuce added, thick and tall—not easy to eat for someone with a small mouth. One of them just about makes a meal.

American breakfasts are, in all fairness, very lush and must not be dismissed just because we are prejudiced in favor of deep-fried crullers wrapped in sesame-seed flat bread. I love «pancakes» and waffles and naturally wanted to try them once on this trip to Seattle. One day the whole family went for breakfast to an "International Pancake House"; though the place was not small there were no empty places, so we had to take a number and wait. After getting a table, we discovered that there were numerous different kinds of waffles, and it was not nearly as simple as it had been a few decades ago. Each of the six of us ordered a different kind, which the waitress found strange. There was a rich variety of flavorings added on top of the waffles, not just simple old syrup. As I was just over an illness, I did not dare let myself go, so I only took several bites. But the pancakes that [my daughter] Wenqiang makes at home for me with a special artificial sweet syrup I find as delicious as can be.

In the neighborhood of Seattle's harbor and the lakeside wharves there are little restaurants specializing in seafood, with dishes like deep-fried fish, oysters, clams, and so on with french fried potatoes and tartar sauce, which have their distinctive flavors. I cannot forget «barbecue»; almost every family in America has equipment for it, an iron apparatus set up in the backyard burning charcoal balls, a big piece of beef ribs sizzling as it grills so that "one family's meat is fragrant for three families." Fortunately [my son-in-law] Shiyao bought a heavy wooden table and chairs, brought them home himself and set them up with his own hands. The job of cleaning the grill afterwards each time is not easy and in fact a burden for the housewife. But a family whether big or small, now cooking and now eating, contented with full stomachs, is a wonderful thing.

America's cafeterias, which can be big or small, are all clean and orderly, devised to meet the needs of a rushed society. Naturally, they do not have the relaxed and leisurely atmosphere of a big banquet or little dinner in our Chinese restaurants, much less do they have the high-spirited atmosphere of our finger-guessing drinking games with glasses and dishes in disarray. But the food is filling and nutritious, and saving time and effort for other things more important than food must be said to be a good system. What is regrettable is that there are more cold things than hot and that things that were originally hot have turned warm by the time they get to your table; really hot food cannot

be obtained. In another kind of self-service restaurant each person pays so much, and you can then keep taking food at will until you are full; in order to preserve the particular Scandinavian flavor of this so-called «smorgasbord», the restaurants are frequently decorated with figures of «trolls» from North European mythology. In such a restaurant the foods served are necessarily not the finest, and if at the end of the line there is a big roast beef, a chef will certainly be standing beside it prepared to carve for you a thin, thin slice!

As for «drive-in restaurants», what they serve can only be considered snacks. All the way from New York to Detroit we stopped for meals at local «Howard Johnson» cafeterias; the food was not bad, sometimes their fried chicken was crisp and juicy and as good as so-called Kentucky fried chicken (invented by a colonel). But every morning and every evening, after a few days the appetite begins to wane, so that when we got to Buffalo in Canada [sic] we immediately went to a Chinese restaurant, and the moment a pot of hot tea was served we felt more relaxed.

Speaking of Chinese restaurants in the United States, in the past they specialized mainly in chop suey and chow mein, which was enough to fool their foreigner customers; in the last few years they have made enormous progress, and I hear that some places are up to Taiwan standards. But when we were in Washington and went to the most famous, * * * Restaurant, we were very disappointed. Leaving aside the unctuous Shanghai manner of the waiters, the service of the dishes was completely wrong: the first thing served was a big bowl of hot-and-sour soup;[5] when the soup was finished, we had to wait half an hour before seeing the second course, and several dishes were greasy and sticky and all made the same way, as though they had no skill to speak of. On the wall were hung several dozen photographs of important American politicians, including presidents, who were said to have been customers at this restaurant; on another wall were a pair of Chinese hanging scrolls, which could truly be called mixing together the refined and vulgar.

When we went to New York, as soon as we arrived Mr. Pu Jialin took us for breakfast in Chinatown, where there were fried crullers, little dumplings, and soup noodles of various kinds, which tasted just like at home. Later we were given a big banquet at a Sichuan restaurant; to have such a treat abroad is rare indeed. Seattle's Chinatown is small and its restaurants not distinguished; once we went to Vancouver in Canada for a gluttonous treat.

---

5. Soup is usually served toward the end of Chinese meals.

All my life I have greatly disliked discussing and hearing others discuss Chinese versus Western culture, for the subject is too broad, one person's knowledge too limited, and unless you have truly mastered China and the West your remarks will of necessity be rash and shallow. But if the discussion is limited to a particular concrete question, then it is easier to make a comparative judgment. If we talk about food there is no reason not to make a comparison—but how hard it is to do! When we Chinese first come to the United States our bloated stomachs have not yet shrunk and are most of the time in a state of semistarvation, and we have not forgotten our philosophy of always seeking the most refined when it comes to food, so that when we see canned food we are apt to regard it as "dog food."

Afterwards, even if our financial situation improves, it is rare to have the opportunity to rise into upper-class society and even rarer to be able to become a "gourmet." Therefore it is not easy to criticize American food. When I was younger I boldly declared that our Chinese cuisine was decidedly superior to that of the West, but today I no longer dare to have such excessive self-confidence. Furthermore, the food of the majority of our people is questionable from the point of view of nutrition. And on average we spend 40 percent of our income on food, which shows that we are still very poor—so how can we talk about an art of eating and drinking? People who are meticulous about harmonizing dishes waste too much time and effort. People who consider food to be heaven are already pitiable enough; as for establishing the nation on the basis of our food, is this reasonable?

# A Family
# Christmas

"Jiejun," ca. 1970

*All that is known about the author of this essay is that she came from Taiwan and was studying at an American university at the time it was written. She spent the Christmas vacation as a baby-sitter in a big American household—an ideal vantage point from which to observe family behavior. Unlike the major holiday season in China—the New Year's celebrations in January or February, a time of family ritual, feasting, and excitement—the American holiday bustle seemed to her to lack meaningful family togetherness.*

## THE WHITE MANSION

The second time I worked as a «baby sitter» was one winter when I was in Minneapolis. School dormitories are closed in the days around Christmas; it is not much fun to spend the holidays overseas to begin with, and having nowhere to live in addition makes one doubly lonely. After feeling sorry for myself for a while, I went out to look for short-term work in exchange for room and board. After going through the ads and making telephone calls, I ended up with «baby-sitter» work again. The place was the White [?] mansion. I call it a mansion not only because it was in the wealthy district of Minneapolis, next to the lake, but also because the White family employed one or two part-time workers in addition to a maid. Mr. White was the chairman of the board of a «hearing aid» company. Though the mother of seven children, Mrs. White was still youthful and pretty. Mr. and Mrs. White were members of the Minneapolis «country club», as I expected.

The objects of my care were their three daughters; Anna, aged eight, Wendy, five, and Shirley, three.

The household had a holiday air to it. Pine branches spread around on the floor of the living room gave off a faint fragrance, and Christmas decorations had been brought up from the basement, where they had been stored for a year. A big calico cat burrowed in and out among the pine branches and between the boxes. Mrs. White briskly fluttered down from upstairs to give orders to the maid, ran back upstairs to get ready to go out, and having just gone out the front door came back to tell the hired woman what kind of material to put on the sofa pillows. Down the kitchen corridor came a gust of warm air and the sweet smell of ginger cakes. The side of the living room that faced the lake had three large glass windows that extended down to the floor (the White mansion was built on the side of a hill next to the lake), giving a view of the surface of the lake and the bare trees surrounding it, and of pale mountains in the distance.

### A FIVE-YEAR-OLD WHO
### NEEDS TO LOSE WEIGHT

The quantity and variety of toys in the White children's playroom would have been enough to open a small toy shop. A television set was in the corner, facing a leather sofa covered with a jumble of jigsaw «puzzles», balls, pencils, string. The wall was crowded with stuffed puppies, kittens, tigers, bears, and so on and so forth—it was a miniature zoo. Piled up in the corner like corpses were dolls that could close their eyes, dolls that could walk, dolls that could talk, and even one wearing a black velvet evening gown. Electric trains, tracks, blocks, and windup cars were scattered around the sofa as though an earthquake had just occurred. A brightly colored «hula» hoop leaned against a chair. Nearby a small dining table set with teacups and plates was next to a small electric stove, a refrigerator, and a portable bar set—every kind of toy you can think of was there.

Were I a child again I would be so happy to touch this and look at that, that I would not know where to start playing; even now I am filled with envy. But a moon that can be plucked down is never as good as the one in the sky. The three mistresses who owned so many toys never valued their things. Dolls' legs and bears' tails were frequently damaged. The game they liked best was jumping and rolling: climbing onto a table, jumping from table to sofa, and then rolling from the sofa onto the floor. The next favorite was forming a three-person train and

coursing upstairs and down. Every time they played this "dangerous" game I had to follow close behind to avert an accident. Due to favorable heredity and environment, American girls are robust, athletic, and probably more energetic than the average Chinese boy. Five-year-old Wendy was so well fed that she had already started trying to lose weight.

REUNION

Christmas day approached. Mr. White's eldest son Tony was going to return for vacation from military school on the East Coast, and the "train" that Anna led raced about even more energetically because a train was soon going to bring her big brother home. Any ring from the doorbell brought the girls rushing to the front hall to see. While their hoped-for big brother had still not appeared, the elder Mrs. White flew in from Pennsylvania. Like most American old ladies, she first appeared too fat to move, but in fact her movements and step were brisk. Though she had just gotten off an airplane, there was not a trace of fatigue on her face; her back was straight, and her high-heeled shoes sounded crisply and rhythmically on the floor. When she had just arrived and called warmly to her children and grandchildren, the first to come to the door were Anna, Wendy, and Shirley, but they seemed not to recognize old Mrs. White and stood staring as at a stranger. Only after their mother had prompted them two or three times did they utter the word *Grandmother*.

To Chinese eyes, the White family's reception of the old lady was somewhat lukewarm, including even that of her son, Mr. White. In the American nuclear family the grandmother is a superfluous person. Old Mrs. White, who had not thought a thousand miles too far to come for this reunion, often watched television alone in the basement to avoid disturbing her children and grandchildren. But she could not count on being able to see a program through to the end there. At any time her little granddaughters might burst in and without even asking their grandmother's permission turn the dial to Tarzan or a western. If the grandmother would say a word to stop this, the granddaughters would howl rudely. Once the old lady had become used to all this, however, she would not get angry but just shrug her shoulders or leave without saying a word. That Americans are polite to strangers and to ordinary friends but cannot maintain courtesy to the elders of their own family leaves one dumbfounded.

When Tony finally arrived, Mr. and Mrs. White embraced him

joyfully while complaining in a mutter, "Why didn't you come home sooner?" Anna, Wendy, and Shirley were at first stunned; after coming to, they threw themselves on him like three Pekinese dogs. He stretched out his arms and bent over and kissed them one by one, but the little sisters were disappointed that he was not wearing his uniform and carrying a sword. When the welcome was over, Tony made a tour of the living room and felt warm and secure to find a fire burning brightly in the fireplace and the piano and sofa in their old places. After a moment he caught sight of his grandmother leaning against the newly painted white wall. Throwing off his overcoat, he ran over and hugged her off the ground. Only then did old Mrs. White's wrinkled face break into a lasting smile.

### AFTER THE BUSTLE, A VOID

Christmas, which comes once a year, is a big event in an American family. Like other families, the Whites excitedly bought gifts, decorated the house, went to the post office to mail cards and packages—not until the day before Christmas could the arrangements be considered more or less complete. Once this activity had stopped, however, the house was so dull and cheerless as to seem strange and even depressing. Old Mrs. White sat on the sofa sadly watching the snowflakes flutter outside the window; nestled against her, the big calico cat slept soundly. Even the mischievous Anna, Wendy, and Shirley were surprisingly quiet, lying on the rug as gently as the cat, listening to "White Christmas" over and over with their eyes open. A big Christmas tree standing in the corner was dressed up like a young lady in her best attire, a shining gold star on her head, countless silver paper necklaces around her neck, and spread all over her skirt colored lights and silver stars and snowflakes—so beautiful, proudly standing in the corner like a lone flower appreciating itself. Mr. White strolled out of the study, a magazine in his hand, and looked around the living room. "Where has everyone gone?" he asked, his voice betraying impatience. He wanted the children to come see the goldfish tank he had just bought. Mr. White was probably already finding vacation at home empty and dull.

He threw the magazine on the sofa and, knitting his brow, asked, "Are we the only ones left at home? What about Tony?"

"He went to see his girl friend," the old lady answered.

"And Eric?" (Mr. White's second son).

"Looking for his schoolmates to discuss tomorrow's party."

"Ronnie?" (Mr. White's third son). He went down the list.

"Ice skating." The old lady pursed her lips toward the lake.

"How come Sheila isn't around either?" (Mr. White's eldest daughter).

The old lady shook her head.

"Sister is upstairs with Mommy washing her hair," whined one of the little girls, waiting to see the goldfish tank.

Americans look forward to holidays with the eagerness of children, but when the holiday comes and they have a few hours of leisure, they cannot stand it. They are used to being busy and want to have a lot of activities arranged for vacation so that it is passed in a state of excitement; otherwise they feel that it was wasted and that they did not have "a fun time playing." The average American does not understand the calm conversing, napping, strolling, sitting quietly, and various other kinds of leisurely relaxation that Chinese enjoy. They think they are alive only when they are "doing" and "moving."

LONELY CHRISTMAS EVE

Christmas Eve arrived. The colored lights on the Christmas tree in the Whites' living room were turned on, and the red, yellow, orange, and purple little lights wrapped around the tree were like clusters of ripe fruit. Plain pine branches were on the mantelpiece opposite, and in the fireplace were two big logs, one of them burning hotly, the flame spreading toward the two ends, accompanied by a light crackling sound. The three little girls hung three big socks on the brass grate in front of the fireplace. It was just like the picture on so many Christmas cards.

The big chandelier in the middle of the dining room, not used on ordinary days, was lit up, luxurious and elegant. The light glittered and shone on steaming steak, boiled peas, and potatoes on the table. Having cooked dinner (because the maid was off), Mrs. White and Sheila went off to find the diners. This simple dinner was probably cooked in forty minutes. (Americans think nothing of spending three or four weeks to paint the walls and decorate a house, but then devote only a few dozen minutes to the preparation of Christmas Eve dinner, which is more or less equivalent to our Chinese New Year's Eve dinner.)

Anna, Wendy, and Shirley were missing from the dinner table. Mrs. White raised her voice and bent over to shout to the basement, "Children, come up to dinner, quick!" There was no response, and Mrs. White raised her voice another notch.

"No, we won't come. The Lone Ranger is on right now," Anna

answered. They were usually addicted to television and had their food served downstairs when they did not want to come up. But Christmas Eve is supposed to be a family gathering. So when her shouting proved useless, Mrs. White had to go down, turn the television set off, and force the children, grumbling, to come upstairs.

This group dinner was eaten in a helter-skelter fashion, with people coming and going from their places. First Mrs. White accompanied Sheila upstairs to get ready for a dance; Sheila was sixteen and had just become old enough to go out. As soon as Sheila and her date had left, Tony wiped his mouth with his napkin and left the table to change his clothes to go out. A few minutes later Eric hesitatingly asked Mrs. White for the keys to the car, but she refused because accidents are frequent on Christmas Eve. So Eric unhappily went upstairs and changed his clothes to take the bus to see his girl friend. Ronnie ate his steak in a fluster and excused himself. Last of all, Mr. and Mrs. White left to go to a party at the country club. The little girls, who were used to seeing their parents go out, did not make a fuss and matter-of-factly said good night to them. After people had left one by one, leaving a mess of dishes and glasses on the table, the old lady sat at one side of the table and concentrated on cutting up the steak on her plate; it must have been tough, for she cut and cut.

As the night drew on people got quieter. The little girls were already fast asleep, and old Mrs. White and I sat idly in the living room. The Christmas tree, tall as the ceiling, seemed to look down on us disdainfully. I gazed around at the four walls, clean, white and empty. The old lady's face seemed especially white in the lamplight, her blue-gray eyes like a foggy sea. I wanted to say a few words to break the gloom; I looked at the rug and the legs of the easy chair, and my heart kept overflowing with tears of sympathy. Several times I lifted my head and faced the old lady, preparing to say something to comfort her, only I still did not know what to say. But there was no need to say anything, for she seemed to understand what was in my mind. With a knowing smile she said softly, "Respect for the elderly is a traditional Chinese custom, isn't it? Are people who still practice it these days really too backward?"

LIFE LIKE A CAROUSEL

Christmas and New Year's were not an hour longer or half an hour shorter than ordinary days. Old Mrs. White had been matter-of-factly received and was matter-of-factly sent off, neither leaving complaints

behind nor carrying joy away. Not long after, Tony boarded a train back to school. When Mr. White heard, he shook his head with limitless melancholy and sighed, "Tony came home, but we never had a chance for a good talk and now he is gone already." In his several days at home, Tony had found it hard to see Mr. White, and when he did see him spoke only a few words, for each was busy with his own parties and activities. I could not stop thinking of the carousels in American children's amusement parks. When one of these is turned on, the horses go ceaselessly around and around, but they never have a chance to come together. American life is certainly busy, but Americans like to be busy, they seek it, and in the end are so busy they do not know what they are busy for.

*( Sent from New Haven, Connecticut, USA )*

# America,
# America

Zhang Beihai, 1986–1987

*The greatest familiarity with America is attained by some
long-term residents who come to have what is really an insider's perspec-
tive. What could be more American than Zhang Beihai's nostalgia for his
first car and his detailed knowledge of hot dogs in the following excerpts?
His column "America America" appears regularly in "The Chinese Intel-
lectual" (Zhishi fenzi), a magazine written in Chinese and published in
New York. Zhang, who has also published fiction in Taiwan, came to the
United States in the early 1960s and now works in New York for the
United Nations.*

"CARS AND ME"

The twenty-some years since I came to the United States can be
divided simply into two periods, my driving era and my nondriving
era, roughly half and half. The first half, from the early 1960s to the
early 1970s, was the period when I drove in Los Angeles. The second
half, from the early 1970s to the present, is my New York subway
period....

This year, 1986, marks the centennial of the invention of the auto-
mobile. Let political scientists and economists ponder its political and
economic significance, and let specialists in engineering comment on its
mechanical capabilities—these questions have no attraction for me.
Just allow me to recall some fragments about cars and me.

I first came to Los Angeles in 1962 and got to know the automobile
kingdom of America and the automobile culture of California while a

235

student at the University of California. At social occasions, on campus or off, the sentence following an introduction was always, "What kind of car do you drive?" When someone was mentioned, it was not "Remember? —That Tom (or Mary) who is studying history," but rather "Remember? —The one who drives a white Corvette." What you were was what you drove. In the early 1960s a student who drove a Corvette was, if not a playboy or a girl from a rich family, then someone shamelessly affecting the image of one.

So as soon as I arrived in America I bought an old motorcycle, a «Suzuki» I think it was, for $150. Gasoline was 22 cents a gallon. For a dollar I could drive for over half a month. Unfortunately, after less than a year I had an accident and was injured from head to toe. The next day I sold the motorcycle for $120 and for $100 bought my first automobile in America, a 1953 Chevrolet, although my dream car was a '56 or '57 Thunderbird.

Already more than ten years old, a '53 Chevy with more than 100,000 miles on it, this car was a tank compared with any new car today. Those years were General Motors' best period for Chevrolets. American boys who liked to street race loved to buy cars made then, put in bigger and more powerful engines, and challenge unsuspecting dupes. More than once when I was waiting at a red light, especially late at night on Santa Monica Boulevard, a four-hundred-horsepower «Pontiac GTO», say, the most popular car then, would pull up and the guy, sure that my '53 Chevy was not an ordinary '53 Chevy, would raise his chin defiantly, step on the gas, and openly challenge me. I could only laugh sadly, for after I had driven it several years this '53 Chevy of mine had become a semicripple needing a quart of oil every twenty miles.

Because I was working while studying then, either at a gas station or delivering goods, or later overseeing a warehouse and dispatching a fleet of vehicles, my relationship with cars was as natural and unconscious as breathing. On the highway in those days I could immediately recognize the company, make, model, and year of any car coming toward me, passing on the left, or moving up from behind. Of course it was easier to recognize cars then than now. There were not so many foreign cars, particularly Japanese ones. I never imagined then—and it was not just me, but the whole United States and the automobile capital of Detroit never imagined—that this was the last golden era of the American automobile kingdom. And I happened to spend this last period when cars were beautiful in California, where the dominant culture was the automobile culture.

Those who have not lived in California, especially southern Cal-

ifornia and Los Angeles, can hardly comprehend the role that auto-
mobiles play in people's lives there. If Americans can be described in
one sentence it must be "Americans like being on the move." Ever
since the first group of mobile Americans-to-be crossed the ocean to
settle in the new world, other groups of Americans on the move have
crossed plains and mountains and rivers and lakes, traveling on their
two legs, on horseback, in horse-drawn wagons, on boats, ships, and
trains, extending the American map from the Atlantic to the Pacific.
This was America before the automotive age, and California played the
leading role even in this earlier act....

Whether one is looking at America with a critical eye or an admir-
ing eye, the most convenient target is California's automobile culture.
To give it concrete shape, just imagine superhighways with four lanes
in each direction, roadside fast-food restaurants, billboards, gas sta-
tions, motels, new car dealers, used car dealers, automobile junkyards,
parking lots, parking ramps, shopping centers, drive-in movies, and
weekday rush-hour traffic jams. These provide an ideal weapon for
people who detest this culture and lifestyle, and, at the same time, an
equally ideal weapon with which to defend their viewpoint for those
who yearn for this culture and life. Cars and the automobile culture are
a little like that psychological test over whether the glass is half full or
half empty.

After five years and another 100,000 miles, my '53 Chevy retired
in glory. I can't remember how many cars replaced it, but none could
compare, at least not in popular aura. In those days I drove my own
car making deliveries for a florist, ten hours on an average day and as
much as fifteen on something like Mother's Day or Valentine's Day.
Although one of my later cars was a 1967 Chevrolet, quite new and
powerful, it was a standard family sedan and no youths would want to
challenge such a car or the kind of person who drove it....

My driving era came to an end at probably about the same time the
era of the American automobile did. In 1972 I settled in New York
because of my work and changed into a subway rider. The embargo
of oil from the Arab petroleum-exporting countries came in 1973.
Twenty-five-cents-a-gallon gasoline and ten-mile-a-gallon eight-cylinder
American cars were, like childhood, gone forever. The age of the small
Japanese car began, an invasion of America of a different sort than
Pearl Harbor; on the contrary, Americans welcomed it with open arms,
the dream of the [Japanese] militarists being realized with each little
Honda and Toyota.

Although the New York subway system is as marvelous as Los
Angeles' superhighways, riding the subway can hardly compare with

driving a car. Except that there is one little response which is very natural, at least for me. Inside a crowded, dirty, chaotic, noisy, smelly, hot, and behind-schedule New York subway car, the sensation always surfaces in my mind of driving at one hundred miles an hour (before the oil embargo) on a straight and open Los Angeles superhighway.

There was one other thing. Coming out of the subway one day last year, I suddenly noticed parked at the side of the street a '53 Chevy exactly like the one I used to drive, even the color, light blue. In the rear window was a "For Sale" sign with a telephone number below. That evening I couldn't resist giving the number a try. The owner said it was the original body, freshly repainted, with a totally new engine and other parts, and the price was forty thousand dollars. He asked if I was a collector of antique cars. I said no, that twenty-odd years ago in Los Angeles I had had a '53 Chevy that was exactly the same, even in color; I had driven it for five years and it had been my first car in America. I reminisced with him about this and that concerning that car and me. He was touched and comforted me over the telephone for a long time.

### "SUMMER AND DOGS"

Summer came early in New York this year and it came hot. From early May to early September although there were not many days over 100° (Fahrenheit), still there were many more than usual over 90°, all of which are called «dog days». "Dog days" are just the perfect days to eat «hot dogs», of course....

Coca-Cola may have a longer history than hot dogs and be more of a worldwide symbol of American culture, and «hamburgers» may be sold wherever there are Americans (the McDonald's sign is quickly becoming an American flag). Still, if you ask any American, adult or child, what they think the true, 100 percent American food is, I will bet it will not be steak, not fried chicken, not even hamburgers, but the hot dog....

This American food is different from typical American foods like hamburgers and fried chicken. You need only crisscross the American continent from top to bottom and side to side to discover a most surprising phenomenon. There is more than one nationwide (or even worldwide) chain selling hamburgers, all the same, all with the same taste. Fried chicken likewise. Only with hot dogs will you find not a single nationwide chain; not even the famous «Nathan's of Coney Island» is able to open outlets across the country. The reason is simple. Although the hot dog is a 100 percent American food, each locality

has its own version and way of eating it, which does not permit standardization: Connecticut slices it open to grill; New York adds cooked onions; Los Angeles has a Mexican flavor and adds hot sauce—this, then, is the reason that hot dogs are the 100 percent American food. A McDonald's hamburger in Boston, Massachusetts, in the northeast, and a McDonald's hamburger in Houston, Texas, in the southwest, are all made in exactly the same way and have exactly the same taste. But hot dogs are certainly not eaten the same way in these two cities; it all depends on local taste. Therefore I consider the hot dog to be the most democratic American food. In the realm of the hot dog there can never be a one-party dictatorship.

All right, since I have actually dragged hot dogs and democracy in together, I might as well take it a little further.... Outside of hot dogs, America is not at all democratic in matters of food, while in China probably only in matters of food is there a slight flavor of democracy. Do I need to give evidence? All right, listen. A Cantonese [Sun Yat-sen] was president of the whole country, but we never heard of the whole country being forced to eat nothing but Cantonese food.... A Hunanese who wielded power [Mao Zedong] was able to purge and kill millions of people but would not have dared give an order that Chinese could eat only Hunanese cooking.... In Taiwan, although the Democratic Progressive Party is the first genuine opposition party in China since the 1911 Revolution, I will wager that it is still not going to ask the Legislative Yuan to pass a law closing all non-Taiwanese restaurants and permitting only chicken in *danggui* sauce to be eaten.

America for democracy and China for food (I'll buy a drink for anyone who can think up a second line to make this a parallel couplet)—I find it surprising that, with all the Chinese students from the Qing dynasty down to today who have traveled thousands of miles to study in America, I have never heard of one who wrote a Ph.D. thesis on this subject. Is it really not worth discussing? Yes, I know, dragging American democracy and Chinese food into a discussion of summer and hot dogs is getting more and more tiresome. No doubt some of you are already annoyed at me. No matter, I don't care, and moreover, in conclusion, I want to say something else that will also make people annoyed at me.

And that is: for Chinese democracy to catch up with American democracy will be just as difficult as for American food to catch up with Chinese food. Those who would scold me should notice, however, that I only said "difficult," not absolutely impossible; this is basically because I am an incurable born optimist.

# VI

# America Rediscovered: Travelers from the People's Republic

$F$rom 1949 until 1979 there was little direct contact between the People's Republic of China and the United States. The United States had supported Chiang Kai-shek's Nationalists in the 1940s civil war and continued to do so long after the Communist victory, refusing for thirty years to recognize the People's Republic as the government of China. For most of that time the U.S. opposed Beijing's entrance into the United Nations, enforced a trade and travel embargo with China, and maintained a close military alliance with the Nationalists on Taiwan, who were committed to "counterattacking" the mainland. In the early 1950s China and the United States were in effect at war in Korea. In the late 1950s open conflict came close in the Taiwan Straits. In the 1960s half a million American soldiers were sent to fight on China's doorstep in Vietnam in order, it was said, to contain Chinese expansionism.

During this period, the Chinese government and media promulgated one-dimensional views of the U.S., often sandwiching the word "American" in between "down with" and "imperialism." And neither private citizens nor scholars could challenge these stereotyped condemnations: travel to the U.S. was out of the question, access to American materials was severely limited, and the political climate was uncongenial to dispassionate analysis.

A dramatic improvement in the relationship between China and America, an inevitable though belated result of China's split with the Soviet Union, began around the time of Nixon's startling visit to China in 1972. But only with the establishment of diplomatic relations in 1979

have visitors once again begun coming from mainland China and writing about America on the basis of firsthand observation. In these accounts, the writers' sense of wonder and discovery—even shock— recalls the responses of their nineteenth-century Chinese forebears. The mainland writers marvel at exotic America and its technology, though their naive enthusiasm is tempered by a fear of the menacing aspects of big-city life. But graduate students on extended visits (some of whom will not return to China) are beginning to become more at home in American society, and one can expect more sophisticated writing about America in the future, some of it in academic journals like *American Studies*, launched in 1987.

# Cold War
# Denunciations

1949–1955

The Chinese intellectual climate in the 1950s was not unlike that in the United States, where Cold War rhetoric and McCarthyist hysteria created tendentious images of "the enemy." From its first days, the People's Republic of China denounced the United States as a predatory imperialist power. The Korean War prompted a massive anti-American propaganda campaign. Thousands of intellectuals who had had a Western-style education or gone abroad and others thought to be infected by American cultural influences were publicly condemned for their "worship-America mentality" and forced to repudiate the United States. In succeeding years, Hu Shi, safely in exile in the United States and Taiwan, was repeatedly castigated in the press for having purveyed American ideas. In 1957 Fei Xiaotong was assailed for, among other things, having been an agent of American cultural imperialism; Xiao Qian was branded a rightist, and even the Communist Party member Yang Gang, fearing that a notebook with some injudicious remarks (though not about America) had fallen into the wrong hands, was driven to suicide.

In 1949 the U.S. State Department issued a "white paper" on the history of U.S. relations with China; accompanying this compilation of documents was a letter of transmittal by Secretary of State Dean Acheson. In response to Acheson's characterization of America's "friendship" toward China, Mao Zedong wrote the following article.

"'FRIENDSHIP' OR AGGRESSION?"
*Mao Zedong*

Acheson is telling a bare-faced lie when he describes aggression as "friendship."

The history of the aggression against China by U.S. imperialism, from 1840, when it helped the British in the Opium War, to the time it was thrown out of China by the Chinese people, should be written into a concise textbook for the education of Chinese youth. The United States was one of the first countries to force China to cede extra-territoriality [rendering foreigners in China immune to Chinese law and Chinese courts]—witness the Treaty of Wangxia of 1844, the first treaty ever signed between China and the United States.... In this very treaty, the United States compelled China to accept American missionary activity, in addition to imposing such terms as the opening of five ports for trade.

For a very long period, U.S. imperialism laid greater stress than other imperialist countries on activities in the sphere of spiritual aggression, extending from religious to "philanthropic" and cultural undertakings. According to certain statistics, the investments of U.S. missionary and "philanthropic" organizations in China totaled US$41.9 million.... Many well-known educational institutions in China, such as Yenching University, Peking Union Medical College, the Huei Wen Academies, St. John's University, the University of Nanking, Soochow University, Hangchow Christian College, Hsiangya Medical School, West China Union University, and Lingnan University, were established by Americans.... Acheson and his like know what they are talking about, and there is a background for his statement that "our friendship for that country has always been intensified by the religious, philanthropic, and cultural ties which have united the two peoples." It was all for the sake of "intensifying friendship," we are told, that the United States worked so hard and deliberately at running these undertakings for 105 years after the signing of the treaty of 1844.

Participation in the Eight-Power Allied Expedition to defeat China in 1900, the extortion of the "Boxer Indemnity" and the later use of this fund "for the education of Chinese students" for purposes of spiritual aggression—this too counts as an expression of "friendship."

Despite the "abolition" of extraterritoriality [in 1943], the culprit in the raping of Shen Zhong [a student at Peking University allegedly raped by an American marine in 1946] was declared not guilty and released by the U.S. Navy Department on his return to the United States—this counts as another expression of "friendship."

"Aid to China during and since the close of the War," totaling over $4.5 billion according to the white paper, but over $5.9 billion according to our computation, was given to help Chiang Kai-shek slaughter several million Chinese—this counts as yet another expression of "friendship."

All the "friendship" shown to China by U.S. imperialism over the past 109 years (since 1840 when the United States collaborated with Britain in the Opium War), and especially the great act of "friendship" in helping Chiang Kai-shek slaughter several million Chinese in the last few years—all this had one purpose; namely, it "consistently maintained and still maintains those fundamental principles of our foreign policy toward China which include the doctrine of the Open Door, respect for the administrative and territorial integrity of China, and opposition to any foreign domination of China."...

Today, the only doors still open to Acheson and his like are in small strips of land, such as...Taiwan....The rest of the land of China—the mere mention makes one weep—is all gone, all dominated by foreigners, and the Chinese there have one and all been turned into slaves....Such is the logic of the U.S. mandarins. Anyone who reads Acheson's letter of transmittal to the end will attest to its superior logic.

*In autumn 1950 China and the United States went to war in Korea, and the Chinese press mounted a major "Resist America, Aid Korea" campaign to discredit America among Chinese. The flavor and substance of this campaign are exemplified by the editor's afterword to a booklet called "Look, So This Is the 'American Way of Life'"!, published in December 1950.*

"LOOK, SO THIS IS THE
'AMERICAN WAY OF LIFE'!"
*From the Editor*

These excerpts were assembled by us from extremely limited materials in a short period of time. The majority of the materials were published in American books, newspapers, and magazines; some are eyewitness accounts by Chinese who have been to the United States. Here the true face of American imperialism is presented to the Chinese people in its entirety and without alteration. Every Chinese citizen who is willing to recognize facts can see from these materials what kind of a country America is. It is a nation that is thoroughly reactionary, thoroughly black, thoroughly corrupt, and thoroughly cruel. It is heaven for a handful of millionaires and hell for countless millions of poor people. It is a paradise for gangsters, swindlers, hooligans, special agents, fascist vermin, profiteers, debauchers, and so on and so forth—all the dregs of humanity. It is the place where reaction, darkness, cruelty, decadence, corruption, debauchery, the oppression of people by people, cannibalism, and all the evils in the whole world today are produced or orig-

inate. It is an exhibition ground for all the crimes humanity can commit. It is a living hell—ten, a hundred, a thousand times worse than any hell the cruelest writer can describe. The countless evil phenomena produced there are more than the human mind can imagine. No one of good conscience can help but wonder how human spiritual civilization could sink to such a level!...

*The official picture of American government and society was based to a considerable extent on Soviet Russian materials, and this view was promulgated in study sessions, particularly in schools and universities. The "Handbook of Current Affairs," published by the government in November 1950, contains a three-part article on the United States. The part titles are: "Hate the United States, for she is the deadly enemy of the Chinese people," "Despise the United States, for she is a rotten imperialist nation, the headquarters of reactionary degeneracy in the whole world," and "Look with contempt upon the United States, for she is a paper tiger and can fully be defeated." The following is from part 2.*

"HOW TO UNDERSTAND THE
UNITED STATES"

I. The United States is now ruled by a small number of large capitalists; the American government is merely a tool in their hands; and President Truman is just a faithful running dog. The large capitalists in the United States have formed a syndicate known as the National Association of Manufacturers, which controls around sixteen thousand huge industries and capital of about $60 billion. This association is directed by a committee of twelve, composed of representatives of a few of the largest capitalists, such as the Morgans, Rockefellers, Mellons, and du Ponts. Mainly through this organization these large capitalists formulate American government policy. All the domestic and foreign policies and plans of the American government issue from or are approved by this organization. A pamphlet published by this organization declares that the Directorate of the National Association of Manufacturers "keeps in touch daily with leaders of Congress and directors of various departments and agencies, collects data for its members, and keeps related government offices (i.e., the American government) well informed of the views of the Association on current problems."

American government leaders like Secretary of State Dean Acheson; W. Stuart Symington, chairman of the National Security Resources Board; W. Averell Harriman, special assistant to the president on international affairs; John Foster Dulles, special consultant in

the State Department in charge of the Japanese peace treaty; Warren Austin, chief American delegate to the United Nations; and John McCloy, high commissioner in Western Germany, have all been sent by the N.A.M. to work in the government. Acheson is the head of the well-known Washington law firm, Covington, Burling, Rublee, O'Brian, and Shrob, which serves the Morgan, Rockefeller, and du Pont interests. Averell Harriman, manager of Brooks Brothers, Harriman Investment Bankers, is one of the wealthiest men in the U.S. Symington was manager of the Emerson Electric Company during the war. McCloy is an adviser to the Chase Bank of New York (Rockefellers). According to data published in Baker's *American Imperialism and the Marshall Plan*, up to the beginning of 1948 Truman had appointed fifty bankers, financiers, and industrialists to key positions in the American government.

Through these agents the large capitalists control every activity and action of the American government. The party in power, whether Democratic or Republican, is under the direct control of the large capitalists. The responsible leaders in both parties are mainly large capitalists or persons closely related to large capitalists, e.g., the Chairman of the National Committee of the Democratic Party at one time was one of the directors of du Pont and General Motors.... The U.S. Congress also is directly controlled by the large capitalists. In the U.S. Congress at present, according to *Izvestia*, there are sixty-eight big industrialists, thirteen bankers, and more than three hundred lawyers in the employ of the big firms and banks.

II. U.S. domestic policy is to oppress and exploit the people and strangle democracy and culture.

A. Large American capitalists hold by far the greater portion of the national wealth; they control the economic life of the whole nation, whereas the masses lead an extremely destitute and miserable life. According to statistical data, the two hundred largest firms in the U.S. in 1933 controlled 19 to 21 percent of the national wealth, 46 to 51 percent of the total national industrial wealth, and 60 percent of the material wealth (apart from the banking business). In 1947, there were forty-five firms, including banks and other kinds of businesses, with individual capital of over $1 billion, and the total amount of wealth controlled by these firms amounted to $103.4 billion. The total net profit of the large corporations in the U.S. during the seven years between 1940 and 1946, as indicated in a book on American labor conditions written by the Soviet writer Keshensky, amounted to $77.5 billion—a sum that exceeds the total income of all American citizens in 1938.

But on the other hand, what is the livelihood of the American masses? On the eve of World War II, the laboring masses, constituting 80 percent of the entire American population, got only 44.4 percent of the national income, according to *For a Lasting Peace: For a People's Democracy, no. 68.* In 1948 over 50 percent of American families had income sufficient to maintain only the lowest standard of living, according to a recently published report of the Bureau of the Census. The number of unemployed and partially unemployed has mounted to 18 million. There are more than 10 million homeless, and another 40 million people live in dirty congested slums.... Such is the real truth of the American way of life much boasted of and publicized by the U.S. propaganda offices.

B. The so-called democracy of the United States is a complete sham. "Democratic" rights can be enjoyed only by the rich, while the masses are completely deprived of them. The American system of elections is deceptive and dishonest. There are more than sixty kinds of restrictions on electoral rights, including property, racial, and residential requirements. One-third of the eligible voters were deprived of the right to vote in the presidential and congressional elections in 1948. Productive workers constitute 50 percent of the entire American population, yet there is not even one representative of them in Congress.

The people enjoy neither freedom to vote nor any freedom of speech, publication, meeting, or association. The secret police rule everything, as in Chiang Kai-shek's regime of regimentation. The FBI is a secret police organization on a grand scale, with over fourteen thousand plainclothes spies who specialize in persecuting people. They

---

*Figure 19.*    "Such Is America," 1950. From *Renmin huabao*, November 1950.

1. Armaments order.
2. "To help fight the Koreans." Tax contribution.
3. "We are digging your grave."
4. Plans for World War III.
5. "Everybody join the show."
6. Atomic king.
7. "Help."
8. Artillery shell.
9. American bakery.
10. Fresh produce.
11. "Eliminate blacks!"
12. List of the dead.

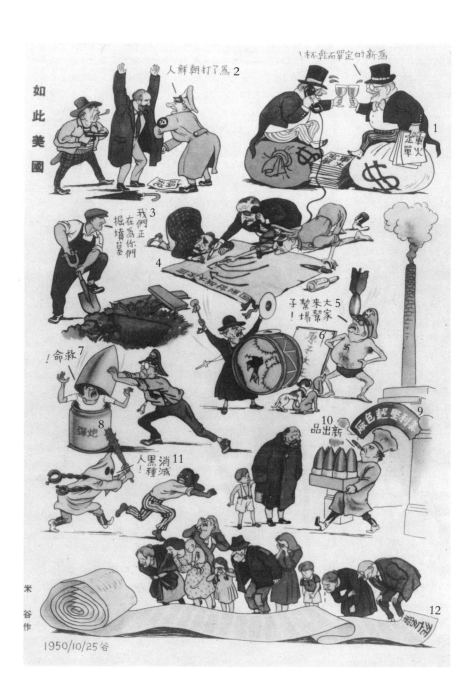

spy on the thoughts, lives, and activities of over two million federal civil service employees and force them to take so-called loyalty oaths. Because of racial discrimination, blacks in particular suffer the cruelest oppression. They cannot go to school with white people, nor walk together, nor sit in the same vehicle with them, and they are often wilfully insulted and arbitrarily put to death. The ruling class in the United States has tried every means to persecute the Communist Party.... The Ku Klux Klan, the American Legion, the America First Committee, the Silver Shirts—all these fascist terrorist groups are becoming more and more active every day. All this proves that the United States has already become the headquarters of fascist reaction.

C. American culture has become completely rotten and degenerate as a result of the oppressive rule of the capitalist class. American publishing houses and newspapers are almost entirely in the hands of the few big capitalists.... The National Publishers' Union and the National Newspaper Publishers' Union are the blood brothers of the N.A.M.; they are all organs of the large capitalists. All newspapers, magazines, and other publications have become war-inciting and antidemocratic tools under the thumb of monopolistic capitalism. Similarly, science and art are also strictly controlled by monopoly capitalists, who yoke them to the service of imperialism. Science is employed not for constructive work but for war; scientists are busy with the manufacture of atomic bombs, instruments of bacteriological warfare, and all the inhuman weapons of murder and destruction. Art does not promote progress but induces degradation; the greater part of American literature, movies, drama, and the fine arts spreads and teaches degradation, degeneration, mammonism, pornography, gangsterism, superstition, fantasy, war hysteria, and the like. The large American capitalists intentionally poison the minds of the younger generation with these noxious and poisonous matters and obliterate their sense of right and wrong in order to make them indolent in spirit and arrested in mental development so that the capitalists can order them around and make them their tools for aggression and war....

*Numerous articles discrediting American science and art were designed to counteract the appeal that these were feared to have for Chinese intellectuals. The following two excerpts are from "Rotten and Decadent American Culture," a book published in 1950. Hua Luogeng, the author of the first piece, is a mathematician who had come to the United States in 1946 at the invitation of the U.S. State Department; he worked at the Institute for Advanced Studies in Princeton and at the University of*

*Illinois before returning to China in 1950. Nothing is known about the author of the second selection.*

"HOW DOES AMERICAN IMPERIALISM
TREAT SCIENTISTS?"
*Hua Luogeng*

American imperialism has most clever methods for luring scientists. They have a so-called wartime research plan. The Navy and Army Departments sponsor such work; scientists who engage in such work can get an extra 40 percent to 60 percent subsidy in addition to their salaries. At first they said, you do not need to change your research plans and can continue to work on your present research; you only need to make two reports a year explaining your research progress. These were honeyed words to win people over; but once you entered the noose, they tightened it bit by bit. First they made certain regulations about the direction of your research, then they gave you some special topics, and finally on the excuse that "You have already participated in national defense secrets" they would take away your freedom of movement. (The above words are based entirely on facts known to me. In order to avoid adding to the difficulties of certain involved people who are still "alive" in America, I avoid mention of their names and the places and nature of their work.)

I heard, at the 250th anniversary meeting of the German Academy of Sciences which I attended, that Einstein had responded to an invitation to the meeting, "I will certainly come if I can get a passport." But in the end he did not come.

Einstein's experience in America can be seen from the following incident. When he published the "General Theory of Gravitation" around the end of last year, some newspapers "praised" it extravagantly in big headlines for a while. However, after Einstein warned the American imperialists this February not to play casually with hydrogen bombs, he offended the capitalists by exposing their dream of world hegemony, and they dispatched Congressmen representing their interests to say, "Einstein has made no contribution to atomic energy. He should have been deported long ago for his leftist attitudes."

How could American imperialist public opinion change so fast in such a short time? The reason is very simply, for American public opinion basically represents the interests of the Wall Street bosses, and from their point of view scientists are nothing but employees. A servant is "praised" by his master when he can be used by him; when a ser-

vant's declaration impinges on the master's interests naturally he will not escape censure.

Since the fate of scientists in general is like this, the treatment of Chinese scientists in America is even worse. Two months ago a Chinese professor teaching in America was suddenly summoned for an interview by the Immigration Bureau and asked to sign a document stating that (1) he was not a member of the Communist party, (2) he was not a fellow traveler, (3) he had no relatives or friends who were Communists, and (4) he would not return to China under the Communist regime. The Chinese scientist naturally could not sign such harsh terms, but in order not to suffer any immediate consequences, he had to reply mildly, "I cannot sign this document because my mother is in China and sooner or later I will have to go back to see her." Consequently the U.S. Immigration Service gave him the choice of being arrested, being deported, or changing his job.

This is a country that calls itself "highly developed in science." This is America's so-called freedom and democracy! Scientists living there are not only denied the freedom of being treated like human beings, they are also denied freedom of work and must do work they do not want to do. An authoritative scientist whom I met in Berlin this time put it well: "After the First World War, America was a haven for German scientists. But now, after the Second World War, American scientists will have to find another haven."

People's Daily, *Nov.* 17, *1950*

"ROTTEN AMERICAN CULTURE AND LIFE"
*Bo Yuan*

The United States publicizes itself as the "paradise of the capitalist world" and says that in this "paradise" there is "freedom," "democracy," and the "American way of life."

Crime statistics published by the U.S. Department of Justice provide an honest footnote to this vain propaganda. According to Justice records there were 1,393,000 crimes in the United States in 1944. This increased to 1,565,000 in 1945, and 1,665,000 in 1947. The number of criminals in 1945 was 6,000,000, which is to say that 1 in every 23 Americans was a criminal. There were 11,000 murders that year, 12,000 rapes, and about 12,000 armed robberies; the number of crimes increases each year....

Teaching people how to commit crimes...are the Wall Street tycoons and the ugly, rotten, dying capitalist system.

The "cultural" masters hired by Wall Street use "works of art" and all kinds of printed matter packed with sex, murder, and crime to drug and poison innocent people. After watching Hollywood movies for two weeks at the Venice International Film Festival in Italy a few years ago, an Italian film critic wrote, "All that played before my eyes in the last two weeks were murderers and other criminals, corpses, funerals, and suicides."...

The film *Blood on the Icecapades*, recently shown in Shanghai was just on this formula. The owner of an ice rink married an ice ballet performer. He also promoted a peanut seller to be his assistant. When the assistant formed a relationship with the wife, the owner tried to shoot him, but he missed and disappeared. Later, the assistant bumped into the owner in his residence and in the end killed him, putting the corpse inside a desk and burning it in a big fire. The wife of the owner became suspicious and the assistant wanted to kill her too, but did not succeed, and another mistress of the assistant's, whom he did not love, shot him. At the end of the movie the narrator says that the reason the assistant killed and was killed was that he was not content to remain a peanut seller all his life.

Not only do movies corrode audiences, nearly all American newspapers and magazines—except for a few progressive publications—propagate sex and murder. These 350,000 spokesmen for sex and murder rely for their living entirely on low-quality rumor and poison; their bosses are on Wall Street. Nearly all the newspapers in America are controlled by the petroleum king Rockefeller, banking king Morgan, chemical king du Pont, and a few other billionaires. American magazines can be said to be predominantly their mouthpieces. «*Time*», «*Life*», and «*Fortune*», which used to flood China a few years ago, are managed by Mr. and Mrs. Luce; he has been to China and ardently supported the reactionary Guomindang government. «The March of Time» newsreel, which used to be shown in China, is also part of his system. All these are also subsidized by the Morgan family. The Twentieth Century and Fox film companies belong to the petroleum king, Columbia Films belongs to a California banker, and Universal Studios belongs to Standard Capital Bank. Out of nine hundred publishing companies in America, eighteen publish half of all the nation's publications; their publications are almost all in the category of pornography and violence, and they ban progressive journals from publication. The American publishers association refuses to publish «Upton Sinclair's» novels exposing American capitalism («*Oil*», *King Coal*, and so on). He is forced to print and sell his works himself;

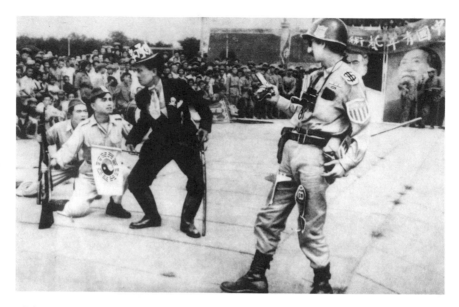

*Figure 20.*    Street theater, 1950. The caption reads, "The China Youth Art Theater performing the living newspaper play 'Paper Tiger' in the streets of Peking. The picture shows American imperialism ordering its running dog, the Syngman Rhee bandit clique, to cross the 38th parallel." From *Renmin huabao*, August 1950.

American newspapers once showed a picture of Sinclair standing on the street holding a copy of *Oil* for sale....

Newspapers and magazines controlled by big capital propagandize war, on the one hand, and sex and murder, on the other. «*Newsweek*», which together with *Time* inundated the Shanghai Bund a few years ago, featured a photograph of an almost naked girl—called a picture "to be cut out and hung on the wall"—in every issue during the gravest period of the war. This magazine was transported in U.S. military planes to American expeditionary forces and all the countries where there were American troops, as if what American soldiers cared about was not the war against fascism but (to use *Newsweek*'s phrase) "how women's legs could be lifted higher" for the camera. Shanghai residents will of course remember a 1946 issue of *Newsweek* in which an author taught techniques of kissing, saying there were three thousand ways to kiss. In the same magazine or similar ones you can find documented: an old man of eighty marrying a seventy-nine-year-old rich widow; a «Texan» betting he can swallow seventy-five lizards at one time; a movie actress becoming the tenth-odd mistress of a certain male

star; 120 cats committing suicide in a certain place one month—and these are just minor matters hardly worth mentioning!

«Pocket books», which have the largest sales in America, first appeared in 1939, selling for fifteen to twenty-five cents a volume; a few years ago Shanghai bookstores were full of them. These books are sold not only in bookstores and newsstands but also in clothing and food stores all over the country, and the publishers also organized large numbers of traveling salesmen to sell them in rural areas. The contents of these "pocket books" are clear from just the titles: *Adultery in the Elevator, The Three-Minute War, The G-Ray Murder Case* (by «G. H. Lee»), *Arsenic and Old Lace* (by «Joseph Kesselring»), and so on.

*Liberation Daily, Nov. 15, 1950*

*As part of the enormous efforts to reform the thought of Chinese intellectuals, pressure was placed on thousands of them, especially those who had been educated in the United States or in missionary schools in China, to confess their "worship-America mentality" and resolve to correct it. Here is a paragraph from a model self-criticism published in* Guangming ribao, *the national newspaper for intellectuals, in 1952. The author, Zhou Peiyuan ( 1902– ) is one of China's most renowned physicists. He had been trained in the United States in the 1920s at the University of Chicago and the California Institute of Technology, and returned twice for several years of research in the 1930s and 1940s. In 1952, when he wrote the article from which the following is taken, Zhou was dean of students at Tsinghua University. From 1967 to 1981 he served as president of Beijing University, the most prestigious school in China. Zhou returned to visit the United States in the 1980s.*

"CRITICIZING MY DECADENT
BOURGEOIS IDEOLOGY"
*Zhou Peiyuan*

During the four years of my first visit to the United States, I was able to see only superficial things like skyscrapers, automobiles, and the shamelessly dissolute and free-spending life of the exploiting classes, but not the tragic oppression of the toiling people by the monopolistic capitalists. I did not realize that the exploiting class had to squeeze the broad masses of the American people and steal the fruits of their toil before they could afford their free-spending lives. I read in the newspapers of the maltreatment and slaughter of blacks by the imperialists, but I did not realize that creating racial hatred was a consistent policy

of the imperialists to oppress the people. I managed to think that only a small number of bad whites were involved in the slaughter of blacks, and that the good whites were against it. I erroneously believed, therefore, that the "democratic" system in America was still "good" and that the people there had freedom of speech. Were not the American papers free to criticize the president? I did not realize at the time that the American president and the so-called government officials were simply lackeys of monopoly capitalism, and that the controversies in the newspapers represented only dissension among the various dominant groups. In short, when I returned in 1929 to take up a teaching post at Tsinghua, my entire being was infected with the ideological germs of the bourgeoisie. I was a peddler of American imperialistic culture and education, had forfeited my sense of national self-respect, and was ready to contaminate the youths of China.

*Thought reform in the early 1950s also involved an extended propaganda attack on Hu Shi, who was seen as the most notorious example of an American-educated academic of the Republican period. Hu was castigated for his gradualist, nonrevolutionary reform politics and his Western-oriented cosmopolitanism, among other sins. An eight-volume collection of criticisms of Hu was published in 1955–1956, at which time Hu was living in the United States.*

### "ELIMINATE HU SHI'S REACTIONARY POLITICAL IDEAS"
*Sun Sibai and others*

Hu Shi studied in the United States from 1910 to 1917, seven years in all.... When he went to America his philosophic ideas shifted from Neo-Confucianism to pragmatism, and he subsequently became a total believer in pragmatism. He took the philosophy of the American bourgeoisie as gospel, and as saints the likes of Peirce, William James, and Dewey.... Politically, he quickly changed to a cosmopolitan after going to the United States, and even called himself "a citizen of the world." At the time of World War I, American imperialism had taken up the slogan of "cosmopolitanism" in an attempt to resist [socialist] internationalism all over the world....

Many of Hu Shi's reactionary words and deeds in support of "nonresistance" are recorded in his diary of study abroad, of which we give a few examples:...On May 27 [in fact, January 23], 1915, he informed Miss Williams of his decision "to advocate the doctrine of 'nonresistance' and work for world peace groups," and "she, greatly

pleased, considered this my most important recent accomplishment, and encouraged me to keep to this resolve without slackening." Hu Shi thenceforward began to be opposed to war....

Then Hu Shi put forward his "fundamental plan." In domestic affairs, he said we were "to promote our education, develop our hidden resources [?], advance our civilization, and cure our politics"—that is to say, to allow imperialism to "civilize" us. In international affairs, we were "on one hand to advocate peace with all our strength, and work with the United States to encourage international morality"—that is to say, quickly to seek the protection of American imperialism....

If offered a choice of "ruler" between Yuan Shikai [President of China at that time] and Woodrow Wilson, Hu would choose Wilson, as "he who chooses Yuan because Wilson is of a different nationality is a fool infected with the poison of nationalism."...He said, "I consider myself a citizen of the world, I do not support narrow nationalism, and I especially do not like sentimental patriots."...

In his seven years in the United States, Hu Shi came to accept American imperialism's colonial education, to be a believer in the philosophy of "pragmatism," to worship the political principle of "cosmopolitanism," to feel awe at America's superficial prosperity, and to admire American "material civilization." At that point his reactionary system of ideas began to stabilize. The reactionary politics he subsequently advocated—things like "education to save the nation," "politics of planning," "wholesale Westernization," and so forth—all began to take shape at that time. This reactionary system of ideas... was formed by Hu Shi's throwing himself, and his original semifeudal culture, into the arms of imperialism (particularly American imperialism), and becoming a cultural comprador protected by imperialism in China and, in particular, a faithful slave of American imperialism.

# A Glimpse
# of America

Wang Ruoshui, 1978

*Mao signaled a broad shift in Chinese policy toward the United States when he received President Nixon in 1972, but diplomatic relations were not normalized until 1979. The earliest significant travel accounts of this new era were filed by a delegation of journalists who visited the U.S. in the fall of 1978. The most authoritative of their number was Wang Ruoshui, a high-ranking party ideologist and deputy editor-in-chief of the* People's Daily, *the official newspaper of the Central Committee of the Chinese Communist Party, in which his long three-part piece appeared.*

*Wang's impressions are freer, franker, and more personal than virtually anything on America that had appeared in the Chinese press since 1949. Still, he is careful to strike a balance between admiration for American technology and criticism of American social problems. This opposition of marvelous technology and bourgeois decadence—computers and striptease, as Wang put it—was to set the tone for much Chinese writing on the United States in the following years.*

*Though Wang was a party ideologue who had, for instance, attacked Hu Shi in the 1950s,[1] in the early 1980s his essays on humanism and the danger of alienation in socialist society were thought too liberal by more orthodox Marxists. During the campaign against "spiritual pollution" in 1983, Wang was dismissed from his* People's Daily *post. By 1986 he was once again writing about such matters, only to be expelled from the Communist Party in 1987.*

---

1. These early pieces might now be dismissed as historical artifacts except that Wang reprinted four of them in 1980 in a collection of his essays, *Zai zhexue zhanxian shang* (On the philosophy battle front) (Beijing: Renmin chubanshe, 1980).

CITIES

The plane was descending. Looking down through the window, I could see a beautiful city come into view on the ground, with block after block of buildings crisscrossed by a network of streets. The many sky-scrapers among them looked like matchboxes standing on end, and the cars slowly moving along the highways like children's toys. The city was so large that it extended beyond the horizon and even from an airplane you could not see where it ended.

This was Los Angeles. It was our first sight of America.

I was a member of a delegation of Chinese journalists that visited nine cities and their surrounding areas, from Los Angeles on the Pacific to New York on the Atlantic, from Detroit on the northeast border to St. Louis in the American heartland, traveling over ten thousand miles in three weeks....

The first thing that strikes your eye, of course, is the tall buildings. The United States has many works of architecture of which it can be proud. In St. Louis we visited the famous Gateway Arch, a stainless-steel parabola like a silver rainbow almost two hundred meters high that arches over one shore of the Mississippi and is visible from almost anywhere in the city. In Detroit we stayed at the 73-story Renaissance Center, a glass structure that includes several round towers—an original and bold concept on the part of the architect. In New York we were taken to dinner at the World Trade Center, two 110-story skyscrapers whose dining rooms can serve twenty thousand people at the same time and which attract eighty thousand tourists every day. The elevator took us to the 107th floor in only one minute. From there, called Windows on the World, you can look down in all directions. The view we saw that night of New York ablaze in lights was truly magnificent.

New York's crowded skyscrapers, however, also give you a feeling of abnormal development. The tall buildings block out the sunlight, and on the streets below pedestrians seem to be in shadowy canyons. People appear tiny, as though they were about to be squashed by these capitalist monsters.

There were many cars in the streets, needless to say, but traffic police were not to be seen at the intersections. The traffic lights are all controlled automatically. Nonetheless the traffic is rather orderly and there is not too much street noise. Sometimes a car coming at you when you are crossing the street will stop suddenly right next to you, but the driver does not honk his horn. Americans think that it is insulting for a

car to honk at you, and some states have gone so far as to prohibit honking except when absolutely necessary....

Service industries are well developed, particularly hotels and restaurants. Every large city has numerous Chinese restaurants. In stores the brightly colored goods are dazzling to the eye. Whether on airplanes or in hotels, in restaurants or in shops, service personnel are all courteous and polite. Of course, there is this business of tipping. In some cases you have to give a tip even to go into a restroom. Still, no matter what you say, the service is always good—as long as you can afford it....

Sanitation is not bad. Although it was late summer, we saw few flies in the cities. The streets were all clean, with the exception of New York's....

### AUTOMATION

Automation has become a part of everyday life.

The hotels we stayed at were for the most part first-class ones, but they had few service personnel. The elevators are completely automated and do not require human operators. If you want a glass of Coca-Cola or a cup of coffee, you can buy it from an automatic vending machine in the corridor. The image of the newsboy on the street has already become a museum piece, replaced by the automatic newsstand.

Most advanced are the automatic ticket-selling machines in the Washington subway, which operate without humans....

### WASHINGTON, D.C.

When Congress is in session, not only reporters but even ordinary people can go in and listen. Is there no fear of people making disturbances? No matter, there are police on guard who can grab troublemakers by the collar and throw them out....

### RELIGION

When we arrived in the United States, Pope Paul VI had just died, and when we left a new pope had just been selected. During this period news about the papacy dominated the newspaper headlines.

There is a Bible in every hotel room. On our visit to the White House I discovered that one of the two books on the president's desk is

a Bible, too. The Bible is the best-selling book in the United States, with about 8.5 million copies sold every year.

I read in an American newspaper of a "public opinion poll" that asked people if they considered President Carter a devout believer. Because many still answered yes, the paper said this showed the president had hope of recovering his prestige.

It is apparent that the dominant ideology in the United States, apart from bourgeois democracy with its basis in individualism, is Christianity....

That religion is still this powerful in the United States, where science and technology are so highly developed can be explained only by reference to the needs of the ruling class and by the fact that people still do not have control over their own destinies. I know that both drug use and religious activities flourished among the American troops who invaded Korea in the 1950s. American reporters at the time correctly pointed out that this was due to the soldiers' feelings of spiritual dejection and of their having nothing to depend on.

An elderly lady with whom we had dinner said that she could not comprehend how anyone could live without religion, that, as she saw it, life would be without hope that way.

And what about young people? What is the view of life of these young men and women who wear blue jeans and chew gum? What are they seeking spiritually?

In fact decadent hippies are rarely seen anymore. Many young people think only about finding a good job and are satisfied to achieve a comfortable material life for themselves. They are not concerned with politics and have lost their religious ardor. Some other young people are still searching for the meaning of life but are in a state of spiritual vacillation.

In a "motor hotel" in Tennessee a young man with long hair and a long beard asked us if we were Chinese, saying he was eager to talk with Chinese. He was a college student and, we soon discovered, his interest was in the philosophy and religion of China and India. Having rejected the civilization of the West, he was looking for peace of mind and spiritual release in the religions of the East. Unfortunately we did not have time for a detailed discussion with him.

We heard that Christianity is on the decline and that people who were originally Christians are turning to Far Eastern religions, including Daoism, Buddhism, and Hinduism. Many people want a god, apparently, and, as Voltaire said, if none exists they will create one.

*Figure 21.*     Hippies, 1960s. [*Top*] "Zhao Ning first sees hippies in San Francisco." [*Bottom*] "The demeanor of a hippy student in class." From Zhao Ning, *Zhao Ning liu-Mei ji*, 12 and 156.

THE PEOPLE

The United States has many attractive things, but what impressed me most were America's people and their friendship for the Chinese people.

Our host organization, the Association of American Newspaper Editors, had made thorough arrangements for our visit. Wherever we went we were received by courteous and enthusiastic people, and everywhere we saw friendly faces and pleasant smiles. Out of their heartfelt feelings, people wanted to approach us and converse. As ambassadors of the Chinese people, we felt very proud.

Americans' living habits are not the same as ours. On first contact, we may feel that their clothes are too bizarrely varied, just the way they may feel ours are too monotonous. At the house of a union official in Detroit, a woman was curious about the Sun Yat-sen suit I was wearing, something she had perhaps never seen before. What kind of clothing is this? Do you normally dress like this? Do Chinese women wear colorful clothes like ours? Why don't Chinese young people wear blue jeans? I said they did not like jeans, that it was a difference in custom. In the past some Americans who came to China thought it strange that many Chinese women wore trousers and not skirts in the summertime, but nowadays Chinese girls are wearing skirts more and more, while with American girls bell-bottoms and blue jeans have replaced skirts in popularity.

More important than such differences in living habits are differences in the social system, in ideology, and in history and tradition. When these differences are compounded by a lack of contact for a number of years, a situation is created whereby in the eyes of many Americans China is a mysterious country and, conversely, America is a strange one to many Chinese. All that is needed is a little more contact, however, and Americans will discover that China is not mysterious, and we will discover that America is not strange. The people of our two nations are capable of understanding each other.

The American people have many things that we can learn from. To be sure, the capitalist lifestyle is inseparable from eating, drinking, and pleasure, but to see only this aspect is too one-sided.

Americans are famous for their pursuit of efficiency. When they are working they are energetic and intense, and they clearly differentiate work and play. We were deeply impressed by this on our visits to numerous newspaper offices, television stations, press services, factories, and research institutes. The people working in these places would usually look up to greet us and then bury themselves in their work again. No one was loafing, nor was there idle conversation.

Although, granted, there are playboys and dissolute girls among American youth, there are also many who study hard and work diligently. Americans like to call theirs a "consumer society," but in fact how could there be consumption if there were no production? A society whose members knew only how to eat, drink, and enjoy th' mselves would have perished long ago. Without the industrious toil of a large number of workers and scientists, it is inconceivable that American production could have reached today's levels or that the United States would have been able to put a man on the moon.

Americans are not conservative or bound to the status quo. In this fiercely competitive capitalist society, anyone who does not strive for technological progress will be weeded out. They do not refuse to learn from abroad, even though their nation's scientific and technical level is the first in the world. The United States took in many German scientists when Hitler was in power and particularly after the collapse of Hitler's Germany, and this accelerated American scientific development, as is well known.

The Japanese are also good at learning from foreign countries. American friends told us that the Japanese had learned from America and even surpassed it in some areas. A leader at the Ford Motor Company admitted that Japan's Toyota automobiles were one of their major competitors, and at the Columbia Broadcasting System the two color television sets in the manager's office were both Japanese models. The manager frankly admitted that Japanese sets were better than American ones, which made me think, why can't we do what the Japanese can do?

We should be able to do even better than the Japanese. The Japanese learned both electronic computers and striptease from America, but we will study the good points of advanced capitalist nations while resisting everything that is rotten. We will study their science while rejecting their philosophy. We can also learn from their experience. Many good-hearted American friends told us they hoped that in the course of realizing our Four Modernizations[2] we would avoid America's mistakes, such as energy waste, environmental pollution, and so on. This is certainly worth our attention. We have a superior socialist system and should be able to avoid capitalist corruption.

We are pinning our hopes on the American people, and the American people are pinning theirs on us.

---

2. The modernization of agriculture, industry, national defense, and science and technology.

# *Working Students*

Xiao Qian, 1979

*Xiao Qian first visited the United States in 1945 (see chapter IV). He returned in the fall of 1979 to spend a few weeks at the International Writing Program at the University of Iowa, which has been host to a large number of important mainland Chinese writers during the 1980s.*

*The following article, published in the official* People's Daily, *was, for that period, remarkably favorable toward the United States. That many American students work their way through college has often caught the attention of Chinese observers, for in China college students enjoy considerable status and are not to be found holding menial jobs.*

It was just getting light and I wanted to do my easy *taijiquan* exercises on the grass across the way while there were few people around.

When I got on the elevator it was already crowded with people carrying multicolored backpacks with the name of the university on them. You could guess what some were studying—a stethoscope was sticking out of the pocket of one white coat. I noticed that not only were there no bell-bottom trousers, but not a single male student was wearing a tie. Some had frayed cuffs and some had leather patches on their elbows. I recognized only one student, who came from Lisbon and was studying economics. He had been in a corner of the library after eleven o'clock one night gnawing on a fat volume. Rubbing his eyes he had said to me, "I can't catch up. We're supposed to read an average of twenty-five books a week." I asked him if for lunch he went back to the Mayflower Apartments, where we both lived. He showed me his lunch box with a partly eaten sandwich in it. At noon he just took a few minutes' nap on one of the sofas in the library corridors.

I hid behind a clump of trees to practice my "single whip" exercises. There was a light mist over the Iowa River and the maple trees on the bank had a late autumn frost on them. Chestnut-colored squirrels scurried around on the grass and up oak trees full of acorns.

Cars carrying people to work were already rushing into the city like a tide. Just after I finished my exercises a blue-route Cambus stopped at the bridge. This is a bus that goes around the university campus, and one can ride for free. I got on in the middle of a crowd of students. The driver was a delicate-looking youth with a pointed chin, a little like Keats; next to his seat was a light-blue backpack.

I followed some others off at Washington Street. A blonde girl student got on. She said "Hi!" to Keats, pulled off her backpack and sat down in the driver's seat. Keats jumped down behind me.

"You must be a work-study student," I said to him.

"Right," he said, smiling, walking toward the university.

I decided to walk with him a little ways. Hurrying along, he told me he could earn four dollars an hour driving the bus. He spent about a hundred dollars a month to rent a room in a cheap boardinghouse. Money from driving the bus was enough for room and board.

"How about tuition? I asked. Looking at his watch and quickening his step, he just said, "I have a student loan, which I'll pay back in installments after I graduate," and he turned the corner at the tennis courts. As I watched him run toward a red building, I worried that my conversation might have made him late.

Turning back and walking toward the center of this college town, I passed shop windows full of all kinds of enticing displays: fashionable clothing, sparkling jewelry, and comfortable furniture. Absorbed in looking at the window of a musical instruments store, I suddenly heard, "Excuse me." A young man in a colored checked shirt was sweeping the sidewalk.

"Are you a work-study student?" I asked.

"Sure," he nodded with a proud expression.

Hardee's is a self-service, no-tipping, informal restaurant. I went in, stood in line, took a tray, and told the girl behind the counter (a work-study student with short brown hair) that I wanted coffee and pancakes. She gave me a packet of sugar and a little sealed container of syrup. I found a table near the window and sat down.

I thought I was eating very economically, but outside on a concrete bench on the sidewalk at the bus stop were two young people, each with a sandwich in one hand and a book in the other.

"Oh, you're having breakfast here, too, sir." A young man from

Shanghai studying computer science at the University of Iowa sat down opposite me. His family is in Cedar Rapids, the father a well-known scientist. We had met in the elevator of the library.

"Are you keeping up with your studies?" I asked with concern.

"It's certainly not easy." This talented student from China looked very worried. "Scholarships here are not like our stipends. They're not automatic, but depend on your grades each year. If your studies are not good, you may not get a scholarship."

Pointing at a waitress pouring coffee, I asked what kind of background these work-study students came from. He told me an interesting story. Last winter vacation he had a job in a big restaurant washing dishes (with a dish-washing machine). He worked together with three girl students. On the day before Christmas a luxury car stopped in front of the restaurant, and he saw one of the girls who washed dishes take off her apron, collect her pay, put on a mink coat, and after saying goodbye ride off in the car. He could not help being astonished. Afterwards one of the others told him that the girl's father was head of a well-known insurance company in Chicago and the family had a villa and a private airplane. At the time he could not understand why she would want to wash dishes. Actually, many American young people take pride in being self-supporting and think it is shameful to depend on their parents for a living. She washed dishes to satisfy this desire for independence.

On the way back, walking down Jefferson and Dubuque Streets, I saw people pushing electric lawn mowers in the yards of houses and a strong young fellow using an electric saw to cut up a dead tree into firewood to burn in the wintertime. They were all hard at work, so I did not bother them with questions.

I pondered how Franklin and Lincoln had struggled to study in their early years, and I turned over in my mind the following: Our officials have "iron rice bowls" [permanent jobs], our students have "iron" stipends. Without competition and without incentives, how are we ever going to catch up and overtake them?

*October 20, 1979*
*Mayflower Apartments, Iowa City*

# America
# Revisited

Fei Xiaotong, 1979

*The social anthropologist Fei Xiaotong, like Xiao Qian,*
*returned briefly to America in 1979 after an absence of many years. At*
*that time he had only recently reemerged from twenty years of political*
*disgrace—for, among many other things, having been an agent of "Ameri-*
*can cultural imperialism." For a month in spring 1979 Fei was part of an*
*official delegation from the Chinese Academy of Social Sciences, the top-*
*ranking research organization for social sciences and humanities. The dele-*
*gation stopped mostly at American universities, where Fei's contacts with*
*sociologists and anthropologists provided a ready source of information*
*about American society.*

*Naturally enough, Fei focused on the great changes that had occurred*
*in America since his visit in 1944 (see Chapter IV). Though particularly*
*impressed with recent technological and economic developments, he is quick*
*to point out his reservations about America's social and spiritual health.*
*Some of his condemnations of American society, however, are followed by*
*partial retractions (for example, the sections below on graffiti and on reli-*
*gion). This nervous uncertainty, quite uncharacteristic of his earlier writ-*
*ing, no doubt reflects his discomfort in the strange world of post-Vietnam*
*America, his uncertainty about the intellectual and political climate in*
*China, and his awareness of his new political prominence.*

## THE TRINITY OF CARS, GAS, AND ROADS

The automobile is nothing new of course; few people in America today
have not been familiar with them since childhood. But it is only since

World War II that it has become a necessity in the lives of the majority of Americans and had a profound impact on American society. The spread of this means of transportation in America in the last thirty years can probably be said to have brought great changes in the lives of Americans. As these changes occurred between my two visits to the United States, the contrast has made a particularly deep impression on me....

The vast expanse of the United States is like a spiderweb, covered with highways going everywhere. Transportation on land by automobile requires not only a car to drive and energy to move it but also a surface that wheels can turn on. Only on level and hard roads can cars move safely and at high speed. So if you want automobiles to go you must have gasoline and highways. Cars, gas, and roads are a trinity....

American cars now have belts on each seat to strap down the rider's chest. The first time I rode in such a car I greatly disliked this belt, which made me feel tied up. But my host persuaded me to let myself obediently be ensnared for safety's sake. This was a new experience for me; the last time I was in America I did not have to endure this kind of suffering when riding in a car....

In the American temple of wealth, as everyone knows, two of the chief deities are the automobile king Henry Ford and the petroleum king John D. Rockefeller. They symbolize the automobile and petroleum industries. Behind the massive growth of these two industries, the third element in the trinity of cars, gas, and roads lies hidden. This third is not part of private but public enterprise.... The interests of these two big industries are best served by having the federal government use national tax funds for this necessarily enormously expensive construction.... The more miles of highways there are, the more cars there are, and the more gasoline is bought. At the beginning of the 1970s the United States had almost 90 million vehicles; today the figure exceeds 140 million vehicles, and gasoline consumption exceeds 200 billion liters. The average for America as a whole is two cars per family. This is the real foundation for these two big industries, and supporting this foundation is none other than the federal government, which builds the highways. This trinity shows the essential politicoeconomic structure of American capitalism.

### THE SUBWAY AND GRAFFITI

In America this time I was considered something of an "honored guest." Being an honored guest restricts one's contacts: busy all day

with "scholarly communication," one sees only professors and prominent people. I am by nature not at ease with such scholarly refinements and always want to go visit the lower strata of society. After giving a talk at Columbia University in New York, I asked an anthropologist whom I know well if I could at least take a ride on the subway. He gladly assented.

Thirty years ago I worked at this university for a month. I lived in an Italian immigrant district of New York called Corona and every day I took the subway to work. Although it was a long time ago, my memory still carries an imprint of that subway route.

We entered the subway station, and my friend pulled out two fifty-cent pieces to put in the automatic fare machine. I started—how expensive!—because I remembered that riding the subway before had taken only a nickel coin, five cents, to enter the station, after which one could ride anywhere. In thirty years the price has risen tenfold. The word "inflation" escaped my lips.... Everybody knows about America's inflation of the last few years, of course.... Most wages have lagged behind prices, leaving an unbridgeable gap between the two. This gap gives employers an opportunity exploit their employees. There seems no way to control or eliminate this situation, which benefits capitalists and can be said to be a disaster for people who are on fixed earnings or rely on savings for their livelihood....

When I entered the subway car and looked around, I was startled to see that the walls were all covered with names and numbers written helter-skelter in paint. What was this? My friend explained it was called «graffiti». Forgive me for writing it in English letters, but I do not know how to translate it. He said that it seems in 1965 there was a youth named Taki who wrote his name in big letters in subway cars followed by the number 138, said to be the number of his house. Nobody understood why he did it or what it signified. Strange to say, it spread like the wind. All over the walls of stations, subway cars, restrooms, and various other public places, people followed suit and signed their names and building numbers. At first the subway maintenance people worked to erase them, but afterwards they came to be written in oil paint and reappeared as fast as they could be erased, so there was nothing to do but take a laissez-faire attitude. After fourteen years the subways are such a mess that, revisiting an old place, I felt strange and uncomprehending. Those who ride the subway every day are accustomed to it and do not notice.

These «graffiti» made me think of famous sites in China where one frequently sees written messages that so-and-so was here, sometimes

even carved with a knife on walls or ancient trees or bamboo lest somebody erase it and extinguish the traveler's hopes for immortality. After coming back to China I told a friend about this strange business and he found for me a reliable source, which said that in the late Tang dynasty there was a famous poet named Xue Feng who could not get used to these people who thought themselves refined for writing poems and signing their names everywhere. He called them "those who scribble here and smear there." So my friend suggested that graffiti might as well be translated as "scribbling and smearing." He also said that it was a common custom in the Tang dynasty to write poems in inns and temples, most of which were too awful to read to the end. The people who ran these stopping places racked their brains and finally came up with the device of providing a wooden board that they elegantly named the "poetry board." When they saw their guests had itchy hands, they would respectfully offer the board and request an inscription. After the guest left, what could not be erased would be scraped off with a knife. He said this should be suggested to the American subway officials. I have written down his suggestion, but I think that the scribbling and smearing of names and numbers by American youths may have nothing in common with the feelings expressed by the Tang dynasty Chinese who left their names in historic sites or wrote impromptu poems. Graffiti, as I see it, are something like yielding to an irrepressible desire to curse; they are a reaction against the new society symbolized by superhighways and the social polarization that it has brought. Such a feeling cannot be washed clean in the present American social system.

I have written this sketch of the scribbling and smearing I saw in the subway out of a spirit of curiosity. As to the social problems it reflects, that is something to be debated. I have not investigated the question deeply and only offer my immediate feelings as something for idle conversation. In conversation, as in a cartoon, it may be permissible to exaggerate the central point a bit.

### A NEW KIND OF SOCIAL TIE

Electronic systems are supplying a new kind of social tie for collective activities in American society. They make it possible for people in widely separated places instantly to organize and act as a group. These collective activities can be undertaken and terminated on an ad hoc basis without the need for a fixed location or a continuing organization.

A new kind of social collectivity is taking shape. I became aware of this newest thing through telephone calls, so let me first say something about American telephones.

The day I arrived in the United States, in order to make contact with old friends scattered in various places, I wrote a number of letters. After two or three days I began to get telephone calls from them. They said they were delighted to get my letter, but almost all of them gave me their telephone numbers and said that from now on I should call them instead of writing, as the mails were too slow. The long-distance telephone call has become an everyday convenience in America.

I have never been comfortable with the telephone. Making a phone call in Beijing is a nuisance. It is not easy to get connected, and once you are sometimes a noise like mosquitoes makes it difficult to hear. You have to shout, which disturbs the neighbors. I would rather take care of something by going around and talking face-to-face in the case of someone nearby, or by writing a letter to someone far away or in another city. I rarely call long distance and so have gotten into the habit of not using the telephone....

Ten days or so after I got to the United States, my host suggested that I make a long-distance call home to reassure my wife, who was sick. I was staying in a hotel in Boston and at nine in the morning I put through a call to my house in Beijing from the telephone at the head of the bed. In no more than ten minutes or so the telephone rang and I heard the voice of my wife as sharp and clear as if we were speaking face-to-face. When I asked her what time it was in Beijing, she said 9:15, the same time as my watch showed, except that she said she had already had dinner and was preparing to go to bed. We were half a world apart, yet you could say we were toe to toe. Between our responses there seemed to be no space as well as no difference in time. In fact we were talking by means of a communications satellite.

For some time after putting the receiver down I could not calm down. This telephone call made me see that a rather profound social change is taking place. People who have studied sociology like to talk about how human collectivities are bound together by certain basic ties.... Bonds of blood and bonds of locality have always been the basic ties used to organize people for collective activities. Can we not therefore say that the system or transmitting information using electronic technology has provided mankind with a new kind of social tie, one that overcomes the limitation of space, and that by means of this tie people scattered in different places are able to participate in collective activi-

ties? These days there are already what are called telephone conferences, in which people do not need to sit at the same table or in the same meeting room to discuss things, make decisions, and organize coordinated collective activities of people in different places. If such a line of development continues, with the spread of video telephones, for example, the effect it will have on the organization of human collective activity is really something to ponder.

We need not look so far ahead. Already the spread of the telephone has made things once impossible or very difficult into common routine matters in factories, firms, and offices. Look at our trip. A delegation of ten people each with a different academic specialty traveled together to ten places, over twenty universities and organizations, and altogether saw several thousand people and carried on several different kinds of activity—all in the course of one month. All in all, it was a collective activity involving countless details and conversations. In a mere ten-odd days from the time that our host was notified of our final date of arrival, the activities were arranged for each person on each day, from the moment we landed in the American capital to the moment we left the country. And we kept to this schedule, going from activity to activity like a factory assembly line. To say nothing of the several thousand people whom we met, for each of whom a separate time and place had to be arranged for seeing us and each of whose own schedules had to be coordinated with ours before we could come together at a certain time and place for eating or talking or whatever activities together! I am afraid even to think about such complex calculations. Just arranging hotels for us to stay in is complicated enough. Each hotel wants to make as full use of its facilities as it can and so wants to have it all arranged ahead of time that this person will leave and that person will come, so as to not have anyone go without a room and also so that no rooms will go empty without guests. I am told that in Honolulu every day as many as forty or fifty thousand people check in and out of hotels. These forty or fifty thousand people are not an organized army but individuals coming from all over, each separately going about his own business and coming together by chance like duckweed on a lake. It is not at all simple for the hotel managements in different places to keep all these comings and goings in perfect order. It seems simple because the service personnel are assisted by modern information systems like the telephone and the computer.

The rapid development of electronic technology in the last ten or twenty years is an important part of the material basis for America's high-speed, high-efficiency society.

A CRISIS OF FAITH

It is already more than two months since returning to China that I write these "Glimpses of America." I read in the newspaper that the energy crisis in the United States is getting worse and worse. I hear that after spending several days of quiet thought in his mountain retreat, President Carter decided that America's real problem is not the energy crisis but a "crisis of faith." The way it is told is that vast numbers of people have lost their faith in the present government and in the political system, and do not believe that the people in the government working with current government methods can solve the present series of crises. Even more serious, he believes that the masses have come to have doubts about traditional American values, and if this continues, in his opinion, the future of America is terrible to imagine. He made a sad and worried speech. I have not had an opportunity to read the text of his speech, but if he has truly realized that the present American social system has lost popular support, that should be considered a good thing because at least it shows that the old method of just treating the symptoms will no longer work.

In fact, loss of faith in the present social system on the part of the broad masses of the American people did not begin with the energy crisis. The spectacular advances in science and technology in America in the last decade or two and the unceasing rise in the forces of production are good. But the social system remains unchanged, and the relations of production are basically the same old capitalism. This contradiction between the forces of production and the relations of production has not lessened but become deeper. The ruling class, to be sure, still has the power to keep on finding ways of dealing with the endless series of crises, but the masses of people are coming increasingly to feel that they have fallen unwittingly into a situation where their fate is controlled by others, like a moth in a spiderweb, unable to struggle free. Not only the blacks of Harlem—who clearly are able to earn their own living but still have to rely on welfare to support themselves without dignity—but even well-off families in gardenlike suburban residences worry all day that some accident may suddenly rob them of everything. As the dependence of individuals on others grows heavier and heavier, each person feels in his heart that this society is no longer to be relied on. Paying insurance premiums of all kinds month after month and year after year, everyone understands that there is no insurance covering the insurance company. If it should collapse, then it is all over for everyone. And whether the insurance company fails or does not fail is

not something within an individual's control. No wonder people complain that civilization was created by humans, but humans have been enslaved by it. Such a feeling is natural in a society like America's. Carter is right to call this feeling of helplessness a "crisis of faith," for it is a doubting of the present culture. Only he should realize that the present crisis has been long in the making and is already deep.

At this point it may be appropriate to insert something about American religion. It is not easy to explain faith in society and culture by using numbers, but statistics about religion may to some degree convey the extent of some people's loss of faith in present society. People in distress call on heaven. When a person cannot feel secure about shelter and livelihood in this present society and the country is traditionally religious, he naturally turns toward God to seek security and reassurance.

The United States is a country with a religious tradition. Many of the original immigrants from Europe were Protestants who had been pushed out of their native countries. When I was in the United States thirty years ago, out of curiosity I asked friends about their religion. I was told that in their childhood, at least, a few sincerely practiced religion. But I never saw any of the people I knew go to church on Sunday. They said when they had been little their parents had taken them to church to be baptized, when they were married they found a minister to do it, and when a friend died they went to church for the funeral. But outside of that, few of them had anything to do with a church. Just how much religious influence there was on their thinking is hard to know. At the very least, stories from the Bible such as the one about the garden of Eden are enjoyed more or less as folk tales. On this trip, too, I asked friends about changes in this realm. They pointed two things out to me: one is that in the last thirty years the number of religious believers has increased significantly; the second is that small religious organizations are flourishing. Leafing through a booklet of American statistics, I see that church members recorded in the census were 86.8 million in 1950, increasing markedly to 114.4 million in 1960, and 128.5 million in 1969. Beginning in the 1950s, a large group of people who originally were not religious believers joined religious organizations. What is most striking is that the members of miscellaneous churches increased from 140,000 in 1950 to 2,180,000 in 1968. "Miscellaneous religions" refers to these various kinds of small groups organized in the name of religion....

In a Chinese restaurant in San Francisco I saw a man with a shaved head and monk's robes who seemed to be a Buddhist. But he

was eating fish and meat and was accompanied by a white woman—so he did not appear to be an ordinary Buddhist. Discussing this privately, my companion said that the tendency in America in the last decade was that the more bizarre a religion was, the more people would become mesmerized by it, to the point where several hundred people had taken a collective suicide pact. This sensational case, apart from being rich in news value, did not provoke any serious reflection in society. When social malaise reaches this level, even though only a few hundred people die, it cannot be taken lightly. If America is said to be at present undergoing a crisis of faith, this should be a powerful warning.

American science and technology is turning myth into reality. But American society is causing its members to turn towards God in disgust with humanity.

<p align="center">* * *</p>

These "Glimpses of America" essays may be brought to a close here, but to end with the crisis of faith does violence to my original intention. History is a stream that flows on and cannot be stopped. Words must be cut off, but history goes bubbling on. It is inconceivable that America will come to a standstill at any crisis point. I have full faith in the great American people and hope that they will continue to make even greater contributions to the progress of mankind....

# I Do Not Regret
## Visiting
## New York

Zhang Jie, 1982

*The stories and novels of Zhang Jie (1937– ) have been popular in China ever since her "Love Must Not Be Forgotten" created a minor sensation in 1978. She came to the United States in the fall of 1982 as part of a delegation of Chinese writers. Although Zhang knew no English, she formed a friendship with the American writer Annie Dillard, a relationship Dillard describes warmly in* Encounters with Chinese Writers *(1984). The slim book Zhang Jie wrote about her trip, "On the Green Lawns There: Notes from a Visit to America," is typical of a number of quick and sketchy travel accounts avidly read in China; another is Ding Ling's* Fang Mei sanji *(Notes from a Trip to America) (Changsha: Hunan renmin, 1984). That such books, written by people without expertise and ignorant of English and based on observations made during short trips, have an eager market in China is a reflection of the general lack of information about the United States there as compared to Taiwan. Of course, a similar observation could be made about many American travel books on China, particularly from the 1970s.*

*As this selection shows, Zhang Jie found New York City unrelievedly tawdry. Though she was occasionally charmed by some aspects of the United States, particularly in less urban areas, and by people like Miss Dillard, on the whole her attitude is marked by a defensive and distanced distaste for America. The language barrier may have been partly to blame, as well as the overwhelming social and cultural differences between the United States and the People's Republic, in making New York seem so repellent and frightening to Zhang.*

281

Many souvenirs can be found in New York with the legend: «I ♡ New York».

I do not love New York, but I do not regret having gone there.

I am grateful to our hosts for lodging us at the Empire Hotel on Broadway, for otherwise I would never have been able to know about America's other side. I would think all America was as wealthy as what we saw in Los Angeles, as cultured and refined as Boston, as relaxed and agreeable as Iowa, as poetic and picturesque as Concord village, as tranquil as Salt Lake City—

For a realistic writer, certainly, Broadway is rich in attraction. Its nightclubs, its venereal disease, its evil activities, its robbery and murder, even its dog-eat-dog competition—such human ills are an inexhaustible creative source for the writer. No wonder so many American writers were first successful in New York.

At every moment you feel you are enveloped in evil and that weird things are happening all around you, stimulating your nerves, so that try as you will you cannot make yourself numb.

Oh, Broadway, Broadway; it is America's other side in miniature. Only on Broadway did I sense a real America.

In Washington a well-meaning lady told me that since we were writers in New York we should go see Greenwich Village, where there used to be many artists' salons.

We didn't. Our host did not arrange a visit to Greenwich Village, did not take us anywhere even a little more elegant than Broadway. I hear that the East Side of New York looks completely different.[3] He honestly wanted us to take a look at the real America. I think this friend who was looking after us must have a relatively deep democratic ideology. He was not afraid of letting others see America's unbearable places.

That evening, lying in bed in a tight little room in the Empire Hotel, which was suffused with I know not what odor, for a long time I could not get to sleep.

I suspected the odor was coming from the old, dirty rug. Actually there was nothing on it, no blood from a human corpse, no drunk's vomit. I felt like lifting it up and taking a look at the floor underneath, where I was more likely to see something, but I did not dare as I was

---

3. According to the itinerary supplied by the National Committee on United States–China Relations in New York, the writers were taken to an elegant reception on East 67th Street and to meetings at the *New Criterion*'s Park Avenue offices and Harper and Row's headquarters, all on the "elegant East Side." And though Zhang later refers to Times Square, the Empire Hotel is about a mile from there, near Lincoln Center.

afraid of getting my fingers dirty or that I might find under the rug a piece of skin with hair attached. Even the clean sheets on the bed made me too uneasy to sleep.

I suspiciously pulled up the blanket that was covering me and smelled it with all my might.

I have faith in my sense of smell; no matter how much the Empire Hotel might try to hide it—hide its own shabbiness—I could detect an evil and rotten smell.

I could not stop wondering what kind of people had stayed in the room I was staying in. For example, had vagabond swindlers perhaps slept in the bed I was sleeping in? Drug peddlers? Escaped convicts? Murderers?

Had anyone ever been killed in this room? I could not sleep.

I lifted the window shade to investigate the surroundings outside and see whether there might have been a crime there. A few meters outside the window was a thick, silent gray wall that could protect any secret.

The window shade came back down by itself, the spring broken; had it been the middle of the day, the room would still have been dark.

The bathroom, too, was rather cold and ugly. The space between the sink and the wall was so narrow that someone a little fatter than I would probably have to turn sideways to get to the toilet. There were not even enough towels; apart from two bath towels there was only a paper washcloth.

There was no glass in the room, so that if by some chance the bar in the restaurant downstairs were to vanish, how could you drink anything if you were thirsty?

The foot of the bed almost reached the opposite wall. Anyone a little fatter would have to turn sideways to get by. Spending the night there, I had the feeling of having turned into a pressed cake. I felt suffocated.

The rug was already faded, the colors run together like a picture that had been soaked in water. The walls could be seen to have been painted over and over again, like an aging woman who has put on layer after layer of makeup....

Every morning, trembling with fear, we had to cross the street, which was under the tyrannical control of taxicabs—they drove as if they had gone mad and were determined to run over everyone—and go for breakfast in a Jewish restaurant. The woman who was responsible for taking care of us said it was a restaurant with excellent cooking, especially its corned beef. But it definitely was not; although I have

only had a few Western meals, I can still make comparisons. That restaurant was the worst Western restaurant I ate in in America, even worse than the underground cafeteria near the Lombardy Hotel, where we stayed in Washington.

That woman was always trying to mislead people. Had she just said that it was more convenient or that this restaurant was cheaper it would have been more pleasing. Our two hosts from the National Committee on U.S.-China Relations, I suspect, had been accountants or foremen or something like that, for they knew how to cut corners on costs.

The Jewish restaurant was very dirty, especially the bathroom in the basement. The floor was wet, whether with water or some other liquid I do not know, and toilet paper, whether used or not I do not know, was scattered all over. There was mold floating in the pickles, and the watermelon was left over from the night before and no longer fresh, which made me with my temperament want to make them bring me another. I wonder if they did this on purpose because I am a small-nosed Oriental.

Afterwards we took the subway to go to a symposium at Columbia University. That part of the subway is filthy in the extreme. I cannot say whether the New York subway is all like that because I only had the good fortune to ride on that little part. The tiny platforms and the sides of the cars were all indelibly marked—I would guess it was permanent acrylic paint—with obscene words and pictures, and the fate of the pretty girls in the advertising pictures was even more frightful. I hear that this wall literature has been collected in a book. And *The Scarlet Letter* is banned in some states on the grounds that it talks about sex—for Heaven's sake!

The streets in the Broadway area are in such disrepair as to make one think of a World War II battlefield. The street surface is full of pits and hollows as though it had just been bombed, and no one thinks to repair it. Where the holes are too bad and would affect traffic, they are covered over with steel plates. When you drive over such a place the clanking sound you hear is enough to make you think you have been forced into some cave. Riding over the places that do not have steel plates, you go up and down like waves of wheat in the wind.

I also rode in New York's Checker taxis three times; I cannot say that all Checker cabs are like this, but these three were all old and broken.... They are not even as good as the third-rate taxis in Beijing in the past couple of years, and those third-rate cabs have already been taken out of service.

The artificial leather that covered the seats must have been an early product. It was as stiff and hard as untanned cow or sheep skin. Between the rear seat and the driver was a kind of wall, the bottom half made of wood and the top of soundproof glass; every piece of glass either had big cracks in it or a hole made by a lump of something—bumped as it was on those streets there is no way it could avoid getting broken....

The evening before leaving New York, out of professional interest, we went strolling on Broadway and 42nd Street, New York's famous sex district. Little black shoeshine boys with a lively expression on their faces smiled at pedestrians, trying to drum up business. I have never been able to imagine sitting on a high platform and extending my shoes; we have been taught completely different attitudes since childhood. In the middle of the street youths on roller skates, leisurely and effortlessly playing tricks, wove in and out between Checker cabs and mock seventeenth- or eighteenth-century horse cabs (even the drivers were in costume).

Various forms of transportation from various periods were in peaceful coexistence, each with its own appeal, no one considering anyone else strange, no one interfering with anyone else.

Black brothers with peaked caps aslant, both hands thrust into the pockets of their blue jeans, shoulders aslant, looking disdainfully out of the corners of their eyes, gazed from a distance at their yellow brothers, giving you not the slightest feeling that they had any natural class sympathy, and furthermore seeming prepared to intimidate you at any moment. There was absolutely no feeling of innocence, purity, beauty, goodness, or anything of that sort to speak of. In the doorway of a nightclub stood a man who was trying to coax you inside, who scared me by grabbing a colleague by the elbow. I wonder how the people on that street could make a living.

New York is the other half of America, and Broadway is probably only one half of New York; but I never saw New York's other part, so I am not to blame.

# America,
# Spacious
# Yet Confining

Liu Binyan, 1982

*Liu Binyan (1925–   ) is a journalist whose fiction and investigative reporting, particularly his daring, sometimes slightly fictionalized exposés of political corruption and injustice in China, have made him one of his country's most respected writers. A volume of his stories and reportage is available in English,* People or Monsters, *edited by Perry Link (Bloomington: Indiana University Press, 1983). In 1985 Liu was elected vice-president of the Chinese Writers Association, but his popularity may have been part of the reason for his startling public dismissal from the Communist Party in January 1987, in the wake of the student demonstrations.*

*Liu spent a few months in the United States in the fall of 1982, at the invitation of the University of Iowa's International Writing Program. In the following article, which appeared in the* People's Daily, *his thoughts go naturally from America's spaciousness to China's density of population. By the early 1980s curbing the rate of population growth had become a major policy goal in the People's Republic.*

The thing that first caught my attention in Iowa City was how much space the people of this tiny city of sixty thousand enjoy. On both sides of the quiet, clean streets are house after house, each quaint and distinctive with little repetition of color or style. The one-family houses have a certain space between them; each house has its own personality, whether grand and elegant or bright and light-hearted, while it strives to be distinctive with its style of roof, doorway, porch, and windows. For a moment I felt I had fallen into a world of moving color pictures.

None of the buildings here has a wall around it. There are neither high brick walls nor low wooden fences. Each door and window faces the world directly. In front of the houses are areas of green grass, and behind are some trees or gardens of varying size. I was told that it was an American tradition not to have fences around houses, except for the mansions of the rich. But traditions and customs *can* change. Nowadays many more people than before in Iowa City may lock their doors at night. And in big cities like New York as many as five or six locks are needed on the door.

What about people? Except for the downtown area of a few blocks and the middle of the University of Iowa campus, you see few pedestrians. One or two young men or women may happen to whiz by you and will often give you a smile. These are students running for exercise.

At this point you may be startled to discover a little squirrel dart in front of you and then, naturally and fearlessly, cross the road and climb an oak tree thick with leaves. They are not at all alarmed or afraid. At Nieh Hualing's house,[4] which is nestled against a hillside, we could often open a window and shake hands with a gray or brown squirrel sitting on the sill and looking around.

Comparing this with the suffocating pressure of a typical big American city like New York or San Francisco leads one inevitably to the thought that people need a certain space. That each person has more space here is an important reason that humanity can live in harmony with nature (including trees), to their mutual benefit. No wonder the Japanese writer Kenji, in a letter to his son in Tokyo, described Iowa's squirrels at great length. The burden on Japan's tight little islands has long been great, and the Japanese perceived comparatively early the importance of limiting population growth.

Making fun of themselves, Americans say that the two most numerous species on their soil are dogs and police officers. In fact, the number of police falls far short of the vast hordes of dogs. A friend from Taiwan who has long lived in the United States told me to notice how no American dog has his head down and his tail between his legs, looking coldly at people. It is true; you can see they are all happy and confident—like the squirrels and the pigeons in big cities like New York and San Francisco, they are loved and protected. No one abuses them. But this relationship between people and dogs reflects a problem

---

4. Hualing Nieh Engle was director of the International Writing Program at the University of Iowa.

in Americans' relations between people and people. You do not need to be wary with a dog, it will not cause you any legal or moral complications; it is just a loyal companion who makes you feel less lonely. Dogs also have practical value, guarding ordinary people's houses, leading the way for the blind. And now they are being trained to use their hearing to serve the deaf. Otherwise the ratio of people to dogs in the United States today would not be two to one.

Living in America for four months, traveling to over ten cities large and small, and keeping careful track, I encountered a total of only four pregnant women. Of course, this figure should be increased a bit because, according to what I am told, American wives, who do not consider a round abdomen something to be proud of, do not go out much when pregnant, and because I was able to count only pedestrians, as I could not see women sitting in cars well enough. But my impression is confirmed by statistics. In the ten years from 1970 to 1980, the population of the state of Iowa, which is almost three million, increased by less than a hundred thousand, or 3.1 percent.[5] Leafing through the *Zhongguo baike nianjian* [Chinese yearbook] for 1982, I see that the population of Asia is over ten times that of North America, but the land area only something over twice as large. China has less arable land than America, but her population is almost five times as great! When we drove on the highway in Iowa and Illinois, the sight of fields on both sides of the road often made me feel as though I had returned to the North China plain. What dispelled this illusion is that over there the land is not densely dotted with villages and that here our fields do not have those huge monsters, silver granaries and green silos.

Americans love children. If they cannot have their own, they find a way to adopt one, at great expense. Why then do they not want to have more children? They want a comfortable life and do not consider it wrong to live for the pleasure of the present moment. They have a comparable philosophy of life in regard to children also, and are not satisfied with just supplying them with food and clothing. If you go into the houses of the majority of Americans, that is to say the middle class, you will see that from an early age the children have their own bedrooms and playrooms stuffed full of all kinds of toys and picture books. For children to grow up well they must have a university education. This requires money and worry, and there must be some savings. To support a middling lifestyle for a family of three or four takes all the

---

5. That the net change in population reflects people moving in and out of the state would not be so obvious to Liu, for in China there is far less migration.

efforts of husband and wife both working at the same time. Having another child would mean a step down from their present standard of living.

Americans also do not feel they must have children to support them in their old age. America has all along upheld individualism, advocating individual independence and prizing not relying on others. From the time children are twelve or thirteen they want to have a part-time job after school to earn a little pocket money. On the day they reach eighteen they declare to their parents, "I am grown up now," and handing over the front door key, leave. No matter how rich their family is, they do not think it proper to rely on their parents to pay for college, and they want to earn at least part of the cost themselves. Thus when the parents become old, the children feel no responsibility to contribute to their support, nor do the parents expect to depend on their children for livelihood. Certainly in America many elderly people in their twilight years are to be pitied, but that they are alone and uncared-for is not because they are childless.

For thirty of the last fifty years Americans have had to worry about their own and their children's economic security. In the last few years, with the deepening economic decline, such worries have come knocking at the doors of more and more Americans. As ample as the physical space is, the human space has been gradually constricting.... In addition to giving needy households reduced-price food coupons, beginning this September Iowa is issuing a large quantity of free dairy products every month in order to reduce the cost of storing them.... During 1982 the American unemployment rate reached its highest mark since the 1940s—10.8 percent. This figure does not include the unemployed who have given up hope and are no longer seeking jobs. In this nation of vast territory, rich natural resources, and an advanced, wealthy economy, what a large number of people have difficulty finding the opportunity to work! How confining the living space turns out to be for these people!

Furthermore, these Americans who are out of a job no longer have a steady income and are unable to make the monthly payments on their houses, so they must leave their spacious comfortable homes and go out into the cold wind to seek shelter. The construction industry is one of America's most important, but it is facing a crisis because homes that have been built cannot be sold, with the result that the ranks of the unemployed are further increased.

In an article I wrote for the *Des Moines Register*, "So Rich, and

Yet So Troubled,"[6] I used the construction industry as an example to explain how China and the United States are faced with entirely different difficulties: while the American construction industry is hurting from not being able to find buyers, Chinese construction companies are at their wits' end trying to carry out an unprecedentedly large job of house building.... Yes, our houses are still small, but in the future they will become more roomy, standards will slowly rise, and Chinese will never have to worry about one day being chased out of their own houses. We will build more and more roads and bridges, yet we will not produce the kind of irrational situation America has today: miles of roads and bridges go unrepaired year after year while at the same time over ten million people are out of work!

But there is something else. We must control the growth of our population, or else we will lose the space our children and grandchildren will need for fields, houses, roads, and the green areas they must have to breathe normally.

6. The article was published in the *Des Moines Register* on Nov. 21, 1982. In addition to noting problems like high medical costs, farm surpluses, and food, Liu wrote, "I feel even more strongly that China has to increase her understanding of America.... Certain qualities of the American tradition and the American way of life are worthy of our awareness and learning."

# Six Don'ts for Chinese Students in America

Wang Yuzhong, 1986

*In the three decades after 1949 virtually no students from the People's Republic studied in American universities. But by the mid-1980s there were 20,000—almost as many as from Taiwan. This horde of new students needed information about the academic system, the applications process, examinations, classes, grades, degrees, and the like. Wang Yuzhong's "Practical Guide for Studying in America" is a typical student handbook, such as has long been available in Taiwan, with useful tips about American colleges and daily life: housing, food, transportation, communications, money, shopping, and health. Wang's primer, reminiscent of nineteenth-century writings such as Cai Jun's (see chapter I), includes the following advice on social taboos. Most of his suggestions are consistent with a contemporary Chinese media campaign for "ethics and courtesy" to develop "socialist spiritual civilization."*

China is an ancient civilization renowned throughout the world for its civility. Wherever they go, descendants of the Yellow Emperor should exhibit the traditional virtues of the Chinese race and be civilized and polite. For this reason I want to add the following on the question of taboos in American everyday life, in order to alert our personnel going to the United States.

1. Do not spit in public. If you want to spit you must do so in a handkerchief or facial tissue. When coughing, sneezing, or even yawning, no matter where, you should cover your mouth with a handkerchief or facial tissue. If there are others nearby say "Excuse me."

2. Do not pick your nose, ears, or teeth. Such behavior looks inelegant and may make people look down on you.

3. When you see something funny or startling such as a strange-looking or oddly dressed person, to point, comment loudly, or stare is inappropriate and may annoy people.

4. At meals, do not bury your head in the food, make munching noises, or make too much noise with the silverware. Except for spoons and forks, utensils used for cutting food are not to be put in the mouth, nor should the plate be lifted to your mouth.

5. For personal clothing, in principle anything clean and neat will do. On formal occasions men should wear a Western suit and tie, and women should wear a suit or dress. Men should habitually shave every day. Neither men nor women should wear nightclothes outside of the bedroom.

6. Clothes should not be hung to dry in visible places in your residence or apartment.

Because China and America have different cultural backgrounds, there are many differences in daily customs and etiquette. These cannot be enumerated here one by one, but I suggest that after arriving in the United States students should at all times pay attention to people and activities around them. You must not be afraid to ask questions if you are to adapt to the environment quickly.

# Private Ownership and Public Ownership

Li Shaomin, 1987

*Naturally the interests of this new wave of Chinese students are moving far beyond matters of social courtesies. Li Shaomin was studying for a doctorate in sociology at Princeton University at the time he wrote the following article. Li's understanding of America may not be unusually profound, but his piece is an interesting example of students using their understanding of American democracy to criticize state socialism in China.[7] Too outspoken to be published in China, Li's analysis was printed in a Hong Kong magazine.*

"Democracy, liberty, and human rights" have already become the ideals pursued by all of mankind today in the twentieth century. On the Chinese mainland in late 1986, a student movement appeared demanding democracy, liberty, and human rights.... But people are not optimistic. The fundamental problem is, Is it possible for socialist countries to realize true democracy?... By "socialism" in this essay is

7. The United States had been cited, sometimes unrealistically, in attacks on the Chinese political system made during the short-lived "democracy movement." In 1979, for example, an article in an underground journal claimed, "An ordinary American citizen will never have to fear another citizen, no matter how great the powers this other citizen holds. Americans will not be charged with 'committing a crime' simply because they criticized in an upright manner the head of their own country, and they will not be arrested and called 'counterrevolutionaries' or 'bad elements.' The supreme head of state also will not be excused from legal sanctions if he ever violates the criminal code. This is because, like any ordinary citizen, he is also subject to the limitations of law, and the law commands an even higher authority than he does." Gongmin, "Letter to President Carter," *Qimeng*, Jan. 1979; quoted in James D. Seymour, ed., *The Fifth Modernization: China's Human Rights Movement, 1978–1979* (Stanfordville, N.Y.: Human Rights Publishing Group, 1980), 236.

meant that a society's means of production are publicly owned and that economic activities are planned.... Among all the nations we can not find one that has both a planned economy and a democratic polity....

The great democratic revolutions of history such as the American or French revolutions all took as their goal freedom, that is to say natural rights, and sought inalienable fundamental rights: the right to life, the right to liberty, and the right to the pursuit of happiness. In those times thinkers about freedom and democracy such as «Locke» said that liberty was to be desired first and only after that democracy. What was liberty and how could it be attained? With a little careful study we can see that it was intimately connected with the market system. Individual liberty implied that each person was free to carry on a business and engage in trade, free to retain the wealth obtained from a business and trade, and free from being expropriated by the powerful....

Here it is necessary to clear up certain misconceptions about Western liberty.

—"Western liberty is false. Not everybody can become president in America." True, in America not everyone can be president at the same time, as there is only one president. But in America as long as a person possesses certain qualifications...he can freely run for the presidency....

—"Western liberty is the freedom of poor people to starve or lose their jobs." Freedom is a right, but in order to realize it a person must have certain qualifications, such as skill, strength, knowledge, and money. As each person's basic endowment is different, the right of freedom is used differently, with differing outcomes from free competition; this is reasonable....

—"Western liberty is only the freedom of the bourgeoisie; there is no proletarian freedom." Not true. Western freedom means that everyone is equal before the law....

Can genuine democracy be realized in socialist countries?... In China, the Soviet Union, and most socialist countries, ownership by the whole people is really ownership by the state, the government, and the party.... The economic activities of the entire country are arranged and planned by the state.... In order to carry out a planned economy, a socialist state must make the entire population believe that the central government's polices and theories are the most correct and its plans the most superior. Accordingly, in every socialist country a mammoth propaganda mechanism exists. On the one hand, this mechanism propagandizes the correctness of the party's policies, plans, and theories; on

the other, it carries out strict press censorship in order to achieve "unanimity of opinion" throughout the whole society. Thus there is no freedom of belief or expression and, moreover, powerful dictatorial methods are needed to establish absolute central authority. This in its basic nature is the opposite of a democratic system. Democracy means government by the majority, government by discussion....

To struggle for democracy requires developing private ownership.... Many theorists who genuinely believe in communism, including a number of reformists, think that public ownership is a basic premise and is economically superior to private ownership. They think that if capitalist advanced technology and democracy are added to public ownership then socialism will triumph over capitalism.... This is not possible: democracy cannot exist under public ownership. Let me cite a couple of facts to demonstrate the relationship between freedom and private ownership. The vice-president of the Chinese University of Science and Technology, Fang Lizhi, was dismissed and transferred [in early 1987, following the student demonstrations] because of his support for Western democracy (democracy, of course, originated in the West) and bourgeois liberalization. If in addition to public universities there were also private universities and institutions in China, Fang Lizhi could go and be vice-president of a private university (assuming he is qualified) and the party would not have the power to have him dismissed and transferred (at least not so lightly)....

Genuine rule of law cannot be established under a planned economy.... Here a news item in a Princeton newspaper from 1985 comes to mind: A police officer stopped a car for a traffic violation and before he wrote out the ticket, he had a feeling that the violator was suspicious. So he forgot to write the ticket, searched the car, and discovered blood-stained clothes and a machine gun. The driver turned out to be an escaped murderer, and the officer took him in to the police station. In doing this, the officer broke a law: to stop and search a traveler's car at will is not allowed. (Since the officer had stopped the car because of a traffic violation, he should have first given the violator a ticket and then proceeded to search; that would not have broken the law.) Due to the officer's negligence, the criminal could not be prosecuted, and in the end the police had to release him.

This is a good example of how seriously the law is taken: once a regulation (law) is established, everyone must obey it—police officers not excepted. Releasing this criminal endangered society, certainly, but this danger is many times less than the harm done to society by the government (or police) trampling on the law and abusing its power. At this

point an opposite example, which I read about on the mainland several years ago, also comes to mind. A certain party secretary was endorsing a court decision "sentenced to one year" (for a party secretary to endorse a court decision is itself against the law), but instead carelessly wrote "sentenced to ten years." When the people who were to carry out the sentence came and asked him to correct it he said, "In order to protect the prestige of the party I cannot arbitrarily change it. Let ten years be ten years."

In a publicly owned economy the relationship between the people and the government is upside-down. People do not pay taxes directly to the government; the government has already deducted taxes from workers' pay before they receive it. This method of indirect taxation distorts the most fundamental fact, that it is the people who provide for the government; it seems to be the party and government who provide for the people. In this distorted situation, the people must constantly feel thankful to the party: the party has allocated funds to build houses for the people; the party has provided educational opportunities for the people. However, if people were to think carefully about it, they would ask where the party gets its money. It is the people, the taxpayers, who provide for the party and government. But in a publicly owned economy the system of indirect taxation turns this relationship upside-down. The people cannot criticize the party and the government, and have no right to inquire how the taxes they themselves have paid are used. In a privately owned economy the government's taxes are collected directly from the hands of the people after they have received their wages and share of the profits, so the people clearly see that it is they who provide for the government. For that reason people can criticize the government and question government policies and expenditures with a sense of righteousness....

# *Afterword*

As this survey of Chinese impressions of America comes to its conclusion, our story would seem to have both run a full cycle and reached a new turning point. The sense of wonder and curiosity with which the early Chinese diplomats greeted this exotic land is being echoed, a century later, by the recent visitors from the People's Republic. But the large numbers of mainland Chinese coming to this country, for short-term visits or for lengthier periods of stay or study, will soon result in a broader familiarity with America, much like that now held by their counterparts from Taiwan. Direct contact and advances in communication make it unlikely that the extreme views of allure and menace that tended to govern early Chinese images of America will reappear.

This is not to say that increased contact and normalized official relations will necessarily bring better mutual understanding. Understanding involves complex mental interactions between a self and a culturally defined other. As Warren Cohen has remarked, "a people's image of another people can be affected by its perceptions of itself and by how it assumes it is perceived by the other people."[1] Changes in the perception of another nation sometimes reflect only shifts in the perceiver's own needs and aspirations. As the last selection reminds us, Chinese intellectuals looking at America have frequently had China on

---

1. Warren I. Cohen, "American Perceptions of China," in M. Oksenberg and R. B. Oxnam, eds., *Dragon and Eagle: United States–Chinese Relations, Past and Future* (New York: Basic Books, 1978), 85. On American views of China, see also Harold R. Isaacs's classic *Images of Asia: American Views of China and India* (New York: Capricorn Books, 1962 [originally published as *Scratches on Our Minds*, 1958]).

their minds. In that sense, Chinese views of America have mirrored the process of China's own self-definition during the painful historical transition from tradition to modernity. In their writings about America, generations of Chinese have voiced concerns about their own country. Not only did they seek in America values and ideals that they hoped to see realized in China, they also felt the need to reaffirm their Chinese identity by means of an implicit contrast with less attractive American features and customs, such as weak social and family ties.

When we look at Chinese and American views of one another against the backdrop of China's history, we see that from the beginning Chinese visitors to these shores did not treat America as completely outlandish or beyond the pale of civilization. The nineteenth-century diplomats were not condescending in their attitude toward the strange customs and manners of a young country, and their wonder at American machines, railways, and skyscrapers encompassed genuine admiration. Their accounts were not heavily "exotic" in the sense of painting the "other" as unknowable and mysterious, bizarre and fantastic in order to enforce a mental distance between self and other. In this regard, the early Chinese visitors seem to have been less lost in this alien new world than were members of the first Japanese mission, around the same time, described by Masao Miyoshi in *As We Saw Them* (Berkeley: University of California Press, 1979).

Much of this surprising openness may be explained by the Chinese reorientation of foreign policy vis-à-vis the Western powers from the 1860s on. The ostrichlike attitude of ignoring the "barbarians" was replaced by a policy of learning how to cope with them by studying their strengths. The United States in the second half of the nineteenth century was regarded on the China coast as not so aggressive as Britain and France, and the official Chinese attitude consequently was not so hostile. Still, a similarity of tone and voice informs Chinese accounts of both America and Europe. The experience of foreign travels and reading about foreign countries had quickly become an essential part of the emerging discipline of "foreign affairs" (*yangwu*). In this context the first period of "exotic America" (from the 1860s to 1880s) was marked by respect and deference. The turn-of-the-century alarm sounded by Liang Qichao, perhaps the most astute observer, came as a warning to the Chinese about the emergent imperialist power that had been neglected—a warning that was nevertheless tied to a feeling of awe and grudging respect, not contemptuous animosity, for a formidable power that could be menacing. With historical hindsight, we realize that Liang's perception was valid.

In the first half of the twentieth century, despite a brief period of nationalistic reactions against a menacing America, Chinese attitudes continued to be generally positive. China remained impressed by several aspects of this newly powerful nation: its amazing technological achievements derived from economic progress, its political and educational institutions based on democracy and pragmatism, and its fabric of social relations that gave ample room for individual initiative and activism, particularly among American women. All these material, institutional, and organizational manifestations were possible models for emulation by the young Republic of China, intent on shedding its old dynastic system and remaking itself into a modern nation-state while maintaining its Chinese identity. America's example had much to offer China—both positive and negative. Chinese criticisms largely concerned American values and morals: racism and prejudice, lack of family closeness and neglect of the elderly, and excessive pleasure-seeking.

Surprisingly for a country that prides itself on its centuries-old civilization, China's attitudes toward America, positive and negative, have been largely without condescension or contempt. The culinary arts are the only area in which a clear sense of Chinese superiority is evidenced. And fear of becoming Americanized seldom enters into the picture; even frequent visitors from Taiwan since the 1950s continued to assert their Chineseness by criticizing, among other things, American food. Most recently, after three decades of vituperative anti-American rhetoric, the People's Republic is rediscovering admirable aspects of American life.

If we compare this overall record with that of American perceptions of China in the last two centuries, the results are both illuminating and alarming. In a well-documented paper on American perceptions of China, Warren Cohen discerns five eras: deference (1784–1841), contempt (1841–1900), paternalism (1900–1950), fear (1950–1971), and respect (1971–present). This, too, represents a full cycle, from early deference to present respect, but the intervening years, from 1841 to 1971, were marked by sharper swings from contempt to paternalism to fear, and a more profound sense of ambivalence and traumatic tension. Even the half-century of friendly relations is characterized by Cohen, fittingly, as an era of paternalism, of benign and protective condescension. This attitude was due partly to the new "imperial" self-image in world affairs set by American leaders at the beginning of the century and the nation's ensuing confidence in its superior military and political power. More significantly, American paternalism was strengthened

by the Chinese willingness to look to the United States as a model. Condescension to China was also encouraged by American missionaries, who "in their writings, their speeches, their appeals for financial assistance—gave the American people a sense that they were doing something for the Chinese people—and that their sacrifices and their efforts were appreciated" (Cohen, p. 68). For all its spirit of magnanimity and service, the missionaries' attitude was founded on a sense of superiority buttressed by religion.

American paternalism during the first half of the twentieth century is exemplified by the works of Pearl Buck, the best-selling author in America writing about China during this period. The portrait of the Chinese people in the *Good Earth* and Buck's other novels is invariably that of earth-bound innocents—good-hearted "noble savages" who must be helped or saved. To be sure, Buck was quite critical of missionaries who did not truly attempt to understand the Chinese, but her sincere effort to portray her beloved China led her to simplistic stereotypes. In the corpus of China-based missionary literature written by lesser-known authors, the image of China is sometimes even more condescending and exotic, the distances—geographical, cultural, and psychological—between the Christian "we" and the heathen "they" more clearly and emphatically demarcated.

We can illustrate the parallels and differences of mutual perception by placing Cohen's schema of American attitudes alongside our schema of Chinese attitudes:

|           | Chinese images of U.S. | American images of China |
|-----------|------------------------|--------------------------|
| 1841–1900 | exotic wonderment; fear | contempt; discrimination |
| 1900–1950 | admiration of model America, criticism of flaws in values | paternalism for a weak China; charity toward its good people |
| 1950–1971 | rampant anti-Americanism on the mainland; friendly familiarity on Taiwan | cold-war fear of Chinese aggression and Communist yellow peril |
| 1971–     | rediscovery and respect | recognition and respect |

Throughout, we would argue, the Chinese can claim the more rational degree of understanding. Americans have tended to be more ethnocentric than the Chinese, showing less respect for Chinese than Chinese accorded American culture. Cohen has perceptively pointed out the

irony: "A relatively egalitarian, frontier society had less appreciation, less use for the fine arts of Chinese civilization" (p. 57). Americans in China tended to confine themselves to foreign-dominated treaty ports and frequently their principal contacts were with servants among the Chinese. Few of these Americans, even among the missionaries, learned to read Chinese. By contrast, the deep immersion of Chinese, particularly students, in American culture and society throughout the twentieth century is impressive.

Up to now the Chinese perception of America has had little bearing on American self-examination. But, as Wei-ming Tu has argued, observations made from a "wholly other" perspective "may turn out to be exceedingly suggestive for intellectual self-identification at home."[2] Genuine intellectual respect for Chinese culture has been rare among Americans, and Americans have not felt the need to understand China on a profound level, as the "other" culture that poses a viable alternative to their own. However, as several Chinese intellectuals have observed, what is lacking in this land without ghosts—the missing element in the Americans' self-confident and dynamic national character—is precisely a shadowy sense of national crisis that would provoke greater introspection and self-examination. If earlier generations of Americans did not willingly scrutinize themselves, perhaps present-day Americans may be interested in encountering a few ghosts of their history and in seeing themselves in the mirror held up by Chinese observers.

2. Wei-ming Tu, "Chinese Perceptions of America," in *Dragon and Eagle*, 88.

# Source Notes

I. EXOTIC AMERICA

Xu Jiyu: Xu Jiyu, "Yinghuan zhilüe" (Short account of the oceans around us), in Hu Qiuyuan, ed., *Jindai Zhongguo dui xifang ji lieqiang renshi ziliao huibian* (Collected documents on modern China's knowledge of the West and the powers) (Taipei: Zhongyang yanjiu yuan jindaishi yanjiusuo, 1972), 525–28, 538–39. Translation generally follows Fred W. Drake, *China Charts the World: Hsu Chi-yü and His Geography of 1848* (Cambridge: Harvard University, 1975), 155–65, but we have restored the original order.

Zhigang: "Bire zhuren" [Zhigang], *Chu shi taixi ji* (First mission to the Far West) (Taipei: Chengwen, 1969, photoreprint of the 1877 ed.), 1:18–19; 26b–28, 39. A punctuated edition has been published by Hunan renmin chubanshe (Changsha, 1981) in a reprint series of works by Chinese travelers to the West before 1911 ("Zou xiang shijie congshu").

Zhang Deyi: Zhang Deyi, *Ou Mei huanyou ji* (Travels in Europe and America) (Changsha: Hunan renmin, 1981), 51–52, 60–61, 66, 69, 73–74, 85, 87, 100–101, 107–8.

Li Gui: Li Gui, *Huan you diqiu xin lu* (New account of a trip around the globe; 1877), "Meihui jilüe" 1:47–48b; "Youlan suibi" 2:41b–42b, 2:39–40b, 2:46. There is also a new edition from Hunan (Changsha: Hunan renmin, 1980).

Chen Lanbin: Chen Lanbin, *Shi Mei jilüe* (Brief record of a mission to America; 1878), in *Xiaofanghu zhai yudi congchao* (Shanghai: Zhuyitang, 1877–1894), *ce* 63, 62a–b.

Cai Jun: Cai Jun, "Chu shi xuzhi" (Handbook for envoys), in *Xiaofanghu zhai yudi congchao, fu* 11:443b, 444b–445, 446b–447.

II. MENACING AMERICA

Huang Zunxian: "Zhu ke bian" and "Ji shi," in Huang Zunxian, *Renjinglu shicao jianzhu*, ed. Qian Zhonglian (Taipei: Zhonghua, 1963), 353–62, 365–77.

The translation of "Zhu ke bian" by J. D. Schmidt is from Irving Yucheng Lo and William Schultz, eds., *Waiting for the Unicorn: Poems and Lyrics of China's Last Dynasty, 1644–1911* (Bloomington: Indiana University Press, 1986), 333–36; reprinted with permission. The translation of "Ji shi" is partially based on that in Chang-fang Chen, "Barbarian Paradise: Chinese Views of the United States, 1784–1911" (Ph.D. dissertation, Indiana University, 1985).

Zhang Yinhuan: Zhang Yinhuan, *Sanzhou riji* (Dairy from three continents) (Beijing: 1896), 1:10b–11, 12–13, 71b–72, 52b–53b; 3:48b–49.

Lin Shu: Lin Shu, "'Hei nu yu tian lu' shu" (Preface to 'A Black Slave's Cry to Heaven') and "——— ba" (Afterward), reprinted in Ah Ying (Qian Xingcun), ed., *Fan Mei Hua gong jinyue wenxue ji* (A collection of literature written in opposition to American restriction of Chinese laborers) (Beijing: Zhonghua, 1962), 658–60.

Liang Qichao: Liang Qichao, *Xin dalu youji jielu* (Notes from a journey to the new continent) (Taipei: Zhonghua, 1957), sects. 13, 14, 15, 9, 6, 21, 29, 31, and 40. This edition seems identical to that in *Yinbingshi heji* (Shanghai: Zhonghua, 1936), *zhuanji* 22 (*ce* 21), except that the latter lacks the former's section 5. There is also a new, nicely punctuated edition from the mainland: *Xin dalu youji* (Changsha: Hunan renmin, 1981). In those editions with forty-six rather than forty-seven sections, the section numbers after section 5 are one less than those given here.

### III. MODEL AMERICA

Huang Yanpei: (1) Huang Yanpei, "You Mei suibi" (Notes on a trip to America), *Jiaoyu zazhi* (Education magazine) 7(8) (1915):83–86, 7(10):102–5. 7(11):107–11. (2) Huang Yanpei, "Dong Xi liang dalu jiaoyu butong zhi genben tan" (A discussion of basic differences in Eastern and Western education), *Jiaoyu zazhi* 8(1) (1916):4–7. (3) "Huang Yanpei jun diaocha Meiguo jiaoyu baogao" (Report of Mr. Huang Yanpei's investigation of American education), *Jiaoyu zazhi* 8(4) (1916):1–8, 8(6):9–19.

Hu Shi: (1) Hu Shi, *Hu Shi liuxue riji* (Hu Shi's diary of study abroad) (Taipei: Shangwu, 1959). (2) Hu Shi, "Meiguo de furen" (American women), in *Hu Shi wencun* (Essays of Hu Shi) (Shanghai: Yadong, 1921), 1:39–41; first published in *Xin qingnian* 5(3) (Sept. 15, 1918):213–14.

Tang Hualong: Tang Hualong, *Qishui Tang xiansheng yinianlu* (Memorabilia of Mr. Tang of Qishui) (Taipei: Chengwen, 1969, photo reprint of 1919 ed.), 99–107.

Xu Zhengkeng: Xu Zhengkeng, *Liu Mei caifeng lu* ("Things About America and Americans") (Shanghai: Shangwu, 1926), 31–34, 142–43, 120–23, 194, 348.

Li Gongpu: Li Gongpu, "Meiguo renmin dui xuanju zongtong zhi taidu" (The attitude of the American people toward electing a president), in *Shenke de yinxiang* (Deep impressions), ed. Shenghuo zhoukan she (Shanghai: Shenghuo, 1932), 378–84.

IV. FLAWED AMERICA

Gongwang: Gongwang, "Meiguo de jiating" (The American family), in *Haiwai de ganshou* (Overseas impressions), ed. Shenghuo shudian (Shanghai: Shenghuo, 1933), 416–25. Originally published in *Shanghai zhoukan* 7 (1932):653–55, 677–79, 700–703. Several other "Letters from America" by this pseudonymous author were published in the same magazine in 1932 and 1933.

Zou Taofen: [Zou] Taofen, *Pingzong yiyu* (1937; rpt. Hong Kong: Shenghuo, 1941), 268–83.

Lin Yutang: Excerpted from Lin Yutang, "Di Mei yinxiang" (Impressions on arriving in America) and "Meiguo yu Meiguoren" (America and Americans) in *Ou Mei yinxiang* (Impressions of Europe and America) (Shanghai: Xifeng, 1941), 3–22. The articles originally appeared in *Xi feng zhoukan* (Shanghai) in 1936 and 1937.

George Kao: "Datui xi" (Burlesque), in Qiaozhi Gao, *Niuyueke tan* (A New Yorker's Talk) (Taipei: Wenxing, 1964), 149–55.

Fei Xiaotong: (1) "Zhen dan gan, nianqing de wenhua" (Truly bold, a young culture), in Fei Xiaotong, *Renqing yu bangjiao: Lü Mei ji yan* (Human feelings and international relations: Letters from America) (Kunming: Ziyou Luntan She, 1945), 24–28. (2) "Gui de xiaomie" (The elimination of ghosts), in Fei Xiaotong, *Chu fang Meiguo* (First visit to America) (Shanghai: Shenghuo, 1947), 106–16.

Xiao Qian: Xiao Qian, *Rensheng caifang* (Covering mankind) (Shanghai: Wenhua shenghuo, 1947), 153–57.

Yang Gang: "Beidi: Meiguo shehui wenti de suoying" (Betty: A cameo of American social problems), in Yang Gang, *Meiguo zhaji* (Notes on America) (Beijing: Shijie zhishi she, 1951), 40–49.

V. FAMILIAR AMERICA

Du Hengzhi: "Xiangcun yi ri you" (A day's outing in the countryside), in Du Hengzhi, *You Mei xiao pin* (Little pieces on my travels in America) (1951; rpt. Taipei, 1966), 175–82.

Yin Haiguang: "Fengge yu caigan" (Style and ability), in Yin Haiguang, *Lüren xiao ji* (A little travel account) (Taipei: Shuiniu, 1966), 75–78; originally published in *Zuguo zhoukan* 10(13) (June 27, 1955):22.

Yu Guangzhong: "Hei linghun" (Black soul), in Yu Guangzhong, *Xiaoyaoyou* (Wanderings) (Taipei: Dalin shudian, 1969), 187–94.

"Eating in America": Cai Nengying, "Lü Mei zhufu hua jiachang" (A housewife staying in America talks about household matters), in Huang Minghui, ed. *Lü Mei sanji* (Notes on staying in America) (Taipei: Zhengwen, 1971), 34–35. "Tan Zhongguo yu Meiguo de chi" (On Chinese and American food), in Luo Lan, *Fang Mei sanji* (Notes from a visit to America) (n.p., n.d. [Taipei, ca. 1971]), 160–62. "Chi zai Meiguo" (Eating in America), in Liang Shiqiu, *Xiyatu zaji* (Miscellaneous notes from Seattle) (Taipei: Yuandong, 1977), 84–86.

Jiejun: Jiejun, "Meiguo de haizi he laoren" (American children and old people) in Huang Minghui, ed., *Lü Mei sanji* (Notes on staying in America) (Taipei: Zhengwen, 1971), 209–14.

Zhang Beihai: (1) Zhang Beihai, "Meiguo Meiguo: Qiche yu wo" (America, America: Cars and me), *Zhishi fenzi* (The intellectual [New York]), Spring 1986, 62–63. (2) Zhang Beihai, "Meiguo Meiguo: Xiari yu gou" (America, America: Summer and dogs), *Zhishi fenzi*, Summer 1987, 25–26.

### VI. AMERICA REDISCOVERED

"Cold War Denunciations": (1) *Selected Works of Mao Tse-tung* (New York: International Publishers, n.d. [1956?]), 5:447–48. (2) *Kan, zhe jiushi "Meiguo shenghuo fangshi"!* (Look, so this is the "American way of life") (Guangzhou: Qiuzhen, 1950). A slightly different version, which had been serialized in the newspaper *Nanfang ribao*, was translated in full in the American Consulate General, Hong Kong, *Current Background* no. 55, Jan. 22, 1951. (3) "How to Understand the United States," *Shishi shouce* (Handbook of current affairs), vol. 1 (Beijing, 1950); translation after *Current Background*, no. 32 (Nov. 29, 1950):5–6. (4) Hua Luogeng, "Meidi shi zenyang duidai kexuejia de?" (How does American imperialism treat scientists?), and Bo Yuan, "Fulan de Meiguo wenhua shenghuo" (Rotten American culture and life), both in *Fuhua duoluo de Meiguo wenhua* (Rotten and decadent American culture) (Shanghai: Xinhua shudian, 1950). (5) Zhou Peiyuan, "Pipan wo de zichanjieji de fuxiu sixiang" (Criticizing my decadent bourgeois ideology), *Guangming ribao*, Apr. 8, 1952; reprinted in *Sixiang gaizao wenxuan* (Thought reform materials) (Beijing: Guangming ribao, 1952), 4:38–48; translation after *Current Background*, no. 213 (Oct. 1, 1952):26. (6) Sun Sibai and others, "Qingsuan Hu Shi de fandong zhengzhi sixiang" (Eliminate Hu Shi's reactionary political ideas), in *Hu Shi sixiang pipan* (Criticisms of Hu Shi's thought) (Beijing: Sanlian, 1955), 7:137–40.

Wang Ruoshui: Wang Ruoshui, "Meiguo yipie" (A glimpse of America), *Renmin ribao* (People's daily), Oct. 17, 18, and 19, 1978. A full (but different) translation of these articles, and others by other journalists in the same delegation, may be found in *U.S. Joint Publications Research Service*, no. 72423 ("Translations on People's Republic of China no. 474: Members of PRC Press Delegation on Life in The United States"), Dec. 13, 1978.

Xiao Qian: "Yi-a-hua de qishi" (A revelation in Iowa), in Xiao Qian, *Yiben tuise de xiangce* (An album of faded photos) (Tianjin: Baihua chubanshe, 1981), 151–54; originally published in *Renmin ribao*, Nov. 14, 1979.

Fei Xiaotong: Fei Xiaotong, *Fang Mei lüe ying* (Glimpses of America) (Beijing: Sanlian, 1980), sects. 4, 6, 13, 20. The articles were earlier serialized in the Shanghai newspaper *Wen hui bao*, in twenty-seven daily installments, from Jan. 9 to Feb. 4, 1980. They are reprinted, together with Fei's *Chu fang Meiguo* and *Meiguoren de xingge*, in Fei Xiaotong, *Meiguo yu Meiguoren* (Beijing: Shenghuo-Dushu-Xinzhi Sanlian, 1985).

Zhang Jie: "Wo bu houhui dao Niuyue qu" (I do not regret having gone to

New York), in Zhang Jie, *Zai na lü caodi shang—fang Mei sanji* (On the green lawns there: Notes from a visit to America) (Hong Kong: Sanlian, 1984), 54–61.

Liu Binyan: Liu Binyan, "Meiguo: Guangkuo er xiaxiao" (America, spacious yet confining), *Renmin ribao*, Feb. 28, 1983.

Wang Yuzhong: Wang Yuzhong, *Shiyong fu Mei liuxue zhinan* (Practical guide for studying in America) (Guangzhou: Huacheng chubanshe, 1986), 115–16.

Li Shaomin: Li Shaomin, "Siyouzhi he gongyouzhi" (Private ownership and public ownership), *Baixing* (Hong Kong) 145 (June 1, 1987):25–27. We are indebted to Andrew Nathan for bringing this article to our attention.

Designer: Barbara Jellow
Compositor: ASCO Typesetting
Text: 10/13 Plantin Light
Display: Plantin Light
Printer: Braun-Brumfield, Inc.
Binder: Braun-Brumfield, Inc.